DESERT

CHAD

REPUBLIC OF SUDAN

Nile

L. Chad

BORNO

79

Bauchi
Jos

80

81

0 75 74 73 57 78
57 62

58 ADAMAWA
Wukari

61

Benue

Sanaga

91 90 93
94a 89 92
85 86

88

95

Douala • Yaunde

Lakoundje

97

97

96

99 • Mekamba

103

97

Libreville

Owe Lambarene

97

GABON

102 105
98
101 • Franceville
112
104 100 99
Djambala 113
111 CONGO 111
SUNDI 114

Boma 115

Stanley Pool

109

Brazzaville Kinshasa

CABINDA
ENCLAVE

108 110

109 107

CENTRAL AFRICAN EMPIRE

148

147

145

Ubangi

Zaire (Congo)

146

Tshuapa

Lokoro

Lulonga

Luilaka

Yenge

Lopela

ZAIRE

128

157
122

KASAI

134

127

Lukenie

119

118 116

154 Mushenge
124 127

123

129 126
LWALWA Kananga
130
159

MBAGANI
KETE-
BIOMBO

LUNDA

Lulua

132

131 155

SHABA

149 149

152

151

194

190

ANGOLA

150

153

Luanda

Cuanza

Lobito
Benguela

Uele

144

143

141 158
142
156 140
Lubutu
139

137

135

137

139

136

138

180

193

187

Lubumbashi

EQUATORIA

161

162

UGANDA

Kampala •

181

165
168
167

137

L. Tanganyika

172 169 • Tabora

189

179

171

191

192

L. Nyasa (Malawi)

186

185

M
A
L
A
W
I

KUA

189

185 184

184

188

BAHR EL

GHAZAL

White Nile

Blue Nile

160

160 • Malakal

• Addis Ababa

ETHIOPIA

RIFT VALLEY

164
163

• Nairobi
166

170

176

173

178

Mombasa

Sadani

182

174

Dar es Salaam

Lindi

183 • Lindi

Rovuma

Meluli

Lake
Victoria

175

175

TANZANIA

GOGO 177

Bafwasende

Lindi

RWANDA

KENYA

Luanda

196 197

Salisbury

ZAMBIA

• Lusaka

Zambezi

MOZAMBIQUE

ZIMBABWE
(RHODESIA)

Bulawayo

Great
Zimbabwe

Beira

Save

NAMIBIA

BOTSWANA

• Windhoek

KALAHARI

DESERT

Limpopo

Pretoria •
198
Johannesburg •
197 200

SOUTH AFRICAN

REPUBLIC

Vaal

201

Orange

202

Orange

201 197

LESOTHO
(BASUTOLAND)

199

Durban

199

SWAZILAND

Can Phumo
(Lourenço Marques)

MADAGASCAR

To Betty Gold who shares
my love for African sculpture

Arman Fillou

March 19th, 1980

Collecting African Art

WERNER GILLON

with an introduction by William Fagg

and photographs by Werner Forman, Jo Furman and the late Eliot Elisofon

RIZZOLI NEW YORK in association with CHRISTIE'S

A Studio Vista book first published in Great Britain by Cassell Ltd.

Published in the United States of America in 1980 by :

RIZZOLI INTERNATIONAL PUBLICATIONS, INC.
712 Fifth Avenue/New York 10019

Library of Congress Catalog Card Number: 79–89508
ISBN: 0–8478–0262–0

Production and design Roger Davies
Set in VIP Palatino
Printed and bound by W & J Mackay Ltd, Chatham

Contents

To Sally,
who shares my love
for African art.
Without her help,
patience and encouragement
this book would not
have been written.

Foreword

The idea of writing this book came to me when I was preparing a number of lectures on African sculpture. I found that many of the general books on the subject had become outdated and that a great number of books and articles that had been published on specialized subjects in recent years had to be constantly consulted. So rapid has been the advance in knowledge, and so numerous the fieldwork reports that to obtain the facts for even a few lectures required complicated and time-consuming research. I thought that a general survey to include as much as possible of all the accumulated new knowledge in one volume for easy reference would be timely. I hope that it will prove to be of benefit to the student and the collector alike.

Neither the study of African Art nor the collecting of it should be based solely on a number of selected masterpieces which have, in any case, been published time and time again. The principles which have governed the making of this book are to concentrate on areas more recently explored and researched, to include the work of lesser known tribes, and to select the best available unpublished or infrequently illustrated sculpture from museums and private collections. The inclusion of unusual pieces will, it is hoped, encourage the collector to look beyond the 'classical' types.

The major part of this book, dealing with regions and tribes (Part II), has been divided into seventeen regions in which over two hundred tribes are surveyed in the text and in illustrations placed—as far as possible—in context with text and bibliography.

Throughout the time it took to write this book and assemble the photography I have been most fortunate in having the enthusiastic and unflagging co-operation of many friends. William Fagg, who was my first guide through the labyrinth of African art, not only wrote the introduction, setting out new and exciting ideas, but spent much time in advising and assisting me. My thanks also to Malcolm McLeod, Keeper of the Museum of Mankind, his colleagues and his staff in the Library and Student Room. The Deputy Keeper, John Picton, and the Assistant Keeper, Dr John Mack, as well as Margret Carey gave me much of their time and their invaluable knowledge in dealing with every aspect of the book. My assistant, Carmel McGill, contributed a great deal by her research work. For the help extended to me by advice, assistance and consultation my thanks to Albert Maesen and H. Van Geluwe of Tervuren, Marie-Louise Bastin of the Université Libre de Bruxelles, Dr Stuart Fleming of Oxford University, Professor K. Krieger, Director of the Museum für Völkerkunde, Berlin, and his assistant, Dr. Rumpf, and Professor J. Zwernemann, Director of the Museum für Völkerkunde, Hamburg. The many contributions of friends among collectors and dealers are also highly appreciated. Last, but not least, I should like to thank the two persons who co-operated with me most closely, especially in the last stages, to achieve the publication of this book. To Conway Lloyd Morgan, as my editor, ever resourceful and tireless in dealing with the many caprices of an author, my sincerest thanks and appreciation. Roger Davies' work as the designer of the book is greatly responsible for its appeal and for realizing many of my ideas on the structure and organization of a book of this kind. W.G.

Tribal Names
Just a short note on the ever present problem of tribal names. The Bantu prefixes have been dropped, except in a few cases, mainly in the Cameroon. The chief reason for this decision is in the interest of clearer indexing. I thought it would be better not to have the majority of tribal names starting with Ba- and Ma- and I hope the reader will soon get used to this change. W.G.

Introduction

Collectors of the World . . .!
WILLIAM FAGG

It was high time that a book on African art should be written by a collector for collectors. In doing so, Werner Gillon has turned himself into something of a connoisseur—a rarer being, though graduation to connoisseurship is surely within the reach of any collector. Collectors will find here the means of making a vicarious pilgrimage to many of the great (and small) museums of the western world. They will also find digested for them a great part of the large and growing corpus of literature on the subject, an excellent stepping-stone to familiarizing themselves with it and developing an independent judgement. I am grateful to him for letting me introduce his book, with a few ideas I have had brewing for quite a long time.

One of the more notable characteristics of collectors is the near-impossibility of generalizing about them, yet all of them are, surely, embarked in some sense upon a journey towards the liberation through art of the human spirit. Often, after many years of close attention to business or professional duties, they have come to realize that they have left themselves too little time to develop the aesthetic side of their lives, and they therefore apply themselves to making up for lost time, first for themselves and in many cases, if they have the means, for the benefit of the world at large.

In modern civilization, collectors and museums have come to pre-suppose each other. Even if they are sometimes in competition, their fundamental relationship is one of complementary development, in which the collectors have tended to take the lead in the foundation of museums.

There is one important exception to this general tendency: the former colonial powers, in the terminal phase of their colonialism, when paternalism was giving place to altruism, began to provide museums which were planned by governments mostly on the patterns which had served satisfactorily in the metropolitan countries. But in terms of the old colonialism they were anti-colonialist, in the sense that their main object was to retain in the country fine examples of its artistic and other products. So late in the day were these museums set up that the progressive-minded (and often eccentric) expatriates who planned them necessarily worked on a 'rescue' basis, concentrating the whole effort of their usually under-staffed museums on the collection of the tribal arts in their terminal phase.

How different the situation would be if the colonial governments had given suffcent thought to this aspect of their 'civilizing mission', and in good time—early in the twentieth century! Even in the centres of international civilization, governments are none too forthcoming in their natural duty of supporting museums, and in some countries even regard them as mere chattels of government rather than the inviolable institutions, owing their allegiance to a superior law, that they are. Even their populations tend to take their museums for granted, vaguely aware of their eighteenth-century origins, first for the benefit of the cultural élites, later for the people at large; and hardly at all aware of their much older and more fundamental function in civilization, the conservation of culture, or the documentation of human achievement, essential to the cumulative character of civilization, which distinguishes it from tribal culture.

Precisely because of this non-cumulative character of tribal culture, there was a real (though unrecognized) need to present the incipient museums as only the urgent first phase of a complete museums service, to be later complemented by museums of world culture. For at the

present time there are not only no museums of pan-African culture, but there are none which collect from beyond their national boundaries. Predictably, this sometimes induces a kind of chauvinism based on ignorance.

It would be almost too much to expect governments to have been so far-sighted, but what was really needed was an anthropological approach to the implantation of such an institution as a museum, making provision for the growth of an infrastructure for it in the evolving society, and seeking the co-operation of its leaders to that end. Above all, there was a need for interested collectors among the African middle classes (which include many a millionaire), and they should have been encouraged if necessary by tax concessions and other marks of favour. To be fair to governments, the single-minded founders of the museums would probably have been bitterly hostile to any such development, seeing them rather as natural enemies than as their main support in society. But with hindsight it can be seen that the establishment of friendly relations with an incipient group of collectors would have been infinitely wiser—and that such a cultural élite could even now be fostered with immense advantage.

Lest the foregoing paragraphs should seem to some to be less than relevant to my text, let it be said, first, that museums—and collectors—are very generally taken for granted wherever they occur in the western world, and that any observations on them, anywhere, may lead to useful discussion; and secondly, that these paragraphs are really more about 'collectors in Africa, virtual absence of', than about museums, and that brings me within sight of one of the main objectives of my argument. For this would be one of the principal problems to which such an international body of collectors as I am going to suggest might very usefully address itself.

The growth of local societies, clubs, councils, etc., devoted to African (and other tribal) arts in various parts of the United States will make it possible quite soon to consider some form of loose or more formal association on at least a national scale—and if so, why should it not begin life on an international scale from the first? There is no reason why it should not be open to the world, since tribal art, like any other art, belongs to the world; and its constitution should be loose enough to encourage Canadian, British, French, Belgian, German, Japanese and other collectors to join. And this would mean that it should meet sometimes outside the USA. The foundation of such a body (national or international) will certainly tend to stimulate the growth of other local chapters, in the United States and elsewhere. As soon as possible, it should actively seek African collectors (in agreement with the African museums) and hold as many meetings as possible on African soil.

For one thing must be crystal clear—such a body cannot afford to be or to seem to be a threat to legitimate African interests, or a bulwark against legitimate action aimed at the recovery of particular pieces. Since a number of perfectly innocent collectors have been very worried about what might happen to their collections, this might seem to some too much of a self-denying ordinance. To be reassured in this matter, collectors should look at an excellent article published in the influential weekly *West Africa* (published in London and Lagos) for 13 November 1978, and reprinted in the *Primitive Art Newsletter* (New York), January 1979. It is about the establishment of the Organization of Monuments, Museums and Sites of Africa, financed by UNESCO, with headquarters in Accra, which has replaced the former organization; it seems to have resolved to take the whole matter out of the sphere of the

Figure of woman supporting a stool
Hemba, Zaïre; made by the 'Master of Buli'; wood,
55.25 cm (21¾") overall. Private collection

politicians (and who can forget their decision, on no cultural grounds, to exclude Israel from membership of UNESCO?), and put it firmly into the cultural sphere, where the generally beneficent work of UNESCO is done.

Among other things, the article says: 'The statutes of OMMSA steer a very diplomatic path in a delicate affair. In essence the aim of the organization is to foster the "collection, discovery, study and preservation of the national and cultural heritage of Africa for the information, education and enjoyment of all." An additional aim is to prevent "illicit trade in natural and cultural heritage in the Continent."

'If applied to Europe, the first objective is best achieved by locating and cataloguing of numerous collections and then ensuring that one way or another these collections are exhibited either in their present country of residence, or in their country of origin. For if the statutes are interpreted in the broadest possible way, as they ought to be, the museum would achieve its own aims and the aims of those involved in the interpretation of Africa's past, by presentation of African works throughout the world, not just in their country of origin.'

Some of the African curators and directors of antiquities have been frequent visitors to the United States and Europe in the past few years and, having met many of the collectors, must have found them not at all the satanic tycoons of legend, but people to be friends with. It is they after all, more than any others, who have elevated African art to even higher peaks of esteem—first, so to speak, sanctioning by their admiration the foundation of museums in Africa and then constantly revaluing their contents, so that, for example, the Lagos Museum is now worth many millions of dollars or pounds, quite apart from its real value to the human race as a treasure house of art.

Yet we are not blameless, and, responding to the new low-key African approach to the problem, we should be willing for example to help the poorer nations to compete in our markets, obtain conservation materials, etc. Such an association as I have suggested could do many things which are beyond the power of collectors as individuals and to that end the publication of this book may provide both a sign and a means.

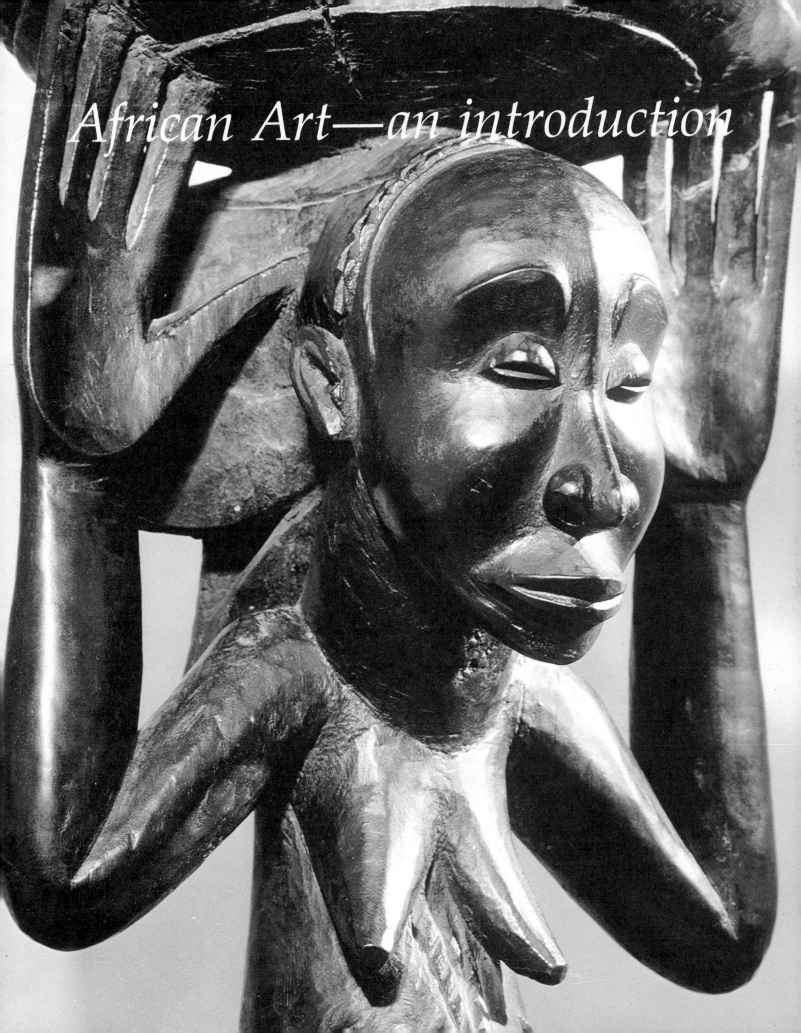

African Art—an introduction

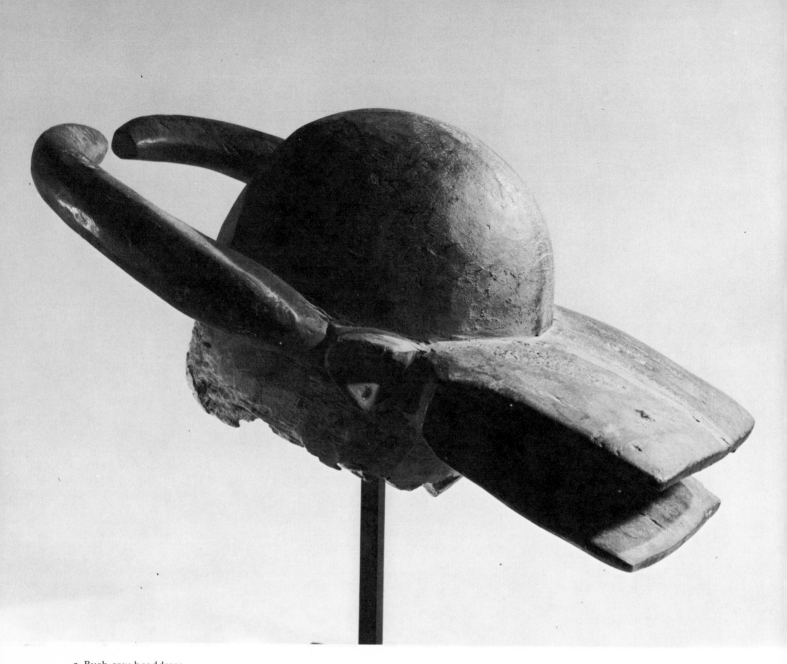

1 Bush cow headdress
Chamba, Northeastern Nigeria; wood, 63.5 cm (25"). Milton D. Ratner family collection, New York

2 Plaque depicting a warrior
Benin, *c.* A.D. 1600. bronze, 49.7 CM (19½") high by 38.45 cm (15⅛") wide

3 Stylized human figure
W. Songye, Kasai, Zaïre; wood, 54.6 cm (21½"). Coll. Josef Herman, London

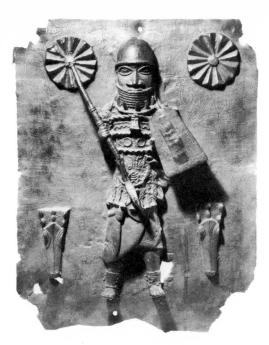

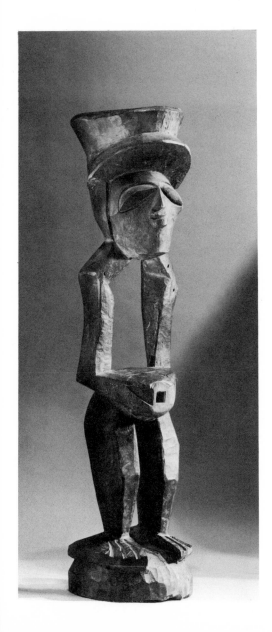

The beginning of Black Africa's sculptural art can—on present evidence—be traced back to 500 B.C. At that distant time—just after the fall of Assyria and a thousand years before the rise of Islam—great art was already being created in Africa. When Europe was emerging from the Dark Ages, the masterpieces of Ife artists saw the light of day. Thus what Europeans found when they penetrated the Dark Continent was not the primitive art of nations in the dawn of their civilization, but great sculpture, evidence of two millenia of African creative genius. Conquest and exploitation, religious conversions and dispossessions took their toll and the tribal culture which produced that art is today in a state of decline. Hopefully the new Africans, when their struggle for nationhood and independence is won, will have an artistic renaissance which will measure up to former splendours.

While it is surprising that practically nothing was known in Europe of Africa's sculptural achievements until the end of the nineteenth century, in the course of the last seventy years the art of the African tribes south of the Sahara has enriched the West and has become part of the world's heritage. Though European travellers, merchants and missionaries had contact with Africa from the fifteenth century onwards, the items of African sculpture which they brought back were regarded as curios and barbarian objects. They were not considered art, and so received neither scientific attention nor proper cataloguing. Early collections, which mainly contained articles made of ivory and stone or objects specifically made for Europeans, like the Afro-Portuguese ivories, did not convey any idea of the existence of a great sculptural tradition in Black Africa. Europe was convinced that its own pinnacle of achievement in art, based on classical Greek traditions, could not be matched by any other civilisation.

99*

At the turn of the century the movement away from the traditions of Hellenism and Renaissance art started. Artists everywhere began to paint and sculpt in different forms and styles, labelled 'Cubist', 'Surrealist' and so on. To these rebels from the naturalistic art form, the statues and masks coming out of Africa, both as a result of ethnographic expeditions and military conquests such as the invasion of Benin, made an immediate appeal, reflected in the inclusion of free forms in their own work. But while many painters believed that the African artist was freely inventing forms conceptualising in outline the human body, in fact African artists were not creating new forms but were working within the canons of a tribal tradition. Of course it is possible to approach a work of art purely through the senses, for its qualities of line, colour, texture or form: many avant-garde twentieth-century artists approached African art in such a way, and were not only among the earliest collectors but helped gain public acceptance for the forms of tribal art along with their own. But the sensed approach to art is perhaps insufficient when dealing with an alien culture. What is needed is a realized approach, that takes into consideration the social and cultural background of the work of art and the needs and ambitions of the society for whom it was created. In the study of African art

77

* The numbers in the margin refer the reader to the bibliography

3 THE STUDY OF AFRICAN ART

this quality is especially necessary: the collector should be familiar with the lands and peoples of Africa, their social organizations and religious beliefs, and the role of the artist, his techniques, materials and aesthetics, to understand the functions of masks, stools, figures and all the other objects they created.

Other non-European cultures offer the same problems of connoisseurship—but in such cases as Chinese, Indian or Islamic art written records and appreciations of those cultures exist. What makes the study of African art more challenging is the lack of such documentation: all that we have is an imperfectly remembered oral tradition, today eroded by the decay and disappearance of tribal society.

To speak of 'African' art is only a handy generalization. There are thousands of tribes, each with its own culture. 'Each tribe is almost a separate world', wrote William Fagg, 'with its own language, religion, social order—and its own art. Sculpture is actually a language of each tribe, often not understood by its neighbours.' These words, though basically correct, would not cover all aspects. For example, the Yoruba people cannot be labelled 'a tribe' but they have a sculptural language nevertheless, while Ibo art varies stylistically from village to village and in Cameroon art styles go beyond tribal affinities. Constant movements of peoples, wars and mercantile contacts throughout history all contributed to cross-fertilization and merging of styles. The style that the artist used was the symbolic language of his tribe, part of its social structure and not an escape from it. Thus the study of tribal art becomes perforce the study of the society for which it was created.

This study concerns African art, and traditionally, the area where African artists have done their best-known work is the Niger and Congo River basins with their tributaries. However, in the immense territories between the Great Lakes and the Indian Ocean, and between the Republic of Sudan and southern Africa, many tribes have also produced sculpture and some are still doing so, although it has always been maintained that with very few exceptions plastic art east of the Lakes is rather primitive and rudimentary.

The sculpture belt is bordered in the north by the Sahara, in the west by the Atlantic Ocean, in the east roughly by the Great Lakes and in the south by the Kalahari Desert. Settlement within these boundaries is concentrated around the great river systems of the Niger and the Congo. This enormous land mass includes a series of plateaux which are generally higher in the south and east. The absence of mountain barriers is the cause of irregular rainfalls. Ranges rising to 5000 metres along the Rift Valley and along the many lakes in East Africa are the only exceptions, and the country varies from sahel through savanna to tropical rain forests, though part of the Congo area is grassland with deciduous trees. In the rain forests where clearings were made and land used for cultivation the soil is poor, the climate unhealthy and living conditions hard. Humus, because of fast decomposition, does not develop to enrich the poor chemical structure of the thin topsoil and in addition the rain leeches away valuable fertilizing agents.

10

4 Ceremonial stool for members of Eze Nri Society
Ibo, Nigeria; wood, 41.30 cm (16¼") high by 31.70 cm (12½") diameter. Private collection

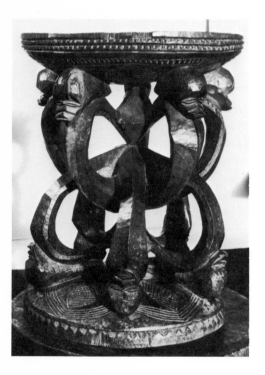

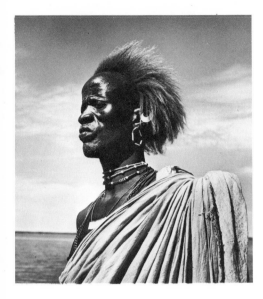

5 Man of the Dinka tribe, Republic of Sudan

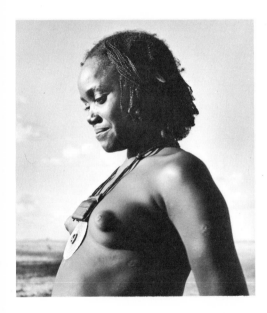

6 Woman of a Nilotic Tribe

Malaria, sleeping sickness and many intestinal diseases are endemic. The Africans' main method of enriching the soil was the burning of wood and plants in man-made clearings. The land was cultivated for three to four years, after which it was left fallow for as many as twenty years while fresh clearings were made and cultivated. The crops in these forest clearings were mainly yams, manioc, sweet potatoes, bananas, maize, rice, sorghum and millet. The isolation of the forest people from outside influences had disadvantages; nonetheless these tribes of the clearings from Sierra Leone through the Guinea coast and over Cameroon, Gabon and large parts of Zaïre produced great sculpture. The savanna stretches from the Atlantic to Ethiopia and the sahel is the land between it and the Sahara. Nowadays crops such as coffee, cotton, cocoa, palm-oil and peanuts are grown for export.

9

72

South of the forest belt is another stretch of savanna and, south again Angola, southern Zaïre, Zambia and Malawi are mostly parkland. East of the Lakes there is once again savanna, stretching on until it reaches the Indian Ocean. Mediterranean vegetation and rain forests abound along the east coast of southern Africa.

The agriculture of the savanna—and even more so of the sahel—depends on rainfall and areas are often stricken by drought. The soil is also poor and the crops produced are predominantly cereals. The forest, the savanna and the sahel had mainly a subsistence economy. Such an economy encourages the development of certain lifestyles: firstly hunting and gathering food, then nomadic cattle-breeding, and finally the settled agricultural community, which often combines elements of the other styles. With the development of agriculture a tribe has the possibility of some leisure and some surplus produce which can lead to the production of art. The social organization needed for agriculture encourages the development of fertility and ancestor rites, which such art could serve. In Africa few of the hunters and gatherers or nomadic peoples produce art, even though the rock paintings of the Sahara and southern Africa were presumably made by such people.

8

Racially the peoples of Black Africa can be classified as Negroid, Bushmanoid or Pygmoid. The Negroes, by far the largest group, are the only sculpture producers. All three peoples originated in Africa in paleolithic times, and the Bushmen and Pygmies were gradually displaced into the less hospitable areas of the Kalahari Desert and the Congo rain forests respectively by the expansion of the Negro tribes. As to the origins of the Negroes, recent classifications tend to define all the west and central Africans (usually grouped as Bantu-speaking) as of one ethnic root. It can be assumed, however, that this race of Negroes with its paleolithic origins must have over the years absorbed many invaders from north and east.

East of the Lakes, the Amharic tribes in Ethiopia are linguistically and racially quite distinct from the Negroids. The people in the south of the Republic of Sudan, the tribes of Tanzania, parts of Kenya, Zambia, Mozambique and Zimbabwe are mostly Negroids with some

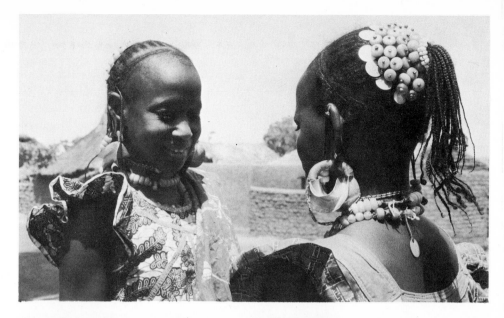

7 Young girls, Bambara, Mali

8 Young Woman, Ngbetu Zaïre
The headdress fits her elongated skull

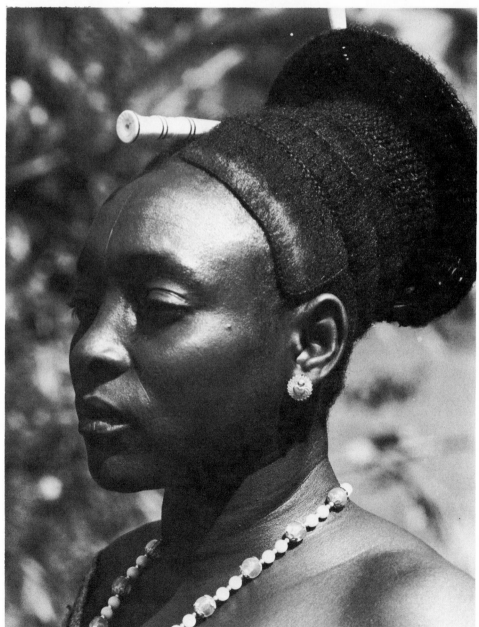

I Female Bust
Nok, Jos Plateau, Nigeria; terracotta. 53.5 cm (21″).
Formerly coll. Lance & Roberta Entwistle

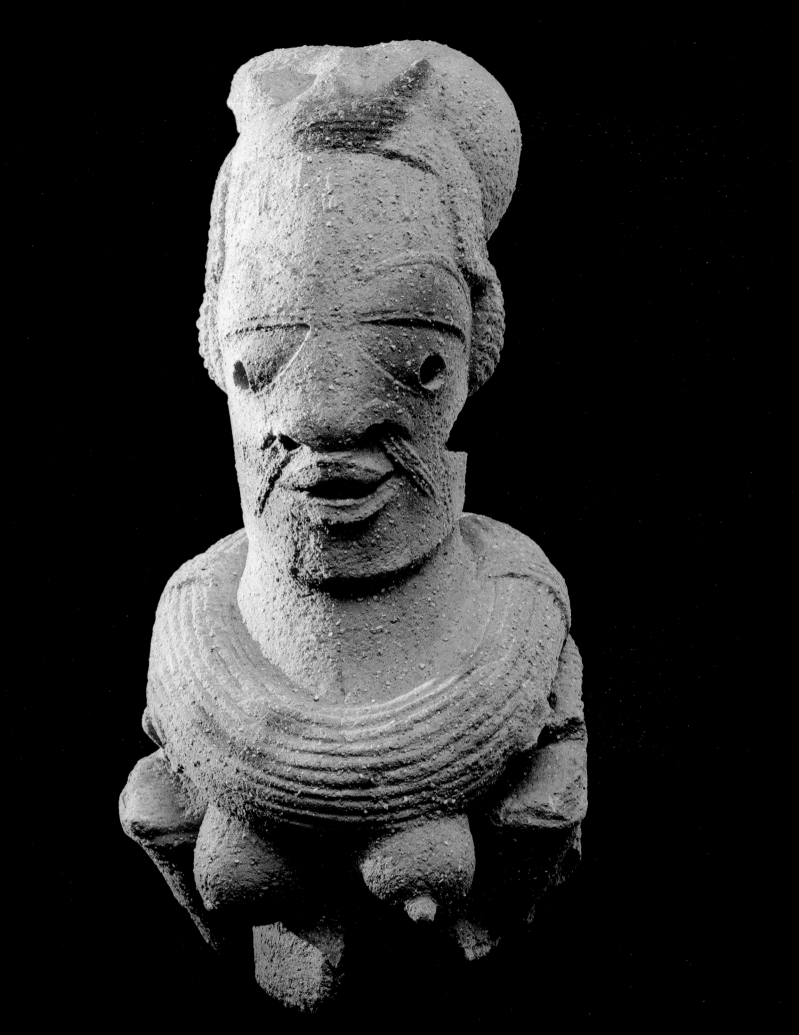

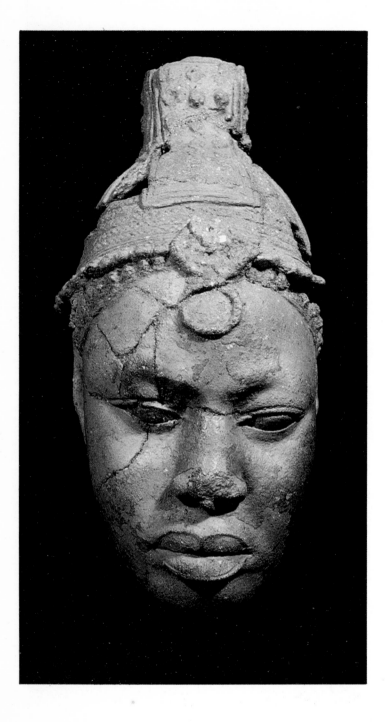
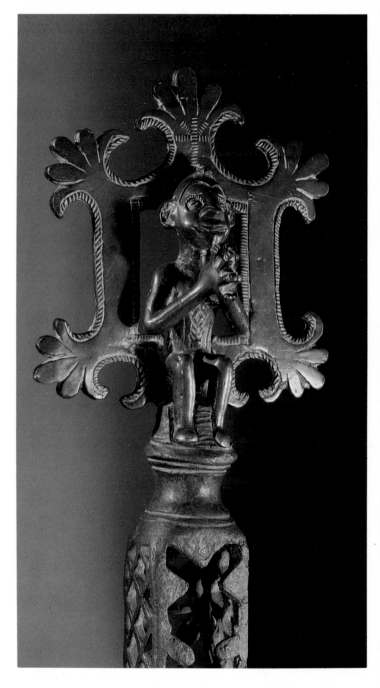

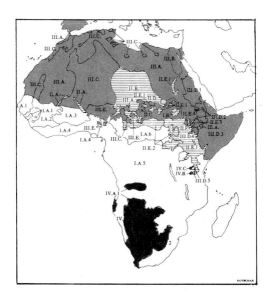

Summary of Classification

1. □
CONGO - KORDOFANIAN
I.A. Niger - Congo
I.A.1 West Atlantic
I.A.2 Mande
I.A.3 Voltaic
I.A.4 Kwa
I.A.5 Benue - Congo
I.A.6 Adamawa - Eastern

I.B. Kordofanian
I.B.1 Koalib
I.B.2 Tegali
I.B.3 Talodi } not shown
I.B.4 Tumtum
I.B.5 Katla

II. ▤
NILO - SAHARAN
II.A. Songhai

II.B. Saharan

II.C. Maban

II.D. Fur

II.E. Chari-Nile
II.E.1 Eastern Sudanic
II.E.2 Central Sudanic
II.E.3 Berta
II.E.4 Kunama

II.F. Koman

III. ▨
AFROASIATIC
III.A. Semitic

III.B. Egyptian

III.C. Berber

III.D. Cushitic
III.D.1 Northern Cushitic
III.D.2 Central Cushitic
III.D.3 Eastern Cushitic
III.D.4 Western Cushitic
III.D.5 Southern Cushitic

III.E. Chad

IV. ■
KHOISAN
IV.A. South African Khoisan
IV.A.1 Northern South African Khoisan
IV.A.2 Central South African Khoisan
IV.A.3 Southern South African Khoisan

IV.B. Sandawe

IV.C. Hatsa

II *right* Top of Staff
Kongo, Lower Congo, brass 28 cm (11″) M.R.A.C., Tervuren

II *left* Head, Ife. Excavated in 1958 at ITA Yemoo
Terracotta, 26.7 cm (10½″) Ife Museum, Ife, Nigeria

nilotic and cushitic elements, speaking a variety of languages. The coastal strip of Kenya, Tanzania and Mozambique presents a different picture, where successive waves of invasions by Arabs and settlement by Persian and other Asian peoples have created a population which is a mixture of these external elements and the original inhabitants. In the urban centres where Islam was strongest little sculpture was produced, but, inland, agricultural tribes such as the Shambala and Makonde continued their traditional tribal art.

The Negroes are divided into numerous tribes; one list giving over 5000 names, by no means all art producers. The equally large number of languages and dialects spoken by these tribes have been variously listed by Malcolm Guthrie, Diedrich Westermann and J. H. Greenberg, and such lists are a guide to the cultural development of Africa. (The illustration shows a simplified version of Greenberg's system.)

72

43

42

The family is the nucleus of African society. On it a variety of systems of kinship and lineages are built which make up the structure of many tribal societies. Most unions in Africa are based on polygyny, that is the marriage of one man to a number of women. The marriage contract involves payment for the bride in some form which varies from cattle and other valuables to bride service, which may be work performed for the bride's father over a period of time. In some areas we find an institution of bride exchange in which a sister or daughter of the husband's kinship group is given in marriage to a male member of the bride's group. The nuclear family becomes an extended family as soon as the second generation, the issue of the man and his several wives, form an extended household. However, the structure of such households varies from tribe to tribe and in different geographical areas. The next grouping in the fabric of tribal society is that of kinship, a close and very important relationship between members of the family descended either through the male line for some kinship groups and through the female line for others. Through kinship a man finds his role in society and it determines the behaviour of members to each other and towards the outside world. Obligations and rights within the kinship group are dependent on the relationship being through blood or, collaterally, through marriage bonds. In patrilineal societies the bonds are strong between a son, his father and paternal grandfather. Uncles are addressed as 'father' and patrilineal cousins as 'brother' and 'sister'. As a result of this there are strong kinship relations between practically all the people of a village, and as all men are 'brothers' they trace their origin back to one common, possibly fictitious, ancestor. In matrilineal societies the authority is not primarily with the father but with the maternal uncle, who may even receive or pay the bride money that is due.

Succession is most often first to the wife's brothers, then to her sister's sons and the sons of the sister's daughters. A lineage is an extension of kinship and consists of all who can trace their origin back to one common real—not fictitious—ancestor, and are descended through male or female lines according to the custom of the respective

group. Whether members of a lineage reside in one village or over a widely dispersed area, marriage inside a lineage is rarely permitted and the rule is in most cases that a wife must be found from another lineage group. As a consequence a village is only partly composed of members of one lineage as by necessity the wives (or the husbands) have joined the community by marriage outside their own lineage. Such grouping of people from mixed lineages have been called clans. By the same token a grouping of clans claiming lineage descent from a common ancestor becomes a tribe. Wherever people develop an ancestor cult they are usually relating to the common ancestors of the lineages.

The lineage principle is the basis for a widespread system of political organization and administration. A council of elders with a headman, elected or hereditary, convenes to deal with all disputes, cases of law and, in fact, any matter brought before it conerning the lives of individuals or the welfare of the community. Decisions arrived at by the Council are implicitly obeyed, though the only punishment it can impose is expulsion. A man so punished would become a pariah. As long as this type of village democracy kept its strength no-one would expose himself to such a risk.

70

In a village where people of several lineages live, even if these lineages are unrelated, the eldest of the senior lineage often becomes the undisputed leader. Where different lineages settle in one locality the people of the lineage that arrived first have precedence. In larger communities where a greater number of lineages is involved a council of heads of lineages presided over by the senior will sit in matters concerning the affairs of the enlarged communities. However, the councils have no power beyond advice and persuasion. It is a unique system of democratic organization which served these acephalous communities well in upholding justice, peace and cultural tradition. Even when the grouping becomes large the lineage and kinship government kept functioning as in the case of the Tiv who are said to have had administrative control of over one million people under the system. It worked well as, in a society with an economy where all that was produced was consumed by its members, no bureaucracy or military organization was possible.

In some societies, especially in east and southern Africa, grouping by age appears to have taken the place of kinship association. Boys enter an age group long before initiation. They may take over certain duties connected with cattle herding and are taught to be responsible as a group to the family and the tribe. The boys of the age set comprising, say, twelve to sixteen years old go through initiation and circumcision rites together. When these are completed they are trained to hunt and are given spears, shields and swords. The next collective duty will be as junior warriors, protecting cattle against raiders and, finally, as men organized as combat units. When they reach twenty to twenty-five years a sort of passing-out feast lasting many days takes place, and they are now considered eligible for marriage. They continue to act

together as a close fraternity and finally reach the grade of elders with powerful influence on the life of the tribe.

In many tribes fraternal or so-called secret societies play a decisive role in the religious, social and political fields. Secrecy in these societies manifests itself in a number of ways which vary considerably from tribe to tribe and even from fraternity to fraternity within a tribe. Membership and rituals are in many cases kept secret from non-initiates and in the case of male societies from women and presumably this acts also in reverse for female societies. It is very difficult to generalize as many tribes and societies are involved, and because of the limited knowledge available to outsiders. However, based on what is known, it appears that membership is generally open to all though each society has its rules as to personal qualities, social status and sex. There are also numerous cases where membership is inherited or can be bought. The societies have their clearly defined rules, constitutions and purposes and the important point is that membership can be chosen instead of being automatically allocated to a kinship or age set group. Secret societies not only give status but are the vehicles of great power. They have their own religious codes of behaviour, their meeting and cult houses and their specific insignia, costumes, masks and ceremonial figures. Members undergo initiation, sometimes requiring many rituals to graduate from rank to rank, and they have society festivals either only for initiates or for all members of the community. Many societies are not confined to a particular locality. For example the *Ogboni* society of the Yoruba has branches all over the people's territory in Nigeria, Benin (Dahomey) and across other national borders. No *Oba*, chief or head of village can make decisions of importance without the advice and consent of the elders of the respective *Ogboni* society. Other Yoruba societies are the *Gelede*, *Egungun* and *Epa*, all with their distinct ceremonials, masks and codes. The Baga have the *Simo* society, the Senufo the *Lo* and the Bambara have a great variety such as the *Komo*, *Kore*, *N'tomo*, *Nama* etc. The *Bwami* society of the Lega which regulates the entire life of the tribe is open to all male members of the tribe and to their wives. Initiations lead from grade to grade and for each of them carved images, many made of ivory, constitute badges of rank. The influential fraternity of the Dan complex is the *Go* society 136 which is an institution of recent times, possibly not more than 150 years old. Of the societies which are not confined to specific tribes or geographical areas the *Poro* is an outstanding example. It is influential in Sierra Leone, Guinea, Liberia and the Ivory Coast. The Mende of Sierra Leone have two main societies, the *Poro* for men and the *Sande* for women. The latter was always considered a unique institution in Africa, but in recent times there has been an increasing awareness among ethnographers of the existence of many societies run exclusively for and by women and there are also mixed fraternities. Hopefully further field work on this subject will be productive even if made more difficult by the ongoing dissolution of tribal societies.

Chiefdoms and other large political units can develop once the

community produces more than it immediately requires. Surprisingly the centralized African states which developed, when the economic conditions warranted it, were not democracies but divine kingdoms. Although the power of these kings was theoretically absolute, they were almost everywhere controlled by councils of chiefs and elders who guarded the state against any abuse of power. As few of the kingdoms, it seems, had built-in provisions for succession, strife, warfare and general disturbances often followed the death of a king. The fertility of the land depended on the power of the king, the immortal guardian of the seed, but when his power waned the community was in danger and the king had to be killed to transfer his power to his successor by prescribed ceremonial. It seems that this ritual regicide was rarely carried out and usually the killing was symbolical: by a new ceremonial enthronement the king was re-born and invested with fresh powers. The divinity of the king demanded other taboos to be observed. He must never touch the ground, never be seen eating, or in some cases not be seen at all, except through a veil or curtain. His subjects, when received in audience, and all members of his court and entourage must prostrate themselves before him, covering themselves with dust and ashes.

241

Chiefs were either elected, inherited their position or were appointed by the king to whom they owed allegiance. They often commanded bands of warriors and with their help seized territories where they established their rule. They collected taxes, out of which they paid tribute to the king, and acting as judges, arrested, tried and punished criminals. As with the divine king, the state of the chief's health and his sexual prowess were of great importance to the well-being of his people.

201

In some areas, chiefdoms joined to form federations which then became 'states'. With the Bembe of east Zaïre, for instance, the senior chief with the oldest matrilineal lineage ruled his own people and presided over the council of the chiefs of the federation. This senior chief had a retinue of some thirty hereditary officials, each of whom was responsible for a secret ceremonial. Some of the chiefs wore the eagle feather which bestowed on them privileges such as the appointment of important officials, which led to the creation of hereditary aristocracies.

240
201

Regarding African religion, though cosmology and beliefs vary from tribe to tribe these are generally based on animism—an assumption that supernatural power resides in all parts of creation—human, animal, plants, rocks and rivers, and this power can be tapped, controlled and directed by ritual means. The dead retain this force and the departed ancestor spirit or the spirit of an animal killed in a hunt, or that of a tree felled may constitute a danger to the individuals involved and to the tribe as a whole until assuaged by sacrifices and other rituals. In the case of the dead ancestor a sculpture or a mask may have to be made to provide a home for the wandering soul and to focus his power to help the living. Wild animals have an especially strong

9 Face Mask *Gonguli*
Used by Sande dancers clowning alongside the wearers of Sande/Bundu masks, made for the women's societies of Mende, Sherbro, Vai and other tribes in Sierra Leone, Mende; wood, 62.26 cm (24½"). Museum of Mankind, London

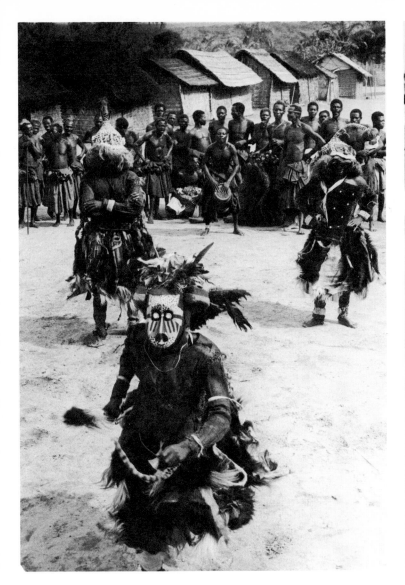

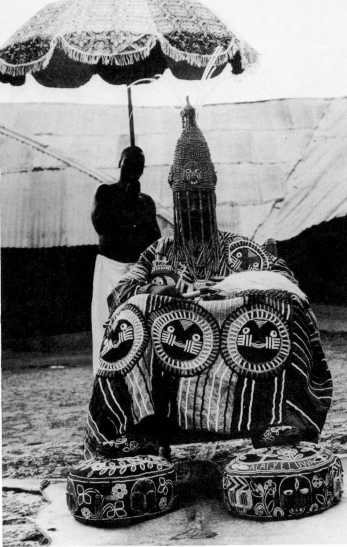

10 Dancers, Kuba, Zaïre

11 Yoruba king in regalia

life-force and such images are often used in sculpture. The representation of an animal may serve to attribute to the mask the power of that animal. The supreme god and creator is almost never represented in effigy and is addressed through secondary deities, messengers, mythical founders of the tribe, primordial and immediate ancestors, or personal and village protectors. Life force is energy rather than matter, and it is generally believed that it can be accumlated by medicine, magic, sacrifices and good deeds, and endangered by antisocial and felonious acts. When these happen, sacrifices and other ceremonies must be resorted to, to prevent witches and evil spirits from harming individuals, the village or the tribe. For such rituals, masks and figures, charms and fetishes may be used and the role of the priest or elder in the procedure is of great importance.

Movement and music accompanying the masquerades and the sculpture used in ceremonies are closely linked with every aspect of the life of the people. The performance of rituals and the production, safekeeping and use of the art objects are often regulated by powerful secret societies. The events for which the ceremonies are enacted relate

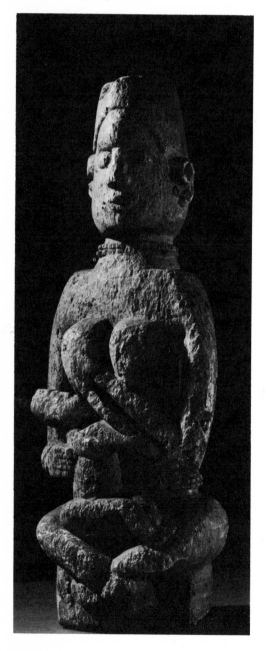

12 Ntadi maternity figure
Boma tribe, Lower Congo; steatite, 41.25 cm (16¼").
Museum of Mankind, London

to the seasons—sowing and harvesting, the desire for increase and fertility of the families of the tribe, their livestock and their fields. Man's life and its major stages—birth, puberty with its initiation and circumcision rites, marriage and death—all have their traditional rituals in which masks and figures are employed. In the administration of law and order, judges, policemen and executioners often use masks and so do the participants in the fight against witchcraft. The warrior may need charms or fetishes to protect him and a mask to frighten the enemy. Initiates into the various grades of secret societies will require badges to indicate their rank or for identification. The medicine man may use a variety of masks and images to deal with illness, bad luck, physical injury or women's barrenness, and for divination many types of sculpture are employed, depending on the tribe's tradition.

The African's approach to other religions, such as Islam and Christianity, has always been pragmatic. Africans absorbed new ideas, adapted them to their own needs and made them wholly African in the process. Quotations of the Quoran were written out and the words were then washed into a container of water and swallowed as strong medicine on a diviner's instruction. Mumuye ancestor figures were hung with crucifixes and written quotations from the New Testament. In these cases the Africans tried to make use of the power of the foreign deities by making them part of their own traditions. However Islam and Christian missionary work was—in spite of the harm done to cultural traditions—of considerable benefit to Africa as a whole by bringing literacy, learning and science to many regions.

The history of black African sculpture is now slowly emerging, based mainly on the discoveries and research of the last seventy years. Large gaps remain everywhere and for some areas of the continent, there are not even the vaguest outlines of an art history. In the meantime the difficulties in the path of research are mounting due to the accelerated disappearance of the traditional social and religious structures. Instead of the ancient system based on kinship and age, village democracy and centralized kingdoms, lines are now drawn by political party loyalties and some of the new African governments are trying to discourage old tribal faiths and customs. The spread of Islam meant for many Africans relinquishing their tribal past and traditions, but even this force with its strong prohibition of making of graven images could not completely obliterate their own art with its representationalism and symbolism. Pragmatic Muslim leaders had to recognize these facts and found it necessary to ignore the resultant syncretism.

In the absence of written records, recent discoveries and research are based on archaeology and finds of art objects in bronze, terracotta and stone, and hopes of increasing our knowledge of the history of African art are centred on future controlled excavations. African tribes preserve their history and mythology by transmitting it orally from generation to generation. Art historians and ethnographers have made use of such information but the secrecy of tribal customs and ritual, coupled with the lack of a proper knowledge of local languages, have in

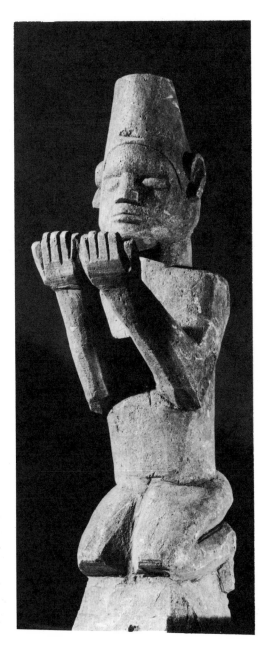

13 Ntadi—kneeling figure
Boma tribe, Lower Congo; steatite, 43.5 cm (17⅛").
M.R.A.C. Tervuren

the past impeded their work. In the last few years a number of African scholars have occupied themselves in research into their peoples' past and into the history of their art.

Items of African sculpture reached European museums and private collections as early as the sixteenth and seventeenth centuries, but little notice was taken of them. This attitude changed only towards the end of the nineteenth century when numerous objects reached Europe from colonized areas. The new trends then developing in western painting caused these sculptures to be regarded as art and more thorough studies commenced.

Among the early pieces acquired by Europeans were ivory salt cellars, spoons and hunting horns, ordered by Portuguese traders in the early sixteenth century. All were most expertly and beautifully carved and were thought to have come from Benin (Nigeria), but it is now generally agreed that the bulk is of Sherbro origin. The whole group of these carvings—usually called the Afro-Portuguese ivories —were made to order for European buyers, thus becoming the first export or tourist art. However, in spite of European themes the style of the carvings is unmistakably African in character. Very little has survived of this early work but it is believed that the known Afro-Portuguese ivories were all produced over a period of only sixty to seventy years, and they are early evidence of the skill and tradition of the African carver.

There are a few early Ntadi stone carvings in the Luigi Pigorini Museum in Rome. These were alleged to have been brought to Italy at the end of the seventeenth century. On new evidence, they came to Rome only in the late nineteenth century, but the age of the figures themselves remains indeterminate. There are also a few ivories from Benin and a Yoruba divination tray in the Wieckmann collection in Ulm, Germany. They were catalogued in the mid-seventeenth century and described as 'devilish' and 'loathsome'. Obviously, the time had not yet come for Europeans to collect African art.

6
2
99

With the exception of the Nok terracottas dating from the neolithic and early Iron Age, there are no known examples of any prehistoric sculpture in subsaharan Africa, although prehistoric paintings and engravings on rock have been found in abundance in eastern and southern Africa and in the Sahara. There, in the desolate country which was fertile land until the third millenium, B.C., rock engravings were first discovered by officers of the French garrison in about 1850, and in 1933 cave paintings were found in the south of Oran, a province of Algeria.

12
61
58
380
381
384
67
91

Prior to World War Two the French scientist Henri Lhote did some preliminary prospecting in the Hoggar and Tassili areas of the Sahara where rock engravings and paintings had been accidentally found. The war interrupted the work and the expedition which produced the general survey was only mounted in 1956 with the results published somewhat summarily in 1958. The carvings were more grandiose, and many of the thousands of paintings, more beautiful than anything

58
61

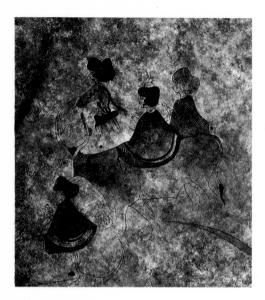

15 Rock Painting
A tribe on the move. Tassili-n'Ajjer, Neolithic period.

14 Entrance to a Shrine
Dogon, Mali

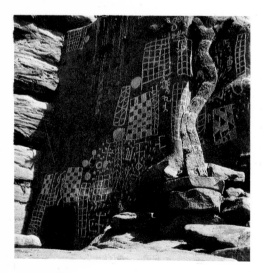

previously discovered in Africa or in the caves of Spain and France, their character varying from naturalistic to stylized and abstracted. A civilization going back possibly 7000 years in time was revealed, and a picture of the flora and fauna and of life in general in the Sahara before its desiccation. Moreover the discoveries showed the great sophistication of the art of the Africans of the pre-Christian era. Some of the paintings may be interpreted as showing masks or masked men which could mean that wooden masks were already being carved by prehistoric Africans, though on the other hand these extraordinary figures may represent supernatural beings.

In the context of the history of African art, reference must be made to the great cultures of Egypt and Meroe even though they fall outside this study. Fortunately there are comprehensive historical data on Egypt and Egyptian art going back some 5000 years. There is also reasonably good knowledge available on some aspects of the culture of Meroe—the ancient Cush—mainly gained by archaeological explorations. Though Meroe had a literate civilisation, the key to the deciphering of their language has not yet been found.

As there are proponents of a theory according to which all higher civilizations in the world derive from Egypt it is not surprising that when the astonishing art of west Africa was first discovered by Europeans, credit was thought to be due to Egypt. There was also speculation about Portuguese or Graeco-Roman and even Chinese influence to explain the unexpected artistic genius of Black Africa. Art styles and techniques were thought to have travelled south-west on the caravan routes from Egypt and the vanished Empire of Meroe. The peoples of Meroe, when their Empire disintegrated after about the fourth century A.D. probably migrated south and west and influenced the art and civilizations of the tribes they conquered or with which they merged. In particular, the spread of iron smelting into subsaharan Africa—to Nok for example—has been attributed to Meroe. Other theories based on linguistics—such as that showing the Yoruba to be an Egyptian people—must be ruled out on the grounds of lack of evidence. The Egyptian institution of divine kingship is another suggested importation, though it is now generally rejected. Nevertheless, Egypt is an African country and though its dynastic civilization bore some Asian influences, its religion, social institutions and art forms can be presumed to derive from an African basis. Cross fertilization may well have existed between Egypt, Meroe and the rest of Africa particularly through the movement of peoples as a result of the desiccation of the Sahara. For example, characteristics of much African sculpture such as symmetry, emphasis on the frontal aspect, impersonal appearance and presentation of all images as though in the prime of life, are all evident in pre-dynastic and dynastic sculpture as well, though these are qualities generally true of tribal art everywhere.

The oldest plastic art objects in subsaharan Africa are the Nok terracotta heads and figures found in northern Nigeria, in the west and south of the Jos Plateau, the home of the Jaba and other people, where

1

7

336

98

83

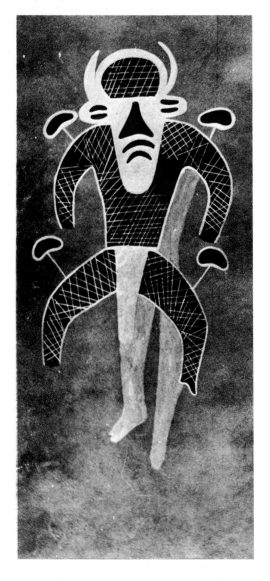

16 Rock Painting
Masked man or supernatural figure, painted in red and
white. Tassili-n'Ajjer, Neolithic period

the first of these finds was made in the course of tin mining operations.
In 1944 investigations were started centring on Jemaa, north of the
village of Nok, the very site where the first finds had been made. Credit
is due to Bernard Fagg, Director of the Nigerian Department of Anti-
quities from 1957 to 1963, for the scientific study of these discoveries.
They occurred in an area spreading some 300 miles east to west and 200
miles north to south in the valley above the confluence of the Niger and
Benue Rivers. As a result of Carbon 14 tests in a stratum containing
neolithic and early Iron Age objects, showing various results dating
the terracottas between 900 B.C. and A.D. 200, it is now believed that the
Nok culture can be dated from about 500 B.C. to A.D. 200. It has been 175
suggested that some of the terracotta heads were made by the subtrac- 176
tive method. Clay is normally sculpted by adding pieces of clay to a 99
model, wooden sculpture by cutting from a block. A subtractive
method in clay suggests that wood was also being sculpted at the same
time. The discoveries were mostly of heads and fragments of figures,
for the heads—being globular—survived better than the rest of the
sculptures when swept into the alluvial deposits where they were
finally found.

The images vary from abstract to naturalistic, human heads being
usually more stylized than those of animals. But even where human
heads are nearly naturalistic, the whole figure will have typical African
proportions, i.e. the head being one third to one quarter of the whole.
Some faces, though bearded, have infantile features, such agelessness
representing the immortal ancestor, be he immediate or primordial.
Both these aspects are found in later African art. Complete figures
would have been about 1.25 metres high and to fire pottery of that size
over an open fire requires sophisticated and experienced craftsmen.
Such achievements show that Nok art was not in the first stages of
development but had reached a high peak. Other features of Nok
pottery are found in later Ife and Yoruba sculpture, in particular the
triangular eye shapes on masks, hair styles with five buns (still found
on African women in the Nok area today) and geometrically stylised
heads. Ife sculpture is a thousand years later than Nok, and there is no
hard evidence of a relationship there, let alone with modern Yoruba,
but the similarities do point to a continuous aesthetic tradition cover-
ing 2500 years.

The tin mines and surrounding areas of Nok have yielded the oldest
examples yet known of any African sculpture, and these are all made of
clay. Discoveries at Igbo-Ukwu in east Nigeria south east of Onitsha in
Ibo country have produced the oldest known African art in bronze.
Some accidental finds were made in about 1938. Controlled excava-
tions under the direction of Thurston Shaw were carried out as
recently as 1960 and yielded a large number of bronze, pottery, iron
and other artifacts totally different in style from that of Ife and Benin
200 miles away. Insects, atypical for African art, are used frequently as
decoration on some Igbo Ukwu bronzes which together with filigree-
like ornamentation give the objects a rococo feeling. As far as age is

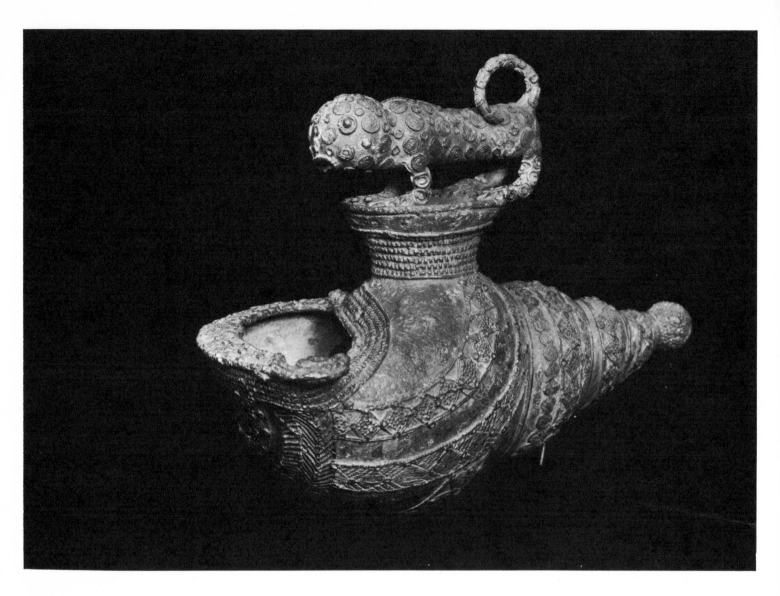

17 Ceremonial Vessel
Igbo-Ukwu; bronze, 25.4 cm (10″) long × 20 cm (8″)
high. Dept. of Antiquities, Lagos. Reproduced by
courtesy of the Trustees of the British Museum

concerned, carbon 14 tests put the period of depositing the art objects
in the ground in the eighth or ninth century A.D. It could, therefore, be
assumed that the Igbo-Ukwu bronzes were made in about the seventh
to eighth century. The fine workmanship of these intricate castings in
bronze—a medium in which, according to European thought, only the
great masters could work—is evidence of the high skill of African
artists at an early period. From the types of the artefacts and the
quantity found in an important burial site, it can be deduced that
Igbo-Ukwu was possibly the seat of a priest-king or divine ruler.

The greatest artistic manifestations in Black Africa are perhaps the
bronzes and terracottas of Ife, north west of the city of Benin in Nigeria,
in which so many art producing tribes of different cultures dwell.
Amongst them are the Yoruba, one of Africa's largest nations, number-
ing about ten millions, including those living in the Republics of Benin
and Togo. It is clear from linguistic and other evidence that the Yoruba
have been established in the area for several thousand years, though
some of their own myths suggest that they came 'from the east' at the
beginning of the Christian era, perhaps a reference to immigrants later

194, 195, 196

assimilated into the tribe. What is certainly well established in Yoruba myth is that Ife is the holy city from which their kingship originated.

According to Yoruba tradition Ife is the centre of the world. *Olurun*, god of the sky, the ruler of the universe, when he created the world, ordered divine messengers to descend to Ife with soil carried in the shells of snails. The soil was emptied into the water and chickens began to scratch around looking for food, and dry land appeared wherever the soil was scattered. Then *Olurun* twice sent a chameleon to inspect the work and when it finally reported that the land was 'wide and dry' the place was called Ife. Many tribes appear to have a myth of creation involving animals which usually are depicted in their art. The Fon in their myth had snakes which coil up to support the heavens; the Dogon a jackal, source of constant trouble. The python of the Ashanti taught the first man the secrets of procreation and the Bambara had *Chi Wara*, the son of the earth-mother and the hooded snake. Some of these stories, as in the Bambara myth, became part of tribal sculpture and dance.

The Court of the Oni is supposed to have promoted art which has been compared with the creations of classical Greece. But it is a distinctly African art, and, in spite of its high degree of naturalism the proportions of head and body conform to widespread African usage. The first European ever to see one of the celebrated Ife bronze heads—the *'Olokun head'*—was the German Africanist Leo Frobenius during his visit to Ife in 1910. He was so excited by his find that he suggested that the artists of Ife were descendants of Greeks from North Africa and he claimed that *Olokun*, the Ife god of the sea, was in fact Poseidon. When he was about to depart from Nigeria with the bronze head and a number of terracottas he was detained by the British authorities who objected to historical objects being taken out of the country. He was subsequently permitted to leave the country with some terracotta heads and figures which came into the possession of the Berlin Museum für Völkerkunde. These are among the few pieces of Ife art which are outside Nigeria, for the bulk of all the Ife objects unearthed to date are now in the Ife Museum. Among these is the *Olokun* head which has proved to be a mystery still unsolved. During a visit to Ife in 1945, the British sculptor Leon Underwood's suspicions were aroused when he saw the casting, and when three years afterwards the Ife heads were sent to the British Museum for treatment, he and William Fagg became convinced that this *Olokun* head was a copy of the original. This means, in fact, that the head presently in the Ife 178 Museum is a modern sand cast, not made in the traditional lost wax technique. Only one bronze head is known to be now outside of Nigeria and that is in the British Museum which leaves the original Frobenius *Olokun* head unaccounted for.

There appears to be little information on the functions of most of the objects—bronze, terracotta, or stone—found in and around Ife. Regarding the bronze heads, of which only seven have been found, the assumption that each of them represents an Oni of Ife is an unlikely

one. However, the absence of stylistic change in the heads suggests they may all have been produced in the span of one, or at the most two, generations. If they do not represent individual Onis, it is possible that the heads were intended to be nailed to wooden posts through holes found in their collars and then used for 'secondary burials' or obituary rites. Such ceremonies are not uncommon in Africa where the dead are usually buried quickly because of the climate and a ceremonial burial may take place after a considerable period of time. This would allow for the arrival of mourners from distant places and the collection of enough money to organize a funeral with the dignity and pageantry due to the status of the departed. The heads could thus have been used several times and may represent the royal or noble office and status rather than being a portrait of the dead person. Further evidence that the heads may represent royalty is given by the inclusion of a beaded crown in some castings and the vertical markings or striations on faces and some bodies, to represent perhaps the royal veil.

The age of Ife sculpture is slowly being established by research. In 1970 carbon 14 tests made by the British Museum and the University of Michigan fixed the time of depositing some Ife objects in the ground as about A.D. 1000, and hence the date of some castings should at present be assumed to be between A.D. 1000–1500, though an earlier date is possible. Excavations at Ife provided further carbon 14 dates ranging from the sixth to the tenth century, showing that Ife was populated at that time, without, of course, proving that sculpture was already being produced then. A time overlap with Nok becomes more and more a possibility, so that hopefully, the thousand year gap between Nok and Ife will one day be spanned, and a connection between these two distant cultures proved.

The most magnificent Ife bronze figure was found far from its place of origin. It is to this day in a Nupe village called Tada which can most easily be reached by canoe. It is one of nine bronze figures of which seven are at Tada and two at Jebba. They are collectively called the Tsoede Bronzes, having—according to legend—been brought to their present places from Idah, the capital of the Igala people, by Tsoede, a fugitive prince. This seated figure is the most naturalistic of all the Ife works, the only one in which the proportions are true to life. The posture of the body differs greatly from the usual rigidity and frontality of much African sculpture. A loin cloth is tucked between the legs, also unusual in African art. The arms and part of the right leg are missing, and as the latter, when the figure was complete, would have extended beyond the present base, it may originally been seated on a stool or throne.

Many more terracottas than bronze objects have been found, in a variety of styles, some naturalistic, some stylized or abstracted. This abundance in numbers and styles has made a study in depth of Ife art more productive than would have been possible with the bronzes on their own.

Ife stone work is being discovered with increasing frequency, and

207
99

177

though the material presents problems of dating and iconography, it will add eventually to our understanding of Ife art.

In the Ore grove—which is in the city of Ife—two large figures were found, one called the *Idena* which is about one metre high and the other called *Ore*, slightly smaller. While the latter has the usual disproportion of head and body, the Idena is almost true to nature. Also in Ife is the tallest obelisk in subsaharan Africa, known as Opa Oranmiyan, standing about six metres above ground and carved out of granite. It is said to be the staff of Oranmiyan, a mythical hero, grandson of Oduduwa, who climbed down from the sky to create the world.

Eight large stone figures were found at Eshure in the Ekiti area, north east of Ife. They are similar to, but more stylized than the Ore sculptures and nothing has so far been learned about their purpose. 173 The largest find of stone figures was made in 1933 at Esie in Yorubaland, and consists of about 800 figures carved in soapstone varying in size from twenty centimetres to 1.20 metres. Though the style is clearly related to modern Yoruba they are of uncertain antiquity and nothing is known of their original significance. They are now regarded by the 174 inhabitants of the area as primaeval beings turned to stone who continue to exercise a beneficient influence on the well-being of the community. In the rites connected with these cults, all villagers, whether 'pagan', Moslem or Christian participate.

In the great jigsaw puzzle of African art history relatively more is known about the art of the city of Benin than about any other aspect of African plastic art. Although reports had reached Europe since the fifteenth century from Portuguese and other sources about Benin, the more detailed knowledge of the art we now possess is mainly due to the violent events at the end of the nineteenth century—the British punitive expedition to Benin of 1897. The British had concluded a treaty in 1892 with Oba Ovonramwen who ruled at that time. The purpose of the treaty was the development of trade but the terms also stipulated an end to human sacrifice which had been practised for centuries. Trade was slow to develop and intelligence reports indicated no let-up in the sacrificial killings.

The British consul informed the court of Benin, that he wished to see the Oba on the subject of the treaty but was advised that the visit was not desirable during the annual ancestor ritual then in progress—part of this ritual involved considerable human sacrifice. The consul proceeded nevertheless with his large party which was attacked and massacred on the way to the city by a party led by disaffected rebel chiefs out to cause trouble for the Oba, and only two members of the ill-advised expedition escaped to tell the tale.

The Oba, apparently unaware of the plans for the ambush, and the citizens of Benin when hearing of the slaughter were seized with panic at the thought of inevitable British retribution and in their attempt to avert the impending disaster, even more sacrificial blood was split. The British force which set out to avenge the attack on the Consul's party reached the city of Benin on 18th February 1897, and when entering the

177

205

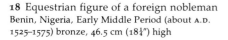

18 Equestrian figure of a foreign nobleman
Benin, Nigeria, Early Middle Period (about A.D. 1525–1575) bronze, 46.5 cm (18¼") high

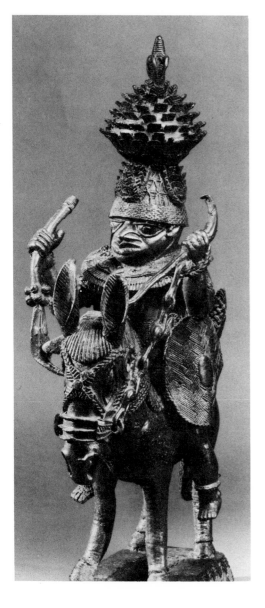

city found—according to contemporary reports—a 'city of blood'.

Vast quantities of bronzes—heads, wall plaques, altars, aquamaniles in zoomorphical form—and many figures of men and animals as well as ivory carvings were found and taken away as booty. When these 5000 objects (listed in Philip Dark's archives of the expedition) reached Europe and were studied in their new homes—mainly British and German Museums and private collections—they were acclaimed as masterpieces.

The Benin which Britain had punished was only the decaying remnant of the Divine Kingdom, the origin of which may reach back to the end of the first Christian millenium, though based on facts known at present, no date prior to A.D. 1200 can be assumed.

The Bini inhabit an area which includes the city of Benin and like the Yoruba belong to the KWA Group, but their languages differ greatly and are not understood by each other. They were—and still are—a grouping of villages, each with an elder as headman or chief but acephalous as a group. Their art is of tribal character, vital, ever changing and made for use in socio-religious rituals, such as their ancestor cult, where in shrines, rattle staffs represented the ancestors. Sculptures in the form of ram heads, were erected in memory of a chief after his death, and simpler altars served for the direct male ancestor of other families. The home of the Bini is tropical forest country bordered in the west by the Ovia, in the east by Ibo territory, reaching southwards towards the Niger Delta where the climate is very hot and particularly humid.

The art history of Benin is slowly being reconstructed. Early theoretical approaches by German historians, von Luschan in particular, have in recent years been fundamentally revised mainly by the works of William Fagg, Philip Dark and R. E. Bradbury. Based on 157, 166 myth, oral tradition, and the results of recent scholarly studies the following picture emerges.

The last of several dynasties before the present—according to Bini tradition—were the Ogiso. Though they started domestic crafts, wood and ivory carving, their rule broke down in chaos and the hereditary nobles of Benin appealed to the Oni of Ife to send them a king. The Oni sent his youngest son, Oranmiyan, who impregnated a local girl to start a new dynasty with his offspring. This story was the legal basis and justification for the dynasty formed in about A.D. 1300 and a descendant of the first Oba or King of that line is still ruling in Benin today. He is the son of Akenzua, the 38th Oba, who died in June 1978.

Bronze casting started in Benin under the sixth Oba, Oguola, who, it seems, asked the Oni of Ife to send him a master caster: previously the heads for dead Obas had been cast in Ife and exchanged for the head of the corpse. The caster Iguegha is believed to have come to Benin at about the close of the fourteenth century to found the industry.

In Benin under the new dynasty, a highly stratified society regulated all aspects of life including the arts. The various crafts were all organized in Guilds led by a hierarchy of Chiefs appointed by the Oba.

The Brass Casters Guild and the Guild of the Ivory and Wood Carvers were called the *Iguneromwon* and the *Igbesamwan* respectively. The members of the Guilds lived in special quarters of the city and their work was done either there or inside the palace compound.

Both bronze and ivory were controlled by the Oba who allocated material to the artists. Memorial heads made by the brass casters for their own ancestors were of terracotta, while ancestor figures used by others were wood carvings of animals.

Among the mass of works brought back from Benin that astonished the European art world in the late nineteenth century were a large number of bronze plaques that, according to a traveller's report of 1688, decorated the royal palace. As they were not mentioned in a report of 1702, it is thought they were taken down after a civil war. This and the depiction of traders in 16th century dress on these plaques enabled William Fagg to establish their date as 1550–1650, which he called the Middle Period. The Late Period continues until the end of the nineteenth century. Although the starting date for the Early Period (to 1550) is not clear, Fagg's chronology is now considered authoritative, based as it is both on the mass of material in the British Museum and on numerous reports. Mention should also be made of a chronology devised by Philip Dark based on known categories of bronze heads and the hypothetical reigns of the Obas.

The bronze plaques, all produced in the Middle Period, illustrate legends and often tell stories of martial events and royal ceremonial. They show various types of arms, musical instruments and ritual objects as well as a great variety of animals. The plaques are not only a chronicle of the period of Benin's greatness but their iconography is a strong link with the beliefs, customs and art of the Yoruba in more recent times. Knowledge about the meaning of the objects and decorations depicted on the plaques is therefore of importance. The symbolism of the animals as seen on many major works has been well explored. The people of Benin classified their animals in three 151 categories: 'home', 'bush' and 'transformed' animals. The difference between home and bush was caused by a rift between Ogiso of the first dynasty and the leopard who challenged him to fight. With the help of god Osanuba, Ogiso was the victor, and since then the god has permitted man to kill bush animals.

Amongst the home animals, all considered docile, vulnerable and beautiful are the cow and the antelope as well as the mudfish, the latter regarded as 'fresh and delicious food, symbol of prosperity, peace, well-being and fertility'. These were all used in sacrifices. The pangolin, a scaly anteater, is considered a 'home' animal too. It rolls itself shyly up in a ball when attacked. and its skin is considered beautiful and was used in chiefs' robes. The red flannel used nowadays instead is still called pangolin skin. In the group of home animals are also the goat, ram and chicken and they too appear on plaques to indicate sacrifices. Carvings of chickens and rams' heads were placed on altars of paternal shrines. The home animal is symbolical of the dominance of

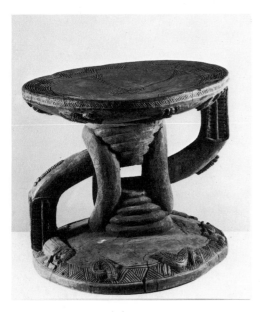

19 Ritual stool
Benin, Nigeria, 19th century; wood, 39.5 cm (15½") high, 42.5 cm (16¾"), diameter. Private collection, New York

man and may be killed by him. On the other side are the wild bush animals that attack and kill man. They stand as symbols of authority and power and comprise the leopard, elephant, python, crocodile and the fish eagle. The leopard as the king of the bush is mythologically, as in art, the counterpart of the Oba, his quality being not only ferocious power but also leadership. The elephant, as rival of the leopard, is considered lord but not king of the bush and is compared with rebel chiefs of the Bini. The python, the messenger of Olokun, ruler of the sea, was admired for its beautiful colours and its power: a brass casting of a phython over the frontal turret of the Palace of Benin is seen on a plaque in the Berlin museum. It symbolized the powers of the Oba and of Olokun as masters of the land and the sea respectively, while the crocodile shares the power of the python—though not its beauty—and is also a servant of Olokun. On plaques a warrior may be shown wearing a helmet made of crocodile skin. The Oba is the only man permitted to take human life but in the order of the world, bush animals exercise the same right under control of divine powers. If men kill a bush animal, amends have to be made and forgiveness obtained, but the Oba is allowed to use them for sacrifices.

The third category are transformed animals which are wild creatures of the night associated with witchcraft and the powers of the supernatural. They include the grey heron, the owl, the bird of ill omen (identified occasionally—though wrongly—with the ibis), the chameleon—because of its power of transformation—snakes, lizards, bats and frogs.

In this category the relationship is not one of dominance but of transformation and the witch, the diviner and the medicine man become both animal and human. The iron staff of the diviner, surmounted by transformed animals gives him supernatural powers. As with the warrior the use of iron links the diviner to Ogun, god of war.

A wealth of historical information has also been obtained from altars 158 of the hand—called Ikegobo or Ikega-Obo by the Bini, Ikenga by the Ibo. An excellent paper on the most important Ikegobo was published by R. E. Bradbury. But as the scenes depicted, apparently referring to the reign of Akenzua I in the early eighteenth century, are based on the oral tradition of one family, that of the Ezomo or the Oba's Commanding General, the object is not just an artefact but an important historical document. It shows something about the relationship of the Oba and the Ezomo, the use of ritual devices in war, the dependence of the Bini on 'medicine' to achieve victory, the types of weapons, dress and ornament of the times. Surprisingly, it reveals that head hunting was of much greater importance in Benin than had been assumed. A comparison with the altars of the hand used by the Ishan, Urhobo, Ibo, Igala and Ijo brings many similarities, apart from head collecting, to light.

Benin plaques also depict traders with their staffs and the brass *manillas* used as money. Decorative motifs include fish, the heads of Europeans, the half moon, and many types of floral and geometrical

III Female figure
Shown kneeling in front of a vessel in the form of a ribbed pumpkin; Lower Niger Bronze Industry, bronze, 20.6 cm (8¼"). Formerly coll. George Ortiz

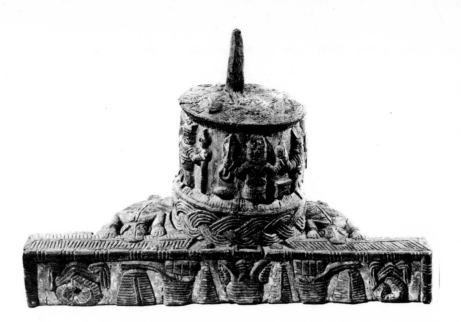

20 Altar of the Hand *Ikegobo*
The spike on top is for an elephant tusk as seen on bronze heads. Benin, Nigeria 19th century; wood, 66 cm (26″) long, 38 cm (15″) high. Private collection, New York

IV Two kneeling figures
From an ancient culture of the Djenni-Mopti area (Mali). Dated by thermoluminescence to the 11th to 13th century A.D.; terracotta, 24 cm (9½″) high. Coll. Lance and Roberta Entwistle, London

designs. It is possible that some of the most frequently used engraved decorations were inspired by similar patterns on handguns and armour bought from the Portuguese.

Plaques were made in both low and high relief, some having only one figure on a background of engraved design while on others every inch is filled. Although many of these castings are uninspiring, some do stand out as masterpieces, classified according to decorations or design as Master of the Circled Cross, and Master of the Leopard Hunt, which are in low relief extremely well modelled and composed. Only seven plaques have been attributed to the Master of the Leopard Hunt. It is possible that they appeal more to our than to the Bini sense of beauty; otherwise, one would assume these two masters might have produced many more plaques in their style.

The heads made for the Oba's paternal altar in the early period were of beautiful simplicity reminiscent of Ife style. They became more rigid and lifeless as time went on until in the late period they deteriorated into baroque sculpture overdecorated with wings and with collars so high that the faces became almost invisible. The castings, originally very fine and sometimes only one millimetre thick, became coarse and heavy.

Among the finest early Benin bronze castings are the four known heads of Queen Mothers and it is thought that these splendid works were created during the reign of Oba Esigie in the first half of the sixteenth century, who is said to have created the powerful position of Queen Mother. Other outstanding Benin bronzes represent horsemen and hornblowers. A lovely figure of a hornblower is in the British Museum and another from the Ingersoll collection recently changed hands at a record auction price. Some consider the two figures in the Vienna Museum für Völkerkunde representing dwarfs, probably court jesters, as the greatest of all Benin works, but their liveliness, vigour and total naturalism does not fit the stylistic frame of Benin art and these dwarfs may in fact be of Ife origin. Among the ivory carvings of Benin are masks worn at the waist, sceptres, boxes, handles of fly

155
156
157

159
160, 166
167
174
177
184

197

177

whisks, gongs, trumpets and items made for Europeans such as the Afro-Portuguese salt cellars. Two well-known figures in the shape of leopards belonging to H.M. Queen Elizabeth II were probably made in the nineteenth century, though other ivory leopards in the museums of Vienna, Berlin and Munich appear to be of an earlier date. That the origin of work of such importance should still be under debate illustrates the difficulty and excitement facing the collector and scholar of African art and artefacts.

A further example is the 'LOWER NIGER BRONZE INDUSTRY'. Various bronzes which were thought to be of Benin origin were later found not to be exactly in the style of known Benin castings. They had certain features in common but none could be definitely attributed to a specific origin. The eight so-called Tsoede bronzes are now included in 28 this temporary category, though the ninth, the seated male figure at Tada, is definitely of Ife origin. The celebrated figure of a hunter in the British Museum, carrying an animal over his shoulder, was found in Benin, but is also not in the style of that city. Another sculpture first classified as Benin and now included in the group of unknown origin is the bronze head from the Webster Plass collection. The masterly realization of the head places it among the greatest achievements of African, or perhaps any, bronze castings. This head is actually one of a pair, one in the British Museum and one in Berlin. 177

Much historical information is available on African peoples and tribes from early Islamic explorers from the eighth century, and from Europeans from the fifteenth century. But in all these reports there is only scant information on native sculptures beyond the occasional mention of idols. One of the Islamic chroniclers, Ibn Battuta, wrote in the fourteenth century about his visit to Mali, capital of that ancient kingdom, describing an audience with the Sultan and telling of poets reciting before the Ruler in what he calls 'a ridiculous make-up . . . with wooden head and red beak, apparently representing thrushes'.

Modern investigation started at the turn of the century. Torday's 285 expedition to the Belgian Congo (now Zaïre), on behalf of the British Museum is an example: his report on the Bushongo is one of the most 286 thorough compiled to that date. Torday stayed with the Kuba for some 287 considerable time, when elders told him the history of their long line of kings and according to their oral tradition the beginnings of that kingdom go back 1500 years. Torday was impressed but not convinced that the tale of the Kuba was historically correct. However, the mention in their recital of an eclipse of the sun and the appearance of a comet were corroborated by reference to British astronomical records as having occurred in 1680 and 1835 (Halley's comet) respectively. So Torday was able to establish the approximate reigns of Bushongo kings from Shamba Balangongo in the fifteenth century who is credited with having initiated the tradition of carving the king's image, a tradition continued in successive reigns. These royal statues, called *Ndop*, all wearing a crown shaped like a mortar board on their heads—as worn

21 Seated figure and pendant
From the ancient culture of the Djenne-Mopti area,
Mali; the figure is brass, 5.2 cm (2"), high, and (the
pendant 5.6 cm (2¼"). M.R.A.C., Tervuren

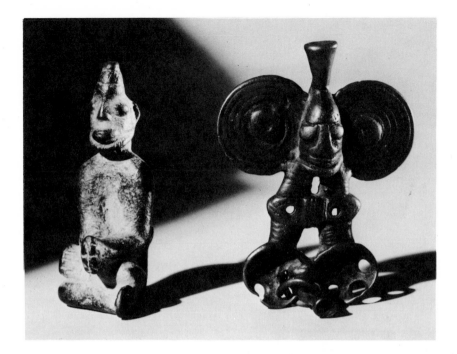

at the king's coronation—and holding a ceremonial knife in the left
hand—also resemble each other facially and were not, it seems,
intended as portraits though the Kuba claim otherwise. All are seated
tailor fashion on stools but on the front of each stool a different emblem
is carved. On one there is a drum, on others, a fly whisk, a *lele* gaming
board, an anvil and so on, said to represent the king's interests or
events occurring in his reign.

However, it is now clear that only seven of these figures, date from
before 1913, of which five were probably made late in the eighteenth
century and two early in this century. There are in addition to these
figures many more inferior ones in collections and these were certainly
made recently, some given to visitors by Kuba kings as souvenirs and
made specially for that purpose by a court carver. Many additional
figures have been produced by the 'airport art industry' and have
reached European or American markets.

In the last thirty years archaeology has also uncovered a new culture
in Mali, west Sudan. The very fine pottery group of a kneeling male
and female illustrated was tested by thermoluminescence and its age
established as between 700 and 900 years. On the strength of these and
other tests this culture, known by the general name of Djenne-Mopti
(the area of the finds), flourished between the eleventh and thirteenth
century in the region of the ancient empires of Ghana, Mali and
Songhai. The stylistic similarity with Dogon carvings is remarkable
and raises fresh questions on the history of the Dogon. Brass castings
have also been found in the area and are assumed to be of about the
same age as the pottery. The actual attribution of the 'Djenne-Mopti'
art to any particular tribe or nation remains a wide open question.

African art has traditionally been regarded as anonymous. For the

289
201

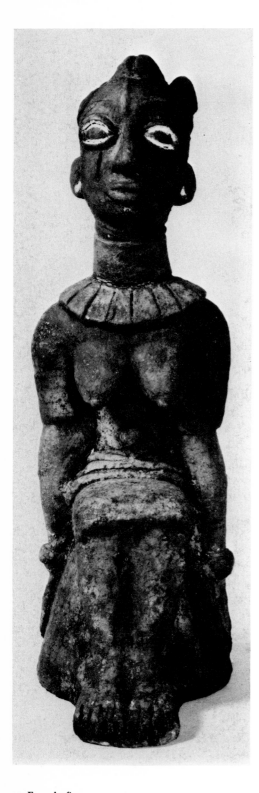

22 Female figure
Made by Azume, a woman of the Goemai tribe,
central Nigeria, 22 cm (8¼") high. Museum of
Mankind, London.

users the tribal conventions were overriding and individual skills
remained largely unrecognized. However, the increase in the number
of objects available for comparison and study, and curiosity about the
role of the artists in the social fabric of Africa, has prompted consider-
able research, notably the pioneering fieldwork of Hans Himmelheber
among the Baule, Guro and Dan. Work among the Yoruba has already
identified named families, artists and workshops, mainly from this
century. In the area of the Luba and Hemba in eastern Zaire, a number
of especially beautiful sculptures were found and these long-faced
carvings, all masterpieces, appear to be by one man or certainly one
school. The works are now generally referred to as 'by the Master of
Buli' referring to the village where they were collected. Though there
were probably two or even three masters all working in the same
workshop, one appears to have been far superior to the others.

In central Nigeria, among the Goemai tribe, identification of artists
has even led to the naming of a woman, a rare phenomenon. She was
called Azume, and died in 1950 and two fine pottery figures by her are
in the British Museum.

The motivation to become a carver or metalworker differs greatly
from tribe to tribe, and so do the methods of selection, training and
work. There are artist families with whom carving is almost hereditary,
special castes living separately in their carvers' or smiths' villages, or
simply individuals who devote themselves to work out of love for the
art, others who hope it will provide them with a good income. There
are tribes whose carvers do nothing else and those where carving is
done by farmers in quiet seasons.

Wood carving, metalwork and sculpting stone are in general the
work of men, whereas women do the weaving, basketry, raffia-work
and pottery. Until recently it was thought that women potters pro-
duced only simple household objects and that terracottas involving
imagery were only made by men—the work of Azume of Goemai was
thought to be an exception. However, this is not so. All Yoruba pot-
tery, including images, are made by women, though Ife and Benin
heads were certainly made by the men who produced the famous
bronzes. It is also now known that in northern Nigeria not only with
the Goemai but also with the Longuda, Daja and the Dakakari of north
west Nigeria all pottery work is done by women. Far away on the
Ubangi river, near the border of the Republic of Sudan, the Ngbetu
also have women potters for all terracotta work. Therefore, women
sculptors working with clay are a much more widespread phenome-
non in Africa than had been previously assumed.

The carvers and blacksmiths who master the mystery of shaping
iron and make masks or figures imbued with magic are believed to be
associated with the supernatural themselves. This may explain the fact
that some of their castes in the west Sudan are said to be 'despised'—
that is to say feared. Otherwise the artist is usually admired and often
venerated by his people. The names of the outstanding masters are
known across the land of the tribe and beyond in their lifetime, but

47
140
278/7
85

276

soon forgotten as their work is discarded when it loses its power, rots in the forests, or becomes the food of the white ant.

This insatiable devourer of wood had a beneficial influence on the continuity of tribal art in Africa, for the perishable wood used in the rain forests has an average life of only one or two decades before falling victim to climate or termites. Through the centuries the need for renewal for the continued ritual of the tribe made the carvers' training and work a necessity and kept their art alive and developing.

A notable example of a society in which artists are of importance is Benin, for the emergence of the Divine Kingdom in the fourteenth century created a need for regal splendours: thrones and sceptres as well as portrait sculpture. The brasscasters, blacksmiths and woodcarvers of Benin—the latter also carved ivory—are organized in Guilds living in special quarters or wards, headed by chiefs and sub-divided in groups equivalent to Apprentices, Journeymen and Masters. The brasscasters' Guild is called *Iguneromwon* and its overall chief is *Ineniguneromwon*. The present *Ine* is still an active brasscaster living in the Guild's ward together with a handful of other casters, said to number at present eighteen, some related by family to the *Ine*, others sons of various chiefs. Orders for castings originated mainly from the Oba of Benin or were routed through him if the work was for priests or Obas of provinces.

Some work was done outside the palace in the casters' quarters and allocated to various men or groups by the *Ine* with whom the order had been placed. However, a memorial head or other important work had to be done in the confines of the palace. The Oba would supply the raw material and the sacrificial animals needed for the prayers on commencement and completion. Thus a true group effort and close cooperation is the background for the works of Benin brasscasters.

The wood and ivory carvers were concentrated in one single ward in Benin, the *Igbesamwan*. In their case too the Guild is highly stratified with three Chiefs heading various grades. However, this order appears to be on the point of collapse as on the deaths of Chiefs no new appointments have been made by the ruling oba. Of the titles *Eholo*, *Obasonyen* and *Ine* only the chief *Ine* is still in office and has to take upon himself the care of the woodcarvers' shrine and the rites and sacrifices according to the Guild's traditions. Ivory is also a monopoly of the Oba, to whom all tusks must be surrendered, and the importance of ivory is shown by the Oba's offering a cow for sacrifice, rather than a goat, on the completion of ivory work.

While the woodcarvers of the Guild do work for the palace, village chiefs and societies are supplied with masks and ritual figures by their own artists.

The Yoruba have had the most prolific production of sculpture in Africa over the last seventy years but they now produce less and less, and very few new carvers are being trained to carry on the traditional work. However there are interesting new developments. Father Kevin Carroll employed several sculptors from traditional carvers' families in

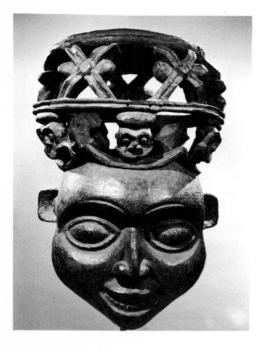

23 Mask
Kom, Cameroon; wood, 56 cm (22″). Coll. Robert and
Nancy Nooter, Washington, D.C.

24 Mask
Yaka, Kwango River Area, Zaïre; wood, fibre and
pigments, 51 cm (20″). Coll. Harold Rome, New York

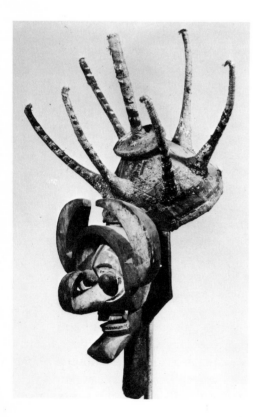

his mission school which he started in 1947 in Oye Ekiti, north east
Yorubaland. Among them was Bandele, a Catholic convert, son of the
'pagan' Areogun, the founder of the best known family of sculptors
from Osi in the Ekiti area of Nigeria. Areogun was apprenticed to
Bamgbose in the same town for sixteen years, though even after such a
long period he did not start his own workshop until he had worked
under another master for several more years. He belonged to all the
important secret societies and was a most respected member of the
community. His output was considerable and his traditional work,
enriched by themes of his own invention, is considered amongst the
best Yoruba art. Areogun's son Bandele was not trained by his father
and his work for Father Carroll, though good, never reached the high
standards of the previous generation.

In and around Abeokuta, also in the west of Nigeria, still another
style can be recognized as being from the hands of members of two
dominant local families, the Adigbologes and the Akiodes, the former
remembered as the better carvers. The founder was Ojerinde, nick- 163
named *Adigbologe* (womanizer) who was born in 1851 and died about
1914. He was a great carver, warrior, Ifa priest, owner of powerful
Ologun medicine, and a politician by virtue of his leading membership
in the Ogboni society. His son Oniyide (c. 1890–1947) was also an
outstanding sculptor with a style of his own, but his grandson Ayo and
the present carvers of Abeokuta cannot be regarded as being in the
class of their ancestors.

In Dogon society the blacksmith plays a central role due to his
association with the tribe's myth of creation. According to that story
eight *nommo* or heavenly messengers descended to earth and the
seventh of these was the blacksmith, who brought with him the secrets
of fire and iron technology. This magical knowledge and his ability to
produce tools, arms as well as wooden masks and sculpture gave the
blacksmith an aura of magic and a most influential position, for he
became the *hogon* or priest of his community and the guardian of the
shrine in which the masks and figures were kept.

The social relationship of artists in the Senufo tribe is confusing and
differs from other tribes. The blacksmiths and woodcarvers are mem-
bers of the low *Koule* caste, have their own secret society and land to 105
till, and do not intermarry with the farmers. In other words, their
power over fire and magic seems to have put them at a distance socially 114
from the rest. However, the precise relationship is not clear; in some 117
cases all the carvers appear to come from a single lineage, for example,
and the exclusivity of their secret society—the *Lo* society—is also
questioned.

In Cameroon and among the Kuba carving, casting and blacksmiths
work is considered a fit activity of chiefs and even kings, and in
Cameroon a trained carver who had served a proper apprenticeship
became at once a member of the council of elders.

An important part of the carver's life was his attendance at the
initiation and circumcision ceremonies of the tribe, for example with

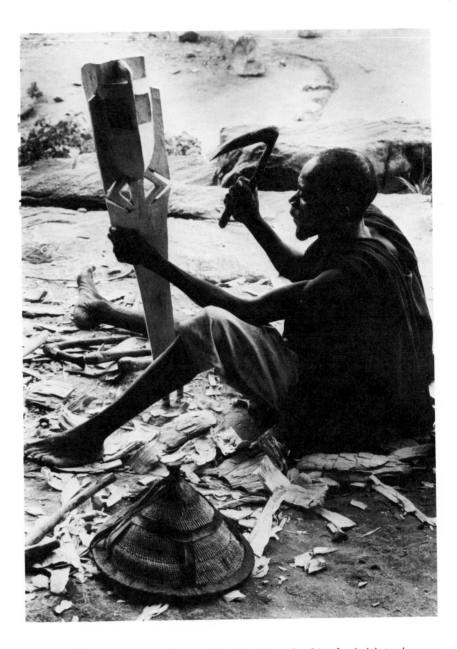

25 Carver using an adze
Dogon, Mali

the Yaka tribe where the carver lived and worked in the initiates' camp for the whole year of ceremonies.

Other tribes, such as the Baule and Guro, have no caste for artists, and masks and figures are made by the peasant farmers in their spare time. Today this work is directed at the non-African art market, for, as elsewhere in Africa, the emergence of modern states has undermined tribal structures and traditional beliefs.

Wood is the most frequently used carving material, but only a small number of the 120 species known in sub Saharan Africa are regularly used. The following are amongst the most common types:

IROKO—CHLOROPHORA EXCELSA Hard, ant resistant. *Especially suitable for houseposts and figures*

RICINODENDRON AFRICANUM Light, ant resistant
FUNTINMINA ELASTICA a rubber tree. Light, ant resistant
ALSTONIA CONGENSIS White, light, not ant resistant
CORDIA MILLENI Brown, not very hard, polishes well. Ant resistant. *Used often for masks, musical instruments, etc.*
OCONO (KHAYA SP) Not ant resistant. Type of Mahogany
AFZELIA AFRICANA Very hard. Ant resistant

Despite all the hard woods available in the Gabon the famous white masks of the Ogowe river are made of an extremely light and fragile balsa type wood possibly because some trees are believed to have special powers.

What amazes all who have seen the actual work is the fact that they were—and often still are—made with a small number of fairly primitive tools. Apart from an axe for felling trees, the carvers' basic instruments were an adze for blocking out, a knife for shaping the image, and a rough leaf for smoothing and polishing. Because green wood is easier to carve, the artist rarely puts the selected block out for drying, which in any case would expose it to the attack of insects, especially termites. Only in the Dogon country is old wood—well protected in caves—the preferred medium.

Most artists have a clear picture of the object they wish to create out of the rough block before them, and proportions of head, torso and limbs are clearly defined in the first operation. They start carving the block with the adze, a long axe-like steel tool mounted at right angles to its handle, and often they go on to shape the detailed features of the image with that tool before working in the final touches with a knife and, if desired, smoothing the surface with a rough leaf. Further finishes may then be applied using palm-oil, carbonblack, various home made pigments, resins and local or, more recently, imported paints.

17

The block is placed in front of the carver who usually sits on a low stool, wielding the adze with his right hand and turning the wood with his left. No vice or other tool for holding the work piece is known in Africa. In recent times some carvers still involved in traditional work have been using a greater variety of tools. Frank Willett describes an exciting experiment in which the sculptor Lamidi, son of Fakeye, carved a Yoruba figure in front of students in the U.S.A. Lamidi showed astonishing mastery throughout; after only a few seconds appraisal he blocked out the head and the outline of the figure with rapid strokes of an adze. The four processes—*ona lile* (blocking out), *aletunle* (dividing up the masses), *didon* (smoothing the forms) and *fifin* (cutting the details)—were performed in 126, 199, 203 and 253 minutes respectively. Lamidi stopped only momentarily for contemplation and worked rapidly for extended periods during each stage. The extent of this carver's vision of the final forms of the object may be judged by the fact that the block measured 46.4 × 15.4 × 10.2 centimetres and Lamidi removed only the planned quantity of wood achieving a sculpture measuring 46.4 × 13.5 × 9.8 centimetres. His tools were two adzes, eight straight chisels, two fishtail chisels, four sloping chisels, six

207

V *left Nkisi* Nail fetish
Yombe, Lower Congo, Zaïre; wood, nails, cowrie shell in navel, resin, beard, eyes inlaid with porcelain both legs restored below knee, (probably while still in Africa). 118 cm (46½"). Private collection

V *right* Spirit figure
Jokwe, ('Expansion' style) Angola or Zaïre; wood, 110.5 cm (43½"). Dona and Lee Bronson Collection, New York

VI Ancestor Guardian figure, *Mbulu-Ngulu*
Kota tribes, Gabon and Republic of Congo; wood plated with copper and brass sheeting 42 cm (16½"). Formerly Tara collection

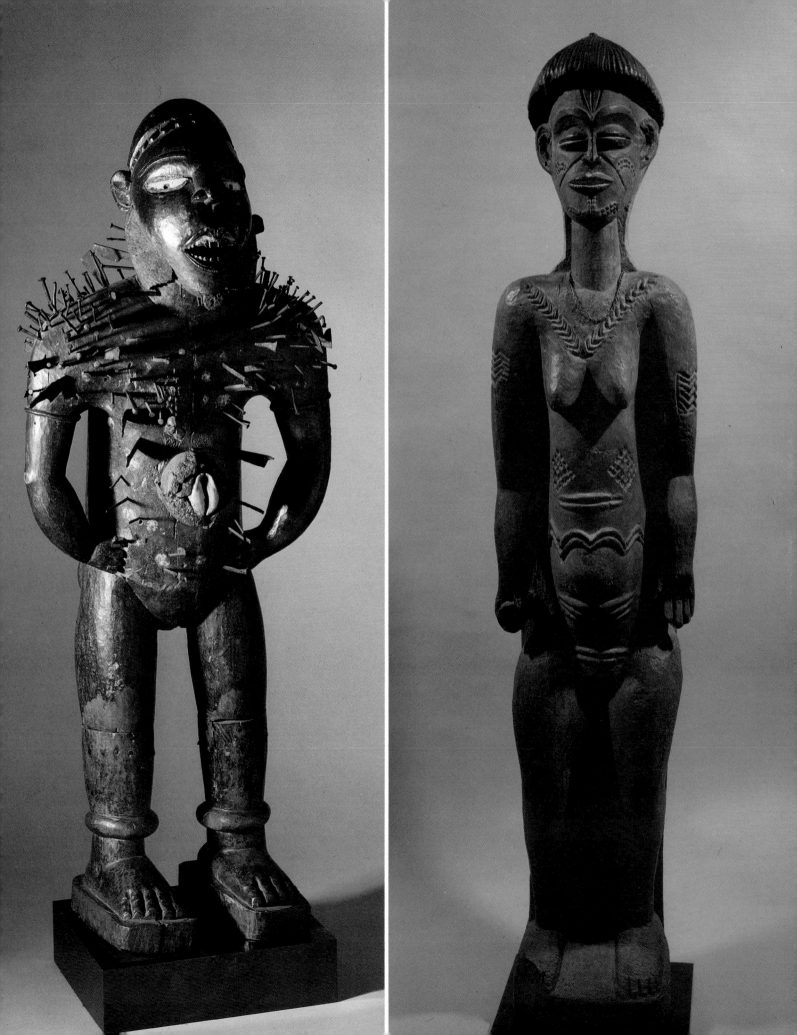

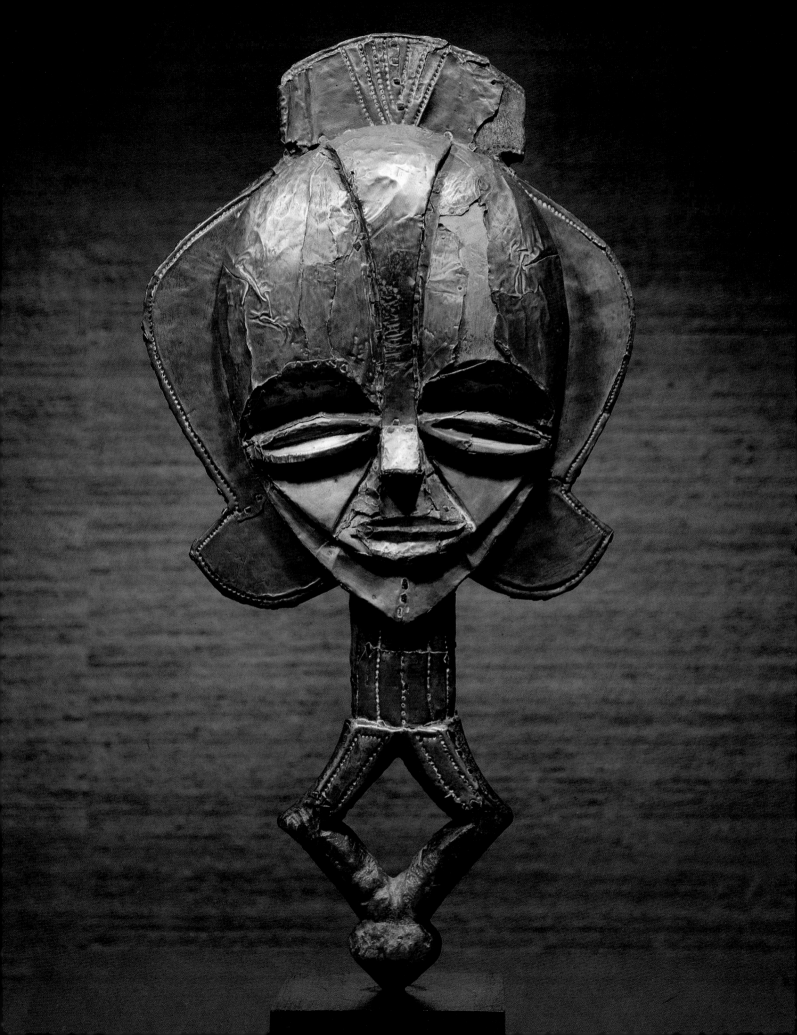

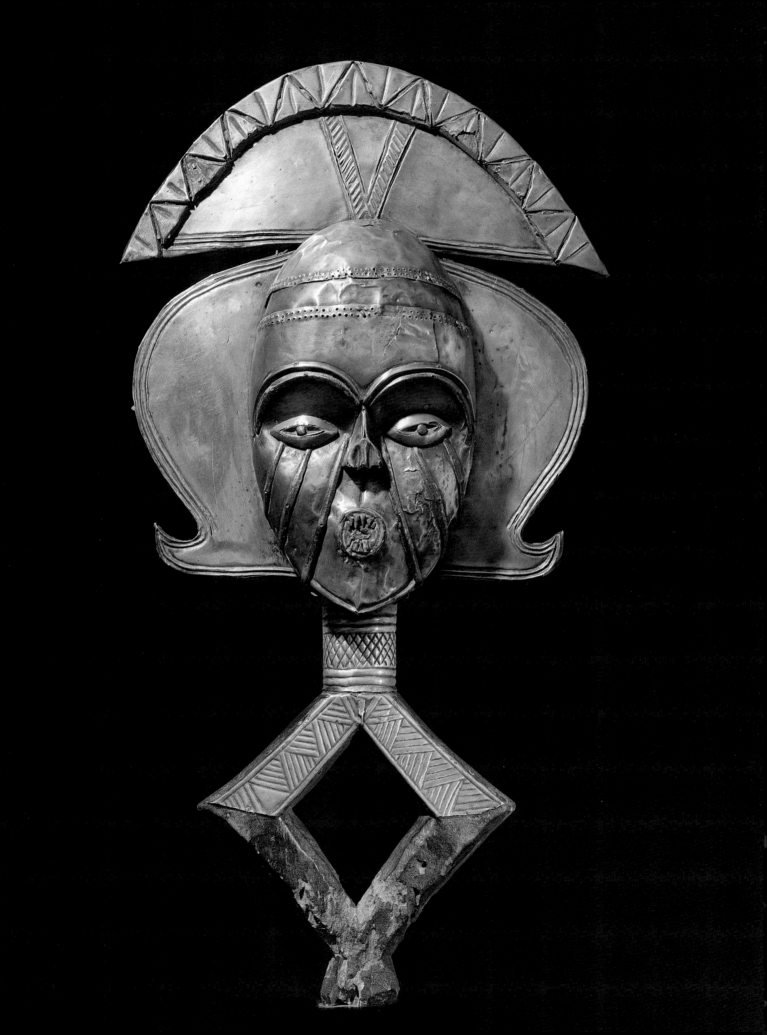

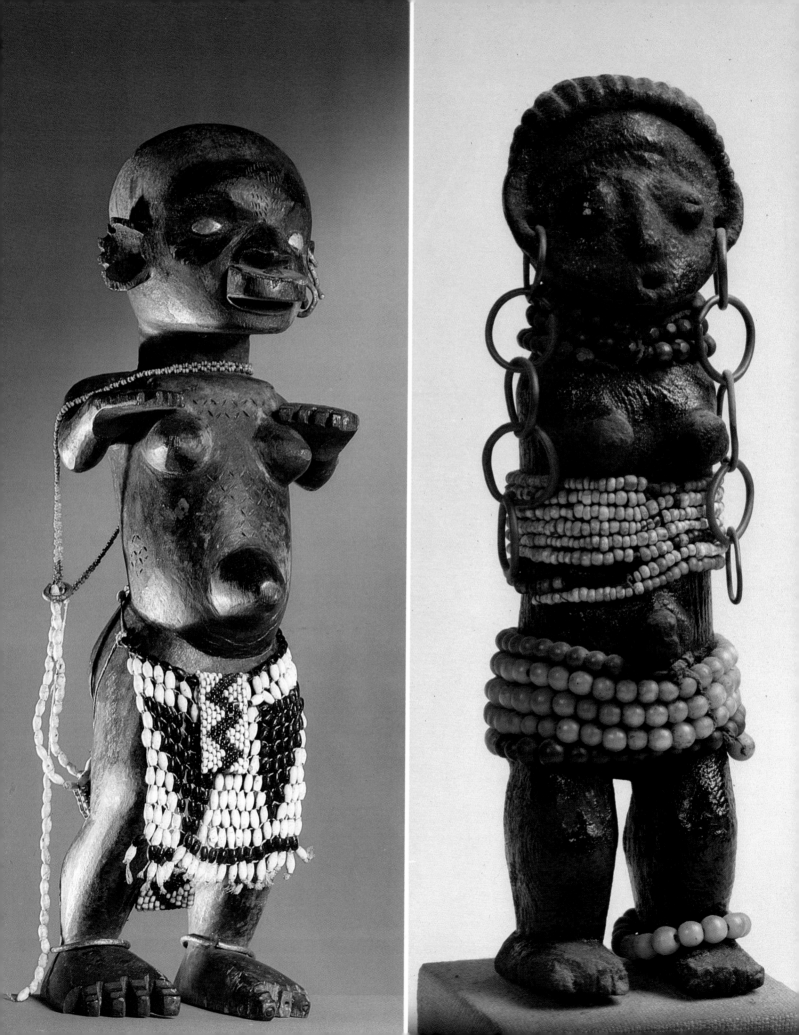

U-section gouges, five V section gouges, three traditional African knives, six Western carving knives, four folding pocketknives and a mallet. A considerable extension of the original traditional African toolkit! He did not, however, use a vice but held the carving in his hand, supported on a piece of knee-height tree trunk. His rhythm showed Lamidi's work to be wholly traditional.

African bronzes have since antiquity been made by the cire perdue method. This ingenious method allows the artist great scope for detail, as the modelling is done in wax and the resulting cast should need no additional suface working. The technique is generally as follows.

A model is prepared in clay which becomes the core, and is covered with beeswax or latex extracted from cactus. The wax is moulded and finished with great care as this work will determine the details and artistic quality of the bronze figure. Delicate projections are formed on iron wires inserted into the core and iron pegs are used to prevent the core from moving. On the top, runners and riders made of wax are then fixed and a fine layer of clay wrapped around the moulded wax. Successive layers of clay will form a strong mould which may, if needed, be bound with iron strips, and when the clay is quite dry it will be baked in an open fire to melt the wax. Meanwhile the metal is prepared in a crucible and heated and, when liquid, poured into the mould until the riders are partly full. After cooling, the clay is broken, the superstructure cut off with a chisel, and the finished casting emerges.

Though the term bronze is used to describe African metal sculpture, the conventional formula for bronze containing five to fifteen per cent tin is not found until ingots imported from Europe were available. Such few tests as have been made suggest the sculptures were in pure copper or copper admixed with lead or zinc.

Iron was not as widely used in African sculptures; as well as such items as *Tsogo* bells, iron altar pieces of the Dogon, Bambara and Yoruba, two major sculptures in metal do deserve mention. From Dahomey came two pieces both representing the God of War and Metal, *Gun* (the Ogun of Yoruba). One, totally made of iron sheet, 1.65 metres high, is in the Musée de l'Homme, Paris, and a unique figure made of rivetted copper sheet, 1.02 metres high, is in the Charles Ratton Collection, Paris.

Stone, pottery and ivory carvings have been made since ancient times. A number of soapstone figures were found in 1933 in Esie in 187 Yorubaland, but although their style relates to contemporary Yoruba, their origins and purpose are unknown. Also unknown are the functions of the carved stones called *akwanshi* 'dead persons in the ground' 2 found in the Ekoi country by the Cross river. These and other such figures are now regarded by the inhabitants as guardians of the crops and general well-being of the villages. The great value of a find of pottery is that it can be accurately dated.

Ivory was carved in ancient times in many parts of Africa where elephants are indigenous or where ivory was freely available through

VII Ancestor guardian figure, *Mbulu-Ngulu* Kota tribes, Gabon and Republic of Congo; wood, plated with copper and brass sheeting 69.5 cm (27¾"). Private collection

VIII *left* Standing female figure Makonde, Mozambique; wood, beads, metal, 40 cm (15¾"). Museum für Völkerkunde, Berlin

VIII *right* Female *Yanda* figure Zande, Wele river region, northern Zaïre; wood, beads, metal chains, 23 cm (9"). Coll. William Brill, New York

trade. We know little of the artists and their techniques, but it seems certain that in historical times ivory was worked by the wood carvers as in Benin, and from the specimens in museums it can be concluded that they produced some wonderfully intricate works of art.

The Luba, Lega, Hungana, Pende, Jokwe and several other tribes and sub-tribes were—or still are—using ivory, warthog teeth, or bones for the carving of figures, pendants, whistles and other small objects. However, less and less ivory is being used nowadays as the elephant is an endangered species and therefore protected in many countries.

The collecting of works of art is a phenomenon dating well back into antiquity. Once it was restricted to kings, the church and the privileged few, but in recent times collecting of art objects has become the pastime—indeed the passion of an ever growing number of people. In the relatively new field of African sculpture, the intending collector is faced at the outset with a number of special problems, not least what area of art to collect. Should it be a cross section of all art-producing tribes, or a particular genre, for example the miniature masks of the Dan, gold weights of the Ashanti, or *Ibejis* of the Yoruba. Or a subject such as mother and child or equestrian figures could be the theme. Whatever the basis, the real pleasure of collecting is the discovery, and possible acquisition of a further item, and to this end a collector should try to make contact at an early moment with museum curators, other collectors, experts in specialized fields and dealers whose guidance will be found invaluable. Buying the best within the means available from the most reputable dealers is of great importance in the assembling of a quality collection.

The art collector's choice of an object is mainly determined by its visual appeal to him, whereas its authenticity is largely a matter of ethnographical considerations, and the question of authenticity is a very difficult one, for which no generally agreed criteria yet exist, despite considerable disussion on the matter. There is some agreement, however, for the view that African art objects deemed genuine must have been made by a traditional artist, in the traditional forms and iconography of the tribe for use in traditional rites or for other purposes of the respective society. In some definitions the actual use in such rites is added as a criterion for authenticity.

The collector may have to make use of expert examination to establish authenticity but knowledge of some basic features can help him to draw his own conclusions. Skilful adze and knife marks and holes made by non-European tools may be proof that the carving was made by a competent traditional artist. Evidence of use can often be established by that type of patination which is caused by wear and handling, which in the case of masks is often uneven colouration with deeper and shinier highlights in places of obvious contact caused by pressure or by sweat. Sacrificial patina should in most cases be well dried and encrusted, and it too contributes to the aesthetic attraction. To achieve the desired patination a traditional artist might stain the object or treat it with mixtures of soot with palm-oil, pigments and fat or a variety of

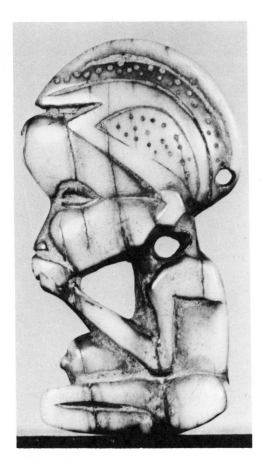

26 Pendant
(Believed to be an initiation badge); Hungana, Kasai and Congo confluence; Zaïre; ivory, 7.7 cm (3") high. Coll. Charles Ratton, Paris

other ingredients. Erosion by termites could also be evidence of age. Conversely, all these attributes can be simulated, so for instance a mask showing an overall inside patination instead of a patchy one should arouse suspicion. Patina on the outside of masks and on figures is sometimes imitated by the application of shoe polish or mud. The impression of old destruction by termites is achieved by deliberate burial or general erosion by the use of acids, which are also employed to induce corrosive patination on metal castings. The resultant colour is often a suspicious unnatural green, although the experienced faker may be able to achieve the impression of genuine old patina.

The legal definition of fake is straightforward: it is fraudulent intention to deceive. Traditional carvers were in the past only rarely directly involved in such fraud. An artist may produce an object in a traditional form and its sale to a customer without pretence of age or use is an honest transaction. If the buyer—African or European—subsequently adds patina or simulates wear and age by artificial creation of 'sweat marks', 'native repairs' or 'erosion', a fake is created and by offering it to the next buyer as an old and used work of art he intends to deceive and commits a fraud. If a non-African orders a carving in the style of the carver or that of another tribe, the article must be considered a fake if resold as made for traditional use, as old or as used in tribal rituals. Fakes vary from poor imitations to highly sophisticated creations which can often fool even the expert.

Purity of form, simplicity and spontaneity are the marks of the best African sculpture. Pretentious composition, or the exaggerated size of non-characteristic features will expose the fake to a perceptive and trained eye. It should be borne in mind also that, quite apart from the question of cross-cultural developments—whereby a Luba carving may genuinely show Jokwe influence or a Senufo mask have Guro features—styles in African art have gradually changed over the years, even though the short lifetime of wooden sculpture makes identifying such change difficult. Equally, objects produced authentically may or may not show wear or patination according to their use—a typical example being 'missionary art', produced by a traditional artist by traditional means but never used. Some tribes such as the Dogon venerate their sculpture in direct relation to its age, others discard a mask after the specific ritual for which it was made. In cases of doubt the advice of museum curators and other collectors can always be sought, and there is an increasing range of scientific tests also available.

Many modern laboratory methods are applicable to the examination of African sculpture. The age of pottery figures can be ascertained by a thermoluminescence test. A drilling will provide thirty milligrams of pottery powder from a part not visible when the piece is exhibited. The dating accuracy is about fifteen per cent. Two methods are available based on different physical principles. The first, called the high temperature method, is used for archaeological purposes and will establish the age of an object in a range from 500 to 30000 years. It relies on

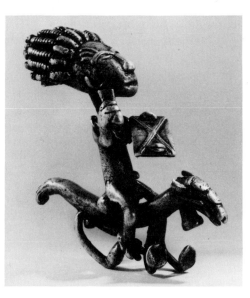

27 Goldweight
Ashanti, Ghana; brass 11.2 cm (4⅜"). Museum of Mankind, London

the fact that all materials including the clay from which pottery is made contain 'traces of natural radioactivity which release nuclear energy as they decay'. The crystals in the clay such as quartz and various types of 32 feldspar can absorb this nuclear energy. Heating of the material to 500°C will release such stored energy in the form of light, termed thermoluminescence. The firing of the pottery object in a kiln (usually 32 at 600°C) destroys the energy accumulated geologically over thousands of years and the terracotta piece thus fired is consequently at zero time. What is measured when heating in the laboratory is the re-accumulation of radio-activity. Possible influences of the environment in which the article was buried or stored are considered by the scientist when working out his equation.

The second method of testing by thermoluminescence is called the 'pre-dose' method, carried out in four stages.

1. Heating to 110°C and checking glow curve.
2. Heating to 500°C. 3.Reheating to 500°C.
4. Application of a further test dose at 110°C.

This method produces accurate dating from 500 years to the present. An examination by this relatively new technique of—for example—an Ashanti funerary head establishing an age of 300 years would authenticate it beyond any reasonable doubt. The apparatus for such tests is, alas, only available in a very limited number of laboratories such as the Research Laboratory for Archaeology and the History of Art at Oxford University, until recently under the direction of Dr Stuart Fleming, one of the few experts in this field.

Thermoluminescence is also useful for the dating of metal castings, providing a sufficient quantity of the core material—which is earth containing minerals—is left in any part of the casting. A small sample of the core must be removed by the scientist and it will then be subjected to the same tests as terracotta. The energy of thermoluminescence in the crystallized minerals of the core was destroyed by the heat generated during the casting process. The absorption of radioactive energy recommenced with the cooling of the brass or bronze casting and its remnants of core. The measuring of the thermoluminescence of the sample of core will date the casting itself. As the core is inside the metal casting, radiation emanating from the area where the casting stood—say inside a shrine—is environmental—and could be a source of error in arriving at a dating. For a Benin bronze of the middle period for example the margin of error would be about forty years. Analysis of the metal itself is of little use in establishing authenticity or age of African metal castings, as the composition of even Ife and Benin castings is far from constant.

Examination by high power optical microscope can assist in checking patination, which if natural, will show deep pitting of the metal's surface: artificial corrosion will show up as a clean line between metal and patina. Many genuine objects were cleaned after collection, including some of the Benin bronzes taken out of Nigeria in 1897. Some of these may have been later re-patinated by artificial means. As a

result it is possible to have an artificial patina on a perfectly genuine piece.

Ultra-violet lamps are useful as they disclose the fluorescence of repairs, additions of resinous material and new castings produced from indigenous scrap metals. This method must be cautiously employed as after a decade or so organic material used in repairs may no longer show up. The lack of fluorescence is therefore not proof that there have been no repairs or other attempts at 'improvement'. The user must also be familiar with the appearance of a genuine surface of pottery, metal or wood when exposed to ultra-violet luminescence.

The use of ordinary clinical X-ray machines, similar to those for examining paintings, have proved very helpful for exposing certain fakes in wooden sculpture. In a recent case an African wood figure was 84 X-rayed and showed that all four limbs had been attached by dowelling, a technique never used by traditional African carvers. The X-ray photographs of the figure also showed the use of nails and extensive repairs with a plastic paste. Instead of having been carved out of one piece of wood the sculpture had been built up. A clear case of fraudulent faking was thus established by a relatively simple method. The Service d'Anatomie des Bois Tropicaux of the Musée Royale de l'Afrique Centrale under R. Dechamps in co-operation with the department of Cultural Anthropology under A. Maesen of the same museum is making a very important survey on the 'Anatomical identification of wood used for sculpture in Africa'. Between 1970 and 1975 they surveyed the sculpture of a considerable number of tribes of Zaïre and Angola.

The identification is made by studying the internal structure of the wood. A sliver is taken from the art object and the specialist examines it under the microscope and compares the structure with specimens in the large library of the Service Anatomique. Working closely with the museum's ethnographers it is usually possible to draw conclusions as to the origins of the piece which are of great value to the museum's curators or to collectors.

The carbon 14 process which has already been mentioned is based on the fact that the ageing of organic material is matched by its gradual loss of radioactivity. It is an important tool of archaeology and indirectly the age of the pottery figures of the Nok culture and that of many other sculptures excavated by scientific methods has been determined with accuracy. When used to establish the age of wooden sculptures divorced from their archaeological context it can be very misleading, as it is is no proof of authenticity. The examination provides proof of the age of the wood but not that of the figure.

Establishing the authenticity of ivory carvings is very difficult indeed. Any old piece of this material might still have been carved very recently and all available testing methods would be useless. Through long exposure to the elements, close contact with the body in the case of pendants, constant handling and the customary treatment with palm-oil, ivory takes on a beautiful patina from yellow to red. Forgers

try to induce the coloration by inserting the object in tea, urine or other acid material, by heating it and rubbing with palm-oil to fake the natural or ritual processes. Familiarity with the styles of the respective area and assistance from laboratories and specialists can help to determine whether the object is genuine or not, but without considerable experience or an expert opinion the acquisition of ivories is always risky.

The rise in the number of forgeries coming on the market in recent years is due to several factors. Most African states have introduced strict export prohibitions to protect their artistic heritage. This has led to an almost total drying up of supplies from Africa and to an increase of prices for objects already in the West. Investment buying and the acquisition of art for tax advantages, particularly in the U.S.A, have caused some prices to rise to an unhealthy degree. Such commercialization may have a dangerous effect on the market for African sculpture which—though growing fast—is still relatively small. Nevertheless, high prices for African masterpieces comparable with those paid for objects from other cultures have become a fact of life. Sales of important collections in recent years highlight this development and some of these auction sales were watersheds.

The sale in 1966 of the Helena Rubinstein Estate brought five figure prices for the first time for African wooden sculptures, when a Senufo rhythm pounder, a Bangwa dancer and a Fang head sold at $27000, $29000 and $24000 respectively. Even so the prices Parke Bernet then achieved seem low in comparison with today's figures, especially for Congo material. When in 1975 part of the Tara Collection was sold, a small Luluwa figure and a Shira-Punu mask were knocked down at an unexpected £20000 each.

Prices also rose well above estimates in the Christie's sale of the Hooper Collection in London in 1976. A fine Owo ivory bowl went up to £22000 and a Yoruba maternity sold for £4400 while a Yombe carving went for £4000 against an estimate of £600 to £1000. In 1978 Christie's sold a wooden Jokwe carving at the record price of £220000. However, auction prices are not infallible evidence, for one could equally list occasions on which prices reached nothing near expectation. Yet the upward trend in the market of African art can be clearly perceived from the results of sales over the last twenty years.

With the virtual drying up of supplies from the African continent itself—only a trickle reaches Europe and the U.S.A. through Wolof or 14
Hausa traders—the chief sources for collectors are now in the West. 14A
Apart from auction houses, these are mainly the many reputable dealers in France, Holland, Belgium, the U.K., Germany, Switzerland, Italy, Denmark and in many towns of the U.S.A. and Canada. The grand days of the great field collectors such as Lemm and Emil Storrer are now gone, but the collecting of African art can still remain an exciting activity, demanding a combination of flair and connoisseurship that is perhaps unique.

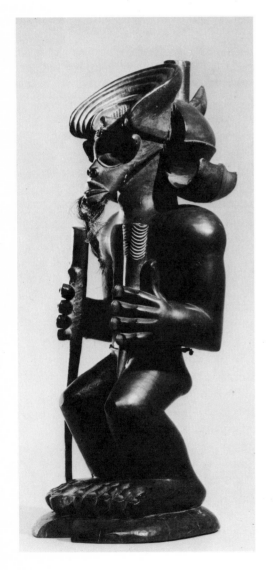

28 Statue of Chibinda Illunga Katele
He is holding a staff and a carved antelope horn and wearing a *Mutwe Wa Kayanda* headdress Jokwe, (Ujokwe style). Angola; wood, hair, leather, 40.5 cm (16″)

The Regions and Tribes of Africa and their styles

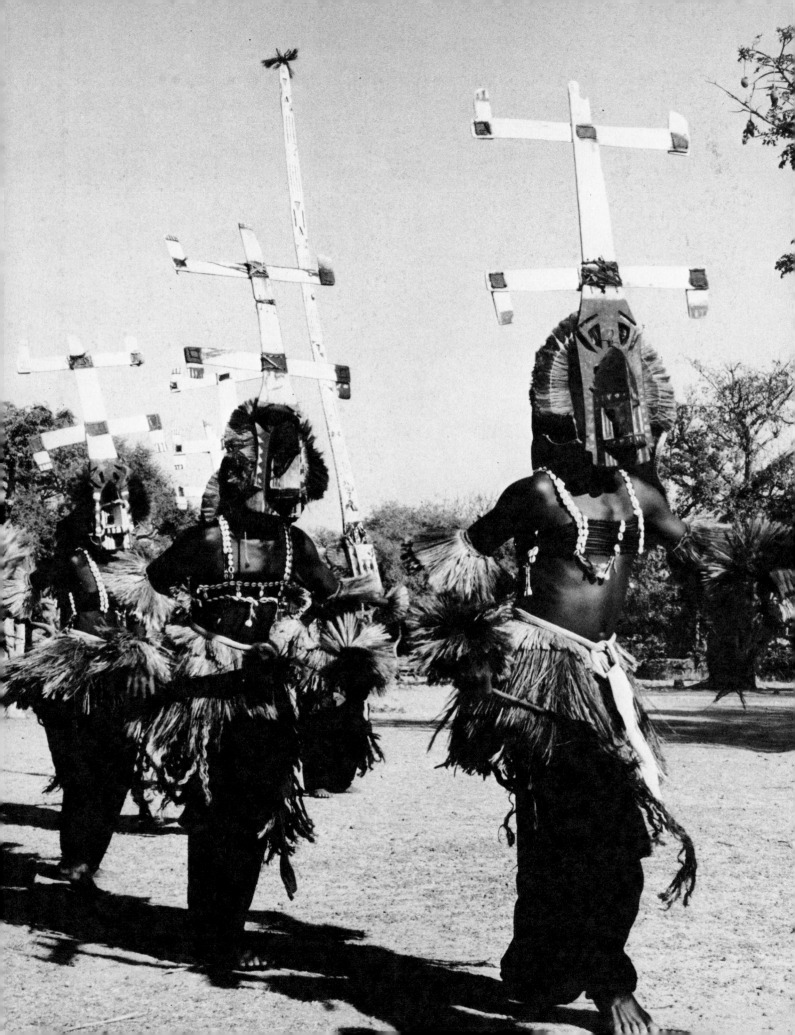

The immense diversity of styles in Africa is the result of separate development of sculptural art in tribal communities and regions, and the influences of indigenous populations and invading migrant tribes on each other. These styles—the subject of this section—vary from naturalistic to expressionistic, cubist to figurative. In spite of this diversity there are certain common characteristics in the treatment of forms and masses in most African sculpture, wherever it originated.

The late Frans M. Olbrechts suggested a number of criteria for analysing the style of African sculpture. For example, he suggests for figures: considering the absence of natural human proportions, the exaggeration in the size of the head, the degree of frontality and vertical symmetry, a lack of movement, and the use of colour (rare except in regions much influenced by Europeans). Olbrechts enumerated the basic characteristics by which regional and tribal origin of figures can be recognized: the posture of the image, bodily proportions, shape of torso, details of hairdress, scarifications, shape of eyes, ears and mouth, hands and feet and type of dress or ornaments. 278/7 100 15

To this must be added that considerable differences may occur in the style of figures and masks originating from the same tribe or region. Figures that are almost naturalistic may be paralleled by highly stylized or cubistic masks.

Masks are sometimes better classified by regions rather than by tribes as their use is often connected with the activities of secret societies whose influence could affect the cultural life of more than one tribe or group.

The media used can also lead to variations in style, particularly with ironwork and stone-carving. In each case tribal characteristics can be recognized and similar basic criteria will fit work in each of the various materials, for African art is conceptual and the sculpture is the traditional tribal image which does not represent an object as seen by the eye but as conceived by the society for which it is created. It is not the portrait of an ancestor or of a woman for example, but, consciously divorced from naturalism, represents a subject as the tribe thinks of it, not as it sees it. Each sculpture is a message about the mysteries of creation, of religion, of supernatural powers, of history, or a symbol of social structure. 21

I Western Sudan including Upper Volta

The savanna, stretching from the Atlantic to the Nile Valley south of the Sahara was called by invading Arabs Bilad-as-Sudan—the land of the blacks. In its western part, bordering on Mauritania, Senegal and Guinea, in the modern states of Mali and Upper Volta, live a number of the tribes which produced some of the great sculpture of Africa. They had no written language and their history has been transmitted orally from generation to generation, though details can sometimes be corroborated by reference to the chronicles of early Arab travellers.

The DOGON people of Mali live in a stretch of savanna near the bend

29 Dogon Dancers
They are wearing *Kanaga* masks and one 'Great Mask' (in centre); Dogon Tribe, Mali

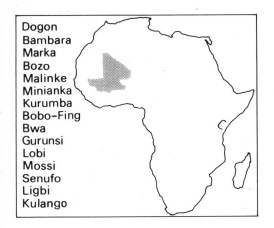

Dogon
Bambara
Marka
Bozo
Malinke
Minianka
Kurumba
Bobo-Fing
Bwa
Gurunsi
Lobi
Mossi
Senufo
Ligbi
Kulango

of the Niger around the cliffs of Bandiagara. According to their traditions the area was once inhabited by the 'little red *Andumbula'*, believed by some to have been pygmies, a common myth in many parts of Africa, and the immediate predecessors of the Dogon were a people they call the 'Tellem'. They themselves, the Dogon claim, came from 'Mande country' and took refuge in the cliffs from the marauding Mossi armies and advancing Islam. This is borne out by the history of the ascent of the Mossi and the disintegration of the Mali Empire in the fourteenth and early fifteenth century. However, recent research in the Bandiagara area and elsewhere throws doubt on the Dogon oral tradition. The Dogon in their mountain redoubt succeeded—until the present century—in resisting the Islamic religion, in spite of the proximity of such Islamic centres as Timbuctu and Mopti. Now they are gradually becoming Islamized and their ancient ceremonies are sometimes performed for tourists.

Thanks to the work of French teams of explorers of the Ethnological Institute of the University of Paris and the Musée de l'Homme under the leadership of Marcel Griaule a great deal is known about the sculpture of the Dogon. Their numerous masks, in particular, have been classified through observation in the field and their use is probably better documented than is the case with most other African tribes. However, the methods of basing the interpretation of Dogon mythology and cosmology on the stories told by village elders through interpreters to Griaule, Germaine Dieterlen and others have been the subject of criticism by more recent researchers. Some stories, though, it seems, are corroborated by the iconography of the sculpture, but even in such cases sumbols may create the myth rather than the myth being the cause of the symbolism.

The Dogon myth of creation is that the great god Amma sent his messengers in the form of eight *nommo*—four twins, each pair male and female—to create the earth, man and all other living creatures. One, who descended in an ark, was the blacksmith who brought with him the knowledge of fire and the forming of iron as well as seeds for agriculture. As the *nommo* twins were the primordial ancestors of man, brother and sister are considered to be ideal mates, but due to the taboos against incest in Africa such a relationship remains ideal in theory only. Other myths concern the crocodile, the snake 'Lebe' and 'Dyugu Seru' who committed incest with his mother, the earth. Sculptures show him hiding his face in shame, though other interpretations are that the figures hiding their faces represent thieves. In initiation rites and at the Sigi festival held once every sixty years, the myths and ceremonies undergo constant renewal. As each generation reinterprets the sculpture and the legends connected with it, changes most probably occur both in the myths and in the figures or masks associated with them, despite the rule that initiation shall be presided over by an elder who must have participated in at least one Sigi. The special Sigi mask (Great Mask or Mother of Masks) which is over three metres high can be seen in the centre of page 38.

103
106

107
108
109
115
116

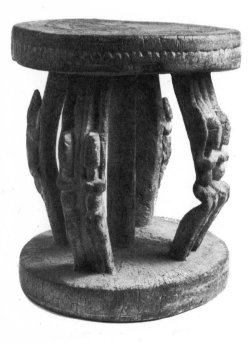

30 Altar
Supported by centre column and four pairs of Nommo;
Dogon (Tellem style), Mali; wood, 35.5 cm (14")

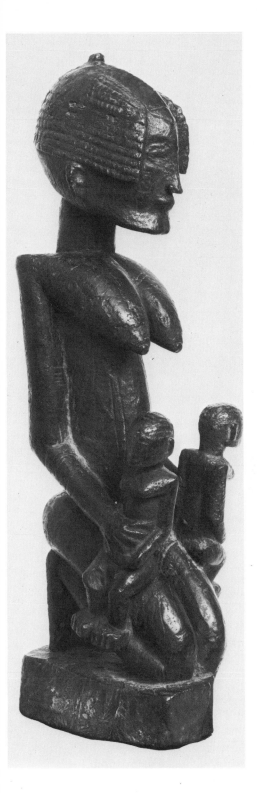

31 Kneeling Woman Holding two Children
Dogon, Mali; wood, encrustation, 39.5 cm (15½"). Private collection, New York

In the Cliff Country bundles of wood carvings held together with iron chains were said to have been found in caves. The Dogon claimed these to be the work of their predecessors, the Tellem who left the area to settle in the Yatenga region of Upper Volta, where they are called Kurumba. This is part of the oral tradition of the Dogon which has for long been hotly debated. In 1977, an exhibition called 'Tellem' was held in the African Museum, Berg en Dal, Holland. In the catalogue Bedaux reported on the research done in Dogon country and Upper Volta which dealt with aspects of archaeology, ethnography and physical anthropology. The findings were that though human occupation in the area by unidentified people can be dated back to the third and second centuries B.C. the Tellem did not arrive until about the eleventh century A.D.: no trace of human activity in the intervening period of about 1300 years could be found. The Tellem people lived in the Sanaga area from the eleventh up to and including the fifteenth century. Consequently only such wooden figures which can reliably be dated to that period should be attributed to the Tellem. Any more recent carvings in 'Tellem' style would have been made by the Dogon.

Carbon 14 tests were made by Tamara Northern for the Museum of Primitive Art, New York, and, though unsupported by archaeological evidence, seemed to the team to be sufficient support for the theory that a Tellem culture produced some of the carvings. These tests, which are still unpublished, were based on thirty figures not specifically identified in the report which apparently divide into three types of differing degrees of abstraction: human figures, often with arms raised, said to be of the 'Tellem' period: figures of animals, all dated from the fifteenth to seventeenth centuries, and more naturalistic human figures of the Dogon culture. Encrustation is no guide in this, for 'Tellem' figures—if such they be—may have none, while later Dogon figures may show sacrificial patina.

The researchers found no evidence when checking skeletal remains in Yatenga Province, Upper Volta, of morphological similarities to the remains found in the Dogon country, and conclude that famine, epidemics and wars led to the gradual extinction of the Tellem. This would rule out the myth that the Tellem were the ancestors of the Kurumba, nor can they be considered to be the forefathers of the Dogon.

Dogon dancers wearing *Kanaga* masks, the superstructure representing a crocodile or possibly a bird are depicted on page 38. While most masks are carved by the blacksmith, this type, about one metre high, is made by the young initiates. The dancers move in powerful rhythm, bending in unison, the tips of the masks almost touching the ground.

The Dogon have a number of images that both illustrate and symbolize their past. These include the figures with raised arms that represent either *nommos* or *hogons* (priests/blacksmiths), both in 'Tellem' and later styles, carvings of single figures or couples, the latter being primordial ancestors, seated, often with four or eight figures support-

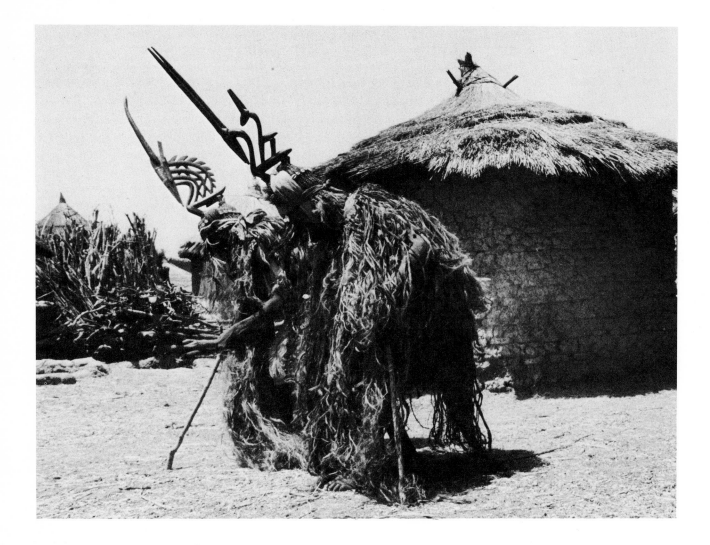

32 Dancers
Shown here wearing *chi-wara* headdresses, from Bambara, Mali

ing the seat, and altars in the form of stools with two discs, for the sky and the earth. The *hogon* can be represented as a standing, seated or mounted figure, and the ark in which the *nommo* descended to earth by troughs or boxes, decorated in relief with crocodiles, horse-heads or zig-zag patterns. There are in addition over eighty varieties of Dogon masks.

Common features in Dogon art are exaggerated breasts and shoulder blades, and the continuation of the sharp, straight nose by the line of the hair to the back of the head. The chin can be extended into a point like a beard, or as a cylinder, representing a lip plug.

Some Kurumba 'Tellem' may have been the ones who found refuge in the Cliff country when the Mossi invaded their territory. They may have brought with them the 'Tellem'-Kurumba style of carving from which the Dogon style developed. This would explain the fact that the Kurumba-Nioniosi style has elements of both 'Tellem' and 'Dogon' art. This is, of course, just as hypothetical as the theory that the Tellem

people were driven out by the Dogon and the true story must await the results of further research.

To the west of the Dogon, also in the Republic of Mali, live the BAMBARA (also called Bamana) whose sculpture is well known and much appreciated in the western world. Like the Dogon, they resisted Islam and preserved for a long time their ancient social and religious traditions which regulated all functions of the life of this agricultural people. However, western influence and the advance of Islam have resulted in the decline of their traditional culture. Most of the rituals and masked dances have either disappeared or are being used for secular entertainment. Until its decline the social structure was based on the male societies such as the *Kono, Komo, Kore*, the boys' initiation society—*N'tomo*—and the *Chi-Wara-To*, devoted to agricultural fertility rites.

The *boli* or altars sculpted by the Bambara are used by all societies but principally by the powerful *Komo*. Some of these *boli* are so crude that they can hardly be called works of art. Others appeal to modern Western taste by their Brancusi-like shapes. Most of their masks are zoomorphic except for the anthropozoomorphic *N'tomo* masks, the human face of which is surmounted by two to eight horns, often decorated with cowrie shells and with human or animal superstructures. The *Komo* society has a mask consisting of a number of horns, poised for attack against ignorance, and the mouth of the hyena, symbol of knowledge and strength. This mask is worn horizontally on the dancer's head. The *Kore* use face masks representing hyenas and horses, the latter dancing in a full 'equine' costume. While the hyena is again used as a symbol of knowledge, the horse is said to be associated with intelligence, intuition and the search for immortality.

The best-known carvings of the Bambara are their antelopes—*chi-wara*—which, attached to a basketry cap, are worn on the top of the head. They dance in pairs of one male and one female headdress, both worn by men, and jump in imitation of antelopes. The pair must never be separated, for death is said to have been the punishment for anyone coming between the male and female mask. There are great variations in the style of the *chi-waras*, representing the mystical animal that taught the Bambara the secrets of agriculture, but in all style variations—however abstracted—the carver must make sure that the sex can be recognized, thus for example, straight horns indicate a female and curved horns or zigzag manes depict a male *chi-wara*. The male figure usually has an exaggerated penis.

There are three basic regional styles. The vertical *chi-wara*, the male usually with beautiful intricate mane, elegantly stylized body and curved horns, the female with straight horns carrying a calf on its back, come mainly from the eastern areas of Segou, Kenedougou and Minianka. The horizontal type, one of the few African wood sculptures not made of one piece, comes from the Bamako and Beledougou districts. They are less stylized; bodies, necks, heads and horns are clearly carved and in almost naturalistic proportions and the upper and

34 *facing page* Mask with horns
Unknown tribe (possibly Malinke) from the source of
the Niger, Mali; wood, metal strip. 48 cm (18¾").
Museum of Mankind, London

33 Maternity
Bambara, Bougouni District, Mali; wood, with black
patina, 95.25 cm (37½") high. Coll. Aaron Furman, New
York

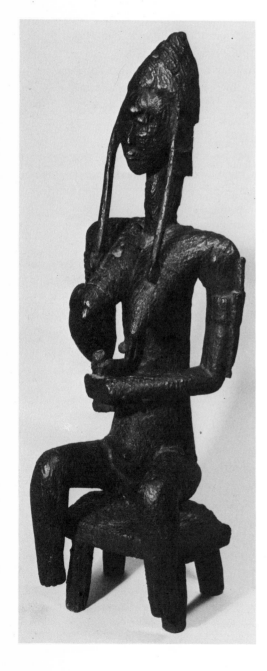

lower parts are joined together at the neck by a metal collar. The most abstracted *chi-wara* carvings, from Bougouni in the south west, are often combined with figures of aardvarks and so reduced to essentials that only the horns remind the onlooker of the antelope they represent. *Chi-wara* headdresses are carved all over Bambara country in a bewildering number of substyles which require a good deal of study for proper geographical attribution. Irrespective of style or substyle they are of great elegance and have always been considered favourite collectors' objects.

The Bambara also carve wooden figures, mostly female, either standing or seated. Their elongated bodies are at once monumental and graceful, some in stereometric style with breasts, neck and head in the shapes of cones, cylinders and spheres. Distinctive attributes of figures from the Segou area are a beaked nose supposedly deriving from a terracotta style in use at the time of the Mali empire five hundred years ago, penetrating eyes, high breasts, paddle hands and block feet. In the Bamako district the profile of the face is straight and the breasts low, while figures from the south, around Bougouni are, on the whole, softer and more sensitive. The beautiful seated female ancestor figure, a very old carving of a mother and child (seen here), is a good example of that style. These figures are sometimes called 104 Queens but are more likely to be fertility symbols or primordial ancestor statues. The Bambara also make iron staffs with female figures or 111 horsemen atop. They are renowned for their beautiful locks, many of 112 which, in zoomorphic or anthropomorphic form, are supplied to 117, 122 neighbouring tribes.

Substyles are those of the MARKA (see pl. XI), BOZO, MALINKE and the Senufo-related MINIANKA. The masks of the Marka resemble those of the Bambara but are generally more geometrically styled and are covered with brass or aluminium strip. Some have metal tresses starting at the corners of the eyes and framing a straight nose, and the face is triangular and chinless with the mouth at the apex of the triangle. In the few known Malinke figures the body is usually more angular, the eyes very stern and penetrating. Cowrie shells and abrus seeds are used for decoration on some Malinke sculptures.

The KURUMBA live in the northern part of the Upper Volta region. In the south and west of that area they are mixed with Mossi and in the north with Songhai people and only in the centre around Mengao are culture and language pure Kurumba. When the Mossi invaded Kurumba country they recognized the indigenous people as 'Nioniosi' 'masters of the land', respected their religious and artistic cultures 119 and—as so often in Africa—probably assimilated to them. Their social 121 structure is based on the Ayo or Chief, the 'royal' families and the 120 diviner. Their best-known sculptures, though few documented examples exist, are the lovely antelope headdresses characteristic only for the north-eastern area of Aribinda and Belehede. Like all Kurumba masks they are family owned and often family made, as in one case by the Tao of Aribinda who, it is reported, were still making these masks

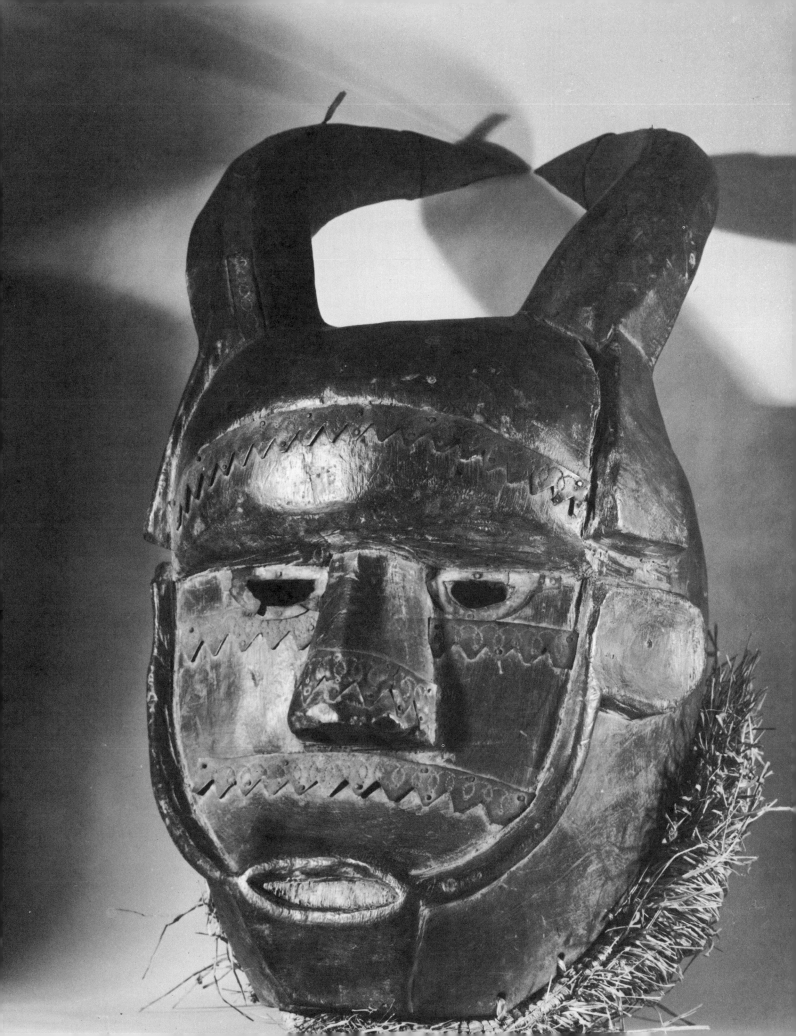

until 1968, some possibly for sale. From that area also come crocodile masks very similar to those of the Dogon. All masks are decorated with traditional abstract patterns, coloured in black, white, ochre and red and repainted before each use in funeral rites.

In the central area around Mengao the art of the Kurumba is very different and their carvings of tombstone stele, posts of wood with forked tops, and masks with slab superstructure are characteristic in design. Posts serve as roof supports in cult houses—often simple sunshelters: many posts are not functional but are used as freestanding altar or memorial pillars. They are abstracted males and females, often having naturalistic human figures in relief carved on them. The family masks consist of a black helmet with two round holes for eyes, two horns painted white and a slab superstructure usually one to one and a half metre high painted with lines, geometrical patterns and small circles in red and white. These slabs are usually indented on the sides or shaped in curves. Each mask is treated with ceremony, given food and drink and conversed with as though it were a living being. Possession of a mask increases the prestige of a family, houses the spirit of a departed member and by ensuring his memory prevents his final or spiritual death, that of being forgotten. When, for any reason, a mask becomes defunct it is buried with the honours accorded to a chief and a new mask is carved.

Other Kurumba art objects are the Ayo ritual cup with a female half figure carved on top of the lid, dance staffs which were possibly used by leaders of female dance rituals, and fertility figures, usually called dolls. The latter are carved in the round, conical, with hanging breasts, linear ornaments and a highly stylized flat head similar to those on the cups and dance staffs.

There is a striking stylistic relationship between Kurumba sculpture and that of the Mossi, Dogon, Bwa (Bobo-Ule) and Gurunsi. One can compare in particular Kurumba stele masks and those of the other tribes in style, iconography and ornamentation. It has been stated that some, if not most, Mossi masks are the work of Nioniosi blacksmiths though only one case was so documented. In the Wagadugu area masks similar to those of the Kurumba are thought to be the work of Mossi carvers as are other objects in that region. The style of the Dogon 'Great Masks' and *kanaga* masks and even that of the ancient 'Tellem' figures with arms raised, often joined and giving the appeearance of a slab, are examples of stylistic similarity with the Kurumba masks of Yatenga. The Dogon claim that the 'Tellem' went to live in Kurumba territory after being driven out from present Dogon country. But there are altogether too many inconsistencies in the oral tradition. If the 'Tellem' went to Upper Volta and became the Kurumba they could not be 'nioniosi'—indigenous—if in fact they arrived after the Mossi and Songhai. If the Dogon went north to escape the threat of Mossi invasions and Islamic conquest it is unlikely that the 'Tellem', dislodged by the Dogon, would leave for the troubled areas to the south where, in any case, no trace was found of them by the Dutch expedition.

The 'Tellem' story and the Kurumba association thus remain an unsolved puzzle.

The BOBO-FING or Black Bobo, the BWA or Red Bobo (also called Bobo-Ule) and the GURUNSI are all Voltaic peoples. The Bobo-Fing, who live in the Bobo Diulasso area, carve a variety of zoomorphic and anthropomorphic masks of the face and helmet type without the high superstructures of the Bwa. Some are surmounted by animals, some by human figures or by abstract structures incorporating zoomorphic elements. The Bwa mask consists usually of a flat disc surmounted by slabs, cut and painted in geometrical patterns. These masks, up to two metres in height, resemble those of the Gurunsi and some evidence points to the latter as being carvers for the Bwa.

To the east of the Bobo, in a triangle made up of parts of Ghana, Upper Volta and the Ivory Coast live the LOBI who carve mainly figures and heads set on poles. They remained for long untouched by any European influence and their sculpture was considered crude and primitive. But a number of works of almost classical beauty have come out of the area, generally carved from very hard wood. Lobi carvings can be classified into divination figures representing humans and birds, always small, about twenty centimetres, and larger wooden or clay figures for home and public shrines. The small-headed figures stand rigidly, arms usually alongside the body with toes and fingers barely indicated, bottoms, belly and calves well rounded. The eyes are of the cowrie shell type and the mouth is characterized by lips standing out like two discs. In general the Lobi figures are more naturalistic than those of other West Sudanese tribes.

In the area of Wagadugu, once the centre of the powerful Mossi empire, Islam is now influential but the MOSSI continued to carve until recently. The style is closely related to the Yatenga-Kurumba—or 'Nioniosi' and the masks have an abstracted oval face with triangular holes representing eyes, and a line running from forehead to chin, scored with zig-zag indentations. These masks are usually surmounted by horns and superstructures of flat slabs sometimes combined with anthropomorphic images. From the area of the Mossi tribe also come ancestor figures, abstracted doll-like images, anthropomorphic locks and other objects.

The SENUFO, who call themselves Siena, are a people of over one million who are found mainly in the northern Ivory Coast, though some Senufo live in Mali, chiefly in the Sikasso region. But their cultural influence extends well beyond their own territories. They in turn were influenced by the styles of the Bambara and the Baule of the Ivory Coast, but the marked Senufo characteristics are easily recognizable in their sculpture, mostly made for the *Lo* society, to which all adult males belong. A member is initiated at puberty and passes through the grades of young boys, adolescents and men. The initiate must serve seven years in each rank after which he enters the group of elders. Women have their own society but unfortunately very little is known about its rituals or customs. The *kpelie* are ancestor masks used

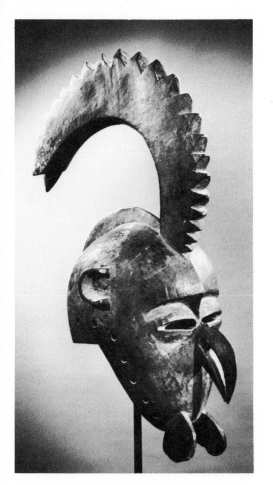

35 Helmet mask
Bobo-Fing, Upper Volta; wood, 61 cm (24"). Coll. Robert and Nancy Nooter, Washington, D.C.

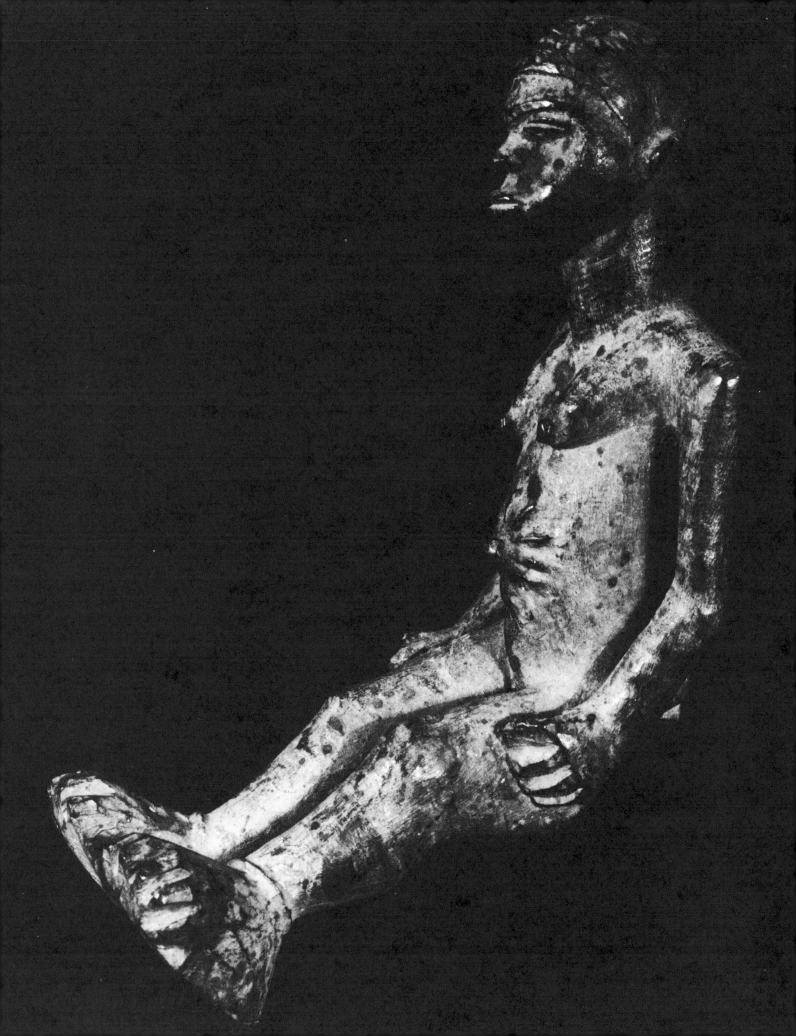

for initiation, funerary and agricultural rites. Single and double face masks are twenty-five to thirty centimetres high, with tribal scarifications around eyes, nose and mouth, and often with horns, palm nuts and figures on top. Their iconography remains largely unexplained. The emblems on top of the masks are said to indicate the ownership of the mask and the double masks may be an expression of the duality of sex. Face masks from the southeast are more naturalistic and softer indicating possible Baule or Guro influence and some older masks are decorated with metal strips and imported furniture tacks. There are also *kpelie* bronze masks and while the old ones are closer in style to the wooden ones, more recent examples often lack traditional scarifications or typical mouths and eyes. Among the many types of Senufo helmet masks are large monster figures meant to terrify. The single and double faced masks are imaginary composite animals, part buffalo, part warthog, part hyena, and incorporating features of antelopes or crocodiles, chameleons, pythons and birds—chiefly the hornbill. They are used in the rituals of the *Lo* society and some, when used at night, appear to blow sparks of fire from the mouth ('firespitters') to reinforce the effect of intimidation.

102

105

Another type is the *kwonro* helmet mask, a round or square board mounted on a wicker basket and cut out into patterns of crocodiles. These are said to have been used for initiation into the adolescent stage of *Lo* membership. The *degele* are pairs of helmet masks with armless figures of a male and a female respectively on top. The bodies consist of spiral cylinders, and the power of the masks depends on the number of spirals. These come from the Korhogo area and nothing is known about their use. In that same area are found some of the finest Senufo carvings of human figures, either male or female, on a cylindrical base, used as rhythm pounders during initiation rites. The Senufo also carve ancestor figures—standing, seated and on horseback—the last type said to be used for divination purposes. The fore and hind legs of these equestrian figures are usually in the form of two slabs. The styles vary a great deal from region to region but the overall characteristics of Senufo human figures are the forward jutting head, the large breasts, powerful shoulders and upper arms.

Staffs—sometimes called *daleu*—usually with seated female finials are reputedly trophies given for outstanding agricultural performance but may also be fertility symbols used in harvest rites. Also apparently connected with agricultural trophies are sculptures of a bird or groups of birds in flight. One of the most frequent images in Senufo sculpture is the hornbill, of which a large version is used either standing on the ground or as a headdress, often well over one metre high. These enormous birds, called *porpianong*, are usually rendered with the beak touching the breast or the stomach and the wings as a square board, often painted with geometrical patterns. The hornbill in Senufo myth was one of the first creatures on earth and a symbol of fertility.

Amongst the examples of Senufo art found in museums and private collections are also doors for shrines and chiefs' houses, drums and

36 Seated figure
Lobi, Upper Volta, Ghana, Ivory Coast; wood, much encrusted, and with a tan patina. 21.5 cm (8½″). Private collection

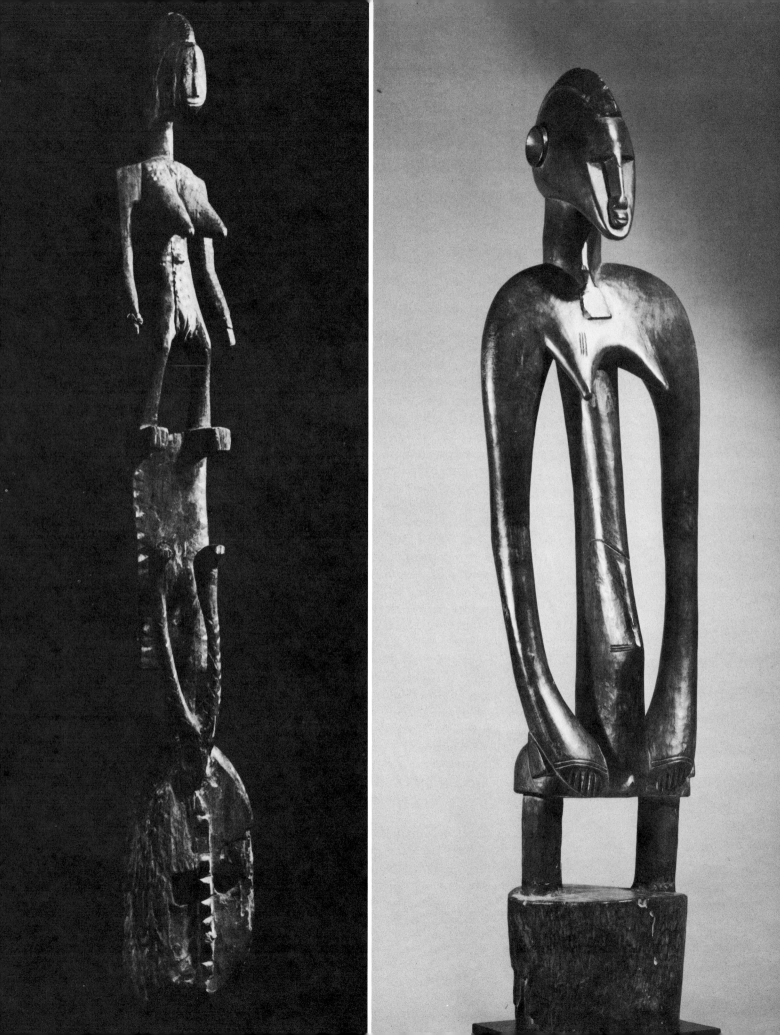

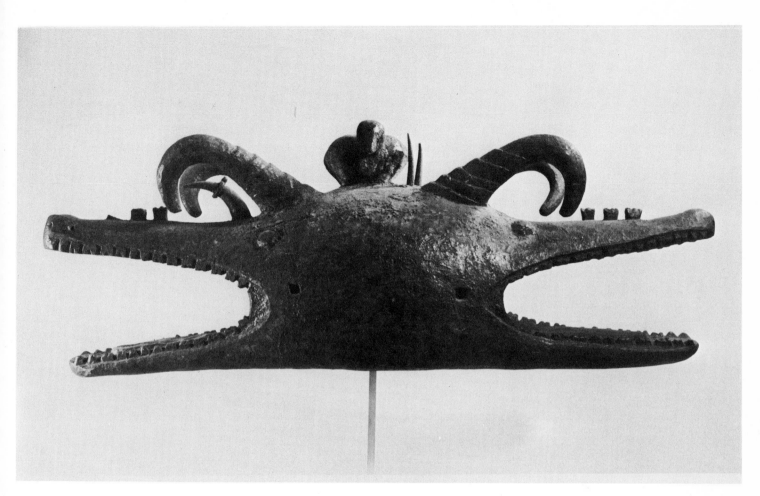

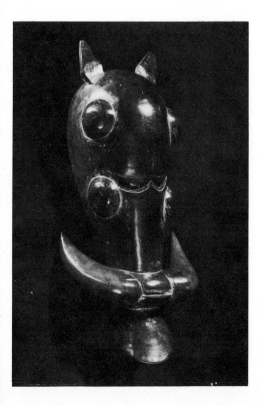

other musical instruments, as well as heddle pulleys all carved with ritual symbols characteristic for the tribe. The Senufo also produce wrought iron sculpture and a variety of small brass castings for their own ritual uses or made to order for neighbouring tribes.

One of the smaller tribes of the area, perceptibly related in sculpture to the Senufo are the LIGBI. Equally little known and also Senufo influenced are the KULANGO.

37 *facing page far left* Mask
Surmounted by female figure. Mossi, Upper Volta; wood, Kaolin and traces of red paint, 114.3 cm (45"). Coll. Aaron Furman, New York

38 *facing page Deble* Rhythm pounder
Senufo, Mali—Sikasso area; wood, 91.4 cm (36"). Coll. Dr. & Mrs. Werner Muensterberger, London

39 *above Gbain* mask
Kulango, Upper Volta and Northern Ghana; wood, encrustation and animal horns, 85.75 cm (33¾") long. Private collection

40 Warthog mask
Ligbi; wood, 44.5 cm (17½"). Museum of Mankind, London

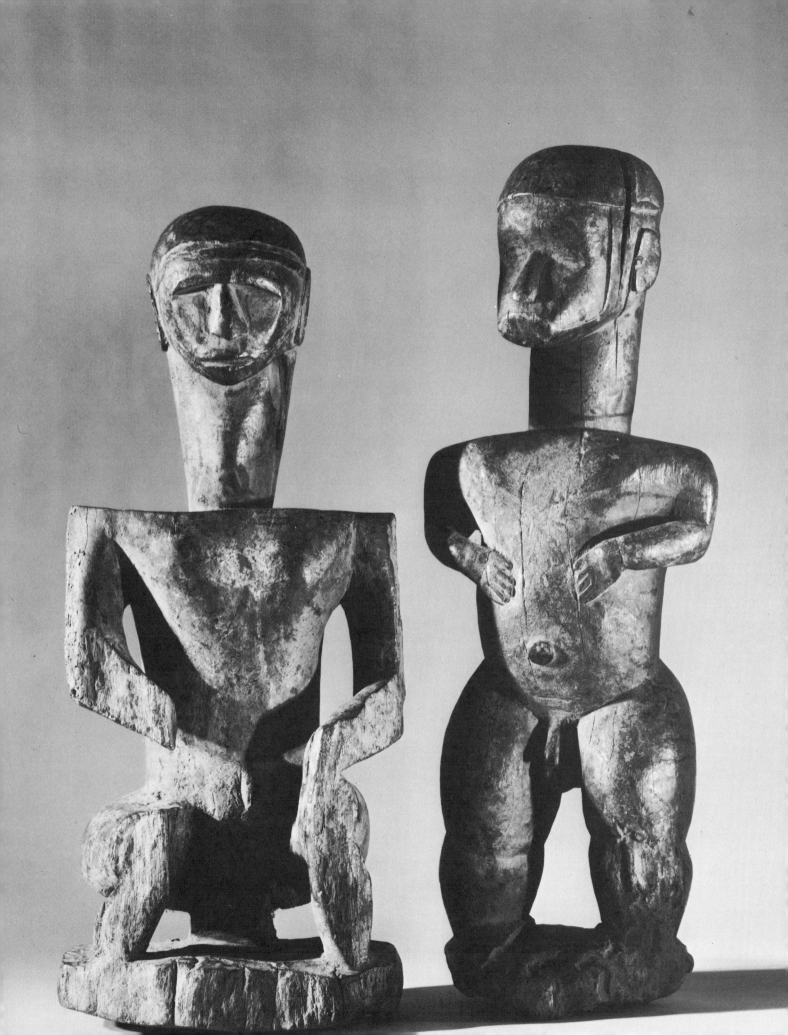

Bijugo
Baga
Nalu
Landu-
 man
Toma
Mende
Temne
Sherbro
Vai
Kissi
Gola

41 Ancestor figures
Bijugo, Bissagos Isles; wood, the standing figure 47 cm (18½″) high, the seated one 43.8 cm (17¼″). Museum of Mankind, London

II Guinea and Sierra Leone

The Bissagos Isles off the coast of Guinea Bissau have always been difficult to approach as navigation in the archipelago is hazardous. Little is known about the islanders' origin, history or art in spite of the fact that the Portuguese had contacts with them as early as 1456 and their wooden sculpture was mentioned by Pedro de Sinta in 1460. Due to the remoteness of the islands, Islamic penetration has been minimal, and at the beginning of this century the original social structure was still functioning in many ways. Women played an important part, though the BIJUGO are not ruled by a matriarchy as was sometimes supposed. But women could exceptionally attain high rank as governors or regents. As with other tribes the Bijugo appear to believe in a creator god but the rituals are concerned with his deputies and messengers. Each island has its own social structure and no secret societies are known to exist.

Bijugo sculpture consists of masks—mostly zoomorphic (used in initiation, funeral and marriage ceremonies), figures—apparently all anthropomorphic—and a great variety of ritual vessels and instruments. The best known dance masks are those representing heads of bulls carved in wood, some with actual bovine horns, or with long wooden horns attached and some heads are covered with animal skins. Also used are masks with heads of sharks, sawfish and pelicans, as well as huge hippopotamus masks which were so heavy that the wearer had to support himself with two sticks carved like legs. Paint, when used, is predominantly white, red and black. Bovine masks were also used as prowheads on canoes plying between the islands and connecting them with the mainland.

The statues, both male and female, are said to be the receptacles of ancestors' souls and were used for many religious, social and judiciary purposes, and sacrifices were frequently made to them. Their statuary comprises heads with elongated necks—some carved with bulging rings—busts, and many types of figures placed on plain or shaped plinths or seated on ceremonial stools. The heads are often shown with a forward jutting chin and the bodies could be naturalistic or abstracted, triangular or wedge shaped. Figures wearing a kind of top hat represent chiefs or other people of rank. All old figures are carved of extremely hard wood, mostly yellow or grey, and usually with heavy sacrificial encrustation. The ritual vessels, supported by human figures 123 and with animal or anthropomorphic images on the lid, are often 124 beautifully carved.

The BAGA, NALU and LANDUMAN live on the mainland in the Republic of Guinea and like the Bijugo belong linguistically to the west 127 Atlantic group. The three coastal tribes are culturally related through 130 the *Simo* society for which their carvings are made. Although specific 133 items of sculpture are usually attributed to one or the other it appears that the figures were used by all three tribes. A most impressive sculpture is the *nimba*, of the Baga, the largest and heaviest dance mask

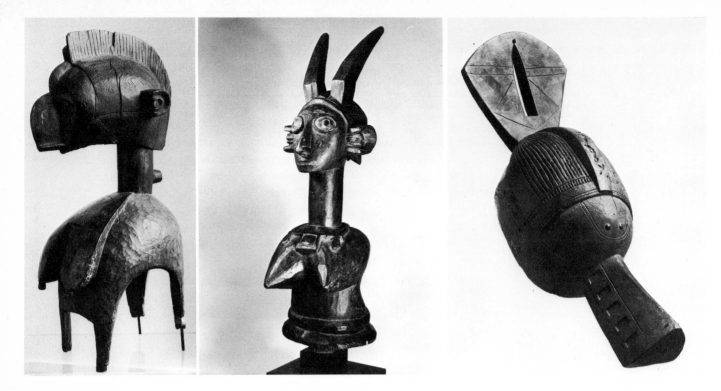

of Africa—said to represent the spirit of fertility. An enormous head with beak nose and horseshoe ears (typical of the work of west Atlantic tribes), the whole heavily scarified, is cantilevered on a long neck. The huge breasts are carved in one with the shoulders and it is worn on the head of the dancer, whose body is hidden under a raffia costume, so that the head and breasts are all that is visible of the carving. The heavy mask is held by its front legs and the dancer sees through holes carved between the breasts.

There are other versions of this symbolic figure in the form of headdresses or standing males holding a *nimba* head. Other Baga carvings include the *anok*, a *Simo* ritual object in anthropozoomorphic form and of unknown use. The Baga also make beautiful drums often supported by female figures for *Simo* rituals. Large birds said to be used in ceremonies connected with the rice harvest are also carved by them. The huge snake *Bansonye*, standing two to three metres high, painted in vivid colours is used in initiation rites. The Nalu make large masks worn horizontally on the head in which animals of various kinds, mostly highly stylized crocodiles and antelopes, form part of a mask with a human face. Another horizontal mask, perhaps a very abstracted buffalo head, is attributed to the Landuman.

The TOMA live in Guinea, Sierra Leone and northern Liberia and belong to the Mande language group. They are said to use a variety of masks for *Poro* rituals, but in a report resulting from a French expedition there is no mention of that society. The Toma are best known for their large *landa* masks, crudely made but impressive in their very simplicity. There are a number of variations but all have a flat face with bulging forehead and long straight nose, eyes indicated by two round lugs, and curved horns surmounting the whole. The mask illustrated on page 55 is that of the great god, *Afwi*, with ram's horns and large

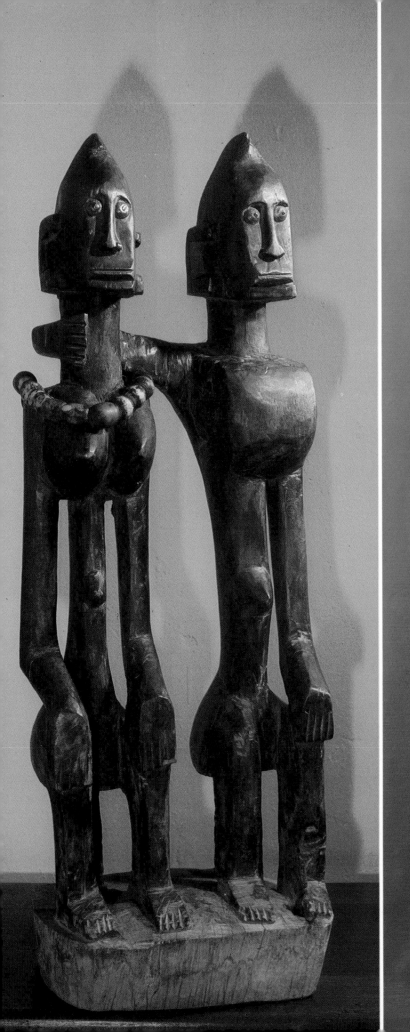
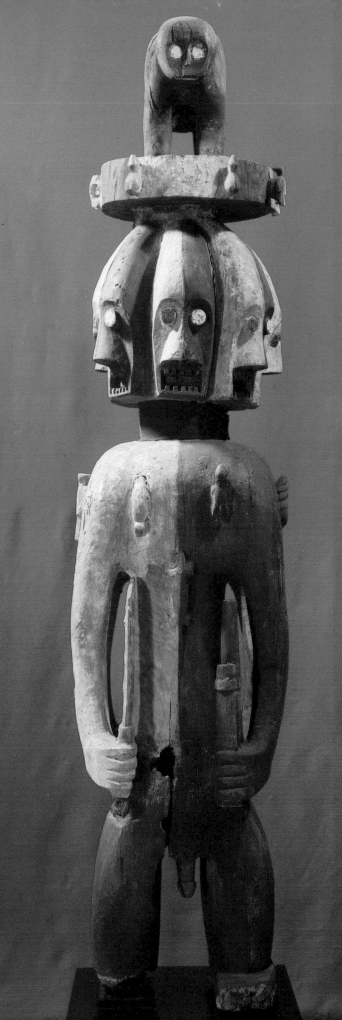

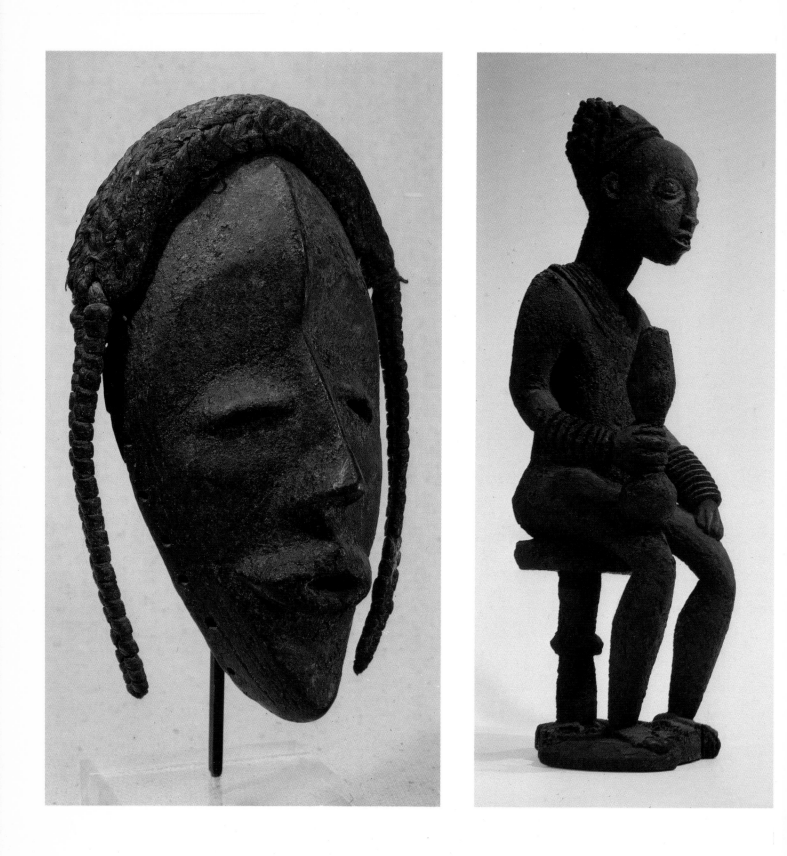

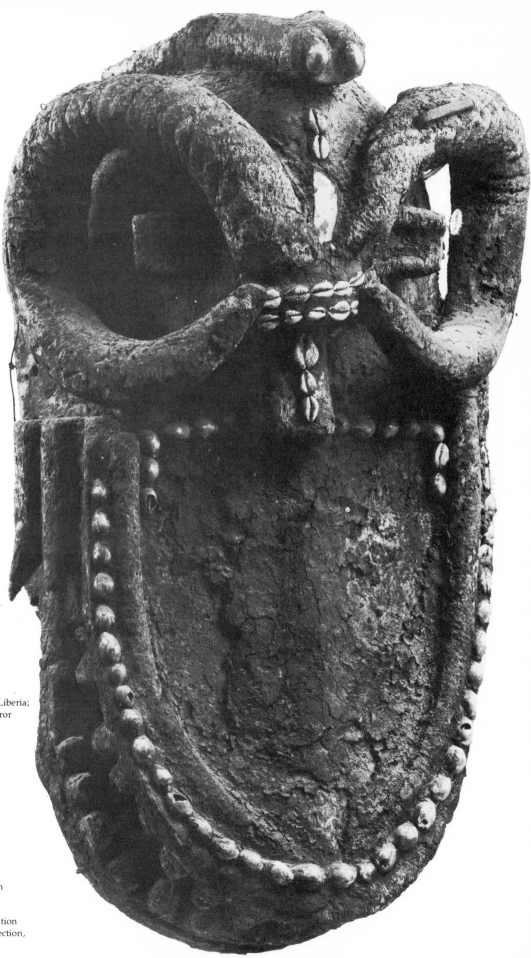

45 *Afwi* mask
Toma, Republic of Guinea, Sierra Leone, & N. Liberia;
wood with encrustations, cowrie shells and mirror
58.5 cm (23″). Coll. William Brill, New York

X *left* Mask
Dan group, Ivory Coast and Liberia; wood,
encrustation, fibre 25 cm (9¾″). Private collection

X *right* Seated figure holding a gourd
Bangwa, Cameroon; wood with heavy encrustation
96.5 cm (38″). Lance and Roberta Entwistle collection,
London

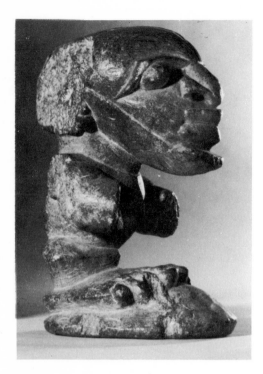

46 *Nomoli* figure
Sherbro, Sierra Leone; steatite, 18 cm (7⅛"). Museum of Mankind, London

crocodile mouth. The secrecy by which the bush religion of the Toma is surrounded was only partly pierced by the Gaisseau expedition. According to P. Gaisseau's *The Sacred Forest*, the mask which is the incarnation of the invisible *Afwi*, with his terrifying voice and other masks of Bush spirits are at the centre of Toma secret rituals. Boys' initiation consists of a great scarification ceremony but circumcision is apparently not practised. Women have their own mask—*zazi*—which appears after their excision rituals are completed. The Toma also carve human figures, paired male and female, kept, however, in separate shrines and united only for certain ceremonies. Although reporting these details Gaisseau offers no illustrations of such figures. The joint guardians of the spiritual world of the Toma and the keepers of the secrets of the Bush are the 'fetischer' who knows all the correct rituals and the 'diviner' who works closely with him. 129

The MENDE and their neighbours the TEMNE, SHERBRO, VAI and KISSI have been in the area of Sierra Leone and part of Liberia since the middle of the sixteenth century though the recorded history of the Sherbro, Kissi, Vai and Temne goes back further in time, as sacred kingdoms of the Temne and Sherbro are mentioned in chronicles of the fifteenth century and may have been in existence long before then.

The stone figures found in that area and used today by the Mende as protectors of the rice fields are called *nomoli*. They may originally have served as grave markers or for an ancestor cult. Made of steatite or other stone they may be recognized by the thrust of the head in an almost horizontal line, negroid features with heavy lips and protruding eyes. There is a stylistic similarity in these *nomoli* to those Afro/Portuguese ivories which are now attributed to the Sherbro.

As with the *nomoli*, the Kissi in north east Sierra Leone use steatite figures made in the past for their ancestor cult and for divination. They are called *pomdo* (or *pomtan* in the singular) and are in their basic form cylinders with a globular head. The *pomdo* is the rediscovered ancestor, now active in their midst, and without appeal to him no decisions can be made. The age of the *pomtan* can sometimes be ascertained by details of dress reminiscent of sixteenth-century Portugese armour. There are stylistic differences between these and the *nomoli*, which are more daringly expressive, and though one may see in the *pomtan* a more elegant concept of face, head position and body, they lack the vigour and earthiness of the *nomoli*. Also in north Sierra Leone larger stone heads and figures—*mahan yafe*—were found and are early *nomoli* style. They are said to date back to the thirteenth century. *Nomoli* and *pomtan* made in large numbers in Sierra Leone and Guinea for the tourist trade are unconvincing imitations of the old style. 134 126 60

The best-known woodcarvings of the Mende are the so-called *Bundu* masks made for a women's society called *Sande*, and such masks are also used, in imitation of the Mende, by women of the Sherbro, the Gola and the Vai. The *Sande* society is involved in the initiation rites of girls and their preparation for family and tribal life, which includes, of course, singing and dancing. The conclusion of the initiation is a ritual

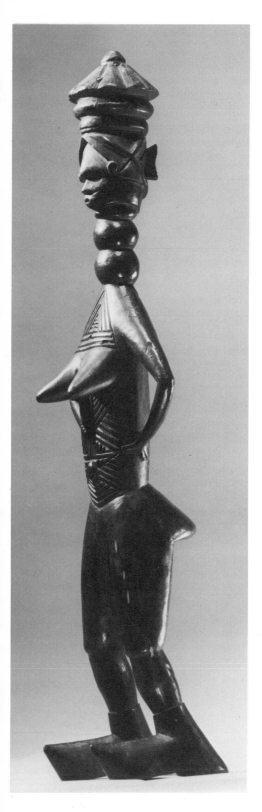

47 *Minsere* figure
Mende, Sierra Leone; wood 58.5 cm (23"). Tara collection

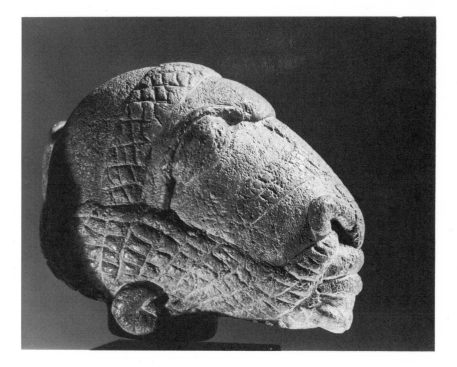

48 Ramlike Human Head
(*Mahan Yafe*), Sherbro, Sierra Leone; Steatite, 25 cm (9¾") high. Private collection

in which the *Sande* spirit appears dressed in black with a *Bundu* mask on its head and a whip in its hand to drive away witches and hostile spirits. The *Bundu* mask (called *Sowei* by the Mende) is of the helmet type with a face carved in relief and with a variety of hair-styles and superstructures. The traditional style still allows a great deal of freedom to the carver for inventive decoration. Powerful 'ugly masks' (*gonguli*) are less well known and rarely collected.

Figures made by the Mende and the neighbouring tribes, especially the Temne, are also for female use. Stylistically similar to the Bundu masks the female figures called *Minsere* often as tall as one metre, are beautifully conceived and sculpturally balanced; in this case breasts, buttocks, arms and headdress are all composed in triangles. Of the known specimens of Temne figures that in the Philadelphia University Museum is the most beautiful. These figures may well be part of an ancestor cult but are said to be mainly for healing purposes and are also used by female diviners of the *Yassi* society. A very rare figure of Mende origin is the *Haniwai* bush spirit: only a few are recorded, for it is a relic of a cult which has now totally disappeared. The elephant cap 131 connects it stylistically to the *obini* mask of the *Poro* society. Illustrated 132 is a specially powerful figure, (pl. XIVr), the hands gripping two pairs of snakes, showing the spirit's domination over any creature. The flat nose is probably a reminder of the *Haniwai's* related spirit, a baboon, while the brutal mouth and staring eyes convey a feeling of power. The apron and shoulder ornaments are characteristic of this spirit figure. 128

III Liberia and the Ivory Coast

The group of Dan related people comprises a large number of acephalous tribes and subtribes in Liberia and the Ivory Coast, some Mande speaking, while others—like the Kran, Gere and Bete—speak Kru languages. There is confusion about the classification of styles and functions of masks attributed to the various tribes of the DAN group but the contradictions that emerge between the writings of Harley, Vandenhoute and Himmelheber and the more recent study by Eberhard Fischer may be due to the fundamental changes that have taken place in the life of the tribes over the last 150 years.

In pre-colonial times inter-tribal warfare was common and villages were fortified areas always ready for defence against neighbours and slavetraders. In those days cannibalism was widespread and the raiders might also have been seeking food—human as well as animal. With colonial rule and with the achievement of independence, wars between villages, slave raids and cannibalism have become matters of the past. The new conditions which have developed brought the villagers, tribes and subtribes of the area into close and peaceful relations. They have become culturally related and today the naturalistic *Dea* masks of the north and the cubistic/expressionistic masks of the southern KRAN, or GERE (Wobe) may have been made by the same carvers and used in identical rituals.

The writings of Harley who arrived in 1926 as a mission doctor cover 138 the thirty-four years he lived in the area. Much of the change took place 139 during that period and many people who remembered conditions in the second half of the nineteenth century were still alive at that time and could supply useful information. According to Harley, the *Poro* society was still all powerful and most masks were made for it. Later this society was outlawed in Liberia and may, as a result, also have lost its influence in the Ivory Coast. Fischer states that many tribesmen are now proud that they have no *Poro* society but this was apparently not always the case. 148

The classification of masks by Vandenhoute was based on regions, which because of the changed conditions, is not valid for masks produced over the last fifty years. However, it is still possible to speak in general terms of a northern and a southern style; the southern being the cubistic, expressionistic type and the northern naturalistic. The tribes and subtribes included in this survey of Dan art are the BASSA, Kran, Gere (Wobe), DAN, MANO, BETE and GREBO. They are now united by the political power of the *Go* or leopard society. An immense and bewildering variety of masks—Fischer describes 139 types—is used by the Dan for a great number of purposes.

Fischer describes the 'mask spirit' in his classification as the realization of the bush spirits who thus incarnated will assist the people in their work and duties, entertain them or teach them. The mask does not represent but *is* the spirit, and it consists of the carved face together with the entire costume. The mask spirits take part in a variety of

49 Mask
Dan Group, Ivory Coast; wood and fibre, 24 cm (9½″) high. Tara collection

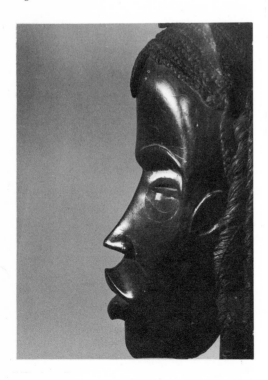

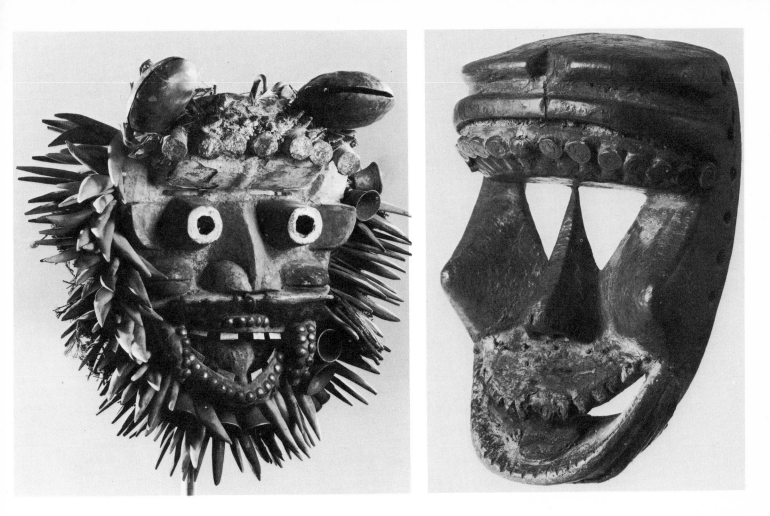

50 Mask
Gere, (Dan Group) Ivory Coast and Liberia; wood,
ivory, cartridge shells, studs, hair, fur, feathers, brass
bells, iron, kaolin, earth pigments, paint 38 cm (15″).
Private collection, New York

51 *right* Cubistic mask Kran, Dan Group
Wood, metal coins; 21.5 cm (8½″) high. Private
collection, New York

rituals and dances: the *dean-gle* look after boys in circumcision camps in
a motherly way, the *tanka-gle* are theatrical and singing masks, the
gunye-gle act as runners and the *zak paei* as fireguards. Wild dances are
performed by the *ba-gle* using mostly Gere type cubistic face masks.
The *bu-gle* are worn by warriors in their rites, and another martial
'mask-spirit' is the *kao-gle* depicting chimpanzees and other animals.
The *du-gle* and the *gle-wa* are both great masks either made especially
for use in important ceremonies or promoted from a lower rank so that
they can participate. Some have long tubular eyes, strong protruding
cheekbones and movable jaws. When used by judges the costume
consists of a red cloth headdress decorated with white fur, leopard skin
or feathers and a red cloak and raffia skirt. A male 'mask spirit' called
gaegon with a long beak, narrow slit eyes and a beard made of monkey 138
hair is described by Fischer as a singing mask used for entertainment 135
while Thompson asserts that this mask is used when felons are 136,88
executed. The dilemma in the task of classifying Dan masks is well 141
illustrated by such divergent views. This is not an exhaustive listing, 143
nor are all types used by all tribes in the group.

Most of the *gle wa* are under the jurisdiction of the *Go* society
and—to add to the difficulties—the society often re-classify masks or
have new categories created for a special purpose. It is possible that the
decline of the tribal rituals has confused the elders who no longer know

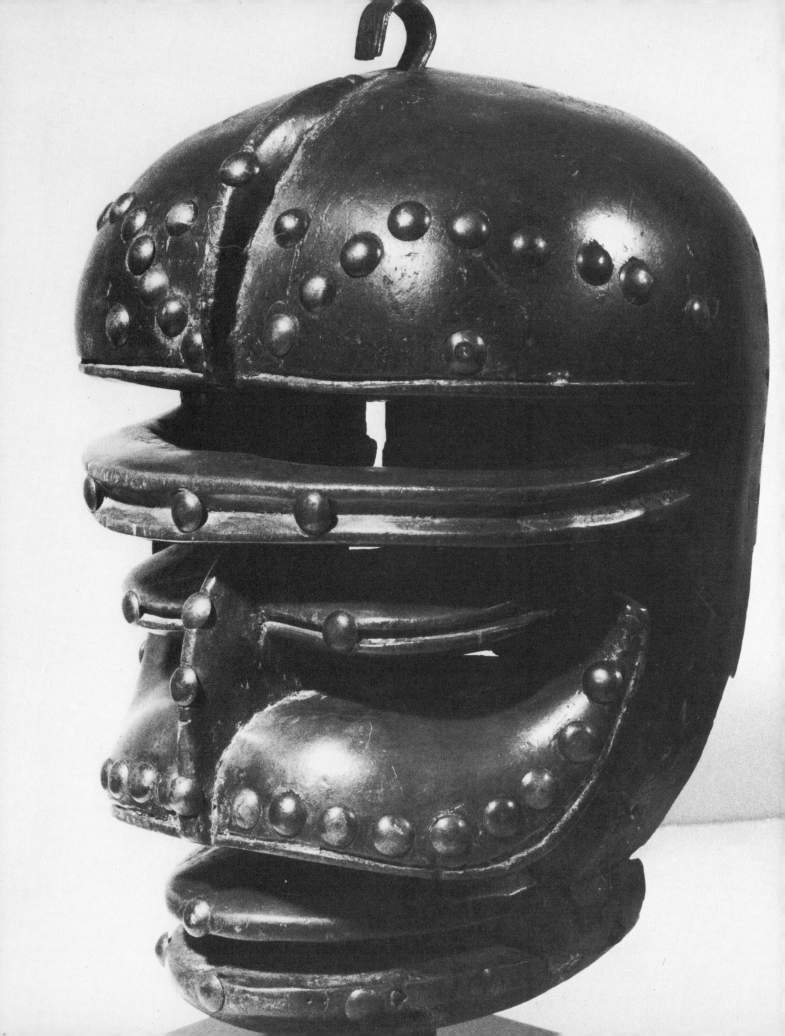

52 *facing page* Mask
Bete (Dan Group) Ivory Coast and Liberia; wood, brass
studs, metal 29 cm (11½"). Private collection

53 Female figure
Dan group, Ivory Coast and Liberia; wood, encrustation
40 cm (15¾"). London collection

54 Face mask
Bassa, (Dan Group) Ivory Coast and Liberia; wood
20.3 cm (8"). Coll. Marc and Denise Ginzberg, New York

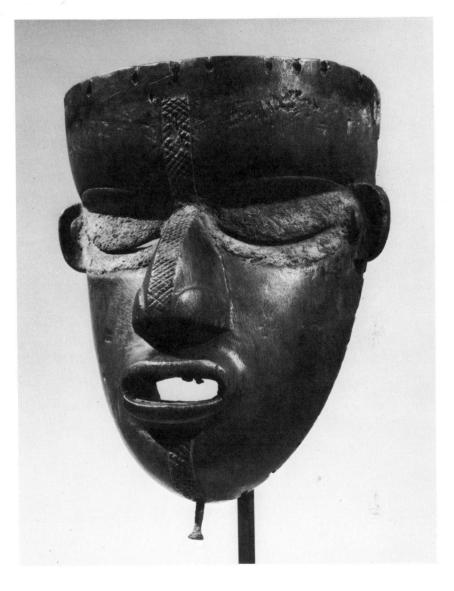

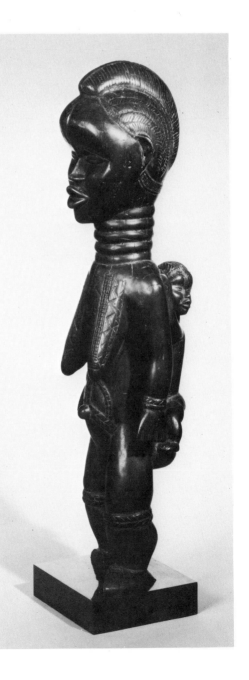

the customs of the tribe nor the meaning or use of the masks. It is also a
fact that they—like elders of other tribes—only too readily confirm
theories proffered by European questioners. The degree of importance
of the various masks usually depends on their age and the power
accumulated by sacrifice and veneration. The greater that power the
higher is the rank of the mask.

Compared with the great variety of masks, the Dan and their associ-
ated tribes in the group make only a few figures, predominantly
female. Rice spoons decorated with human or animal heads, sometimes
attractively abstracted, are made to be used in ceremonials. The spoon
is the emblem of the chief's wife or is the possession of the *wunkirle*
meaning 'hospitable woman' who serves rice to guests at important
festivals at which the primordial ancestor would be deemed to be
present. The spoons are considered living beings and many anecdotes

are told about their astonishing feats. People of the Dan group also produce brass figures, jewellery and implements in the lost wax process, pottery—made by women—and a variety of other objects. Most of the wooden mask types are also produced as miniatures used for sacrifices, for rituals in the ceremonies of sacred societies and in circumcision camps. Women are allowed to own miniature masks but they are not permitted any contact with the regular types. 60

According to Fischer the figures of the Dan are never used in ancestor cult although George W. Harley did state that in the past masks frequently represented ancestors. Some are supposed to be portrait images of people, either commissioned or made by the carver for his own pleasure.

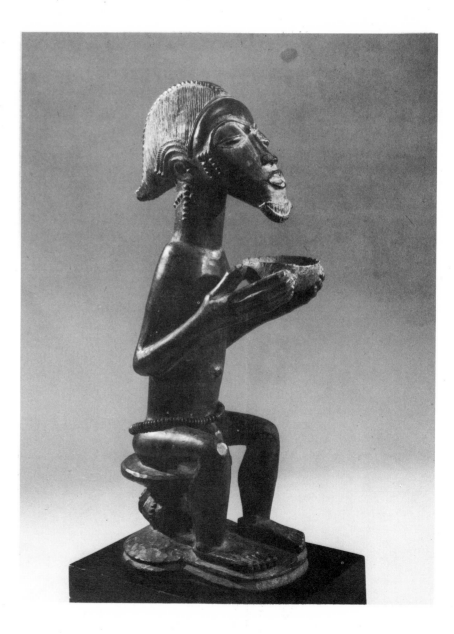

55 Male figure
Shown seated on stool, holding a cup. Baule, Ivory Coast; wood, beads 38.5 cm (15⅛"). Coll. Marc and Denise Ginzberg, New York

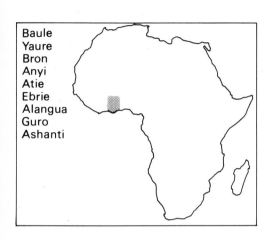

Baule
Yaure
Bron
Anyi
Atie
Ebrie
Alangua
Guro
Ashanti

IV Ivory Coast and Ghana

In the east of the Ivory Coast and reaching to the border of the Ashanti country in modern Ghana live the BAULE, the Guro and related tribes who have all produced quite outstanding carvings.

The Baule are Akan-speaking and according to oral tradition their kingdom was founded at the beginning of the eighteenth century by an Ashanti Queen Mother, Aura Poku, who fled her country together with a large number of followers. Most of the invading Ashantis merged with elements of the original population, though some preferred to live separately, like the Mande-speaking Guro.

These newcomers originated in an area where gold and brass castings were made by the cire perdue method, but which had little tradition of wood carving. It is believed that as no gold was to be found in their new country, the Baule developed wood carving with the help of the Guro and Senufo tribes. The Baule brought with them the traditions of a well organized court as constituted in the sacred kingdom of the Ashanti, together with a rich mythology and a large pantheon, and so the demand for ceremonial and religious ritual symbols was assured. The result is the calm and dignified Baule art created by professional carvers who at times reached great heights of perfection. The quiet beauty of Baule figures and masks with their attractive dark, almost metallic patina made them desirable objects for the early French collectors. Thereafter increased output and the desire to please these alien customers changed the sculptural quality of their carvings and they became sweet rather than powerful.

The Baule at their best made beautiful masks with naturalistic yet stylized human faces and one of the greatest of these *Go* masks is that in the Charles Ratton collection. Other masks are zoomorphic, the best-known type being a *Guli*, with discoid face, powerful round eyes set in heart-shaped sockets and a rectangular mouth, the disc surmounted by horns. Another *Guli* mask is a helmet with two discs, an animal mouth and horns. *Guli* masks are abstractions of the buffalo but are also said to represent the sun and to be in the service of the sky god *Nyame*.

Both standing and seated Baule figures of males and females are of an almost unearthly serenity, dignity and beauty. Though the Baule have an ancestor cult they do not carve ancestor figures: the male and female images carved by them are either figures to accommodate the dangerous spirits of nature or they are spirit lovers. These are made on the recommendation of a diviner either to provide a home for the nature spirit or for the pre-natal lover, for the jealousy of the spirit lover and the dangerous activities of nature spirits may be assuaged by these carvings. When first produced there is no difference in the images to distinguish nature spirit from spirit lover but as the latter is 149 fed from a bowl, always cleaned and fondled, its patina will be smooth 145 and shiny, while the sacrificial offerings made to the nature spirit image are simply thrown over it and therefore the figure becomes

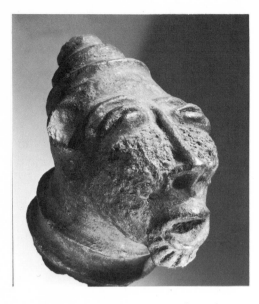

56 Head of a tomb figure
Called 'Krinjabo', the name of a 17th century kingdom.
Atiye, or Anyi, southeast Ivory Coast; terracotta 16.5 cm
(6½"). Private collection

57 Mask
Guro, Ivory Coast; wood 42 cm (16½"). Private collection

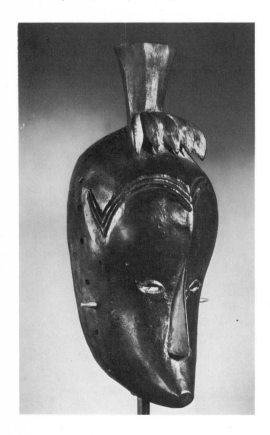

encrusted and dirty. Details are always well carved, the hairdress carefully incised and precisely detailed and faces and bodies have raised cicatrice marks. Baule figures usually have small mouths, finely modelled eyes with delicately carved lids and eyebrows continuing into the line of a straight nose.

Very different in style is the *gbekre* or ape spirit, the guardian, often placed at the village gate, bowl in hand. He is also the patron of the farmers, who sacrifice to him to ensure fertility in the field, and protection from evil spirits.

The Baule also produce a number of other art objects all beautifully carved. These include shrine doors decorated with fishes, crocodiles, birds and horsemen. Rightly famous are the Baule weaving pulleys carved with heads, masks and other symbols. There are also finely carved vessels, combs, and drums and brass figures, the latter stylistically reminiscent of Ashanti castings.

The working of gold is of particular importance as part of the Akan heritage of the Baule and it is often difficult to distinguish between Baule and Ashanti castings—both in bronze and gold—but miniature masks and ram heads worn as pendants are mostly of Baule origin. Gold is also used by the Baule in the form of very thin foil, covering 147
carved wooden human figures, handles of fly whisks, ceremonial sword handles and various other objects. The carving is first covered with fine incisions in geometrical patterns, then rubbed with resin. The 47
gold foil is pressed into these incisions. Amongst the various substyles the YAURE are most noteworthy, and their masks are distinguished by a zig-zag line framing the whole face or running from ear to ear. Often birds, animals or human heads surmount these well carved masks which in facial expression and hairline are nearer to Guro style.

Other Akan tribes to be mentioned are the BRON (or Abron)—best known for two magnificent bronze masks, one in the British Museum and the other in the Metropolitan Museum of Art—the ANYI with their *krinjabo*, pottery funerary images, the ATIE, the ALANGUA and the EBRIE—the last three one prefers to call collectively the Coastal Akan —and whose wood carvings have bulbous arms and legs and coiffures plaited into buns.

The non-Akan GURO produce very few figures and their masks are stylistically akin to the Baule except that they are carved much more in the round. The small mouth, thin nose—a sharp line ending in a point—and the curves of the coiffure are characteristics by which some anthropomorphic masks and the zoomorphic *zamle* masks are easily recognizable as products of Guro carvers. These masks are often finished with polychrome paint or have glossy polish. Some of the most magnificent African weaving pulleys were made by Guro artists.

With their capital Kumasi, the ASHANTI are today part of modern Ghana, occupying the central area. At the height of their power, in the eighteenth century, their divine kingdom ruled most of Ghana and their power extended into the Ivory Coast. The basis of their wealth

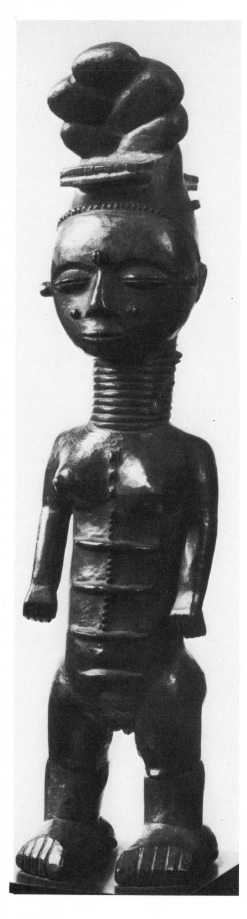

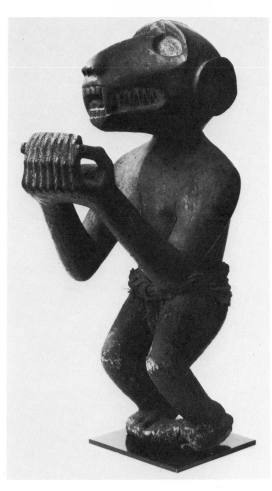

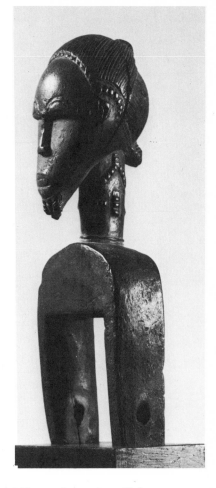

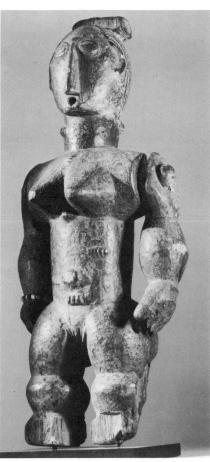

60 *above left* Figure of a monkey, *Gbekre*
Baule, Ivory Coast; wood, encrustation 73.5 cm (29").
Private collection, New York

61 *above right* Heddle pulley
Baule, Ivory Coast; wood 18.5 cm (7¼"). Private
collection, New York

58 Standing woman
Coastal Akan, Ivory Coast; wood 43 cm (17"). Coll.
William Brill, New York

59 Female figure
With articulated arms Coastal Akan, southeast Ivory
Coast; wood, beads 38.5 cm (15⅛"). M.R.A.C., Tervuren

and power was gold: today's Ghana was, of course, the Gold Coast of colonial times.

The fame of Ashanti art is based on brass casting and gold work, all the monopoly of King and Court. Some very fine terracottas were made in the area by the various Akan tribes with stylistic differences characteristic for the various peoples involved in their creation. The best-known Ashanti woodcarvings include some splendid maternities, but the *akua'ba* dolls, abstracted female figures with discoid heads are the most celebrated work of Ashanti carvers. The neighbouring FANTE tribe have a similar fertility doll, but with a rectangular head. Among the less known woodcarvings of the Ashanti are genre groups such as a queen mother standing under an umbrella accompanied by fan bearers, groups of sword carriers, priests and priestesses and figures used by medicine men, especially those used in witchhunting procedures, and many charming musicians—individuals and groups. Like most other tribes the Ashanti make drums and many ceremonials are oberved in their production, beginning with the felling of the tree and ending with sacrifices over the finished drum.

The differences between Ashanti art and that of other Negro cultures, makes it necessary to look at their special socio-religious background. As in other sacred kingdoms power is vested in the divine king, who after the victory of the Ashanti over their neighbours in the eighteenth century emerged as absolute ruler over a large area. The matrilineal monarchy, with a powerful queen mother, developed a splendid court in which the symbols of royalty were lavishly displayed, making processions during Yam and other festivals into shows of incredible wealth and splendour. The symbol of divinity, of state and tribe is the stool, deriving from the legend of the Golden Stool which is said to have dropped from heaven in about 1700 into the lap of the founder King Osai Tutu. This stool is holy, and used as an altar but must never be sat on, not even by the king. Like the king himself it must never touch the ground and stands on a chair of its own.

The 'rites de passage' of the people encompass ceremonies at birth, puberty, marriage and funerals. Ashanti religion includes the belief in fairies and monsters of the forest, witches and black magic and the possession of a soul by trees and animals. The supreme god *Nyame* and a pantheon of minor and major gods and ancestors are at the centre of the Ashanti relationship with matters of life on earth and with the supernatural. As well as a large number of artefacts in wood, metal and pottery, woven textiles in splendid colours played a role in Ashanti religious rites and in court art.

147a, b

Around the gold industry various objects were created which, perhaps even more than the royal regalia, typify Ashanti art. For the trade in gold brass weights were produced by lost wax casting and we can hardly think of a more delightful art form than this, the figures that comprise its subject matter mostly connected with the daily life of the tribe. Many are based on and depict the proverbs which have a great influence on the daily life of the Ashanti people.

140
142
144
146

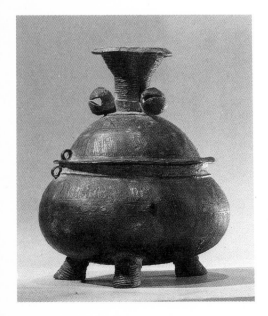

62 *Kuduo*
A vessel for storing ritual or secular valuables. Ashanti, Ghana; brass 18.5 cm (7¼"). Tara collection

Ewe
Lamba
Kotokoli
Moba
Fon
Yoruba
Bini

63 Standing male
Perhaps an ancestor figure. Kotokoli, Togo; wood
125 cm (49¼"). Collected in 1899. Museum für
Völkerkunde, Berlin

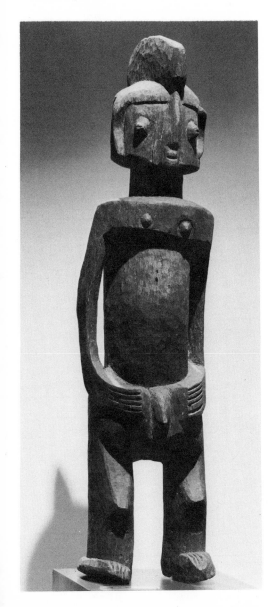

Also in cire perdue, small rectangular boxes were cast to contain 147
gold dust and larger boxes were called *kuduo*. These are said to have
been made to receive the souls of deceased ancestors, and were buried
with their owners and contained jewels, gold dust and unguents for
the annointing of the body in after life. Some are in classical shapes of
great simplicity and some have elaborate scenes cast on the lid.

V Togo, Benin (Dahomey) and Yoruba (Nigeria)

Very little art is known from Togo, though a considerable number of
simple primitive woodcarvings, mainly ancestor figures, are preserved
in German museums, and the illustrated example of a Kotokoli figure
is one of the finest. A beautiful abstract terracotta head of a water-
buffalo collected in Togo is in the Metropolitan Museum of Art in New
York. Its artistic concept is so outstanding that it could perhaps be
concluded that Togo had an artistic tradition and that while their
carvings went the way of all wood in the African climate, archaeolog-
ists may yet discover buried treasures of Togo terracottas, though it is,
of course, possible that the buffalo head belongs to a different culture
based outside the territory of Togo. There are some Yoruba living
in Togo and their traditional sculpture is part of Yoruba heritage
and must be considered as outside the culture of the EWE, LAMBA,
KOTOKOLI and MOBA, which are the main Togo tribes.

The Republic of Benin—formerly Dahomey—links its history to that
of a divine kingdom which flourished from the seventeenth through
the nineteenth century. Its wealth was based on the slave trade and its
art largely connected with the requirements of the king and the court.
King Agadja united most of the tribes at the beginning of the eigh-
teenth century and developed his powerful court in Abomey, the
capital. A great demand for art was created in this process, and while
much of this was influenced by their Yoruba neighbours to the east,
there are some outstanding creations for which the FON of Dahomey
are famous.

Well known are the three painted wooden statues all about 1.70
metres high of King Ghezo, King Glele bearing a lion's head and King
Behanzin with a shark's head and torso, to which human arms and
legs are attached. All three are in the Musée de L'Homme.

The wooden and metal-clad lions in the Musée de l'Homme are also
royal art and part of Dahomey's mythology. The statuary is distinc-
tively Dahomean and especially so the anthropozoomorphic portraits
of kings which have no equal in west African iconography. They can be
dated roughly to the mid to late nineteenth century (before the French
colonial takeover) and their great craftsmanship has a vaguely Egyptian
feeling. 150

Royal staffs, also with the lion as their symbol, are, of course, a 180
common African feature and closer to other traditional African carv-
ings than are most of Dahomey's art objects. Metalwork is an on-going
art of the Fon and the illustration overleaf is a good and amusing

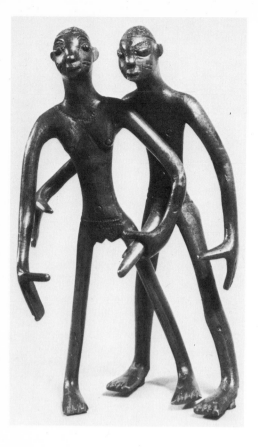

64 Male and female
They are separate castings. Fon, Abomey City, Republic of Benin; brass 9.5 cm (3¾"). Coll. Aaron Furman, New York

65 Statue
Possibly of Eshu, the messenger or 'trickster' god. Eastern Yoruba, Ekiti, Efon-Alaye, Nigeria; eroded wood 72.4 cm (28½"). Milton Ratner family collection, New York

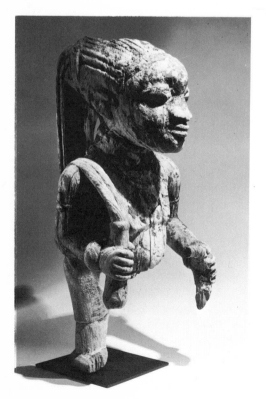

example of modern secular art of that tribe.

The YORUBA, with about ten to twelve million people, mostly in Nigeria, constitute the largest art producing people of west Africa. They founded urban centres of great importance and power probably more than 1000 years ago. They made each town into a centre of art with the capital of Ile-Ife founded according to legend by the ancestral god *Odiduwa* himself. The Yoruba myth of creation makes the city of Ife the centre of the world and the kingmaker of the Yoruba, (as it is the seat of the Oni, religious head of all the Yoruba people, and the direct descendant of the celestial messenger *Oduduwa*). This is also the reason why rival city states like Oyo-Ile never achieved a similar importance. The Yoruba are still prolific carvers and have produced outstanding art until quite recent times. We have thus a situation, unique in west Africa, of a people, the creators of the Ife bronzes, which probably initiated and influenced casting in Benin, and whose present style has unmistakable similarities with the Nok sculpture of 2000 years ago, still carving and observing the customs of their forefathers. The study of these customs, the possibility of observing contemporary carvers and the connection of their work with the institutions, religious beliefs and social structure of the Yoruba of today gives a rare insight into the history of an important segment of African art.

To assist in the understanding of the art objects, it is helpful to look at the complicated picture of the Yoruba pantheon of *orisha* or spirits as well as at some of the most important societies and their patron *orisha* for whom art is produced in one form or another. *Olorun* is the supreme god, a remote being too important to be directly involved in matters concerning mortal humans. No images are made of him and he is not worshipped except through an *orisha*, especially *Eshu*, to whom sacrifices for *Olorun* are made by proxy. 161

There are hundreds of *orisha*, as each family and clan had their own, and every situation in life such as birth, sickness and death was related to an *orisha*. Altars and shrines are dedicated to the *orisha* and an unending number of carvings or castings are used in connection with sacrifices or when appealing for the help of the spirits.

Eshu or *Elegba* is the only one occasionally represented as a person while the other spirits have masks, figures or symbols indirectly related to them. *Eshu*, *Olorun*'s messenger, recognized usually by his long cap, sometimes in the shape of a hook, and attributes such as whistle or knife, is the trickster, representing uncertainty, change, chance, malice and conflict in life. Thompson sums up his character: 189 204 198

He is King and enfant terrible,
an elder capable of childishness—
Eshu is, in short, mankind.

The constant companion and counterpart of *Eshu*, the trickster god, is *Ifa*, standing for fate, cosmic order and wisdom. His chief implements are the divination tray, usually with a head of Eshu carved on it,

66 Kneeling woman *Agere-Ifa*
She is carrying a child on her back and supporting a
bowl on her head. Used in Ifa divination to hold palm
nuts which the diviner throws to read the oracle.
Yoruba, probably from Oyo, Nigeria; wood 25.75 cm
(10⅛"). Tara collection

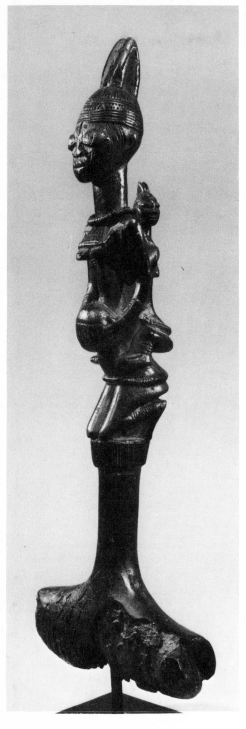

67 Staff—*Oshe Shango*
A devotee of the *orisha Shango*, she kneels on the inverted symbol of Shango, the double axe, and carries a child on her back; Yoruba, Nigeria; wood, beads 52 cm (20½"). Coll. Marc and Denise Ginzberg, New York

XI Mask with hand grip
Marka, Mali; wood, metal, cloth, 45.75 cm (18"). Coll. Robert and Nancy Nooter, Washington, D.C.

divination bowls (*agere-ifa*) and tappers (*iro-ifa*), all of them designed to predict and influence fate as well as counteract *Eshu*'s malice by restoring man's confidence.

The *Ogboni* society devoted to the cult of the earth spirits was, and in fact to some extent still is, powerful. It keeps priests and secular rulers **186** under control by uniting them in a common organization. The ritual implements of the *Ogboni*, except for the *edan* staff, are kept and used in great secrecy. The *edan* are two cast brass figures, a male and a female, **203** joined by a chain. They are said to represent threeness, one of the aspects of *Ogboni* symbolism, of which the third and invisible part is the earth worshipped as a source of moral law. Other objects used by the Ogboni are the sacred drum, *agba*, small figures and ornaments. **203**

Shango—the spirit of thunder and lightning—is represented by the neolithic axeheads which are dug up all over Yorubaland and regarded as thunderbolts. They symbolize power and are depicted in the double axe-shaped batons associated with the cult. The figure to which the axe is affixed, is a *Shango* worshipper—always a woman. Of great importance is the *Ibeji* (or twin) cult. The high incidence of twins among Yorubas and the rate of child mortality in a society which did not have **164** modern hygienic and medical help combined in the development of **181** this cult. A figure is carved for the dead child, then clothed and fed **185** alongside its live twin, and a resting place for the spirit of the dead twin is thus provided by the *Ibeji* figure, as otherwise its vengeance would for ever threaten the parents. If both children die, two figures will have to be provided. The *Ibeji* figures are among the best known Yoruba carvings. The Yoruba are one of the few peoples in west Africa to have such a cult, though twins and twin lore are widespread.

The *Gelede* cult is devoted to the problem of witchcraft. All women are potential witches because witchcraft is the negative, malevolent **154** aspect of womanhood—just as motherhood is its positive, benevolent **168** side. Men who dance in *Gelede* rituals therefore often impersonate **171** females. The cult fights the dangers to fertility, the perils of the sea, and of the epidemics brought about by the action of witches. There are two kinds of masquerade performance—*Efe*, a single mask which sings at night and *Gelede* a pair of masks which dance in the afternoon. The witches are supposed to be entranced and amused by the singing and dancing which makes them forget their malevolent plans. The rituals of *Gelede* are in effect the means of controlling witchcraft. The masks are worn on top of the head and some have elaborate superstructures.

Epa is the common name for a third type of Yoruba mask prominent mostly in north-eastern Yorubaland around Ekiti but also made and used for fertility rites in Owo, Efon Alaye and other centres. It consists of a potshaped mask on top of which are usually large complex carvings painted in strong colours. Some are as high as two metres and these may weigh up to fifty kilos. Only the strongest young men could balance them on their heads while performing the jumps and twists of the traditional dances. However, the masks usually average only ten kilos—not excessive for Africans used to carrying heavy loads on their

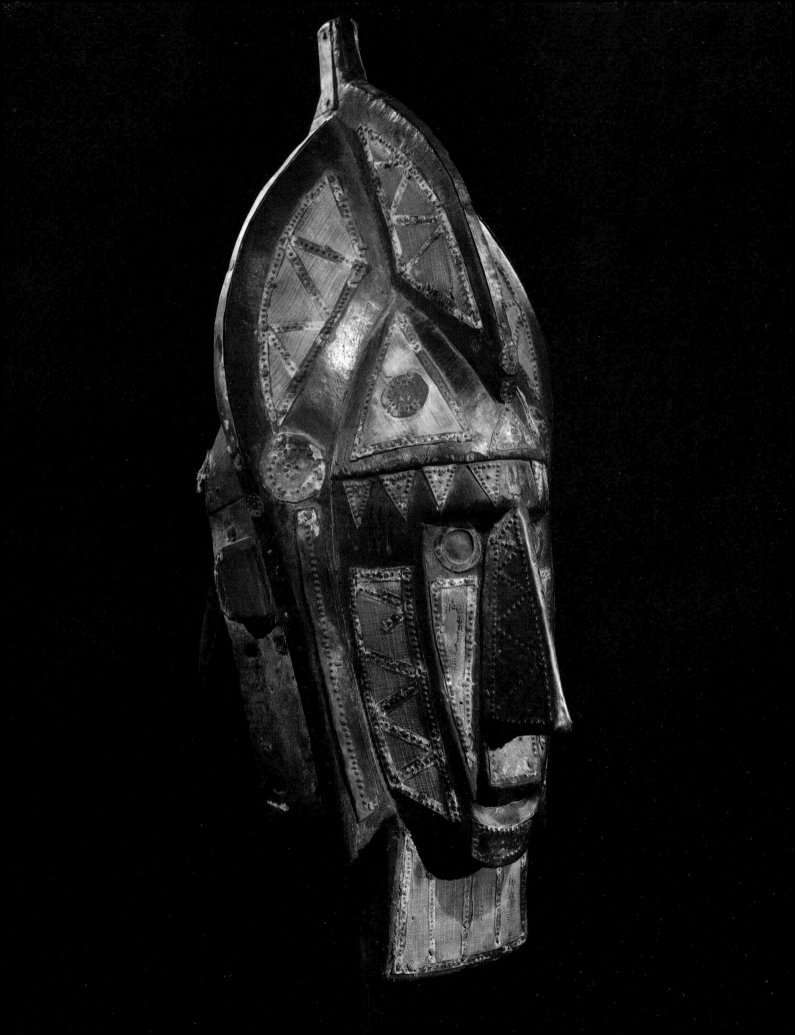

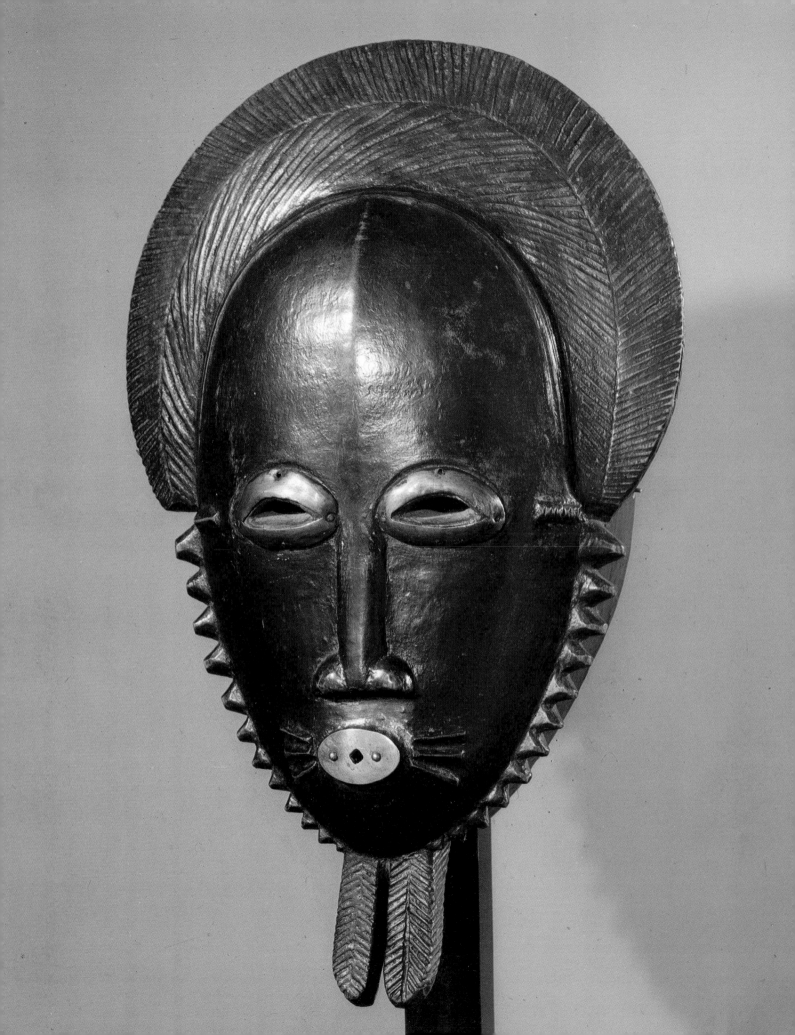

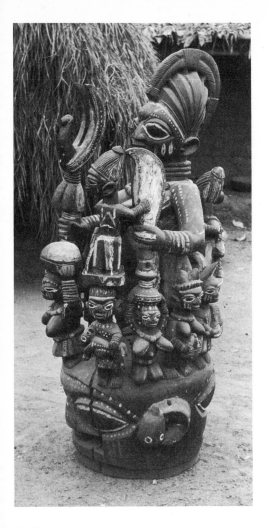

heads. Many of the inventive artists who carved these impressive masks with their figurative superstructures are nowadays known by name or their school can be identified.

The *Egungun* rites are connected with ancestors and other forces affecting the lives of the people. One type of mask, carved at Abeokuta, features hares' ears and teeth, and a drum above the forehead, while another has a long tuft of hair falling to the left of the face and is usually associated with hunters. Vials of medicine are often carved on the foreheads or on top of the coiffure and represent the magical power concentrated in the cult, which had its origin in the city state of Oyo.

169
170
182
183
190, 191
152
198

Ogun has as his devotees all those who work or use iron, most especially blacksmiths, warriors, hunters and woodcarvers, and as *Ogun* is still regarded as a powerful force, his worshippers today include cyclists and the drivers of motor vehicles. Anything made of iron may be used as a symbol though some masks, pokers, etc. are specially made for *Ogun* rituals. In some Ekiti towns in eastern Yorubaland, the festival of *Ogun* is a great occasion at yam harvest time. Ancestors are worshipped in family shrines in addition to the numer-

68 *Epa* mask
It depicts a woman holding an *Ifa* priest's staff (*Orere*) and a cutlass; she is surrounded by numerous figures, including children. Carved by Areogun of Osi, Yoruba, northern Ekiti, Nigeria; wood, pigments 114 cm (45"). Photographed by William B. Fagg in 1950 at Otun, Nigeria

69 *right Egungun* mask
It is in the form of a female bust, the breasts in the shape of crocodile mouths, a face carved on each breast. Yoruba, Nigeria; wood, length 34.3 cm (13½"), height 23 cm (9"). Coll. William Brill, New York

XII Face mask
Baule Yaure, Ivory Coast; wood, metal 33 cm (13"). Formerly Chauvet collection

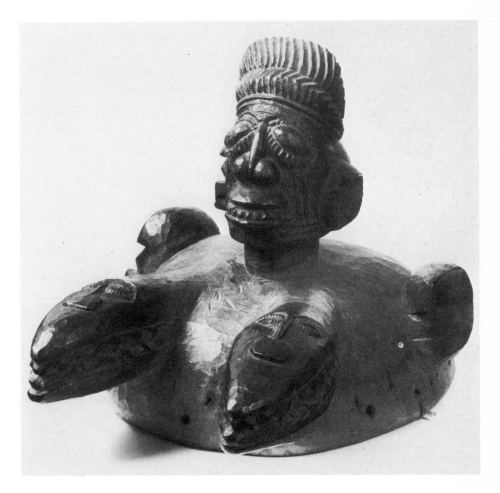

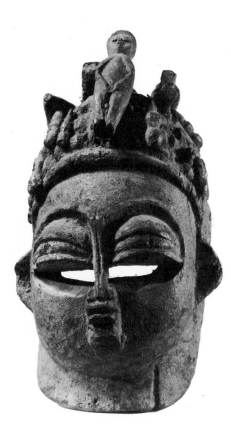

70 *Ekpo* mask
From a village near Benin. Bini, Nigeria; wood &
encrustation 31.75 cm (12½"). Coll. William Brill, New
York

Ibo
Ibibio
Eket
Ogoni
Oron
Ijo
Urhobo
Isoko

ous *orisha* protecting individuals and groups against any and all dangers from sudden death to stomach ache. In Owo—in the east—chiefs have wooden rams' heads or human heads with rams' horns in their shrines, similar to the heads used by the Bini, outside Benin city itself.

The overall style of Yoruba woodcarving, though varying from area to area and from artist to artist, can be described as quasi-naturalistic, although body and head are in the usual African proportions. Faces have heavy lidded, bulging eyes, sensuous mouths, the lips of which end in angular corners sometimes displaying a fixed smile and under the finely detailed hairdress is a large forehead. Breasts are prominent and together with rounded limbs give most Yoruba carvings an opulent character. The finish may be polished wood, paint or a mixture of both.

The style of Yoruba ironwork differs from that of the woodcarvers because of the difference in material. Several types of wrought iron sculptures are of importance. Among them are *orisha-oko*, staffs made from worn-out hoes for female initiates of the cult. These are beautifully designed, about 1.5 metres high and may sometimes be covered with a beaded sheath. Staffs for *Osanyin*, the *orisha* of medicine, with birds mounted on a ring crowning the whole, are used by diviners and doctor-priests in curing afflictions of all kinds. The design is elegant and light and some of these implements must be included amongst the Yoruba masterpieces of art. Bronze casting has remained a traditional form of art and includes pairs of *Ogboni edan*, bronze heads and figures on iron staffs.

Many ivory carvings have the quality of the great art of ancient Benin, and armlets, trumpets, ceremonial staffs, swordhilts and many other objects are in the style of the city of Owo which was closely related to that of Benin.

The BINI outside the city of Benin produced carvings and masks such as that illustrated, for their tribal needs and for ritual use. However, the headdress masks from the Ughoton area are stylistically nearer to the Ijo of the Niger Delta, and not typical for Bini art.

VI Southeast Nigeria and the Niger Delta

The IBO, probably the largest art producers after the Yoruba, are estimated to number about eight million people, who in their tribal state have no urban concentrations nor any centralized government, being rather groups of villages with village economy and culture. They live mainly east of the Lower Niger, and are a very ambitious, hard-working and diligent people. Most of them are now Christians, yet the old traditions still have a powerful influence on the life of the tribe. The style of their figures and masks varies greatly from place to place, often incorporating carvings in the manner of neighbouring tribes so that it is impossible to speak of a uniform Ibo style and often difficult to determine the origin, tribally or geographically, of a piece. The masquerade societies have a great demand for ritual objects which might include

71 Mask
It has an articulated jaw, and was used by *Ekpo* society dancers. Ibibio, Nigeria; wood, paint 28 cm (11″). Museum of Mankind, London

72 *below* **Mask with articulated jaw**
Ogoni, Nigeria; wood, kaolin and encrustations 22.25 cm (8¾″). Private collection

the white-faced 'maiden spirit', mask of the Onitsha region or water-spirit masks similar in type to those used by the Kalabari Ijo, or *ikenga* altars for the cult of the hand.

The white *mmwo* masks of the 'maiden spirits' are among the best known Ibo masks. They are used for initiation rituals, the festival in honour of the earth goddess, and funerals. The mask with its costume is a male interpretation of female body painting, and a finely carved face and sculpted hairdress are usually surmounted by large intricate crests. The Ibo of the Onitsha district also made ancestor figures, often over life size, some of great power and dignity, and usually painted in vivid colours.

The altar of the hand, called *ikenga*, is a personal cult object which the Ibo have in common with the Igala and other tribes and with Benin. It enshrines the life force of a man's right hand and is made for a newly founded household, to be destroyed on the owner's death. Palm wine and kola nuts are presented to it and a ram sacrificed on special occasions. The cult of the *ikenga*—*okega* among the Igala—is old and has variously been described as being associated with the 'God of War', 'a personal protective deity', 'God of Fortune' and with head hunting. It has also been described as the symbol of a man's personal achievement or as representing 'the essence of man's will to success; it is viewed as part of a man's personal God, more specifically of his age set'.

There are two major styles: the abstract type made of hardwood where a small face is subordinated to the relatively straight horns and a cylindrical body with relief patterns. The other type, carved in soft wood, is less abstract, has smoother planes, the face is given more importance, the horns are usually curved and the figures are seated. The Igala have in addition 'tiered' *okega* with two or more groups on top of each other and these are owned mainly by men holding hereditary titles.

The *mmaji* mask of the Afikpo Ibo, one of the great abstractions of African art, differs totally from the very naturalistic Ibo sculptures, and is used for initiation rites and for the Yam Festival. The curved top part represents a knife and the other protrusions are said to be teeth.

The IBIBIO are a large group living south and east of the Ibo but whereas the latter are a Kwa speaking people the Ibibio's language is Bantu-related. Their socio-religious organization is centred on the *Ekpo* secret society which creates a uniformity of style. The faces of their sculpture are often built up from curved planes, some have movable jaws as have the masks of the neighbouring OGONI and some are completely naturalistic. However, they also make masks showing distortions caused by disease and these masks are meant to fight dreaded afflictions, such as leprosy or gangosa. The EKET are known for disc type masks and impressive ancestor figures.

In villages at the mouth of the Cross River, near Calabar, live the ORON. Their style is quite unique and has no relation to that of the Ibibio or other tribes in the area. They are known for dignified ancestor

210

213

219

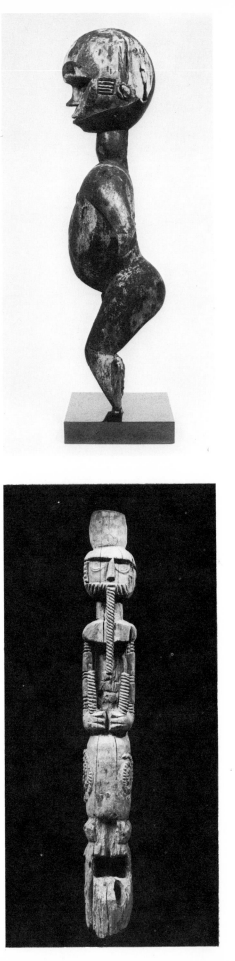

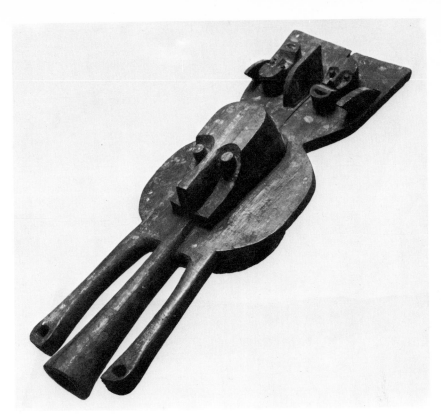

figures from fifty centimetres to over one metre high. These skilfully sculptured figures, carved over the last two centuries, are greatly venerated by the Oron people. A large number, though mostly weatherbeaten and damaged by white ants, were gathered from their shrines into a museum at Oron, from where about twenty were stolen in 1958. Some of these were later recovered from Europe and America. The greatest loss occurred during the Biafran war, when over 500 of the 660 sculptures were destroyed.

The IJO, comprising approximately forty tribes of related cultures, live in the east of the Niger Delta and are known, amongst others, for the water spirit masks of the Kalabari Ijo called *otobo*, the hippopotamus. These, adorned with leaves and feathers, are worn horizontally on the head. The carving is thus exposed to the sky and the onlookers can hardly see it. During the ritual a number of men wearing the masks wade into the sea, turn around and slowly approach the

209

214

216

73 *facing page, left* Figure
Possibly of a female ancestor. Ibo, Nigeria; wood 146 cm (57½"). Coll. Milton D. Ratner, New York

74 *facing page, right* Altar of the Hand, *Ikenga*
Ibo, Nigeria; wood 64 cm (25¼"). Tara collection

75 *above left* Figure from a dance crest
Eket (subtribe of the Ibibio) Nigeria; wood, pigments 52 cm (20½"). Coll. Ulrich von Schroeder, Zurich

76 *left* Ancestor Statue
Oron, Cross River, near Calabar, Nigeria; wood 133 cm (52⅜"). Private collection

77 *above* Water Spirit Mask
Western Ijo, Niger Delta, Nigeria; wood 74 cm (29"). Coll. Ulrich von Schroeder, Zurich

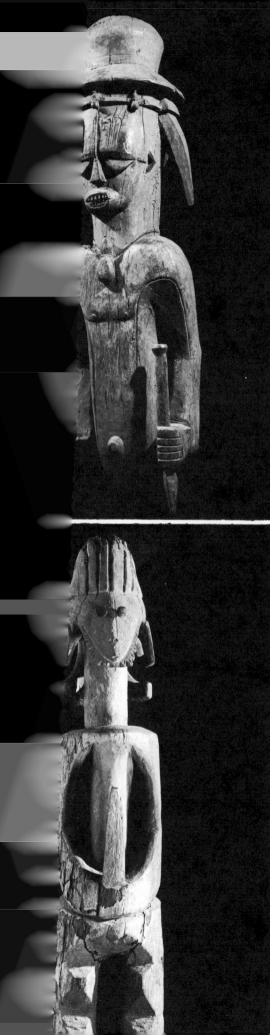

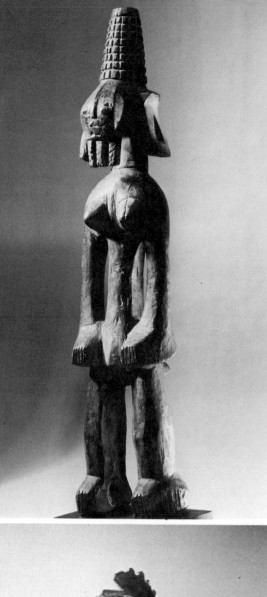

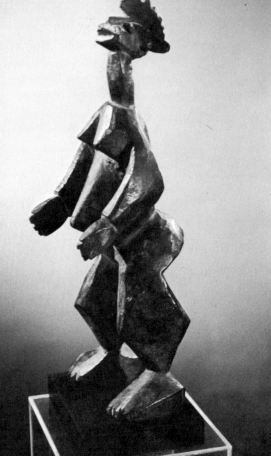

78 *top left* **Edjo ancestor figure**
Urhobo, Niger Delta, Nigeria; wood 120 cm (47¼"
Coll. Ulrich von Schroeder, Zurich

79 *lower left* **Ancestor figure**
Jukun (northern style) Benue River area, Nigeria;
iron 76 cm (30"). Coll. Josef Herman, London

80 *top right* **Ancestor figure**
Of a style said to be older than that of Fig. 79. Juk
(northern style) Benue River area, Nigeria; wood
69 cm (27¼"). Tara collection

81 *lower right* **Female figure**
The work of an unidentified tribe probably North
Edo-speaking or possibly from the Jos Plateau, N
wood 30.5 cm (12"). Coll. Robert and Nancy Noo
Washington, D.C.

shore. They are thus re-enacting their legend that the water spirits first **89**
came floating in from the sea. The masks may appear to western eyes
as masterpieces of cubistic sculpture but the form is strictly traditional
and to the Ijo they appear rather repulsive; indeed, pregnant women
must not see them if they are not to give birth to ugly children. The Ijo
also make funerary screens, *duen fobara*, showing in effigy the dead
man with his sons, brothers and slaves. The central figure in such
screens is usually shown wearing the headpiece of the masquerade for
the performance of which he was famous in his lifetime. Unlike charac-
teristic African sculpture, which is carved from one piece of wood,
such screens are built up of separate parts fastened together with strips
of cane. This is probably due to the influence of European ships'
carpenters with whom these coastal people must have had contact.

The URHOBO and the ISOKO are, like the Bini and the Ishan, Edo- **222**
speaking peoples livings to the south of Benin, but their basically Edo **211**
art style shows also the influence of the Western Ijo. The monumental, **212**
architectonic sculptures of the Urhobo called *edjo* represent the spirits **214**
of water, trees, land and the supernatural powers of their primordial **215**
ancestors. The Isoko also produce mud sculptures sited in private and **221**
public shrines. Some Urhobo carvings, *ivwri*, resemble the fantastic
compositions of the Ijo called *ejiri*, with composite animals mounted by
human figures, rider and mount often joined into a single ferocious
and aggressive being.

VII Central Nigeria and the Benue River Valley

Many areas of Africa still remain virtually unexplored and amongst
them are the northern region of Nigeria. Little is known of its history
and sculpture from the area has reached the west only during the last
twelve years, except for a few pieces in the British Museum and
continental museums. Even of these some were wrongly attributed
and it was only in the sixties that fieldwork began to provide better
knowledge of the art of the 'pagan' tribes of the area, and research into
the fascinating sculpture of these tribes is still in its early stages. They
remained for long without contact with either Islam or Europeans and **249**
retained their own culture until very recently. Indeed some of them,
like the Chamba and their subtribes, still adhere to their ancient relig-
ous and social tradtions.

The NUPE live north of the Niger river and together with many
subtribes number about 400000 people. They were forcibly converted
to Islam when the Fulani invaded their territory in a jihad in the first
quarter of the nineteenth century, and stopped carving images. A
handful of Nupe masks are known, and all are said to have been
collected by Frobenius in 1910. According to Nadel and Stevens, masks **242**
of a similar kind are still in use in certain areas of Nupe land in **247**
connection with the *Elo* masquerade observed by them at Mokwa. The **248**
masks are no longer connected with ancient Nupe ritual but are used
for entertainment and the celebration of Muhammad's birthday.

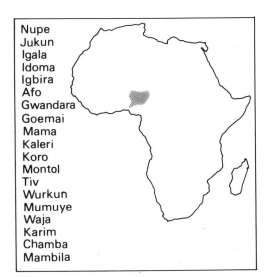

Nupe
Jukun
Igala
Idoma
Igbira
Afo
Gwandara
Goemai
Mama
Kaleri
Koro
Montol
Tiv
Wurkun
Mumuye
Waja
Karim
Chamba
Mambila

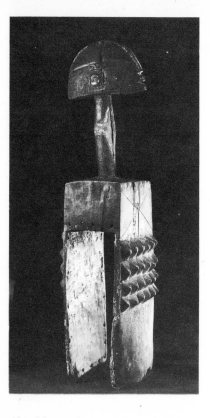

82 Shoulder mask
Formerly attributed to the Waja, Benue River area, northeastern Nigeria; wood 128 cm (50"). Private collection, Lausanne

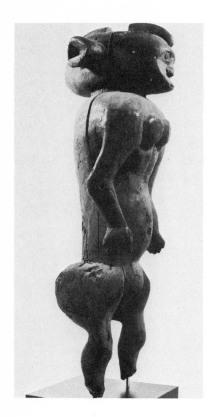

83 Ancestor figure
Montol, Shemankar River valley, northern Nigeria; wood 76 cm (30"). Coll. Ulrich von Schroeder, Zurich

The JUKUN, now a small tribe of about 35000 people, once constituted the powerful state of Kororofa ruling over many vassal tribes including the Igala and the Nupe. Prior to A.D. 1550 they occupied south west Borno and by the seventeenth century had extended their domain over a large part of what is now eastern and northern Nigeria. Their ruler was a divine king and Meek's description of the ceremonials connected with the election, coronation, life and death of the king, the nation's history and legend, its customs, religion and art is comprehensive, though not entirely corroborated, and many aspects of the divine kingship of the Jukun in Meek's story resemble those told of other African deistic states. The ruler is chosen by a small group of chiefs and courtiers, takes leave of his friends, relatives and parents whom he must never see again and after secret initiation ceremonials is declared god-king. When appearing, he is veiled and does not speak but 'gives vent to squeaks'. Seed grains are given to him and held by him until planting time. Should the crop fail or should he be found lacking in sexual prowess or should calamities such as epidemics befall the nation, he would be subject to death by strangulation, even before his term of seven years was completed. But there are few, if any, records of this ritual regicide ever having been carried out. The death of the king—natural or otherwise—is never announced to the people who are told that he has returned to the sky. His successor (like some of the Yoruba kings) must eat the heart and other organs of the dead king, so that the divine power should pass to the new ruler. Very little factual information is available on any aspect of their religion and the Jukun always have been—and still are—most reticent on the subject. During certain festivals, in particular for the celebration of the king's coronation, two images and a number of masks were used. While Meek does not show photographs of any images there are drawings of the very abstract masks *aku-maga* and *atuku*, similar to a mask from the Berlin Museum für Völkerkunde. They are amongst the most abstracted forms of human heads found anywhere in Africa. The Jukun speaking people use their bronzes, mainly bracelets and ornamental weapons, as status symbols and regalia or in connection with observances related to healing and protection from misfortune. Most bronzes have openwork surfaces with non-figurative decorations. Some were made for women's societies and were kept in the possession of members, whose priestesses carried ceremonial adzes consisting of an iron haft bearing a bronze terminal in the shape of a head with a blade issuing from the mouth.

Some tribes in the Adamawa area and in the Benue River valley including the MAMBILA, CHAMBA, WURKUN and Jukun used wooden figures either stuck on iron rods or with tapered base which apparently served as guardians of growing crops. The WAJA, to whom enormous shoulder masks were attributed in the 1960s, and the KARIM both have Jukun connections. However, Arnold Rubin stated in a note of 20 November 1975 to the author that he had surveyed most of the major Waja villages south of Tula and found only a small number of ceramics,

241
240

244

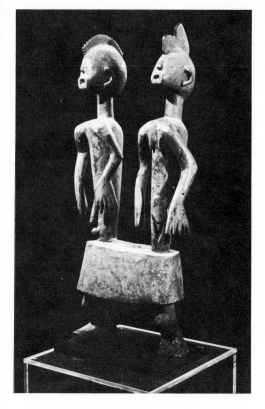

84 Male and female figure
They are joined at the base and share one pair of legs.
Chamba, Benue River Area, northeastern Nigeria; wood
encrustation 53 cm (21″). Coll. Robert and Nancy
Nooter, Washington, D.C.

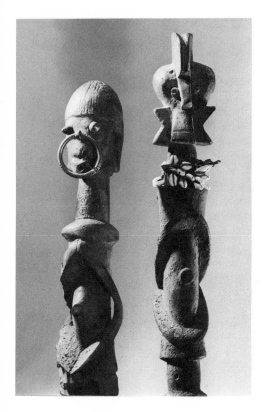

85 Two ancestor figures
Both have a socketed iron point at the base. Wurkun (a
Chadic speaking tribe) Benue River area, northeastern
Nigeria; left figure: wood, encrustation, metal eyes and
nose ring, 38.75 cm (15¼″); right figure: wood,
encrustation, fibre, cowrie shells 45.75 cm (18″). Tara
collection

nothing in wood. The correct attributions of the 'Waja' shoulder masks and other 'Waja' carvings must, therefore, await further research. Some at least seem to be from the northern Jukun. Like most tribes in the territory, the MONTOL and GOEMAI are Chadic speaking tribes that settled along the Shemankar river. Jukun influence is clearly noticeable especially in the case of Montol masks and statues. East of the Montol are the Wurkun whose sculptures were also until recently thought to be of Waja origin. One of the statues illustrated here has been identified as Wurkun, probably from the vicinity of Bampur.

The Chamba are another small 'pagan' tribe of about 30000 people including a number of subtribes. Until quite recently practically the only Chamba sculpture known were bushcow helmet masks, and a double figure in the Linden Museum, Stuttgart. Two figures in the British Museum originally documented as from the Chamba are now attributed to the Mumuye. In the mid 1960s a large number of wooden figures collected in the Benue River valley reached Europe and were believed to be of Jukun or Chamba origin, but are in fact MUMUYE. At one time it was wrongly stated that the Chamba did not carve at all and obtained all their sculpture from the Mumuye, but it is now established that the Chamba group of tribes had a considerable output of wooden figures and also produced some bronze castings. Some of their carvings are powerful and daring in concept and brilliant in execution as is the double figure, (seen here) growing out of a socle, as it were, and united by one pair of legs. Such double figures were 'fetishes against the death of twins'. A morphological study by Philip Fry—not based on fieldwork—is so far the best guide for the variety of stylistic types of Mumuye statuary. Some are as small as thirty-four centimetres but the majority are between seventy and ninety centimetres high. The very large figures of up to 1.85 metres high may be of very recent origin aimed at export rather than traditional use. All Mumuye figures have small stylized heads, bodies in a slightly curved dancing stance and arms enveloping the trunk—powerful and reminiscent in their form of Henry Moore's enclosed space.

In the Adamawa region and spreading southwards into Cameroon live the MAMBILA, a small tribe of under 20000 people with a very distinctive carving style. Their face and helmet masks are usually painted with black, white and red pigment and used for funeral and agricultural rituals. Certain figures are made of cane pith, a material used only by the Mambila, painted in the same bright colours as the masks.

The IGALA are a large tribe south of the Benue and east of the Niger and they claim a close relationship with the Jukun. There also appears to have been a certain relationship with Benin as among the regalia of the king of the Igala—the Ata of Idah—is a famous early sixteenth-century bronze mask of Benin origin. It is still in use today.

The western Igala carved large helmet masks painted black, while the eastern style is typified by the use of black and white paint on masks with flat or concave faces. Both face and helmet masks are made

249

227

54

245

99

246

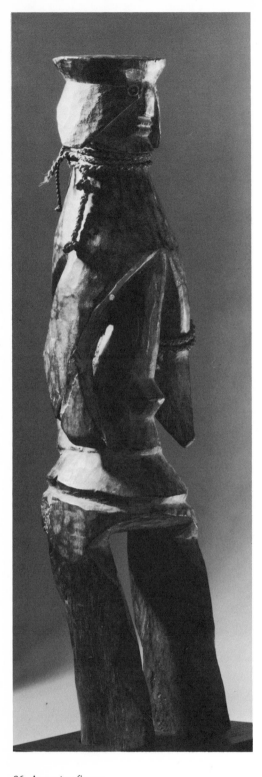

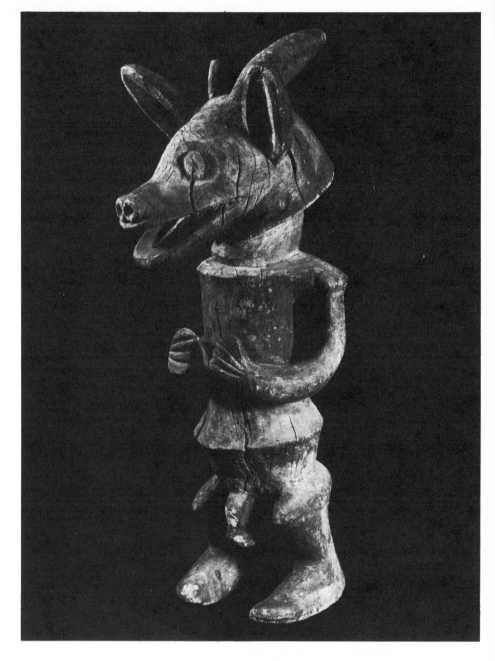

87 Male figure wearing horned animal mask
Mambila, southern Benue valley, Nigeria; wood, traces of pigment 50 cm (19¾"). Coll. Aaron Furman, New York

88 *on right* Mask
Mambila, southern Benue valley, Nigeria; wood with black, white and red pigment, and fibre 28 cm (11"). Coll. Aaron Furman, New York

86 Ancestor figure
Mumuye, Benue River area, northeastern Nigeria; wood, 56 cm (22"). Tara collection

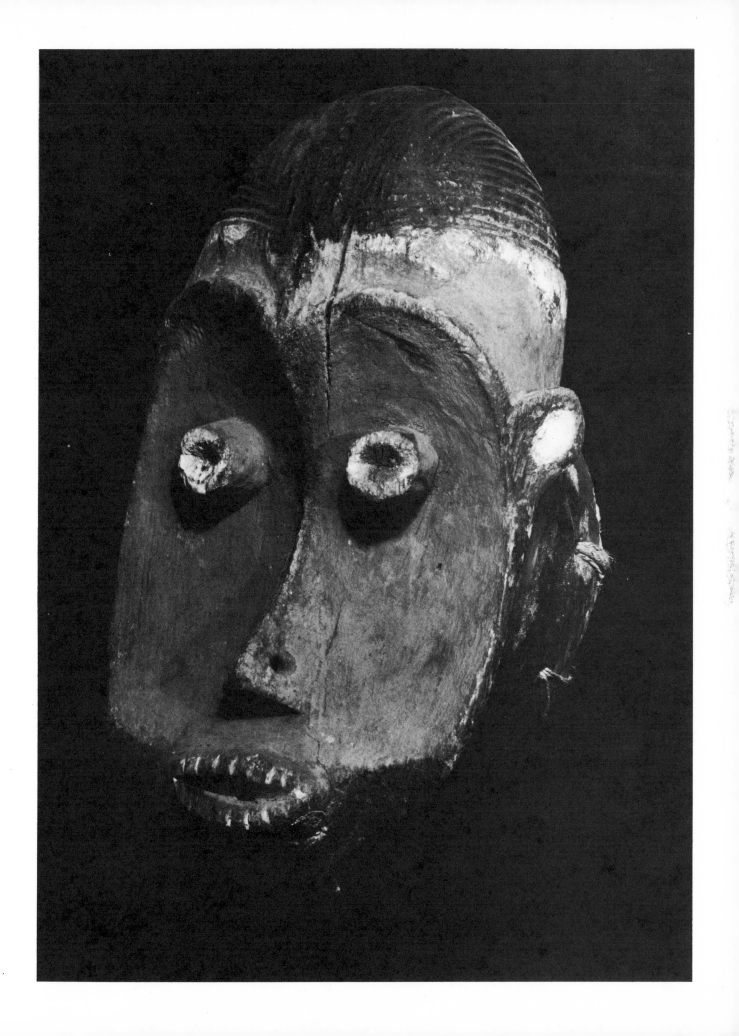

in both areas. They were all used in ancestor rituals and in the administration of justice. The only known type of figure carved for social or religious purposes assisted in the prosecution of thieves. Little is known about the purpose of other Igala statues which are believed to have served as family guardians or for an ancestor cult. The Igala also carved dance crests, doors, bowls, stools, and altars of the hand, *okega*.

The IDOMA, a large tribe of a quarter of a million people, live to the east of the Igala. Their masks, crests and figures are carved for secret dance guilds and the carvers have greater licence than is usual in Africa for individual styles, without departing completely from tribal tradition. Until recently the Idoma were still carving and using their masks and figurines in the service of their religion and for their social needs.

224

89 Headdress
It takes the form of a bird perched on a mythical animal. Afo, central Nigeria; wood, 20 cm (8"). Coll. William Brill, New York

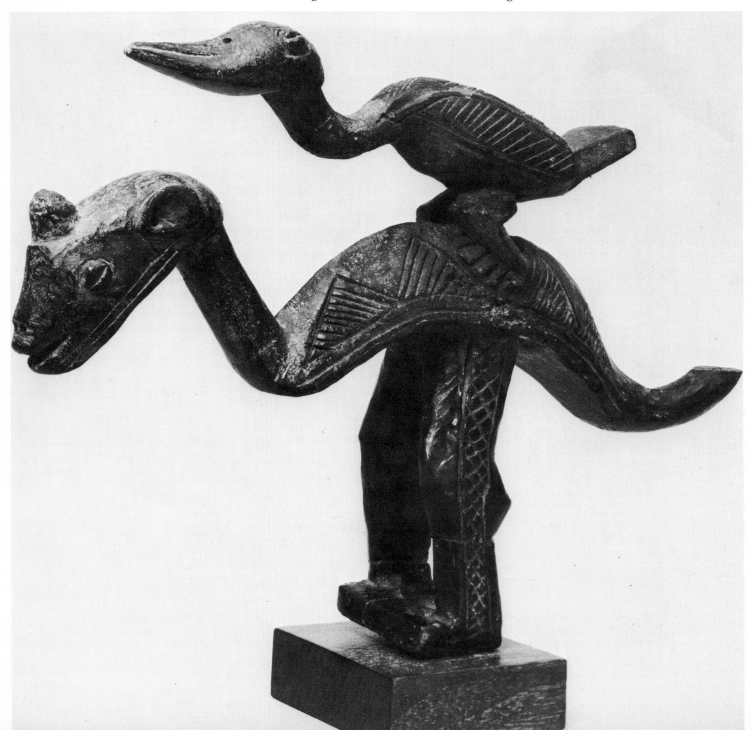

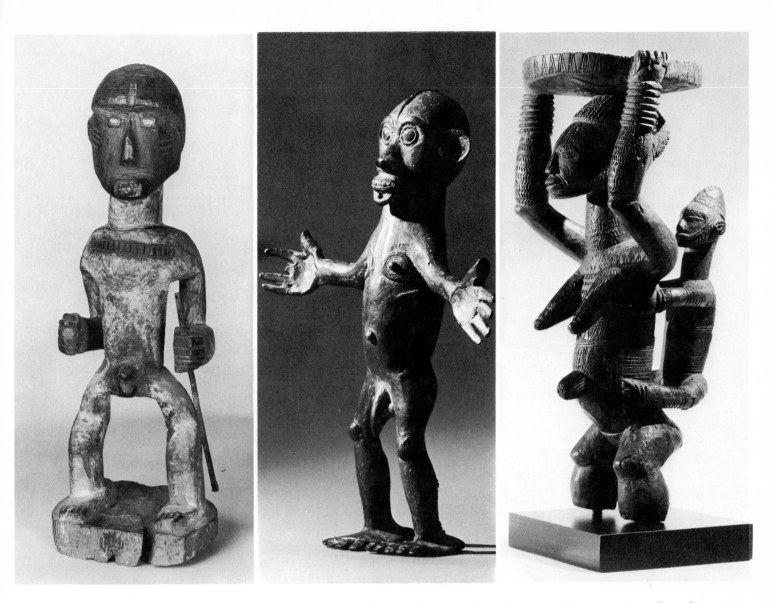

90 *left* Standing male figure
Idoma, Nigeria; wood 30.5 cm (12"). Coll. Josef Herman

91 *centre* Male figure
With outstretched arms Tiv (?) Central Nigeria; brass
33 cm (13"). Coll. Lance and Roberta Entwistle, London

92 *right* Stool
The caryatid figure is carrying a child on her back and
holding the seat on her head. Afo, central Nigeria; wood
58 cm (22¾"). Coll. Paul Tishman, New York

South of the confluence of the Niger and Benue rivers live the
IGBIRA, whose ritual life centres on the masquerade. Their masks are
made by amateurs and are only attractive to the collector as ethnologi-
cal specimens. The Igbira also use masks bought from neighbours.
Amongst those of 'foreign' origin are ebony masks of 'airport art' type,
which have actually been used in an Igbira *Ecane* festival. The TIV are 243
the largest tribe in this area but only very few of their artistically
extremely fine wood carvings and bronze castings are in collections. A 239
number of fine bronzes of indeterminate age have been found further
south in the Cross River area.

The AFO are a very small tribe of less than 10000 whose language is of
the Kwa family. They live to the east of the Nupe and Guare. The
oldest known carvings, dating back to the last quarter of the nineteenth
century or earlier, are seated mother and child figures probably repre-
senting founder ancestors. The most famous of these are in the Horni-
man Museum of London and are truly masterly sculptures. The Afo
still make statues (though now of poor quality), masks representing
ancestor spirits and zoomorphic dance crests, often composed of

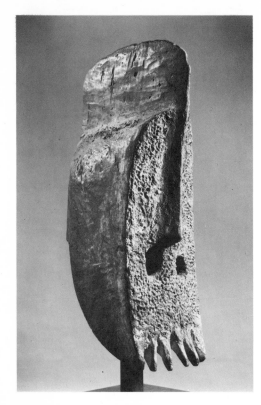

spiralling horns, crowned by a chameleon or a cock and decorated with red seeds. Their neighbours, the small GWANDARA tribe, have carvings in a similar style, though possibly acquired from the Afo. Genuine documented examples of the powerful sculpture of the Afo are very rare indeed.

Also in northern Nigeria, near Jos, are the MAMA with their wonderful abstract buffalo masks stained red with camwood and worn on top of the head. A similar type of mask, much rarer than the abstract masks of the Mama, is attributed to the neighbouring RINDERI. In the same area are the KALERI of whose sculptures only very few are known and even these may well have been carved by neighbouring tribes. However, the example shown here must rank amongst the masterpieces of African abstract art.

In the same region live the KORO, known for their anthropomorphic ritual drinking cups carved for their neighbours, the JABA. In their region is the village of Nok, where the oldest African terracottas were first discovered. The Koro pottery horse is of unknown age and great rarity.

93 Mask
Kaleri, Jos Plateau, Nigeria; wood, with some remaining red abrus precatorius seeds. 57 cm (22½"). Private collection

94 Male ancestor figure
Mama, Jos Plateau, Nigeria; wood, fibre 40.5 cm (16").
Coll. Josef Herman

95 Buffalo headdress
Rinderi/Mama, Jos Plateau, Nigeria; wood, 50 cm (19½"). Coll. Ulrich von Schroeder, Zurich

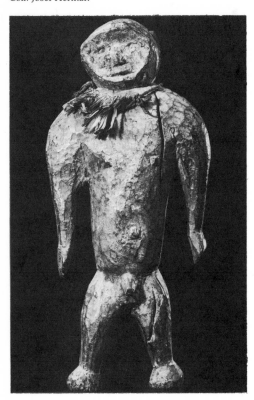

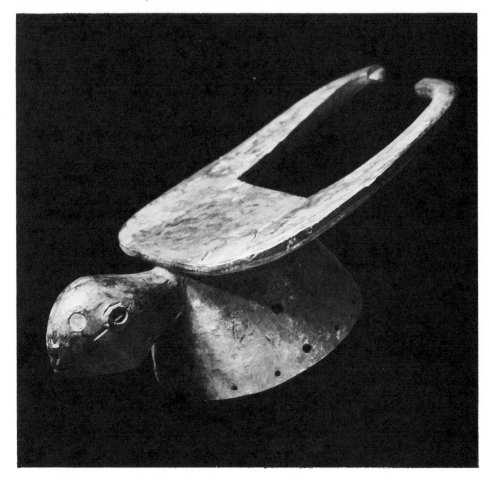

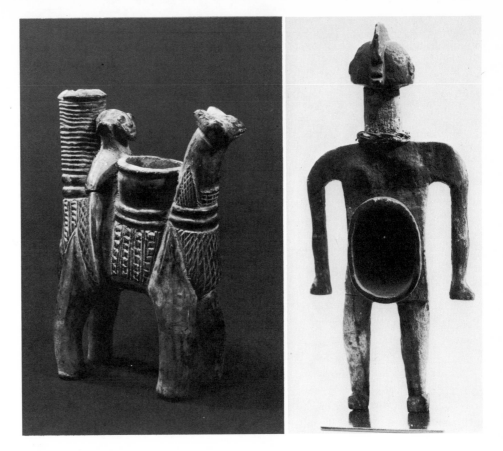

96 *left* Pipe
The form is perhaps that of a horse and rider. Koro, Jos Plateau, Nigeria; terracotta 12.7 cm (5″). Private collection, New York

97 *right* Ceremonial cup
Called *Gbene* it takes the form of a human figure and was used for ritual drinking of palm wine. Koro or Ham/Jaba, Jos Plateau, Nigeria; wood, fibre 28 cm (11″). Coll. Ulrich von Schroeder, Zurich

VIII Chad, East Nigeria and Cameroon

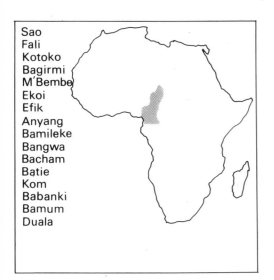

Sao
Fali
Kotoko
Bagirmi
M'Bembe
Ekoi
Efik
Anyang
Bamileke
Bangwa
Bacham
Batie
Kom
Babanki
Bamum
Duala

The northernmost part of Nigeria and the region of Lake Chad are almost totally Islamized and are now in the midst of great political upheavals. Very little art is produced there at present. Evidence of an ancient empire south of Lake Chad called SAO or 'Non-Believers' by the Mohammedans has been found in excavations. There were Sao people in many parts of the area as early as the fifth century A.D. and the peak of their civilization was between the tenth and sixteenth centuries. After this date wars with Borno caused the empire to collapse and the Sao people disappeared without trace. The powerful pottery figures are in human, animal, or composite form with legless bodies and rudimentary arms. The heads are often finely sculpted and developed from their original abstraction to a more naturalistic style in the fourteenth and fifteenth centuries. The finds also included pottery masks with similar stylistic characteristics, exaggerated eyelids and protruding lips. Also found were utensils, bronze jewellery and various ornaments. The FALI of northern Cameroon are described as 'post Sao'. They produced pottery figures which are even more primitive than the very earliest Sao sculpture. The KOTOKO also live in the area of the Sao who are cited as their possible ancestors. Shown is a wax doll, a typical example of the tribe's contemporary art.

In the same area are the BAGIRMI about whose history little is known. Practically the only art objects made by them are figures, probably fertility symbols, usually called dolls. The example illustrated shows the artist's sophisticated reduction of the female form.

236
237

234

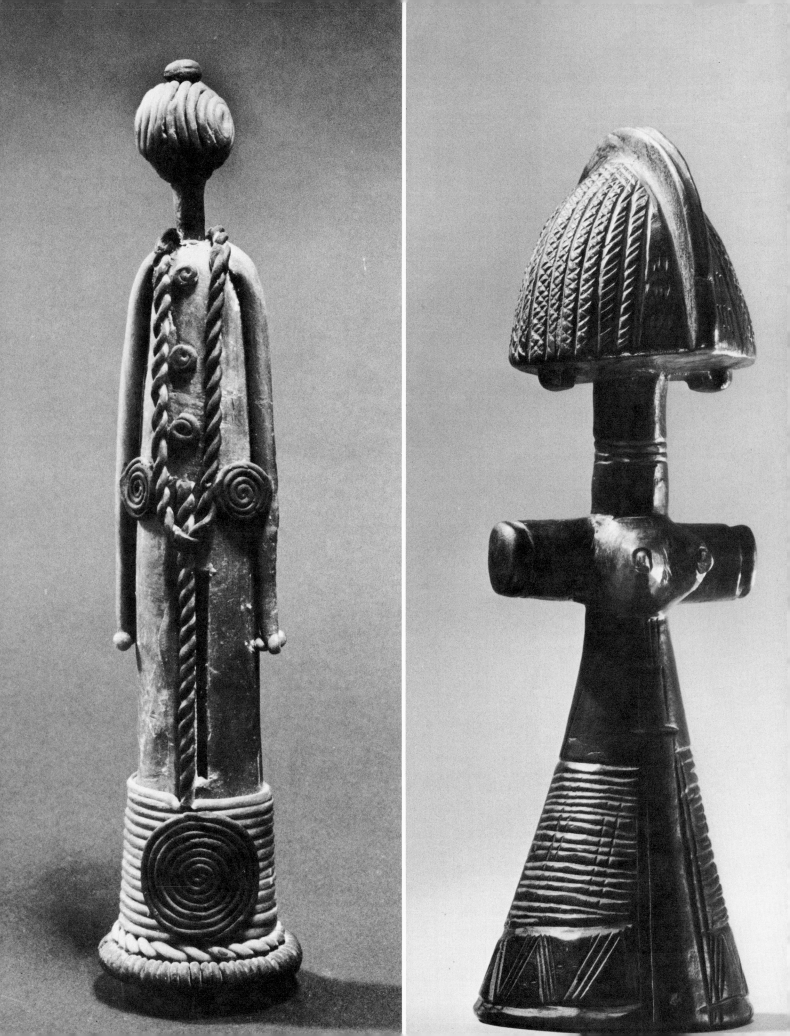

98 *facing page, left* Female votive figure
Kotoko (a Chadic speaking tribe of Borno province of
Nigeria and Chad), tan and black wax 21.6 cm (8½″).
Private collection, New York

99 *facing page, right* Female figure
This is possibly a fertility 'doll' similar to the Ashanti
Akua Ba. Bagirmi, Chad; wood, 26.5 cm (10½″). Tara
collection

100 *right* Chief's commemorative figure
This once formed part of a giant drum. M'Bembe, Cross
River, Nigeria; wood 82 cm (32¼″).) high and 62 cm
(24½″) wide. Private collection

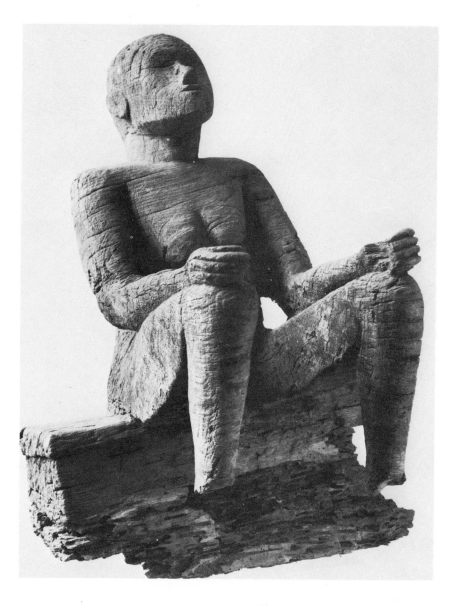

The M'BEMBE, a little known small tribe of 30 to 40000 people,
inhabit the Cross River area and their neighbours are the Ibo and the
Ekoi, but the M'Bembe developed a highly individual style of their
own. They used to carve huge slit drums, measuring three to four
metres. Their powerful call was heard over long distances when the
people were summoned to attend ceremonies or to prepare for war.
The drums are also reputed to have been used as altars on which
human sacrifices were made. Only a few of these were ever taken to
Europe but statues, probably ancestor figures, which were carved into
one or both ends of the drums, measuring between sixty-five and 110
centimetres in height, may have rotted or were sawn off and sold.
These drums and sculptures appear to be of considerable age and one
in the Berlin Museum für Völkerkunde, collected in 1907, may well
have been 100 to 200 years old at that time, though claims that such

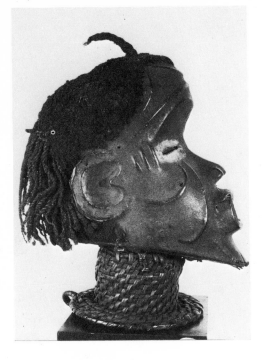

101 Dance headdress
Ekoi, Cross River, Nigeria, and Cameroon border;
wood, animal skin, human hair and basket work 29 cm
(11¼"). Coll. Lucien and Mariette van de Velde, Antwerp

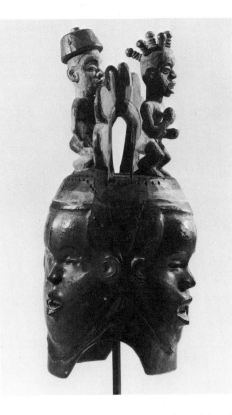

102 Janus mask surmounted by male and female
figures
Ekoi, Cross River, Nigeria and Cameroon border; wood,
animal skin 71 cm (28"). Private collection, New York

drums could be 500 years old are wholly speculative. The drums as well as separate ancestor figures were made of the very hard wood of the *Afzelia africana* and the drum-related sculptures were carved against the grain of the timber. This gives the large figures the appearance of eroded sandstone and an additional grandeur and monumentality.

The EKOI live in the rain forests of south east Nigeria and the Cameroon Cross River area. They call themselves Ejagham and form a group which includes the Keaka, Anyang and other minor tribes. Their style is most realistic and distinctive features are human and animal heads and articulated figures usually covered with skins. The Ekoi were head hunters and it is believed they danced with the severed heads, and sprinkled blood on the soil, to enhance fertility. Wooden carvings were probably a recent replacement of human heads and though antelope skins are used nowadays, the skin of slaves and slain enemies is said to have been commonly used to the end of the nineteenth century. The dance crests, fixed on the head by means of a woven attachment are often surmounted by an array of spiral shaped horns and this type of headdress is also made by their neighbours, the EFIK, a tribe in the Ibibio group. In both cases they probably represent female coiffure styles.

The Janus helmet mask is an Ekoi symbol of duality: white and female for life, black and male for death. The masks are covered with skin and then painted.

In 1969 Professor R. F. Thompson was given the following meaning of a particular Janus mask by the chief of Otu, a town in the Ekwe–Ekoi area:

This mask represents Tata Agbo, a man born in war, and his wife. All his brothers and sisters had been killed in combat, only he and his wife remained. Whenever he went to battle, his wife went behind. When he shoots, she loads, till he wins. That is why when Tata Agbo died they made that skin-covered helmet as remembrance, the man facing the battlefield, the wife was in back, loading. It is a double remembrance.

88

As these masks are thus defined as commemorating aggressive warriors this, in Thompson's view, may explain the bared teeth common in Ekoi skin-covered sculpture, 'so different from the closed lips prevalent in the Yoruba visual aesthetic' and, indeed in that of many other African tribes. The masks or crests were worn during funerals and were also used to appeal to the spirits in case of illness or tribal misfortune.

The steaming hot southern rain forests gradually ascend to a plateau of grassland most of which is flat terrain at an elevation of about 1500 metres with occasional mountains rising to 3000 metres. These Cameroon grasslands are described as amongst the most beautiful landscapes of Africa. Conditions here being very favourable to agriculture, many tribes settled in these highlands and formed well administered societies. The result was the development of numerous chiefdoms and kingdoms varying in size from small village states to large

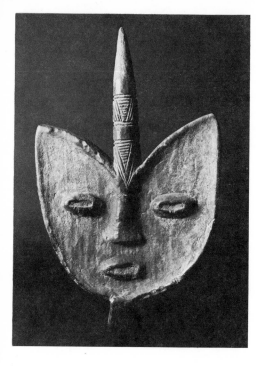

103 Mask
The shape is that of a stingray or bird with a human face, Keaka, Gembo District, southeast Nigeria; wood, 62.25 cm (24½"). Coll. Aaron Furman, New York

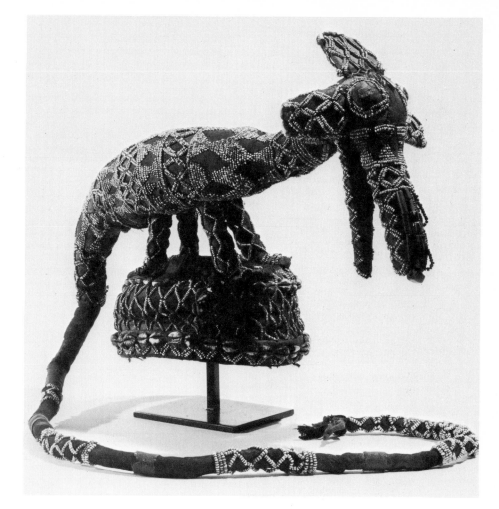

105 Headdress
It takes the form of an animal with long tail, surmounting the cap. Bamileke, Cameroon; cloth, beads, cowrie shells; total size with tail 142 cm (56"). Private collection, New York

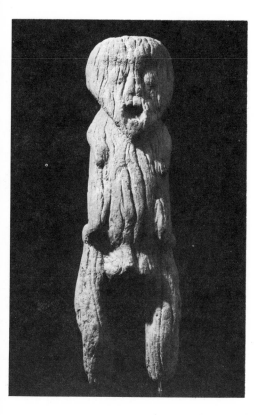

104 Ancestor figure
Keaka, Cameroon/Nigeria borders; eroded wood 51 cm (20"). Coll. Ulrich von Schroeder, Zurich

territories ruled by divine kings. Tribes of many different origins merged and gave birth to 'Cameroon' art, the general stylistic character of which is easily recognizable, in many respects differing very considerably from that of all other African sculpture. Its hallmarks are great vitality, movement rather than rigidity, lively facial expressions with open and often smiling mouths, the adze mark finish and a patina often derived from oil, sacrificial substances and smoke.

There are two main groups into which Cameroon grassland art is usually divided, though the classification remains confused and arbitrary. The BAMILEKE and their subtribes the Bangwa, Bacham, Batie and others are the largest group and their area extends from the border of Bamenda Province roughly to the River Noun. Their styles vary from village to village, so that exact attribution is almost impossible, even if the place of collection is documented. Due to the fact that art objects were traded between tribes, and artists travelled widely to locations where their products were needed, a carving may have been made in a village situated far away from the spot at which it was found.

The Bamileke used beads and beaded cloth extensively to cover wooden figures or to create sculptures in beaded textiles. The BANGWA

228
230
231

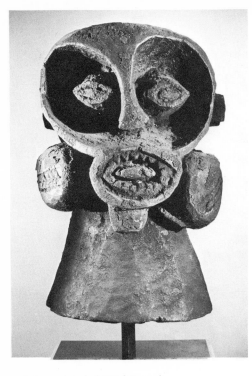

106 Janus headed 'Night' mask
Bangwa, Cameroon; wood 40.5 cm (16"). Coll. Robert
and Nancy Nooter, Washington, D.C.

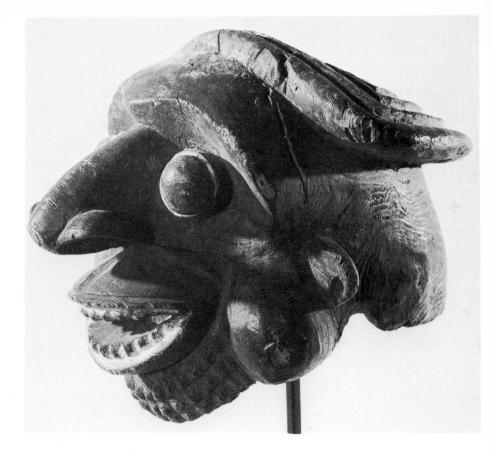

108 Mask
From Wum, Bamenda Highlands, Cameroon; wood 28 cm (11"). Private collection, New York

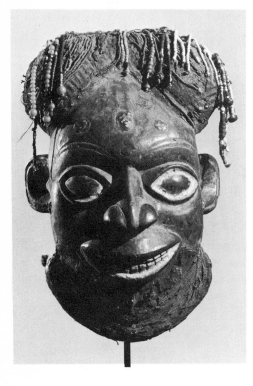

107 Mask
Probably Kom, Cameroon; wood, textile, fibre, beads
42 cm (16½"). Private collection, New York

produced outstanding ancestor figures, statues of females represent-
ing mothers of twins and maternity groups, all in lively movement.
They also made anthropomorphic fetishes used by medicine men for
protection against disease and evil-doers. The Bangwa still have a
number of secret societies, the *Night* society being the most powerful.
It is involved in many functions and rites, religious, administrative and
legal. At the head are the nine people who are the tribe's kingmakers
and who are all direct descendants of the founder of Bangwa's royal
dynasty. Their masks, which are usually carried on the shoulder rather
than worn on the head, are expressionistic and intended to intimidate. 225
Gigantic headdresses from sixty to ninety centimetres high, most
impressive in their conception of the head, were at one time believed to
be also Bangwa Night masks, but are probably from central Bamileke
country. One of the finest of them is in the Rietberg Museum. The 233
helmet mask illustrated here is in a rather naturalistic style, and poss-
ibly originated in Wum in the Bamenda Highlands. The BATIE are a
small tribe in the Bamileke group and they too have developed a very
lively style.

The other group comprises the Kom, Babanki and others, all said to
have been influenced by the Tikar, a migrant people about whose art
very little is known. The BAMUM who are geographically and stylisti-
cally separate, are also said to show Tikar influence, mainly in their
bronzes. Kom carvings are of great vitality and their masks, some

109 Mask
Batie, Northern Bamileke, Cameroon; wood, with
brown patina 29.25 cm (11½″). Private collection, New
York

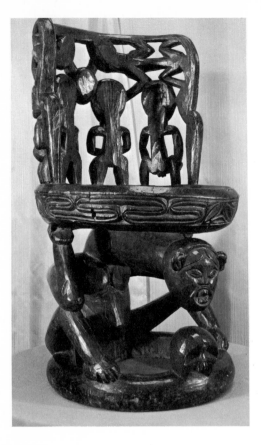

110 Chief's chair
It is supported by a seated human figure, with a skull in front of it and figures of two human pairs and a large chameleon carved to form the back of the chair. This chair was a gift by the Fon of Bafut to an Assistant District Commissioner. Bamenda, Cameroon; wood, 99 cm (39″) high. Katherine White Reswick collection

anthropomorphic, others representing buffaloes or other animals were worn on top of the head. A special mention must be made of the Kom thrones with majestic figures rising from them, and of their seated statues. Very fine stools were collected from the Palace of the Fon of Kom at the beginning of this century by the Germans when they were the colonial rulers of the Cameroons. These stools or thrones are now in the Museums für Völkerkunde in Berlin and Frankfurt. The Grassland tribes provided many fine chiefs' stools usually supported by totemic figures, human or animal, and others carved with a variety of symbolical patterns. Another famous product of the Grasslands are tobacco pipes and pipe bowls in pottery, metal and wood. The Bamum created some of the finest in all three materials and many beautiful examples also originated in the Bamenda Highlands. A large helmet mask surmounted by a seated male holding a funnel or drinking vessel in the form of an animal horn probably of Babanki-Tungo origin is illustrated on colour plate XVIII right.

The Bamum are a small tribe but have an important artistic tradition. Their great King Njoya made the capital city of Fumban into a centre of learning and art, and he even started a museum at the turn of this century and developed an indigenous African script. Impressive masks with exaggerated pouched cheeks carved for the *Kwifon* society have the sacred lizard in the upper part. Royal stools with symbolical decorations of the earth spider, bead covered sculpture and examples of their fine tobacco pipes in bronze or pottery are found in many 229 collections.

The coastal strip of Cameroon is inhabited among others by the DUALA who live in and around the port city of Duala. Their sculpture 62 underwent considerable degeneration due to early contacts with European traders and by the end of the nineteenth century they ceased 54

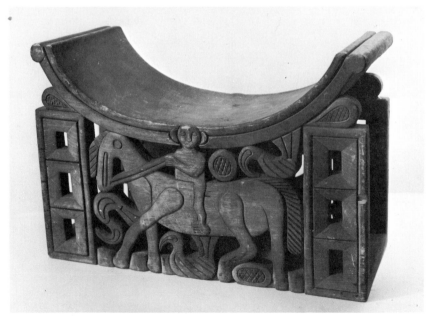

111 Chief's stool
Collected in 1902. Duala, Cameroon; wood, 39 cm (15½″) high. Museum für Völkerkunde, Hamburg

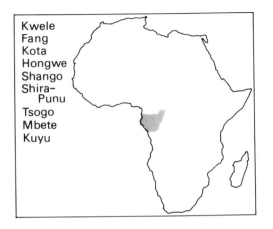

Kwele
Fang
Kota
Hongwe
Shango
Shira–
Punu
Tsogo
Mbete
Kuyu

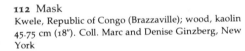

112 Mask
Kwele, Republic of Congo (Brazzaville); wood, kaolin
45.75 cm (18"). Coll. Marc and Denise Ginzberg, New
York

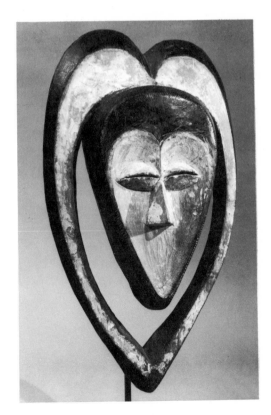

to produce art for their secret society—the *Ekongolo*—and no longer carve stools and staffs for their chiefs. What is known of their sculpture, as for example elegant ship prowheads, were in more recent times covered in gaudy colours with imported aniline paint.

IX Gabon and Congo (Brazzaville)

The KWELE live on the Sangha River in Congo Brazzaville and are best known for simple masks of great appeal and sensitivity: some of these are surrounded by a heart-shaped frame. Other Kwele masks are 250 antelope and gorilla heads in highly stylized forms. Most known pieces of Kwele art were collected in 1930 from one shrine by a French administrator, Aristide Courtois, and by a Swedish missionary at the beginning of this century. According to them some were used as face masks, others were hung on the walls of the shrine, though the report does not explain the purpose of displaying the masks. They may have been stored there while not in use or they might have served in initiation rites.

The FANG, Pangwe, or Pahouin, occupy areas in southern Cameroon as well as in Gabon and in Equatorial Guinea (Mbini, previously Rio Muni—Spanish Guinea). They are especially known for their reliquaries—*bieri*—heads, half figures and full figures—used as guardians on bark boxes containing the skull and bones of ances- 250 tors. *Bieri* is also the name for ancestor worship and of the shrine containing the bones of the founder of the family. The styles, which 252 have been analyzed by Perrois, differ from area to area—they are also 253 carved by the Cameroon tribes overrun by the Fang. But the sculptures 256 are mostly of classical beauty showing the ancestors not as old but as men in their prime, though often they have infantile features and limbs, depicting man halfway between infancy and old age and stressing the relation of the ancestor with the uninitiated boy. It is a symbolic combining of ancestor cult and the ever present concern with increase in African tribal cultures.

The Fang people, numbering now about three quarters of a million, came to their present area not more than 300 years ago, displacing other tribes. They were cannibals and ferocious warriors who produced some of the most sophisticated sculptures in Africa—which can be classed as among the great art creations of the world.

The Fang also made beautiful, highly stylized masks both of the face and the helmet types, usually painted with kaolin. Some have cicatrice marks or the outline of the heart-shaped face emphasized by lines of small holes. They are said to have been used by the *Ngil* secret societies in their rites.

In spite of the great variety in local styles requiring expert knowledge for correct attribution, the *bieri* and the masks have features which make it relatively easy to identify them as of Fang origin. The concave faces of the statues are often heart-shaped, have a high, bulging forehead and a pouting mouth, and a head large in proportion

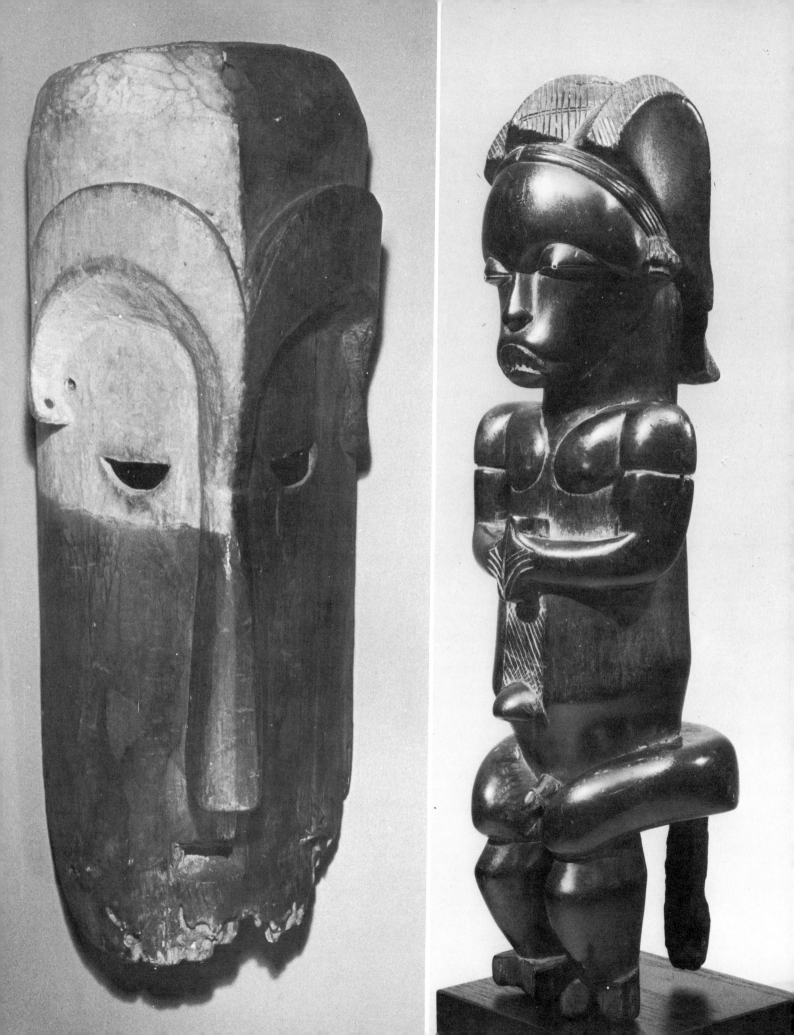

to the body. Arms and legs are usually bulbous, varying from very short to elongated. A variety of hairdresses is also a feature that assists in recognizing the origin of the carving. The treatment of the eyes varies from cowrie shell shapes to round metal discs. Most of the full figures have a sticklike extension from the buttocks for insertion into the bark cylinder on which the *bieri* sits. Some figures and busts are decorated with metallic bracelets, earrings and tacks.

The KOTA inhabit an area in the forests of the Democratic Republic of the Congo (Congo Brazzaville) on both sides of the Ogowe River and their territory stretches into Gabon. They are a group of tribes related by languages, culture, religion and social structure. The *mbulu-ngulu* reliquary figures of that group are—somewhat like the Fang *bieri*—placed on bark cylinders or baskets containing the skull and smaller bones of an ancestor. However, the extraordinary wooden sculptures of the Kota covered with brass or copper sheeting are two-dimensional in appearance and highly abstracted by comparison with the rather naturalistically conceived *bieri* of their northern neighbours.

The faces of the sculpture are usually concave though some have a convex forehead. At one time it was said that the convex forms were male and the concave female but there is no conclusive evidence for this. A substyle of the *mbulu-ngulu* is a more naturalistic type with a high relief face like the one illustrated in colour plate VII. There are also some Janus figures, one side usually concave and the other convex, which does suggest the female/male dichotomy.

Like the Fang and the Kota, the Hongwe, the Shango and the tribes of the Shira-Punu cluster use reliquary figures to guard the bones of ancestors. As early as 1876 a German explorer, Oscar Lenz, collected a reliquary figure of an even more abstract type than those of the Kota: a wooden armature in a half ovoid shape, covered with copper wire and sheeting cut into strips, it was found in Ossyeba territory in Gabon. These figures were for a long time called Ossyebas until their origin was established as being from the HONGWE who live in the Mekambo area south of the Ivindo, and call these figures *bwete* or *bwiti*. They are fixed on cylindrical boxes made of bark, on fibre bags or in woven baskets, in each case containing bones of ancestors. The neighbours of the Hongwe—the Shake and the Shamaye—use similar figures in slightly different styles. The Hongwe also produce masks in the style of the Kota and the Kwele. To the southwest of the Kota between the Ogowe and Ofoue rivers, live the SHANGO whose reliquary figures, usually fixed on ossuary bags, are nearer to the Kota style, though the heads are smaller and the neck proportionally longer.

Masks daubed with kaolin are made by tribes in the area of the Ogowe River and of the Lower Congo and are now generally called SHIRA-PUNU. This term, first applied by Leon Siroto, following Guthrie, is a linguistic classification replacing the names previously used (such as M'Pongwe, Ogowe, Lumbo, or Punu). The use of these white masks is, however, so widespread that even Siroto's classification does not fully cover the peoples amongst whom they are

250
251
254
255

254

254

250

113 *far left* Mask
Fang, Gabon; wood, kaolin, red pigment 64 cm (25¼").
Private collection, New York

114 *far right* Male ancestor guardian figure *Bieri*
Fang, Gabon; wood, 51 cm (20"). Coll. Marc and Denise Ginzberg, New York

115 *below* Ancestor Guardian figure *Mbulu-Ngulu*
Shango (Kota Group) Gabon; wood, metal 21 cm (8¼").
Private collection, California

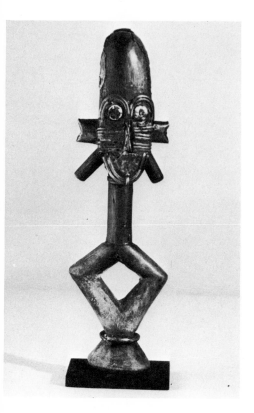

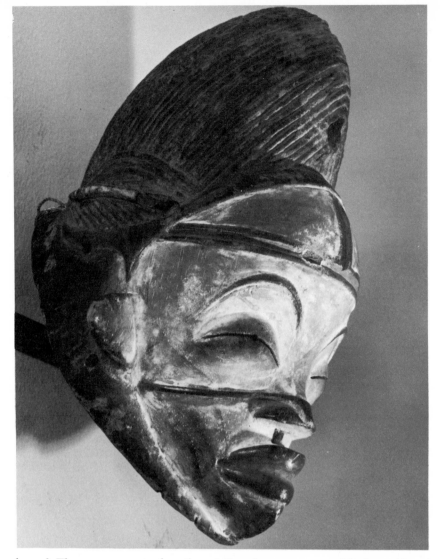

116 *below* Half figure
Ancestor guardian figure or *Bwete*. Tsogo, Gabon; wood, coloured with a mixture of red camwood, ochre and kaolin, and white metal 33 cm (13″). Formerly Tara collection

117 *right* Mask
Shira-Punu group of tribes (or possibly Kota), Gabon; wood, pigments 33 cm (13″). Formerly Tara collection

118 *facing page, left* Figure representing an ancestor
This was used as a reliquary, and contained the bones of tribal ancestors in an opening in the back of the figure. Mbete, Gabon; wood, black and white pigments, metal inlaid eyes 62.25 cm (24½″). Coll. Aaron Furman, New York

119 *facing page, right* Serpent figure
This is associated with the *Kebe-kebe* cult. Kuyu, Republic of Congo; wood 84 cm (33″). Lance and Roberta Entwistle collection

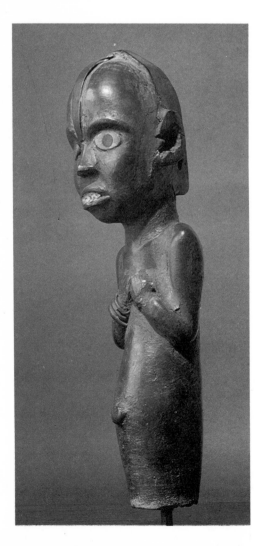

found. They represent a female spirit and some are used in funeral and other rites, the masked dancer sometimes appearing on stilts. Some of these masks like that illustrated may have been made by the Kota.

The TSOGO who live to the west of the Ofoue River where—like their neighbours—they were driven by the conquering Fang, make lifelike figures, as guardians of the remains of their immediate ancestors, and these too are called *bwete*. They are painted with red camwood, ochre and kaolin. In the illustrated example the eyes and the strip on the forehead are made of white metal. They also make masks in the Shira-Punu style, as well as anthropomorphic gongs. The MBETE, who live to the east of the Hongwe, use large wooden statues carved in stereometric form, also to guard the remains of ancestors. But here the bones are kept inside the figures which have a lid in the back of the hollow cylindrical or rectangular trunk.

On the Upper Congo River, in the Democratic Republic of the Congo (Brazzaville), live the KUYU Their heads, dance staves, whole figures and, very rarely, helmet masks are used in the *kebe-kebe* dance devoted to the sacred snake *Ebongo*. Their carvings often excel in body ornaments and recent examples are painted in vivid colours.

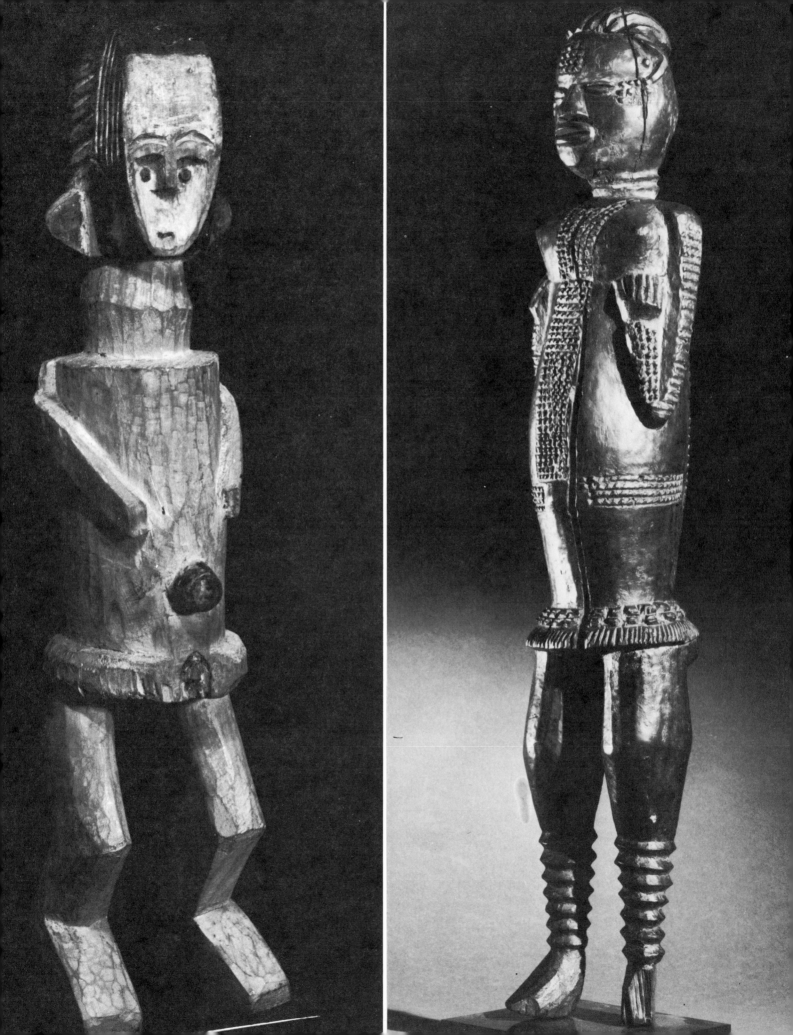

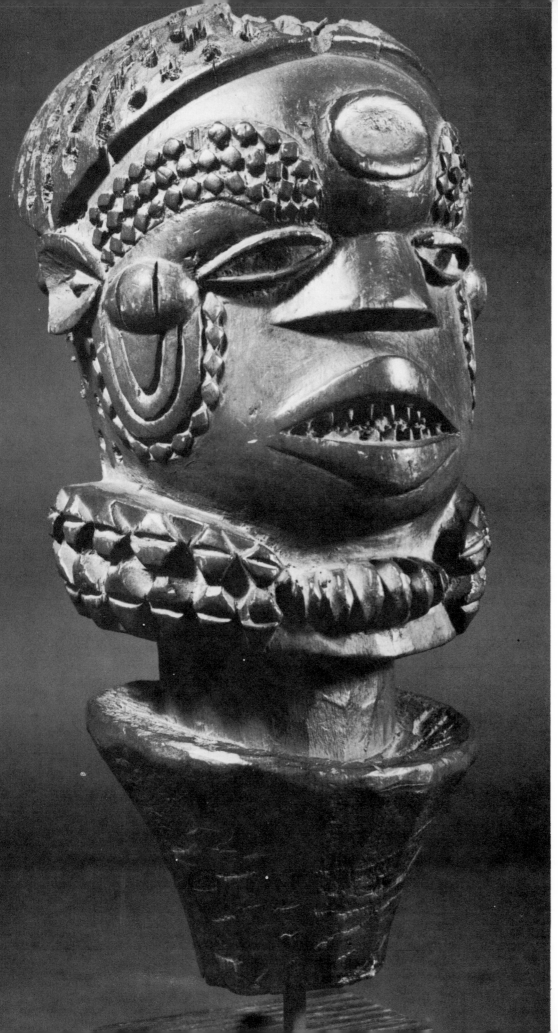

120 Dance headdress
Also associated with the *Kebe-kebe* serpent cult, Kuyu, Republic of Congo; wood 26.5 cm (10½"). Coll. William Brill, New York

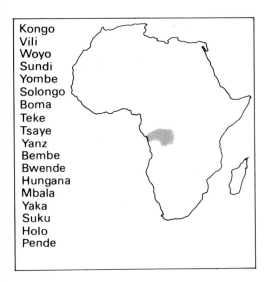

Kongo
Vili
Woyo
Sundi
Yombe
Solongo
Boma
Teke
Tsaye
Yanz
Bembe
Bwende
Hungana
Mbala
Yaka
Suku
Holo
Pende

X Lower Congo, Stanley Pool and southwest Zaïre

The Congo River and its numerous tributaries dominate the vast belt of forest and savannah which stretches from the Lower Congo region in the west to the Great Lakes in the east and from the Ubangi River in the north to Zambia and Angola in the south. The modern nation states in this Congo region are the Democratic Republic of the Congo (Brazzaville) which was the French Congo, Zaïre (formerly the Belgian Congo), the Central African Empire (formerly Ubangi-Shari or the Central African Republic), and Angola, and borders everywhere cut indiscriminately across tribal areas.

Some of the most important Black African art developed in the heartland of this belt, which is mostly fertile savannah. In it are almost as many—and probably more—varieties of sculptural styles as there are tribes. The social structure ranges from the village rule of the Ngbaka to highly stratified kingdoms like those of the Kongo, Kuba, Luba, Lunda and in the North East those of the Ngbetu. Their plastic art varies from the naturalistic figures of the Kongo and the Kuba to the highly abstract *Teke*—or *Tsaye*—masks and the *Kifwebe* masks of the Songye. Remnants of a pre-Bantu culture dating to the ninth century have recently been found in excavations along the Upper Congo, including pottery, iron and bronze objects.

There are, perhaps because of a common Bantu origin, overall similarities in the religious beliefs, cults and rituals throughout the whole Congo region and even the terms used are often related. All 201 Congo peoples believe in a creator or great god for whom there is, 267 however, no organized form of worship, and of whom no images are 266 made. Ancestor cults are widespread and there is universal belief in witchcraft, nature spirits and often in the magical power of specially prepared objects, generally called fetishes. Resort to divination and spiritual healing is also a common practice. The external features of rituals are somewhat similar everywhere and include animal sacrifices and discovery and punishment of witches by poison ordeal. Secret religious societies exist throughout the area. These organizations, beliefs, cults and rituals are the inspiration for the great sculptural traditions of the Congo people.

The KONGO people are made up of related tribes: the Vili, Yombe, Woyo, Sundi, Boma and Solongo. Their territory extends from the Atlantic on both sides of the mouth of the Congo River to the Stanley Pool in the north and into Angola in the south. As a political unit the kingdom of the Kongo realized its greatest power during its alliance with the Portuguese in the fifteenth century. Portuguese influence and the temporary adoption of Christianity left on the whole few marks on the traditional culture of the Kongo people, except for the incorporation of Christian religious symbols such as the crucifix into their own iconography. A tendency to naturalism in their sculpture may have been a feature of their art even before contact with Europeans.

The oldest known figures of the Kongo group are steatite carvings

121 Potlid
Woyo, Lower Congo, Zaïre; wood, 17.75 cm (7″) across.
Coll. Marc and Denise Ginzberg, New York

122 *facing page* Mask
Yombe, Lower Congo, Zaïre; wood, kaolin, black
pigment. 38 cm (15″). Coll. William Brill, New York

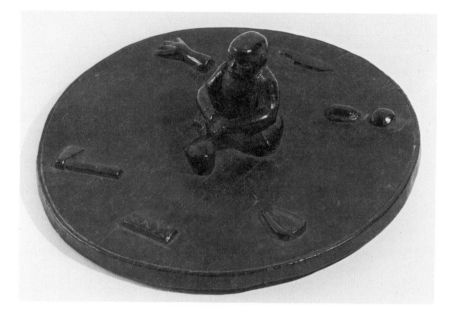

called Ntadi. Some date back to at least the 17th century and they were probably still being made up to the outbreak of the First World War. They possibly represented chiefs' ancestors and were kept in the home until they were placed on the graves at the time of the funeral, though other theories are that these usually well-carved images were prestige tombstones not connected with the ancestor cult. Many were male figures, kneeling or seated tailor fashion, chin in hand. Others held plaques with the deceased's name, date of birth and death. Very often the Ntadi were conceived as maternity figures. These may have represented the wives—or possibly the mothers—of the buried chief. As most of the stone sculptures were found in the areas of the Boma and Solongo sub-tribes they are presumed to have been carved by them.

The remarkable maternity figures, with the mother shown seated tailor fashion, are among the best known art produced by the YOMBE who live between the Congo and Kwilu Rivers to the north. Such figures are also found mounted on staffs, flywhisks, bells or trumpets. They are carved in wood or ivory in the round, the face beautifully detailed, looking straight ahead—never at the infant. The figure becomes thereby a symbol of fertility rather than a picture of the mother and child relationship. The mouth is usually open showing teeth filed in accordance with local customs. The body is adorned with jewellery and scarified ornaments, and hairstyles vary greatly. The intense naturalism of the carvings have led many European art critics to state that the figures were influenced by European cultures and in particular by Christian icons. But in fact the maternity figures of the Yombe are as indigenous to Africa as are the bronzes of Ife. Apart from the African proportion of head and body these figures of the Yombe convey the strong feelings of the African artist rooted in his own tradition. Lehuard gives excellent details on the history, the great

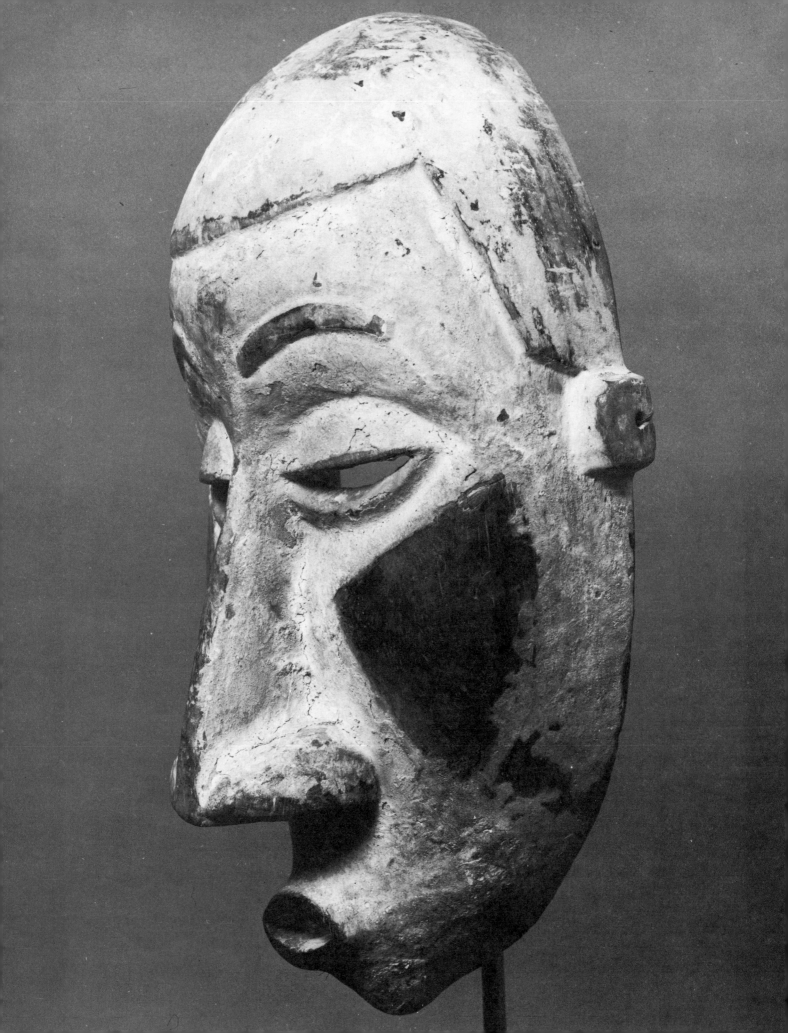

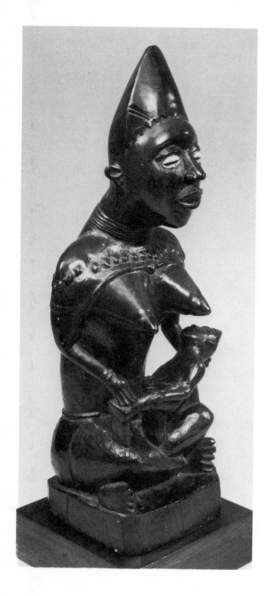

123 Woman seated tailor fashion
The 'mitre' she is wearing is a mark of prestige. Yombe, Lower Congo, Zaïre; wood, cowrie shell eyes 38 cm (15"). Coll. Marc and Denise Ginzberg, New York

XIII Head
Part of figure. Ashanti, Ghana; terracotta 33 cm (13"). Private collection

variety of types and the general morphology of these creations of Yombe art in his recent book.

Nail and mirror fetish figures—or *nkisi*—are a unique and important phenomenon of Kongo sculpture. Most other carvings appear to be related to the ancestor cult, and constitute a receptacle for the spirit of a primordial ancestor or immediate elder. The figure itself has no power: the ancestor, remaining a part of the family even after his death, is relied on for action. The *nkisi*, on the other hand, if properly endowed with magic substances and additions by the *nganga* or doctor has the power to act in a number of ways. According to Maes there are four main types of *nkisi* used for different purposes.

Nkondi are fetishes of ill omen, usually brandishing a spear or a knife, while *npezo* are just as evil, but less menacing in attitude. *Na moganga* are benevolent figures which protect against sickness and dangerous spirits. They help the hunter and the warrior, and, lastly, *mbula* protect against witchcraft.

But since this classification was made several Africanists have come to the conclusion that all *nkisi* can be used for a variety of purposes and that their meaning is ambivalent. Furthermore, the reports of an Englishman, Andrew Battel, who visited Loango at the beginning of the seventeenth century and a book by Weeks (published before Maes wrote) show that one and the same *nkisi*, whatever its form, could be used to destroy or to protect, to cause an illness or to cure one. The basic figure may have nails and knives driven into the body, or may be hung with medicine, charms or vials filled with gunpowder, or a receptacle containing magic substances might be attached to the belly or the head. Made by more than one person, they thus can be properly described as accumulative art.

The *nganga* will order a wooden figure from the carver in which the elements of its function as a *nkisi* will already be incorporated. Some *nkisi* have very sensitive heads and well sculpted bodies, others may have a fine head while the body is poorly carved. The figure is not yet a *nkisi*: it must now be given to the *nganga* who will attach a box made of resin filled with medicine—or fetish material—sometimes covered with a mirror. He may add a headdress and hang horns, chains, snake heads, carved figures, beads and vials around the neck and on the arms of the figure according to the purpose for which the fetish is being prepared. After the necessary rituals have been performed the *nkisi*, endowed with its power, is kept by the *nganga*. A further transformation is then begun with those *nkisi* into which the *nganga* will drive nails, blades etc. for malevolent or benevolent purposes. This co-operation of carver and doctor creates the ultimate figure and its aesthetic appeal to the European eye is in the overall effect of the wooden statue and the added attributes. But a *nkisi*, however impressive, will be discarded by the *nganga* if it appears to have lost its power.

The Yombe doctor sometimes uses masks. They are daubed with kaolin and the forehead may be striped horizontally or vertically with metal strips or painted black or red lines, which may continue down

268
269
270
271
275

292

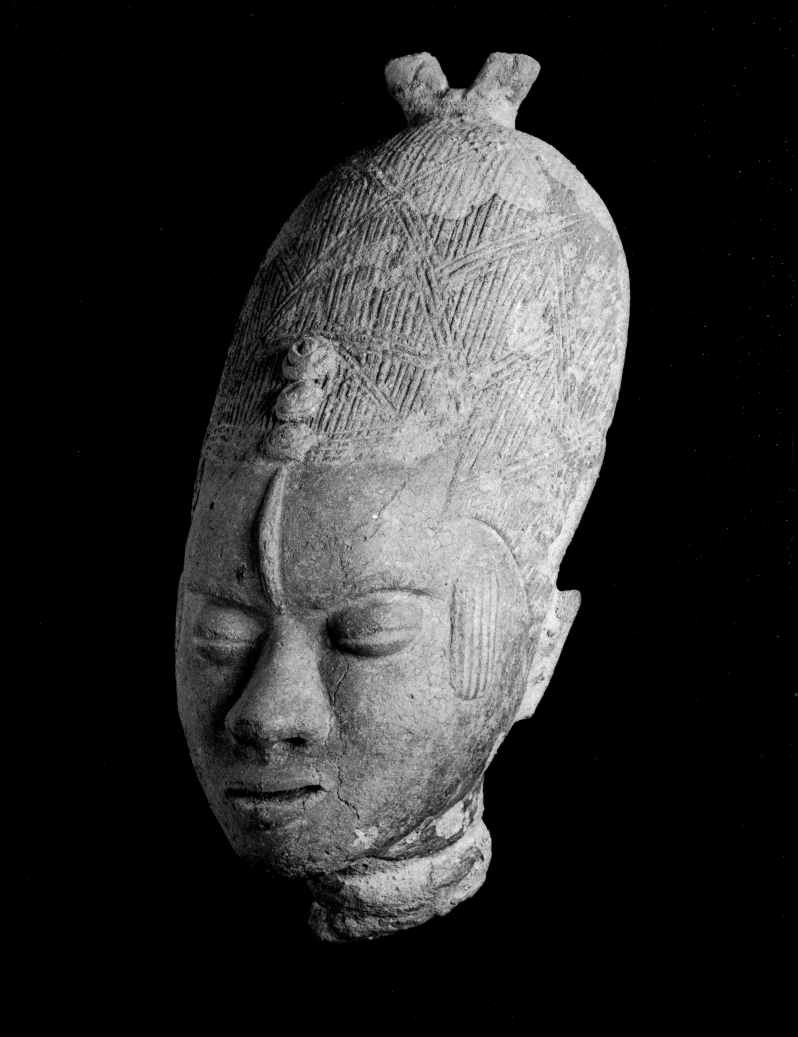

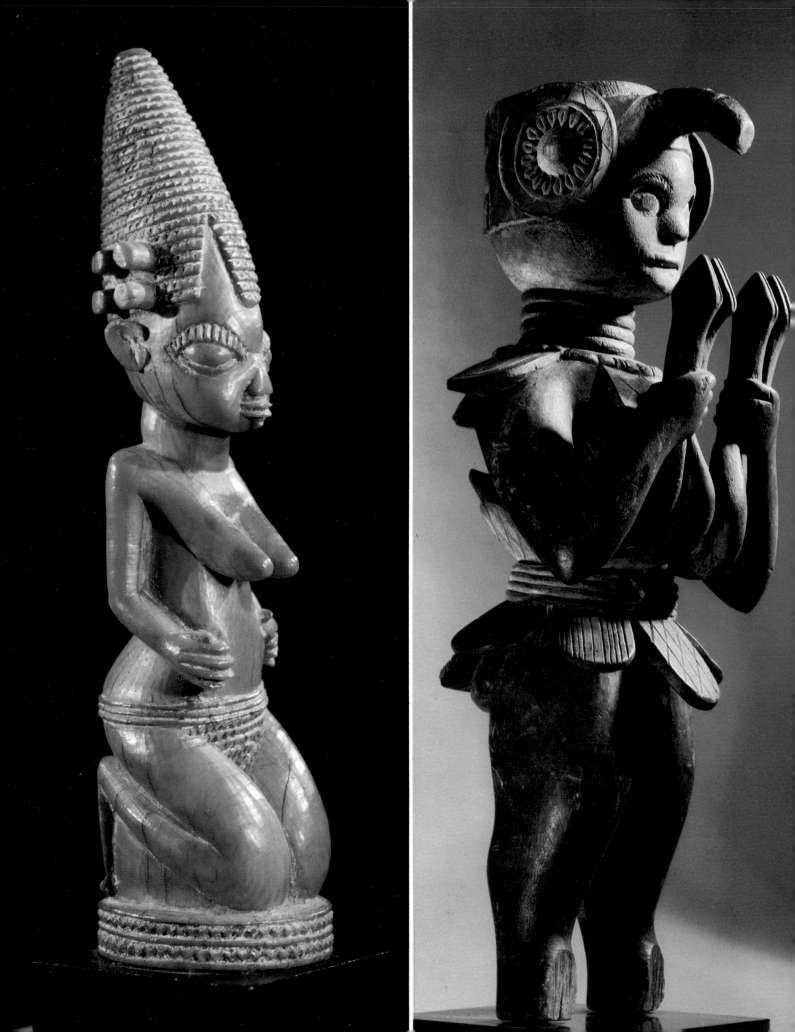

the ridge of the nose. The eyebrows and lips may be emphasized with black paint, and in some cases the cheeks are painted and the hair or headdress carved in geometric patterns. The Yombe mask illustrated is one of the most beautiful of the naturalistic types. The Kongo people also excel in the making of ivory carvings and in casting brass objects in cire-perdue. These include bracelets and crucifixes in which they incorporate Kongo iconography. 259

The WOYO of Cabinda carve large dance masks said to have been used for initiation and funerary rites, and somewhat resembling the Kongo masks used in *Ndunga* society rites. A product unique to the Woyo are carved wooden potlids, used by a wife to remind her husband of any shortcomings, the design being based on proverbs whose meanings are well known to all. A lid might have a high relief carving incorporating three firestones and the proverb illustrated would be that three stones are needed to support the pot, meaning that all good things come in threes and in marriage that would require that the husband must supply clothes, the wife must cook, and there must be children. On a potlid where the stones are scattered and cannot support the pot, it means that something is amiss and by using the lid, one of several in her armoury, the wife asks the husband to right matters. Even in this matrilineal society the men eat apart and often guests, who are meant to see the lid, are asked to arbitrate. In the example illustrated the central figure is in the act of divining. The egg-shaped object in the right foreground is a local fruit, *chialimioko*, which appears on most Woyo potlids, and the other items refer to diverse proverbs. 288 285

The VILI are another tribe in the Lower Congo region who have nail and mirror fetishes for use as protection against evil forces and for communication with the dead. One of the few Vili statues to have been published is an ivory mirror reliquary. It shows the fetish in the form of a chief sitting on a leopard holding a child, and a mirror reliquary box is fixed to the chief's stomach. It is well carved in the naturalistic style of the Kongo tribes. A rare altar with the carvings of three human figures is depicted here.

In the region of the Stanley Pool in Congo Brazzaville, live a large number of tribes, some of whom have a tradition of carving. These are the TEKE with subtribes and neighbours including the Tsaye (or Sisi), Lari and Sundi, the Dondo, the Bembe and the Bwende. Robert Lehuard, who worked in the area in the 1920s and 1930s, was an early student and collector of sculpture from the region. 264

An Italian, Savorgnan de Brazza, acting for the French government, started a trading station in 1880, which later became the town of Brazzaville. He met the great Teke king, Makoko, and with his consent the region became a French colony in 1885 in which de Brazza served as Commissioner General. The king Ilo Makoko was one of a long line of divine rulers which was mentioned as early as the fifteenth century by Portuguese travellers. The Teke carved anthropomorphic figures—both male and, less frequently, female—for spirit and ancestor cults though documented details are scarce. Standing or seated 258 275 263

XIV *left* Kneeling female figure
Possibly used in Ifa divination in the Owo and Ondeo area of Eastern Yorubaland. Yoruba, Nigeria; ivory 17.75 cm (7"). Coll. Robert and Nancy Nooter, Washington, D.C.

XIV *right* Figure of a bush spirit, *Haniwai*
Mende, Sierra Leone; wood 58.5 cm (23"). Tara collection

124 Altar with three figures
Vili, Lower Congo, Zaïre; wood, metal 24 cm (9½″). .
Coll. Aaron Furman, New York

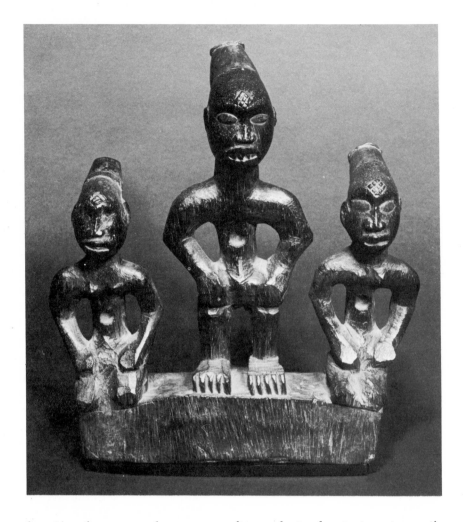

figurines for personal use were often only twelve to twenty centimetres high, while those for the use of the *nganga*—diviner, judge, priest or medicine man—may have been thirty to fifty centimetres high. Most of them have a well carved head with scarifications and coiffure corresponding to those of the subtribe to which the carver belongs or for which he was carving. The arms are mostly carved in low relief on the body, beard, mouth and male sex organs are well emphasized. The body is usually rectangular and box like, and the shape of the legs and feet sketchily outlined. Some male statues have a square opening in the front of the trunk and are filled or enveloped with a sanctified paste made by the *nganga* from a great number of ingredients. The whole is covered with potter's clay or resin under which most of the body, from neck to knee may be hidden. They are called *butti* while those without provision for the magic concoction are called *nkiba* or *tege*. A *tege* is the repository of an ancestor spirit whereas a *nkiba* represents a dead person who distinguished himself in life as a warrior, hunter or as the father of a large family. Special carvings are made for the fight against witchcraft and for trial by ordeal in which poison is often used.

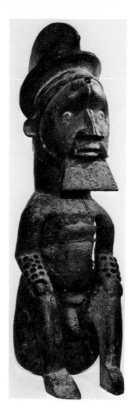

125 Seated male figure
Collected 1924 in a Sundi village. Teke, Stanley Pool,
Republic of Congo; wood, encrustation, upholstery
nails, 38.4 cm (15″).

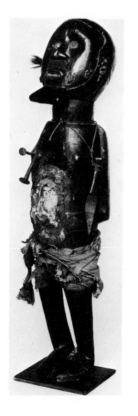

126 Standing male fetish
Teke, Stanley Pool, Republic of Congo; wood, nails,
hunting knife, cloth, and fetish material 63 cm (25″).
Museum für Völkerkunde, Hamburg

The Teke also make musical instruments of various types including trumpets carved of ivory, drums, whistles, chiefs' staffs, tobacco pipes and pottery. Weapons made of iron are said to have been fashioned by the neighbouring YANZ. The Teke also cast objects in brass but appear to use open moulds rather than the lost wax process; a wooden model is used to impart the impression to the earth or second mould.

A small subtribe of the Teke called TSAYE live to the north west of Stanley Pool between Djambala and Franceville, across the border in Gabon. They are famous for extraordinary abstract wooden discs—said to be masks—of which few documented genuine examples 264 exist. But many undocumented masks—probably recent copies—have come on the market. The genuine 'masks' were made for the *kidumu* society which, it appears, ceased to perform its rituals at the beginning of this century. A Tsaye 'mask' was once owned by André Derain. No eyeholes are provided in such masks for the dancer and it is therefore possible that these discs were not made to be worn on the face, although there is a round rim at the back which suggests such wear. Whatever their true purpose, these discs are most intriguing creations and it is not surprising that Derain was fascinated by them.

The BEMBE who live between the Sibiti and Niari River carve statues similar in purpose but very different in stylistic concept to those of the Teke. The magic substance, said to be 'the spirit of the ancestor' which gives power to their fetishes, is inserted into an anal opening. The figures are usually small—ten to twenty centimetres high—and represent males or females standing, or—in rare cases—seated. The bodies are scarified and some have cicatrice marks on the forehead. Not all are made to contain magic material and there are a few exceptions to the miniature size of Bembe figurines, one in the University Museum of Zurich being fifty-eight centimetres high. The Bembe also made anthropomorphic cloth figures called *kimbi* to contain the bones of an ancestor and these, clothed in a red cloak with tribal scarification marks painted on them are seated with arms extended and offerings are made to them to obtain protection against evil spirits. Although they are reminiscent of the *niombo* of the Bwende their ritual use is quite different for the *kimbi* are not buried but kept as ancestor effigies. 282

The BWENDE who live along the Congo south west of Congo Brazzaville carve small figures much like those of the Bembe, but are best known for their curious huge funerary figures, called *niombo*, 282 three to four metres high, which are constructed out of palm fibres and many textile garments to form the mummy casing for the desiccated body of a deceased chief. The funeral takes place weeks—or sometimes months—after death has occurred and is accompanied by dancing, chanting and complicated ritual. The cult is well documented and an excellent report on it was written by the Swedish missionary Widman in 1965.

In the Kwilu valley live the HUNGANA, the neighbours of the Mbala, but little is known of their history or culture. A few wooden sculptures are in collections but their features, hairdress and stance with hands 258

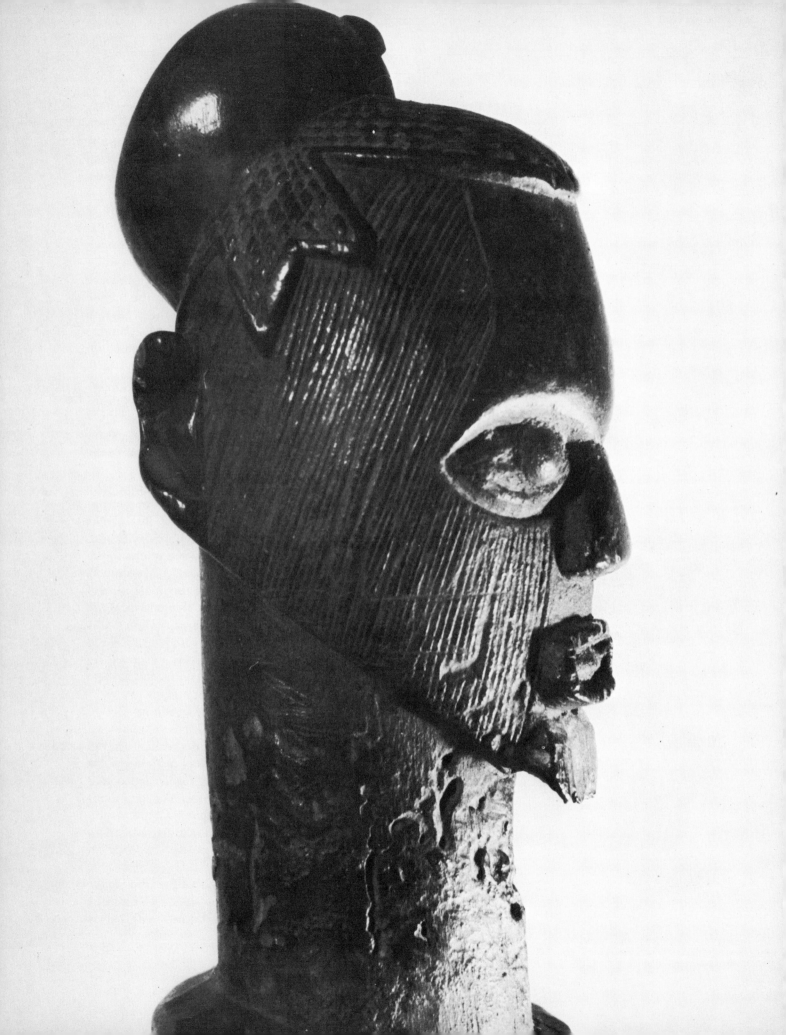

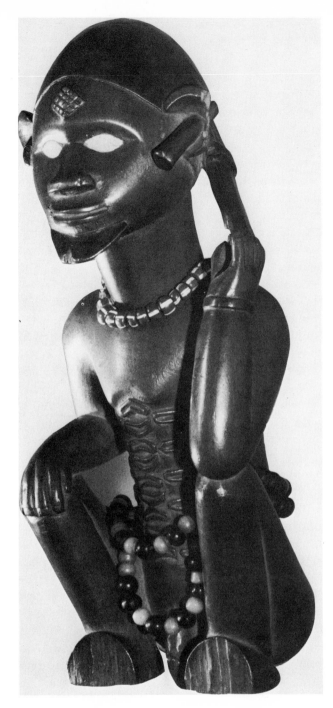

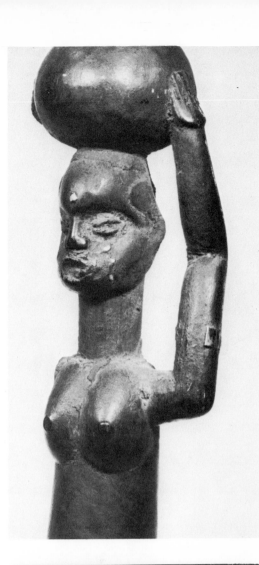

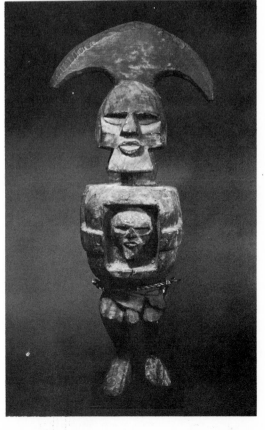

127 *facing page* Head
Part of a male figure, collected in 1927. Lari
(Mayama region), Stanley Pool, Republic of
Congo; wood, 35.4 cm (14″).

128 *above* Seated male figure
Bembe, Stanley Pool, Republic of Congo; wood,
glass beads, porcelain inlay in eyes, 20 cm (8″).
Formerly Tara collection

129 *top right* Detail of a kneeling female
figure
She is carrying a calabash on her head. Dondo,
Mboko-Songho region, Stanley Pool, Republic of
Congo; wood, metal 39.2 cm (15½″).

130 *lower right* Standing male fetish figure.
It has crested headgear and a head carved in
body cavity. Tsaye (Sisi), Stanley Pool, Republic
of Congo; wood, fibre 70 cm (27½″). Private
collection, New York

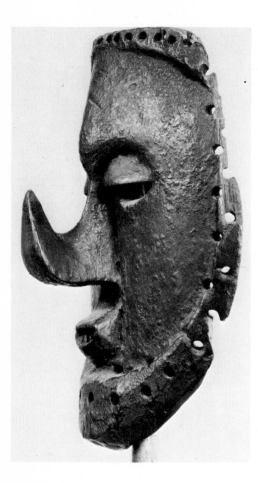

131 *above* Mask
Yaka, east of Kwango, Zaïre; wood with encrustation,
51 cm (20″). Coll. Harold Rome, New York

132 *right* Male cult figure with horns
Hungana, Kwilu River Valley, Zaïre; wood, iron
neckrings, 43.5 cm (17⅛″). M.R.A.C., Tervuren

133 *far right* Drummer
Mbala, Kwango-Kasai area, Zaïre; wood, 71 cm (28″).
M.R.A.C., Tervuren

raised to the chin is so similar to Mbala and Suku style that definitive 273
attribution has been difficult. The rendering of the shape of the head,
the hairdress and the long cylindrical body of a figure in the Berlin
Museum, a male figure with ram's horns in Tervuren, and another 275
male figure in the University Museum of Philadelphia define the
characteristics of the few wooden sculptures that can be attributed to
the Hungana with certainty. Some fine wooden figures were also
collected by Torday and these are in the British Museum. Their ivory
pendants are most original, depicting seated or kneeling human
figures in profile with a helmet-like hairdress, hands raised to the chin
while others are frontal images, sometimes double carvings of two
heads joined at the chin.

The MBALA live in dispersed groups between the Kwango and Kasai
rivers. They are best known for their figures of mother and child,
drummers and other musicians, all vigorous and in movement, with-
out the rigidity or symmetry of other African styles. The illustrated
example which comes from the southern part of Mbala country shows
a certain affinity with the Pende in hairstyle and facial expression. The
Mbala carve ancestor figures to use for the same type of cult as that
practised by neighbouring tribes but the maternity and musicians'
statues are linked with the investiture of chiefs and are symbols of 273
authority. On the death of the chief his successor must lie down with
such a figure beside him to enable the power of the chief to pass to him.

The YAKA who live in south west Zaïre, east of the Kwango River,
are the descendants of warriors and hunting nomads who conquered
the area in the sixteenth century and absorbed the local peasant popu-
lation: these two cultures seem to have fused. The tribe's societies to
this very day impose a strong disciplinary schooling on the initiates in
the *Mukanda* circumcision camps, where they reside for up to a year.
One type of mask for the rites connected with initiation is used by the
elders in charge of the camp and by the leader of the returning initiates,
and conforms strictly to traditional patterns. But the other type, com-
prising the bulk of Yaka masks, is made and used by the initiates
themselves and allows for imaginative variations of shapes and forms.
They are constructed of basket weave and raffia with only the face
carved in wood—probably by professionals. Some of them are in
zoomorphic form, and in the anthropomorphic types the nose is
upturned sometimes in a bizarre or absurd way, and the superstruc-
ture, often in animal form, is gaily decorated in many colours. The
Yaka also made figures, whose exact purpose is not known, hung with
an abundance of magic material in calabashes, with small figures and
other paraphernalia, and these presumably represented a magical force
used in ways similar to fetishes of other tribes in the Congo area. The
figures were carved with typically upturned noses and with consider-
able imaginative variations.

Many artefacts such as combs, whistles, cups and head rests were
also made by the Yaka. Ceremonial adzes, fly whisks and chiefs' staffs 258
with well-carved decorations were produced for those in authority, as 275

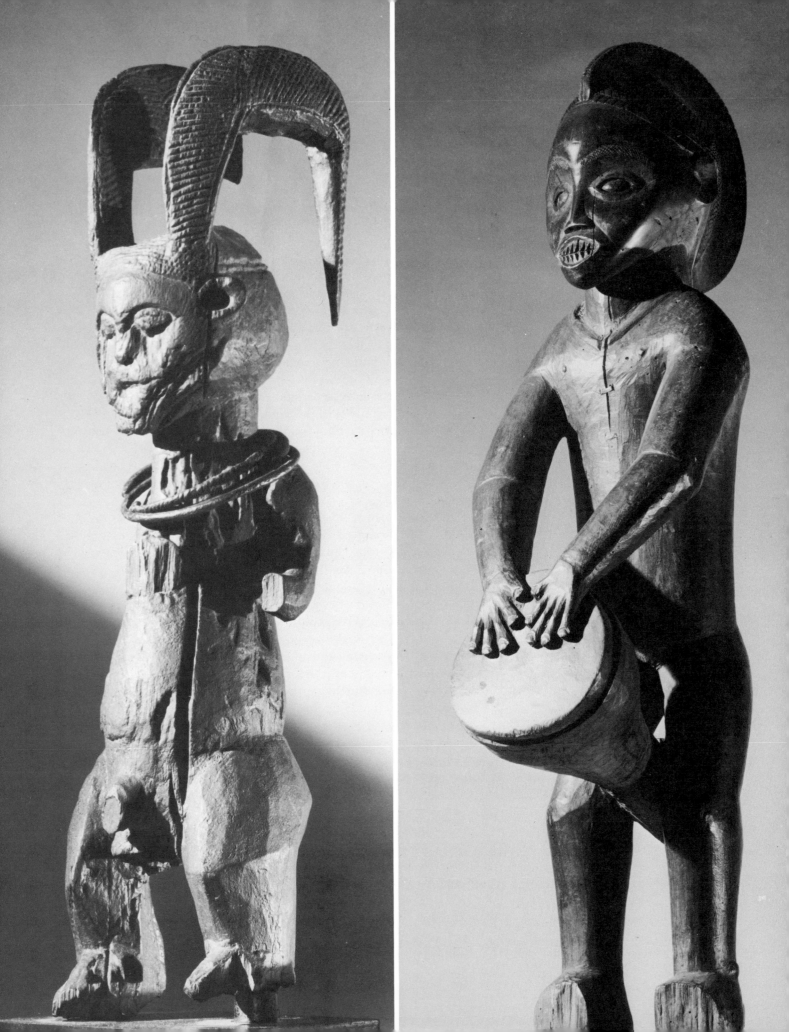

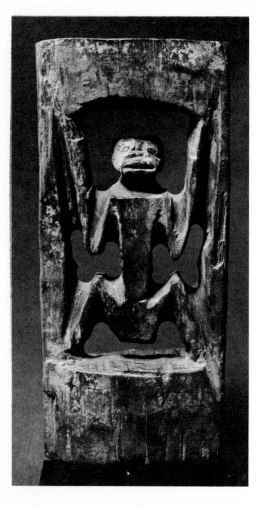

134 *above* Nzambi figure in frame
Holo, Angola and Zaïre; wood, tukula, kaolin, 20 cm
(8"). Coll. Aaron Furman, New York

135 *facing page, left* Kneeling female figure
Yaka, east of Kwango, Zaïre (or possibly Zombo,
Angola); wood, 24.75 cm (9¾"). London collection

136 *facing page, centre* Large male statue
Suku, Kwango Region, Zaïre; wood, animal horns,
93.6 cm (36¾"). M.R.A.C., Tervuren

137 *facing page, right* Standing female figure
Yaka, east of Kwango, Zaïre; wood, 51 cm (24"). Coll.
Marc and Denise Ginzberg, New York

were slit drums, gongs and other musical instruments adorned with human or animal heads.

The SUKU are neighbours of the Yaka but in spite of artistic and cultural similarities they do not appear to be of the same origin, for while the Yaka had a well functioning system of political organization the Suku did not benefit from the advantages of central rule. Their rare figures resemble those of the Yaka but only a few have the turned-up nose, and some figures are much more naturalistic than those of the Yaka. Others again, with arms raised to the chin, triangular face and short legs tend to abstraction, variations that may be due to the fact that the tribe is divided into two groups.

The masks, also similar to those of the Yaka in some respects, are more subdued, with bulging foreheads, carved coiffures, often surmounted by an animal or in rare cases with a human image. They were, however, usually carved in wood, of the helmet type and mostly without cloth or basket weave, but with a raffia skirt around the neck. Instead of the multitude of colours used by the Yaka, Suku masks were predominantly painted in white, camwood red and black. For their initiation and fertility rites the Suku employed large male and female masks with raffia surrounds called *kakunga* and *kazeba* respectively. These masks often featured large bulbous cheeks reminiscent of some Cameroon highland types. Brass bracelets, ceremonial adzes and knives and other regalia were all made by the Suku and many were of great artistic merit.

258
275

The HOLO occupy an area south of the land of the Yaka on both banks of the Kwango River and on both sides of the frontier between Angola, which is the country of their origin, and Zaïre. Allegiance to their Queen, who rules from Angola, extends to the Holo in Zaïre. Their art is of high quality but few specimens of it are known, as missionaries from the seventeenth century onwards are said to have condemned much of the sculpture they found as heathen idolatry and destroyed it. The Holo then adopted Christian religious objects like statues of the Madonna and crucifixes as instruments possessing great power and linked them to their own spirit cults. This syncretism appears to have led to the very remarkable *nzambi* carvings of the Holo (some were also made by the Suku) which consist of a human figure, male or female, or both together, set in a frame with arms and legs spread, probably representing crucifixion. The Holo also made brass crucifixes in their own style and numerous images for their spirit and ancestor cult, many of which show Jokwe influence. Masks for circumcision rites, both anthropomorphic and representing buffalo or antelope heads are more reminiscent of Yaka art.

273
274
258

Amongst the other fine objects made by the Holo are ornamental combs, slit drums and other musical instruments, often with well carved human heads. Products made of iron and bronze include ceremonial adzes decorated with human and animal figures, which were carried over the left shoulder by chiefs and by the Holo Queen as symbols of power, a practice common to many tribes in Zaïre.

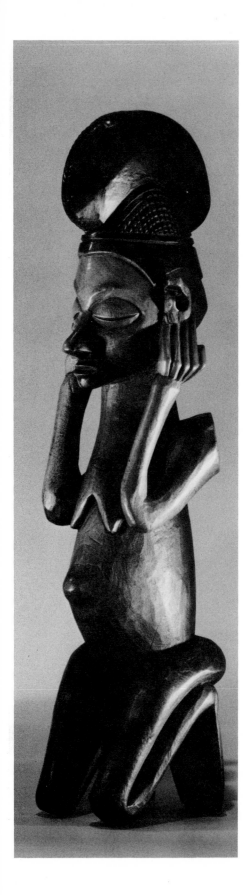
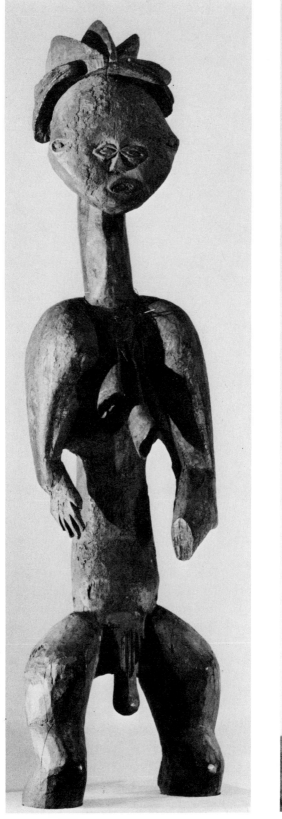
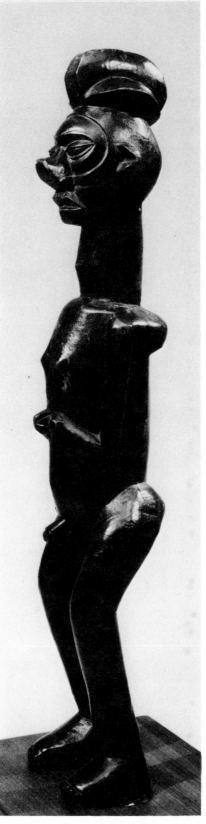

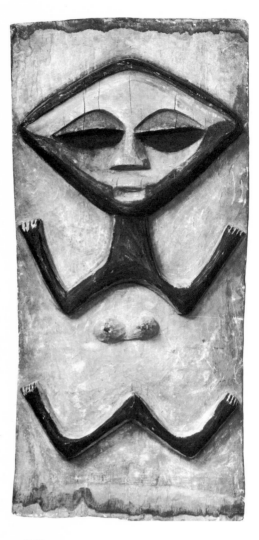

138 Door
Acquired in 1902 from Leo Frobenius. Pende, Zaïre;
wood, kaolin, pigments, 99 cm (39") high. Museum für
Völkerkunde, Hamburg

In the very detailed report by Torday on his visits to the Congo region between 1900 and 1908 he tells of the high regard which the Jokwe or Chokwe and Kuba people had for the art of the PENDE. Both these tribes, amongst the greatest producers of wooden sculpture, pottery and textiles, claim they learned these arts as well as the secret of iron smelting from the Pende. Much wooden sculpture of the Pende is still extant both in museums and private collections, but little or nothing remains of their textiles, pottery or iron work. The high level of art of the Kuba and the Jokwe was to a great degree due to the patronage of the courts of kings and chiefs, and to an affluent population well established in the region centuries ago. Compared with the Jokwe and Kuba the Pende are a vanquished people who at the time of the Lunda and Jokwe expansion had to leave their original home in Angola to settle between the Kwango and the Kwilu, only to move further east, following renewed Jokwe pressure. In spite of their enforced movements and defeats the Pende remained fiercely proud of their identity, and preserved their language, which is Kikongo, in an area dominated by Chiluba. They live now in two groups between the Lutshima—a tributary of the Kwilu—and the Kasai Rivers. The West or Kwilu Pende occupy a region east of the Lutshima and on both sides of the Kwilu, while the East Pende are concentrated to the south east and along the Kasai River. The political system of the Pende is basically acephalous, though some groups have Lunda chiefs. They maintained—at least until recently—a high level of carving in wood and ivory of masks and such objects as were required for religious purposes and for the ceremonial of the ruling chiefs, judges and diviners. The sculptors, who were often also the blacksmiths, were highly esteemed in Pende society and produced objects of a very fine quality. Pende style characteristics are triangular eyes, looking down, triangular mouth, pointing upwards and a slightly upturned nose with prominent nostrils. There is always an unbroken relief line joining the brows, often V-shaped with the lowest point just about at the root of the nose. 278/7 This describes, however, only the style of the central chiefdom of Katunda, the most widespread of all the Pende styles. Generally speaking the masks made in the west show Suku, Holo and Mbala influences and those made in the east by the Kasai Pende show Jokwe traits. The Holo and Pende claim a brotherly relationship and it appears that the Holo, Mbala, Yaka and Suku all came, like the Pende, from Angola in a wave of Bantu migrations. For detailed classification of Pende art and a thorough study of its social role, de Sousberghe's 283 book is an excellent academic work but it is not an easy reference book for the collector. For general purposes the various types of Pende art objects are masks, ivory pendants and whistles, miniature heads, used for divination, and staffs. Wooden helmet or face masks are used both for rites and entertainment and are of Kwilu, Katunda and Kasai origin, of which the *mbuya* type in Katunda style are predominant. They are of wood and have a coiffure made of raffia or other fibres. There are many variations, each type having its own name. Some have

139 Helmet Mask, *Giphogo*
The beard is decorated with black and white triangles.
East Pende, Kwango region, Zaïre; wood, kaolin,
pigments, 18 cm (11″). Coll. Paul and Ruth Tishman.

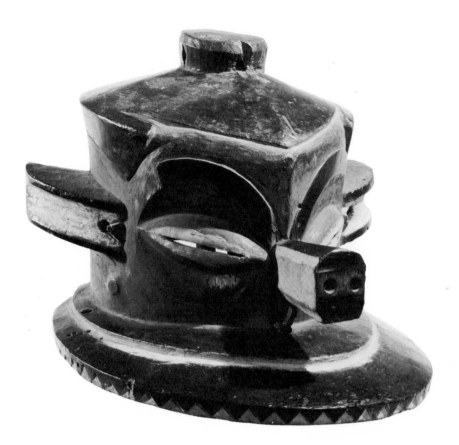

a long wooden beard, while others have facial distortions, and all represent certain traditional figures in the ceremonies.

The large *giphogo* helmet mask ornamented with geometric patterns has an almost horizontal nose and is of east Pende origin. A very curious mask consisting of a large disc made of raffia with two cylindrical eyes, the whole surrounded by a ring of feathers, is called *mingaanji* and is attributed to the Gungu area in the west. Another little known 276 Pende mask of the *mingaanji* group called *gitenga* comes from the Kwango area. It is made of very light wood forming a disc on which geometrical painted designs, mostly in black and white, frame a heart-shaped face without a mouth. The disc is set in a fibre frame decorated with feathers and is exquisitely designed in a style reminiscent of Klee or Picasso. It is said to represent the sun but may symbolize opposites such as day and night, safety and danger. The famous ivory pendants are miniature *mbuya* masks worn by men round the neck to give them the same protection the large masks offer.

Chiefs', jurists' and orators' wooden staffs surmounted by human heads or figures are usually well carved and most of them come from the Mihango zone in West Pende territory.

The Pende also make stools with caryatides, head rests and chairs decorated with human figure groups often in lively action, many

clearly influenced by Jokwe carvings of a similar nature, though carved in west Pende style.

Ceremonial adzes, mortars and drinking cups are similar to but less elaborately decorated than Kuba or Lele artifacts. Sculptural decorations were found in the houses of chiefs: on the roof would be a large figure of the chief's wife carrying an adze over her shoulder as an emblem of power. Other Pende sculpture varies in size from twenty centimetres to over a metre including a number of standing or seated maternities. These were probably ancestor and 'fetish' figures but very little is definitely known about them. They are of excellent sculptural quality and the style of some—especially the maternity figures—is very reminiscent of the best Mbala statues.

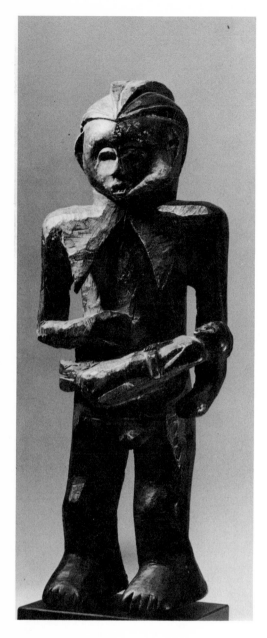

140 Standing female figure with child
Pende (formerly attributed to the Mbala); left bank of
Kwilu, Zaïre; wood, 42.5 cm (16¾"). Tara collection

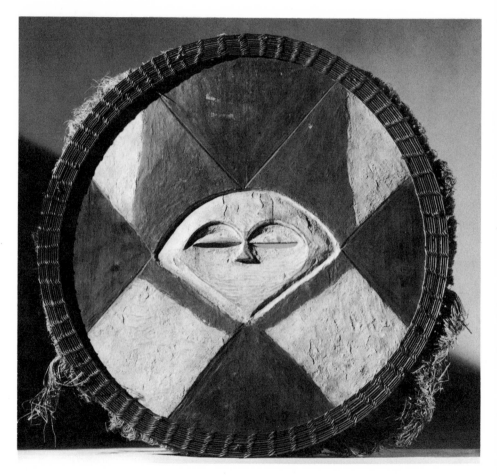

141 *Gitenga* mask
Pende, Kwango Region, Zaïre; wood, raffia, palm
fibre, kaolin and pigments, 39.4 cm (15½"). M.R.A.C,
Tervuren

142 *facing* Half figure
Kuba, Kasai, Zaïre; wood, 49.5 cm (19½"). Private
collection

XI Central Zaïre

The DENGESE live along the Lukenie River north of the Kuba who influenced their carving style. Their ethnic roots are, however, with the large Mongo group and they are closely related to their eastern neighbours, the Nkuchu and the Yaelima. The few Dengese figures known include some male torsos and one female, all tall, impressive figures, the elongated trunk, chest and arms covered with tribal scarifications, a long neck carved with grooves, and discoid scars adorning temples and forehead. The hairline and shape of head resembles Kuba sculpture but the cylindrical extension in the head is a Dengese feature, based on the headdress worn by members of the *Etochi* society. The torsos are seated on a base formed by the hips. All these figures were carved in hardwood, and have a dignified, regal appearance, but very little is known about their use. The *Etochi* society, had great power in social, religious and political fields and may have used these statues in their rituals. Another possibility is that they were memorial figures placed in shrines or on tombs of members of that society. All the known figures were collected at the turn of this century at which time the Dengese apparently ceased to carve them: it is very unlikely that any further sculptures of this kind will emerge.

275

258

260, 273

The KUBA—or Bushongo—rank very high amongst those African nations which produce important court art. According to Kuba lore their divine kingdom is 1600 years old, although the dynasty founded by their great ruler Shamba Bolongongo can only be dated back about 370 years. But according to Kuba oral tradition Shamba Bolongongo was the ninety-third ruler. Eighteen tribes linguistically related make up the federation of Kuba, occupying an area between the Kasai and Sankuru Rivers. Stories of the origin of the Kuba are confused. While Torday developed theories to prove a linguistic and cultural relationship with the Zande of the far north, Cornet tells of the primordial ancestor *Woto* ('Woot') leading the people up 'the Congo and Kasai River country', and that Shamba (Bolongongo) invaded 'from the west'. The similarity of the posture of the *ndop*—royal statues—with the *ntadi* of the Kongo points to a possible origin of part at least of Kuba culture from the Lower Congo region. There are also stylistic similarities between Kongo and Kuba ivory trumpets and textile designs. The court of the once powerful divine *nyimi*—or king—seen in his splendid robes overleaf is backed by a feudal ruling class. The chiefs of the federated tribes are of the royal house. Carvers and blacksmiths belong to the highest grade of the aristocracy and several kings have engaged in these pursuits.

258

275

286

287

The Kuba art style is similar to that of many of the tribes of the Bushongo federation and other neighbouring people such as the LELE and Wongo, who specialized in the making of wooden drinking cups. The best known statues of the Kuba are the *ndop* portrait figures of kings. These carvings of royal effigies are clearly meant for the cult of ancestors of divine kings whether or not ancestor worship is general,

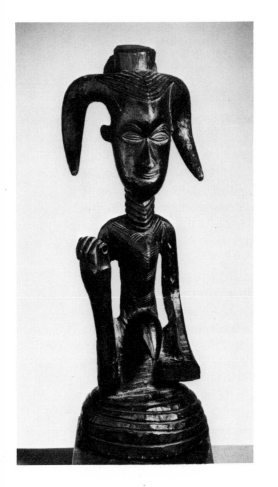

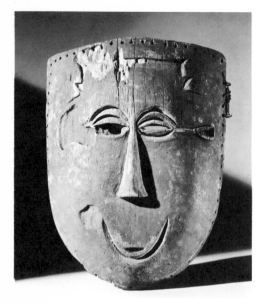

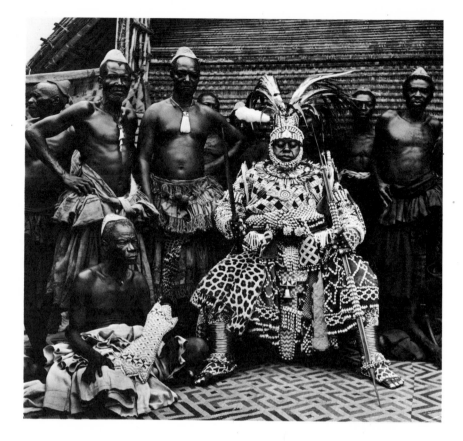

143 *above* Mask
Lele, Kasai region, Zaïre; wood, 30.5 cm (12").
M.R.A.C., Tervuren

144 *right* The Kuba king Mbope Mabinshi in
coronation robes.
Mabinshi reigned until about 1970, and his robes show
the ornateness resulting from European influence: those
described by Torday were simpler.

145 *facing page, left* Standing female figure
Kuba, Kasai region, Zaïre; wood, 29 cm (11¼").
M.R.A.C., Tervuren

146 *facing page centre* Kuba dancer wearing a
Ngadi-a-Mwash mask
A mask made of palm fibre, cloth, polychrome paint,
beads and cowrie shells.

147 *facing page, right* Mask
Kuba, Kasai region, Zaïre; wood, encrustation, 40.6 cm
(16"). Coll. Robert and Nancy Nooter, Washington, D.C.

for during coronation ceremonies the new king must sleep with the
statute of his predecessor by his side so that the power of kingship with
which the *ndop* is imbued may be transferred to the new ruler. Very few
types of other figure carvings are known, although there are a few
large statues for initiation and smaller ones used for unknown magic
purposes. The Kuba have a number of secret societies but the courts of
the king and his chiefs exerted the most important influence on art.
The masks of the Kuba are used for dances in religious ceremonies,
initiation, burial and rituals based on their rich traditions. About ten
styles have been classified, of which three relate to the myth of Kuba
origin.

The *mwashamboy* is a helmet mask: the stalks of palm leaves form the
base of a head made of cowrie shells, beads, skin and cloth, often richly
embroidered. The masks are coloured in blue, white, red, black and
ochre and have a long tubular extension protruding from a conical
headdress which typifies an elephant's trunk, a symbol of royal power.
This mask personifies the son of *Woto*, the mythical founder of the
Kuba people and is said to be used in initiation rites. After spending a
few days in a shelter in the village square the boys, wearing masks to
frighten away women and uninitiated children, move to enter a sym-
bolical tunnel. The way is blocked by a masked man—*Nndup*, who is
really *Woto*—and diving between his legs they emerge at the other end
of the tunnel between the legs of another masquerader, *Kalyengl*, the

275
279

289

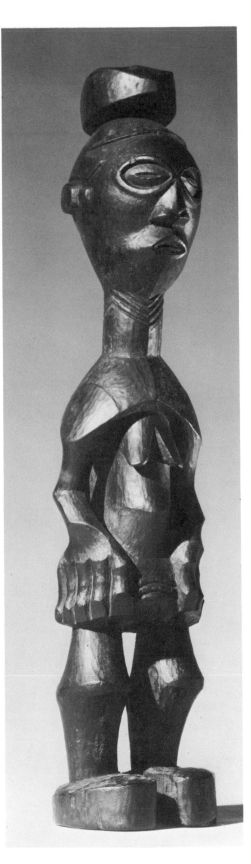

mother of the spirit of initiation. The two masks dance together and are driven out of the village by the people, as the dance signifies incest which they reject. The boys are then led to the wall of the initiation camp by two other masks. *Woto*—the king and first ancestor—is the inventor of the rites and plays a leading role in them. The wall has three triangular peaks, representing hills and on them are hung the masks of *Yol*, the policeman, of *Mbombo* and of *Mwashamboy*. On other parts of the wall are a Janus mask on the left, symbolizing the separation of village and bush and to the right a phallic mask *mbongakwong*, which stresses the sexual teachings of initiation alongside its social and religious aspects. The wearing of the *mwashamboy* mask is the privilege of the king's son but it must not be worn by the royal heir who, in this matrilineal society is, according to legend, the son of the king's eldest sister.

The *mbombo* is a striking helmet mask made of wood and covered with copper sheeting, cowries, beads and skin. A large, bulging forehead is one of its distinctive features. It is not worn by men of royal extraction as it represents opposition to the king either by the common man or, as some people assert, by the Pygmies.

The third character in this tale is *Ngadi mwashi*, the king's wife/sister, whose mask is made of raffia and painted wood, ornamented with beads and cowries and although normally worn by men it is occasionally donned by a woman. The other Kuba masks are carved in wood, mostly in a cubistic style with the forehead and hairline typically

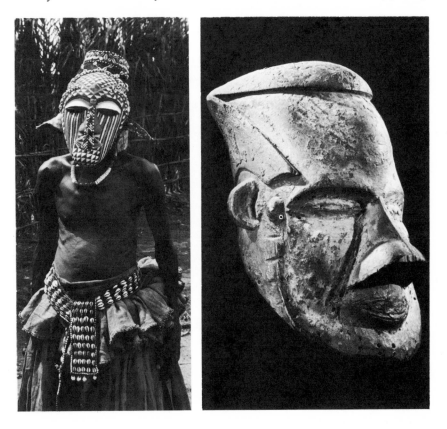

IKOKI NUINA

WOTO KUNJE

BASHUNGU

NAMBA (knot).

Specimens of Kuba designs and their names

spreading outwards. Some have cylindrical eyes set in sockets surrounded by holes.

The creation of objects solely for prestige or for the enjoyment of form and decoration is extremely rare in Africa. The Kuba may be the great exception to this, as the finely decorated and varied carvings of fly whisks, headrests, boxes, vessels, and pipes were made for secular use. Some of the wooden palm wine goblets in the form of human heads or whole figures may have also had ritual or symbolical uses. Some of the intricate geometrical and figurative patterns in such carvings may also have ritual significance, for each pattern carries a name. 286 The ownership of fine *objets d'art* is widespread among members of the court and this may be due to the social structure and historical experience by which the Kuba differ from many other African peoples. The members of the royal house, the chiefs and courtiers and a great number of people were able to accumulate wealth, for an abundance of slaves resulted in surplus production. In the capital, Mushenge, the wealthy and the privileged congregated and found in the acquisition of decorative art objects an outlet for their desire for prestige and the symbols of rank.

A considerable number of Pygmies, estimated at 100000 by Murdock, live among the Kuba and in adjacent Mongo country. They are known by the Bantu name of TWA, 'the little people', and are the only Pygmy group to produce wooden carvings. But as a result of their integration and intermarriage the Twa have become as tall as the Kuba and indeed indistinguishable from them. Their masks have Kuba traits but can be identified by their individual style, as can their headrests. 72

The northern KETE tribe is widely spread south of Kuba and east of Luluwa territory, believed to be their country of origin. They are linguistically related to the Luluwa. Their political system is linked

148 Headrest supported by male and female half figures
TWA, Bushobbe village, Kasai, Zaïre; wood, 27 cm (10¼") long. M.R.A.C., Tervuren

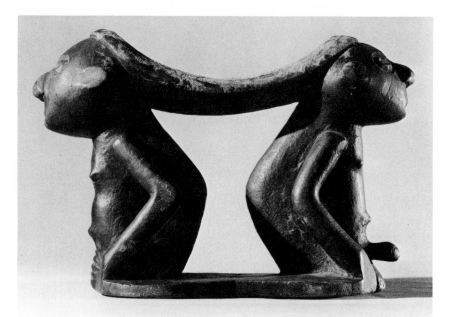

XV Dance headdress
In the form of a woman with articulated arms. S.W. Yoruba, Benin (Dahomey); wood, beads, fibre, red and black paint 98 cm (38¼"). London collection

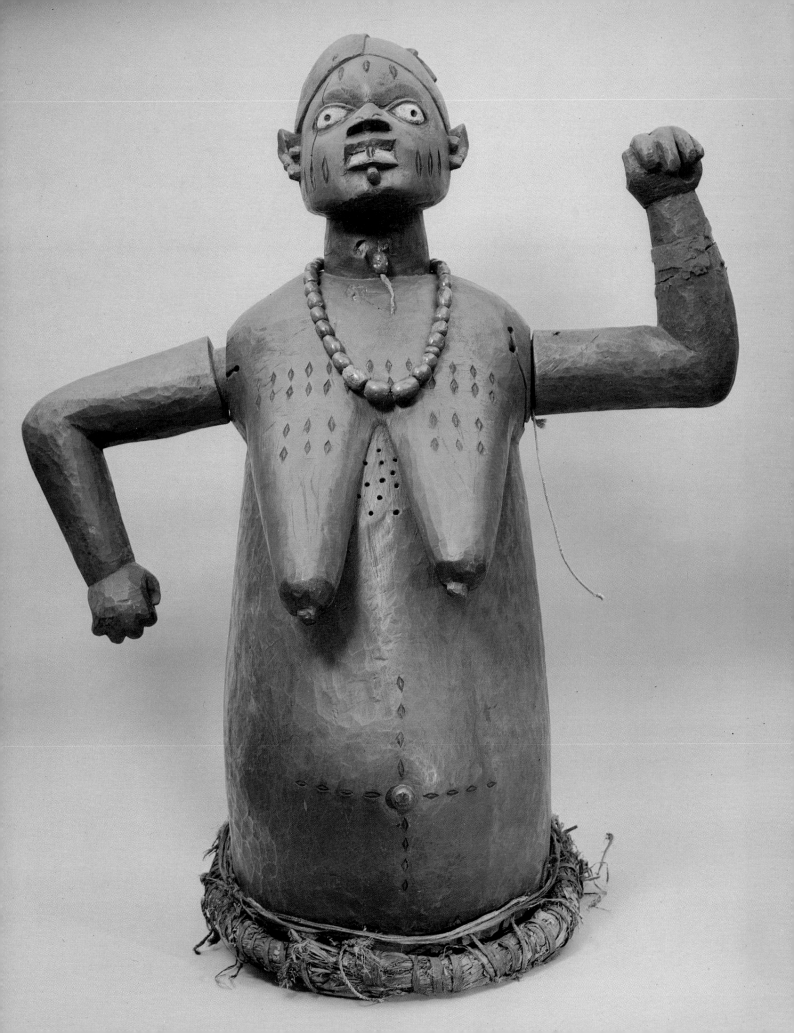

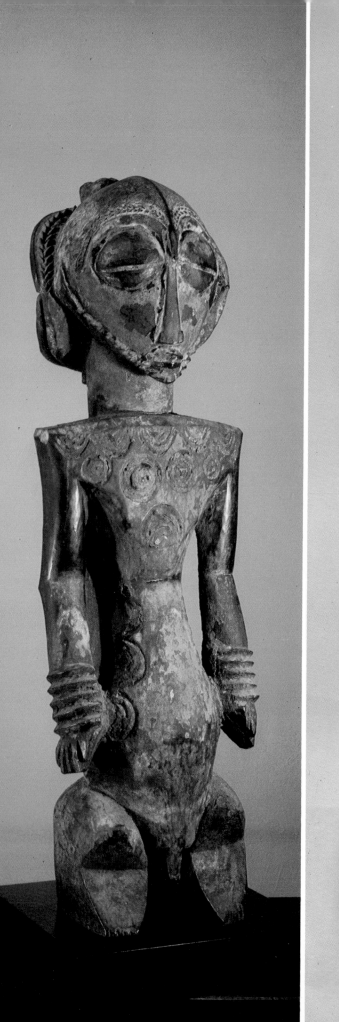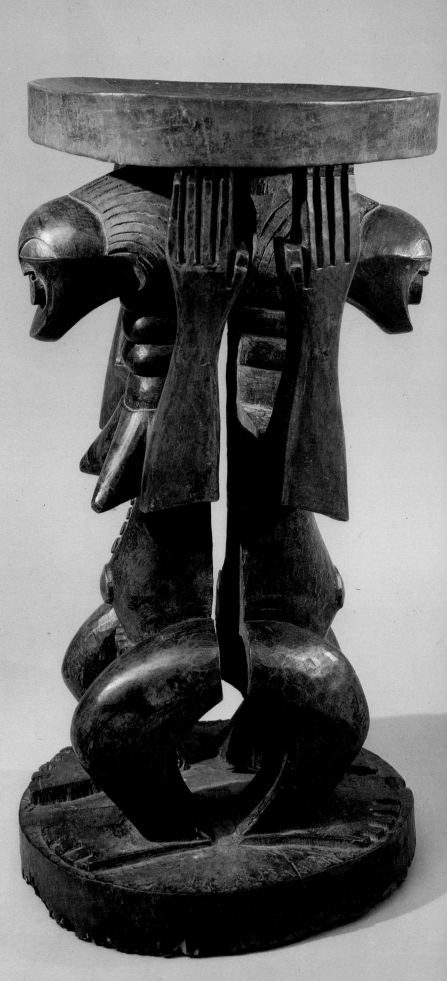

149 Cup in the shape of a head
Kuba, Zaïre; wood, 20.5 cm (8"). M.R.A.C., Tervuren

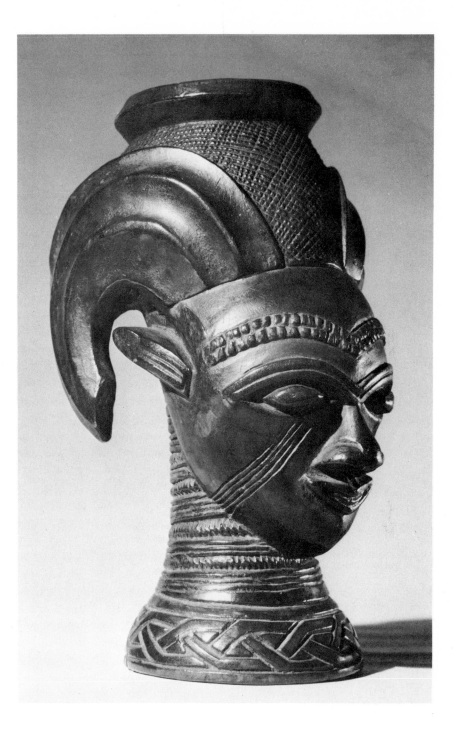

with that of Kuba but they differ in their initiation rituals and religion. 275
They are related to the BIOMBO who live in the same area: both groups
make a variety of masks and figures, most of which are stylistically
influenced by the Kuba, though in the masks of the Biombo some
Eastern Pende features are noticeable. The Biombo masks are of a large
helmet type, have protruding eyes in the shape of cones and are
painted in ochre, black and white geometrical patterns. The Kete

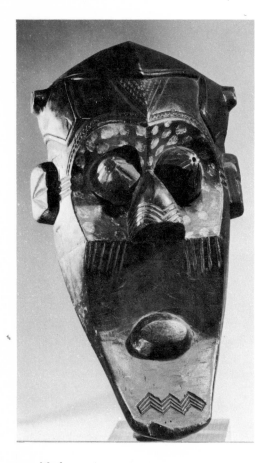

150 Mask
Northern Kete, Kasai region, Zaïre; wood, pigments, 45.75 cm (18"). London collection

151 *right* Male *Mbulenga* figure holding a knife and cup
Luluwa, Kasai, Zaïre; wood, red camwood paint, 30.5 cm (12"). Formerly Tara collection

152 *far right* Adze haft with male figure
Luluwa, Kasai, Zaïre; wood, 45 cm (17¾"). Tara collection

masks too are stylistically influenced by Kuba art but have developed individual characteristics with sharper contours, large eyelids and white decorations of lines and dots. The southern Kete, who are politically not part of the Kuba group, live on the left bank of the Kasai river. They came under Jokwe influence and their statuary, combs and other artifacts show this to such an extent that they are often mistaken for Jokwe work. Kete initiation masks, however, have maintained their own distinct character.

The large LULUWA tribe whose carvers have produced some of the most remarkable art in all Africa live to the south west of the Kuba. Their origin and history are obscure and they probably constitute a grouping of several branches of neighbouring people and they and the Luba may share common ancestors. The Luluwa have never had a centralized government and clans are ruled by elected chiefs. In an attempt to unite the groups into a nation, chief Kalamba Mukenge assumed power in about 1870 and introduced a 'hemp' religion, discouraging the making of sculpture and palm wine. Though the regime was short-lived—at his death the Luluwa reverted to their traditional customs, beliefs and rituals—one unfortunate result of the Mukenge 'coup' was the destruction of much of the statuary and masks. The best known sculptures of the Luluwa are the beautiful figures decorated with intricate tribal markings covering the head, neck and often the entire body, probably all made prior to 1870. Even after that date many remarkable figures continued to be carved but smaller and usually with fewer cicatrice marks. These marks were patterned after those which Luluwa men tattooed on their bodies and this practice also ceased during the Mukenge regime. The figures are of different sizes, apparently corresponding to their importance and purpose and vary from fifty to seventy-five centimetres for warrior and ancestor figures. Others range from thirty to fifty centimetres and the smallest figures are between ten and twenty centimetres (including most of the crouching statuettes). The head usually measures one fourth of the whole body, and the hair is arranged in a long pointed coiffure or a short knot. The long neck, strongly emphasized navel, short legs and large feet are common features of these impressive figures. Most of them are standing, and those representing a warrior are adorned with a leopard skin, prerogative of chiefs, and hold a sword and shield. Others hold a cup intended for medicine—*bijimba*—in one hand, and serve as protection against sickness and evil doers. They are treasured for *mbulenga*—beauty—which is their generic name. The larger and more richly decorated ones are ancestor figures. They also serve many other purposes in the control of spirits and in divination and magic. The smaller less decorated statuettes belong to a category called *lupingu lwa luimpu* and are believed to serve as protective charms for newly born babies and temporary repositories of ancestral spirits. Equally beautiful and similar in style are the mother and child figures, in which the neck is usually less elongated and head, neck and sometimes the body are decorated with concentric circles and cicatrice marks. They may be

284

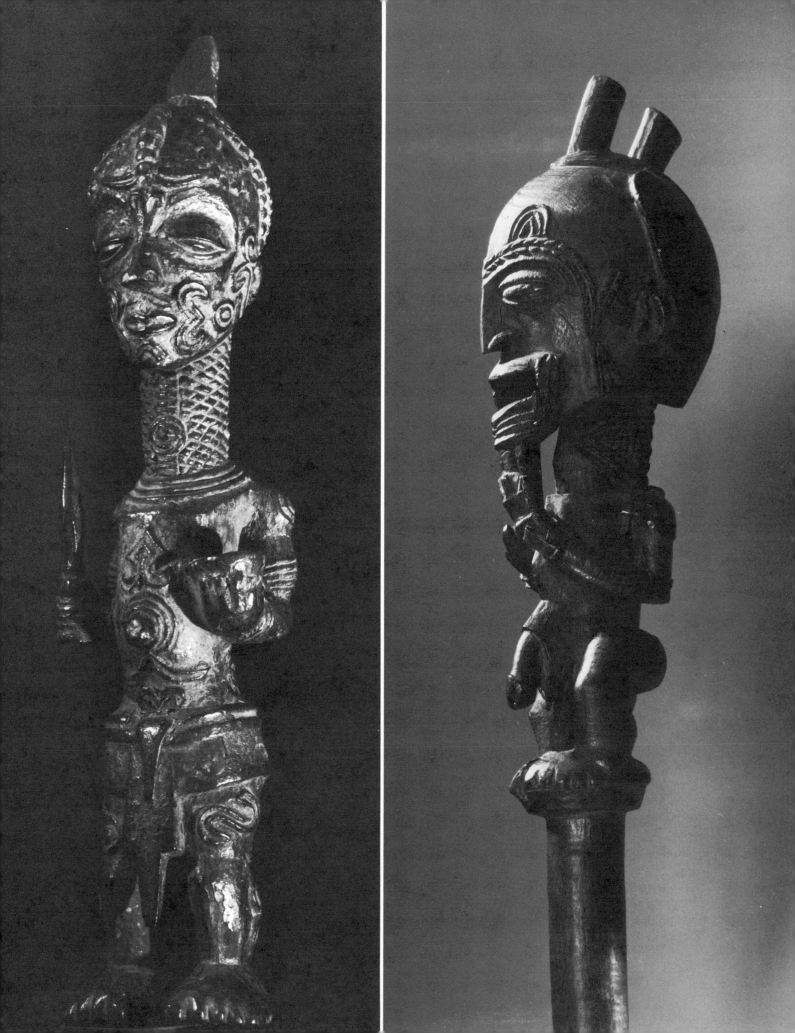

used in fertility rites and to protect mother and child during pregnancy, childbirth and the period of lactation. However, the major purpose these figures of mother and child serve is in the cult of *Chibola*, which is widespread amongst people of the Kasai region, for women who have lost children by miscarriage, in childbirth or early in the infant's life. In such cases the diviner advises the woman's initiation into the cult to pacify the spirit *Chibola* and a figure representing a mother and child or a pregnant woman is acquired to protect the afflicted mother against possible future mishaps and to ensure the reincarnation of a dead child.

273

Small male figures often hung with a calabash or other receptacles containing magic material are used as hunting fetishes. Crouching figures with hands supporting the head and surmounted by tobacco boxes or mortars and anthropomorphic pipes are among the many different carvings of the Luluwa. The adze haft illustrated is clearly of Luluwa origin, but the style is rare and idiosyncratic, possibly, as Maesen suggests, that of a single carver from a little explored part of the Luluwa area. It is a remarkable piece of art. The sculptural concept of their masks is clearly based on the style of the statues. They are generally less naturalistic, some having geometrical or abstract ornaments in various colours resembling designs on Kuba masks. Others bear cicatrice marks similar to those on the figures.

The art of the MBAGANI is related in style to the Luluwa and the Jokwe. The LUNTU are also close to the Luluwa but their sculptural styles differ greatly. Some of the Luntu masks are very abstract and painted with polychrome designs.

The LWALWA deserve more research as little is known of them and their very striking masks and fertility statues. A crested coiffure, jutting nose, low forehead, rectangular slit eyes, bulging curved lips, and pointed chin are the characteristic features of the male mask, the female mask having a less prominent nose. In spite of the proximity of the Jokwe in the south and of other strong style areas on their borders, the gifted Lwalwa carvers developed a highly individual sculptural art.

The SALAMPASU are a warrior tribe who live on the Upper Luluwa River and they are neighbours of the Lwalwa and the Lunda. They successfully resisted Lunda political domination but some cultural influence is evident in their rituals. Salampasu masks used in circumcision and in ceremonial or war dances have a high bulging forehead, large openings for eyes, a short but prominent nose and a rectangular white mouth with bared teeth. The face is often covered either partly or wholly with strips of copper sheeting and the hairdress may consist of feathers or of plaited cane. The figures carved by the Salampasu consist mostly of heads set on top of wooden cylinders or painted relief figures on panels. The heads resemble the masks in style.

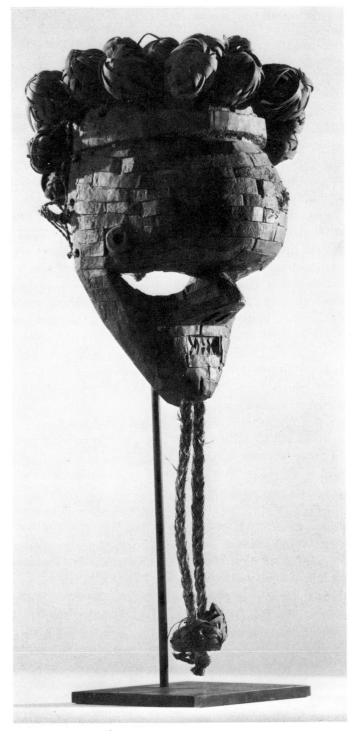

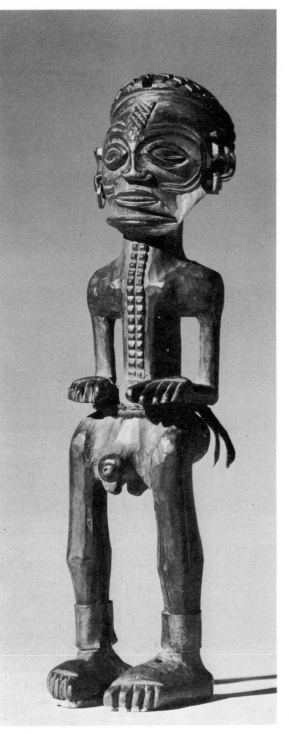

153 Initiation Mask
Salampasu, Luluwa River, Zaïre; wood, pieces of copper sheeting, fibre, 56 cm (22″). Private collection, New York

154 Figure
Possibly of an ancestor, Mbagani, Kasai, Zaïre; wood, metal, 25 cm (9⅞″). M.R.A.C., Tervuren

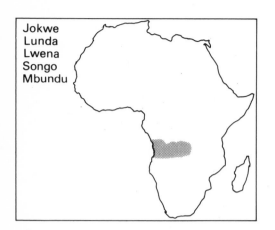

Jokwe
Lunda
Lwena
Songo
Mbundu

XII Angola and southern Zaïre

The JOKWE, numbering about one million, are a tribe of hunters and warriors. The great majority live in Angola, their original homeland, and the rest, some 200000, are widely dispersed in southern Zaïre. Their expansion to the north and west brought them to the south west of Shaba Province (formerly Katanga) and to the Kasai River area. Their history is closely involved with the Lunda Empire founded at the beginning of the seventeenth century by Mwata Yamvo, the son of Chibinda Katele Ilunga, 'The Hunter', son of a Luba prince who had married the ruling daughter of a Lunda king. 'Mvata Yamvo' became the dynastic title of the rulers who established a strong hegemony over the Jokwe and other tribes in the area. Their success was due to the political genius of the Lunda, aided by their bi-lineal system of succession, both patrilineal and matrilineal. They set up chiefs related by blood to the king and to each other, and through them exacted tribute and ruled the Jokwe as they did numerous other tribes in Angola and in central and south eastern Zaïre. The Jokwe rebelled against Lunda rule and in the second half of the nineteenth century they invaded the region of the Mwata Yamvo and started the expansion which established them in their present territories. Though they had been conquered by the descendants of the legendary Chibinda Ilunga, it was he who became the Jokwe's great hunter hero. Hunting remained the tradition of the Jokwe in their new lands and their freedom from Lunda domination gave them licence to hunt the two highest priced commodities—elephants and slaves. In cultural matters, and in particular in sculptural and other arts, the Jokwe remained dominant.

Several Africanists including Diaz de Carvalho and Baumann, visited the Jokwe territories and published their findings. Kjersmeier and Olbrechts expressed the view that LUNDA art was influenced by and inferior to that of the Jokwe and, in fact, Kjersmeier asserted that the Lunda copied Luba art in Zaïre and Jokwe art in Angola and had thus no original tribal art of their own. Marie-Louise Bastin, to whom we owe our most detailed knowledge of Jokwe art, went further and came to the conclusion that the Lunda never produced any sculpture at all. They adopted Jokwe rites and ceremonials and acquired the sculpture for these as well as chiefs' stools, chairs, sceptres and other items of 'court art' from Jokwe carvers. Jokwe carvers also supplied other neighbouring chiefs with their regalia. In an article on Jokwe styles, Bastin distinguishes between the art of the country of origin—*Ujokwe* style—and the style of the Expansion. Until recent times Jokwe carvers in Angola and in Zaïre have produced carvings of artistic distinction in Expansion style. But their greatest achievements were in the *Ujokwe* style. There are statues of Chibinda Ilunga, often in movement, sceptres with heads of chiefs, seated chiefs with legs crossed, tobacco mortars and exquisitely carved chairs. These were decorated with relief masks or heads and lively scenes of initiation rites, war, divination and copulation, all sculpted in the round. Their individual style is

307
301
277/8
53
300
299
304
305

a. Jokwe
b. Lwena
c. Songo
d. Mbundu
e. Gangela

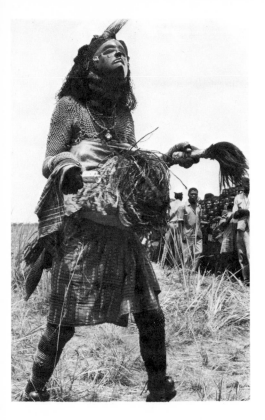

155 Jokwe male dancer
He is masquerading as a girl acrobat, and wearing the *Mwana-Pwo* mask.

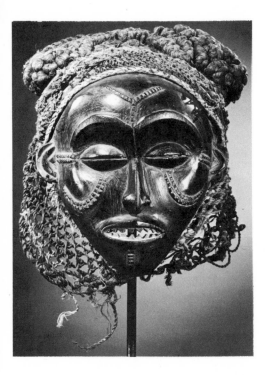

156 *Mwana Pwo* mask
Jokwe, Angola; wood, fibre 19 cm (7½"). Coll. Robert and Nancy Nooter, Washington, D.C.

easily recognizable. The eyes are set in large oval sockets and the faces show deep lines between the nose and the corners of the large mouth, and the chin is adorned with a beard sometimes horizontally carved or made from fibres or natural hair. Arms, legs, hands and feet are large and convey a sense of great physical strength. The emphasis placed on the age of the venerated chief and on movement contrasts strongly with the usual agelessness and frontal rigidity in African sculpture. These figures, both male and female in the *Ujokwe* style are all old and, wherever collected, they originated in Angola and were probably taken by the advancing Jokwe to Kasai, Shaba and other areas at the end of the nineteenth century. Figures other than the great effigies of ancestors and heroes represent spirits of nature and from the world beyond, their faces serene and ageless, and while the court art came to an end in the dispersion as chiefly power dwindled under colonial rule, the Jokwe continued to carve spirit figures in their new lands. Although they are semi-nomads the role of the chief remained of sufficient importance to warrant the need for splendid decorated chairs and badges of authority, but they are all in the style of the expansion.

Masks too were equally in demand. Three types of masks are known and two of these, that of the *chikungu*, which is the symbol of the sacred power and of the rights of chiefs, and that used in *mukanda* circumcision rites, are made of resin. The third are the dance masks usually carved in wood, of which the best known are the *chihongo* male mask and the *mwana pwo* representing a young maiden. The *chikusa* mask in the shape of an antelope horn is made of fibre and is the most important of those used in circumcision rites. The faces of the *chikungu* masks are modelled of black resin applied to woven cloth stretched over a frame of pliable branches. The narrow horizontally split eyes are set in hollow sockets also forming the sunken cheeks. The long, thin nose issues from a high forehead, surmounted by a tall, winglike coiffure. The whole is designed to present the ferocious forces of ancestor and nature spirits. These masks are usually painted in red, white and black which accentuates their impact. The wooden dance masks were also originally made for sacred ceremonials but have recently been used for village entertainment where women and uncircumcised boys can see them. The foreheads of both the *chihongo* and *mwana pwo* masks are usually decorated with an emblem resembling a Maltese cross which some have thought to be the result of Christian influence. The *chihongo* with filed teeth and carved beard jutting out horizontally is usually highly stylized while the *pwo* realistically depicts a beautiful girl.

To the east of the Jokwe live the LWENA, a smaller tribe of about 100000 people who occupy areas in north-east Angola, border areas of Zaïre and north-west Zambia, where they are known by the name of Lovale. They are related to the Jokwe by language and possibly ethnically: indeed their sculpture is so similar to that of the Jokwe that it has generally been attributed to them. Research by Bastin revealed the differences and established the Lwena as producers of sculpture in 301

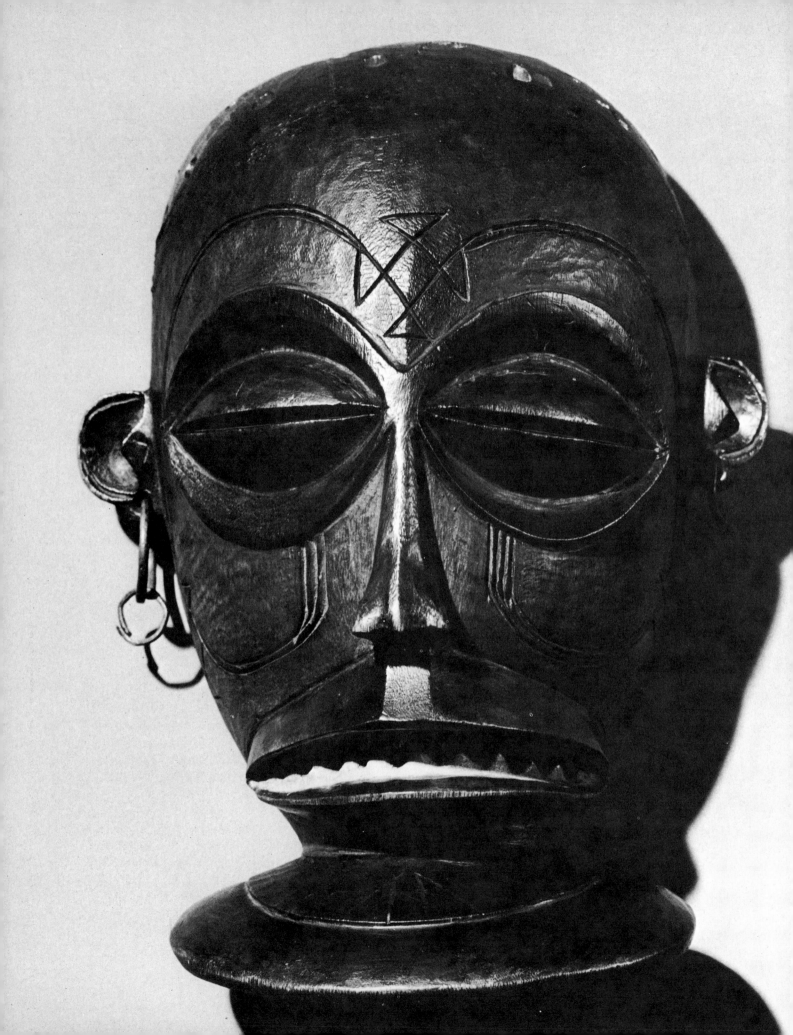

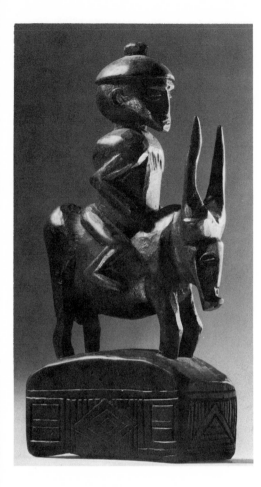

158 *above* **Nzambi** figure
It shows a white man riding an ox. Songo, Angola;
wood, 20 cm (8″). Tara collection

157 *facing* **Chihongo** mask
Jokwe, Angola; wood, metal earrings, 24 cm (9½″). Coll.
Marc and Denise Ginzberg, New York

their own right. Like their western neighbours they are great hunters, but while the Jokwe have a reputation as fierce warriors, the Lwena are known as a peace-loving people. This difference in character is clearly expressed in the respective sculpture of the two tribes. The figures and many of the masks of the Jokwe are ferocious and sharp-edged while the statuettes and masks of the Lwena are gentle, elegant and rounded in line and in form. Again the Lwena, a matrilineal society, carve preponderantly female figures, while the Jokwe seem to concentrate on the male. Apart from this general difference in the sculpture a number of details can assist in determining the actual origin. The distinctive coiffure on Lwena masks consists of twisted strands of hair falling on both sides of the face from a centre parting. But another frequent hairstyle, the arrangement of the hair in smooth plaits, called the tiara, is common to both tribes. The Lwena also use the Maltese cross-like emblem on forehead and cheecks but the triangular corners become loops on most Lwena sculptures. Distinctive scarification marks of the Lwena are concentric circles, and triangles set inside each other in groups of three. An important difference is in the wood and finish used by the two tribes; the Lwena carver prefers a natural finish of carefully chosen, finely grained, light-coloured wood to give the figures additional softness; the Jokwe, on the other hand, use various types of wood and achieve the required finish by the application of red earth and palm oil.

The Lwena use fewer types of masks and their principal sacred mask is the *katotola* corresponding to the Jokwe *chikungu*. Both are made of resin and similarly constructed. The *chihongo* mask of the Jokwe does not seem to have an equivalent in Lwena art while their *pwevo* mask is similar to the Jokwe *pwo*. The chiefs' stools are round or square, some with animal hide used for the seat, while the European-type chair covered with sculptured decorations used by Jokwe chiefs is rarely found among the Lwena. Their diviners use small female figurines which are tutelary spirits consulted during rituals.

The SONGO are the western neighbours of the Jokwe with whom they share a common ancestry. Their art is thus closely related. But the Songo certainly developed an individual style, and their figures portraying a white man mounted on an ox are their own creation, called by them *nzambi*. The inspiration for these figures seems to have come from white traders and from explorers like von Wissmann and Livingstone who gave preference to the ox over the horse because of its greater resistance to the tsetse fly and because it was more suitable for travel in the bush. These *nzambi* figures have magic powers and became the object of a cult into which members were initiated. Material wealth, fertility, ancestor worship and good hunting are all involved in this Songo mystique. Other original Songo artistic creations are a stool, the seat of which is borne on the hands of a caryatid. Her elbows rest on her knees and the head rises above the level of the seat. They also carve long tobacco pipes made up of several sections and liberally decorated, mostly with heads and figures in relief, and these, as well as clubs

302

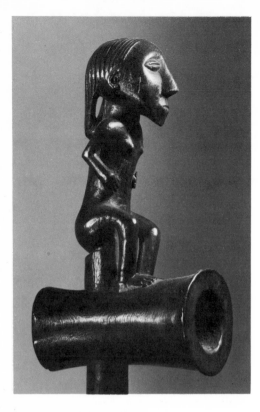

159 Pipe with female figure
Mbundu, Angola; wood, metal tube, brass edging on pipe bowl, 26.5 cm (10½") without tubular stem, which is 15.25 cm (6") long. Private collection, London.

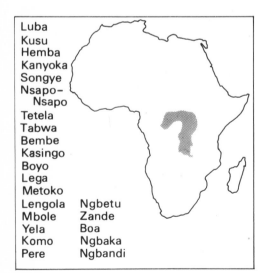

Luba
Kusu
Hemba
Kanyoka
Songye
Nsapo–
 Nsapo
Tetela
Tabwa
Bembe
Kasingo
Boyo
Lega
Metoko
Lengola Ngbetu
Mbole Zande
Yela Boa
Komo Ngbaka
Pere Ngbandi

topped by carvings, staffs and other objects, all had ritual purposes. The Songo have cicatrice marks on the cheeks of their *mwano pwo* masks in the shape of the sun. The coiffure on female figures and masks still corresponds to the hairstyle described by Buchner as 'braided or lightly curled locks close around the face, lightly touching the shoulders and creating an overall tufted effect'. In view of all these differences it is surprising that Songo art was lumped together with Jokwe carving as late as 1971, when an ox 'mounted by a chief' was described as being Jokwe. In fact Bastin's study of the Songo and their art had been published in 1969.

The MBUNDU, who live on the high plateau of Benguela in Western Angola are a large tribe of about one million people with an agricultural and pastoral economy, who also form part of the Jokwe style region. Their carvings too have for a long time been thought to be of Jokwe origin, although they can be clearly distinguished by their more naturalistic faces and elongated bodies. The women wear their hair in long plaits tied together at the neck in horseshoe shape, and that is reflected in their carvings. Circular cicatrice marks on the cheeks and a 303
branch-like motif on the forehead are characteristic for most Mbundu carvings while their naturalistic style may point to European influence. They did not carve masks and acquired both fibre and wooden masks from their neighbours, mainly the Jokwe and the GANGELA as they did chief's chairs and ceremonial adzes. The most frequent objects made by Mbundu carvers are female statues, staffs surmounted by female heads with a shiny black patina, and pipes.

XIII Eastern and northwestern Zaïre

Archaeological research in Shaba Province of Zaïre has discovered 96
evidence of an ancient culture that produced fine pottery and metal-work in the eighth and ninth centuries. By the twelfth century a well organized political structure and widespread trade, mainly in copper, had developed, and this was followed by the creation of divine king-ship rule in the sixteenth century by the Lunda and LUBA. The sacred right to rule of those of royal blood was first introduced by Kalala Ilunga, according to the Lubas' oral history, and was later adopted by the Lunda when his son the Luba hunter-prince Chibinda Ilunga became their ruler through his marriage to the daughter of a Lunda king. In the process of the creation and expansion of the Luba and Lunda empires there was a great deal of rivalry and interaction between the two peoples. The Lunda were able to keep the upper hand and their bi-lineal succession gave them the same advantages over the Luba as they had succeeded in establishing over the Jokwe in Angola. Many Luba groups had, as a result, Lunda chiefs who were able to guarantee a stable government.

However, in the world of art the Lunda failed to benefit from their contact with the Luba, one of the greatest peoples of sculptors in

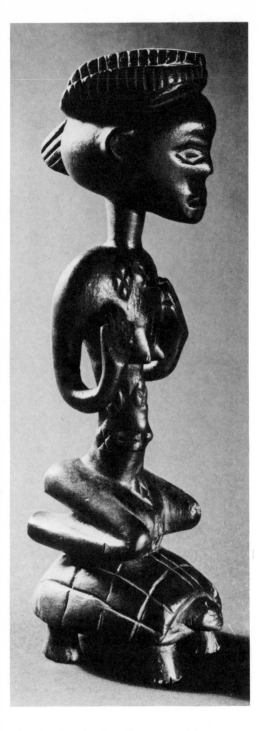

160 Female figure kneeling on a tortoise
Luba, Zaïre; wood, 40.5 cm (16"). Coll. Aaron Furman,
New York

Africa. In the same way they never became carvers for themselves, despite their patronage of the Jokwe and despite their involvement in their politics and government. The influence of the Luba on the cultural life of their other neighbours and in particular on their sculpture was, however, profound. The group of tribes of many different origins who live in the Shaba and Southern Kasai Provinces were to a certain degree unified by their exposure to Luba art. In the Kasai the word 'luba' means slave and came to be used of them because many Kuba slaves were of Luba origin. Not all people called Luba are in fact of Luba origin. Luba influence, for example in matters of belief, reached eastwards as far as Tanzania and Zambia.

General characteristics of Luba style are naturalistic figures (the majority of them female), carved in soft rounded form, the torsos shapely with graceful arms and legs. Finely detailed coiffures and scarification marks on the body assist in the attribution to a tribe, subtribe or area. The choice of the female figure in Luba carvings may be due to the role played by women in Luba society and in the tribe's myth of its creation.

Luba masks are relatively rare. Many are similar in concept to the Songye *kifwebe* masks with grooved stripes outlining the shape, but the Luba masks are softer and rounder; some are very large and circular with white curved lines emphasizing the spherical character of the face. Probably the grandest Luba mask known is the helmet mask in the Tervuren Museum depicting a bearded man with buffalo horns. 275

Luba statuary is very varied. The ancestor figures, always serene, dignified and carefully carved and finished represent both males and females, the latter often shown with hands on the breasts. The spirit figures, seat of all the many forces of nature, are carved in similar naturalistic style but appear to be less carefully finished. Many figurines are for divination or are fetishes with magical matter in the head, in animal horns (usually carved in wood), or in the stomach. Some are hung with animal skins, snail shells, beads and other ornaments or symbols. Many other statuettes such as Janus heads and hermaphrodites, whose use is still a mystery, may also be the instruments of impersonal force. They are usually made of wood but a few ivory figures are known. A typical Luba sculpture is the *mboko* (or *kabila*) depicting a woman either kneeling or seated, holding a receptacle with both hands and balancing it either on her head or on her outstretched legs. They are sometimes mistakenly called beggars' bowls but are probably for divination: they are also used to help women in childbirth. The vessel held by the female ancestor figure contained kaolin—*pembe*. 273

Some of the finest Luba carvings are the ceremonial stools supported by figures, most often in the form of a woman, others held up 316 by two figures, male and female—side by side or back to back. Other Luba sculptures are stands for bows and arrows, usually incorporating a female figure supporting the stand and chiefs' staffs, in the form of a ceremonial paddle surmounted by one or two female figures or with a

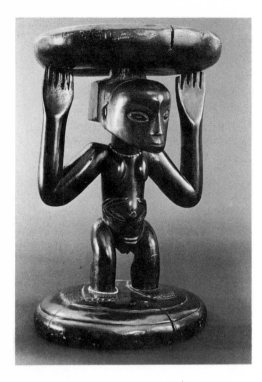

161 Stool with caryatid figure
Luba, Zaïre; wood, with reddish-brown patina and beads, 45.75 cm (18"). Private collection, New York

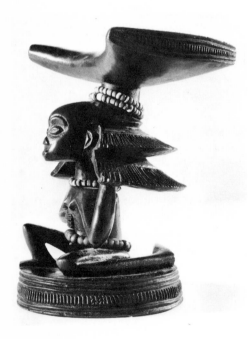

162 Headrest
It is supported by a female seated figure with 'cascade' hairstyle. Luba-Shankadi, Zaïre; wood, beads, 19 cm (7½").

relief carving on it. There are also headrests with caryatides in both wood and ivory. Ivory or warthog tusk was also used for the carving of charms in the form of female busts, and decorated with the circled-dot motif. The *katatora* is a divination instrument in the form of a hollow rectangle and the fingers of the diviner and the person consulting him touch in the opening as they work it to and fro on a block. A human head surmounts the carving which responds to questioning by inclining to the left or the right.

The Shankadi style of the Luba who live in Shaba Province is distinguished by a cascade coiffure descending to the sides and to the nape of the neck. The eyes are in cowrie shell shape, the lips are pursed. Scarifications follow motifs used in basket making. The torso is carved in the shape of a long cylinder with small pointed breasts.

The Mwanza substyle of the people to the east of Shaba is a cross between the Shankadi and the Hemba. The shoulders are wider and the face rounder with a square mouth and hair waved from the forehead and finely detailed at the back. The body is richly covered by diamond-shaped scarifications and in the case of the *mboko* figures the bowl has a lid sometimes in the shape of a female head, which may represent a child.

The HEMBA are part of the large group of peoples whom we may call the Greater Luba. The river Congo forms the western border, and the Luika, Lukuga and Luapula-Luvua also flow through their territories. In their sculpture the Hemba are the most Luba of the Luba, though their style has individual characteristics, only recently studied and classified to give a clearer picture of their work. The finely patinated ancestor figures with squared shoulders and oval faces express great dignity and serenity, while their cruciform coiffure is a distinctive feature. The great works of the Master or Masters of Buli, previously described as Luba, must now be classified as Hemba or as a mixture of Luba, Kusu and Hemba, on the basis of hairstyle and other features. Typical for these sculptures are the fine elongated faces and the head which is even larger in proportion to the body than is common in Africa. The subjects of the carvings are mainly women: carrying a bowl (*mboko*) or serving as supports of chiefs' stools.

One Hemba substyle is that of the KUSU about whom very little is known; they are part of the Tetela group and are ethnically and linguistically Mongo, not Luba, but their culture and in particular their carving style are strongly influenced by the Hemba. This is most noticeable in the south near the border of Songye territory, where the Kusu style shows Hemba as well as Songye trends in figures and masks. Kusu figures often have the hair arranged in plaits instead of the cruciform coiffure of the Hemba.

To the south of the Kasai Luba live one of their subtribes, the KANYOKA. Their best known carvings are hemp pipes in the form of human figures and the pair illustrated is an attractive example of a Luba-ised style. This style, though it may be relatively recent, has nevertheless become identified with Kanyoka art and very few older

321

323
324

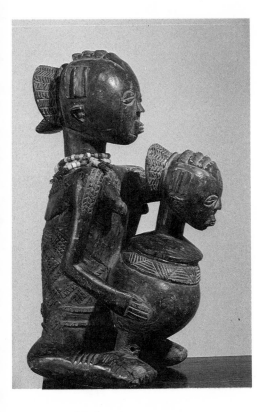

163 *above* *Kabila* figure
It shows woman holding a bowl with lid in the shape of
a head. Luba—Shankadi, Mwanza substyle, Zaïre;
wood, beads. Tara collection

164 *on right* Male and female seated figures
Kanyoka, Zaïre; wood, 36 cm (14¼″). Coll. William Brill,
New York

works are known. One of the finest of these is the stool illustrated here.
The faces are triangular and the figures lack the Luba realism and
feminine softness.

The carvers of the Kanyoka produced *mboko* figures, naturalistic
helmet masks, headrests supported by caryatids, adzes surmounted
by anthropomorphic heads, the blade projecting from the mouth,
decorated ivory combs, *katatora* divination instruments, and cups in
the shape of human heads. All these have been produced in the old
and 'new' Kanyoka styles but the number of known carvings in either
is small. A remarkable old-style Kanyoka mask was collected by
Frobenius in 1906 and is now in the Hamburg Museum für Völker-
kunde.

The SONGYE are the north western neighbours of the Greater Luba.
They have also common borders with the Tetela and the Kusu and
their very large territory reaches as far as the Sankuru River in the
west. Their political organization is a centralized bureaucracy and the
Bukishi secret society plays a dominant part in religious and lay
administration. They are reputed to have been fierce warriors and

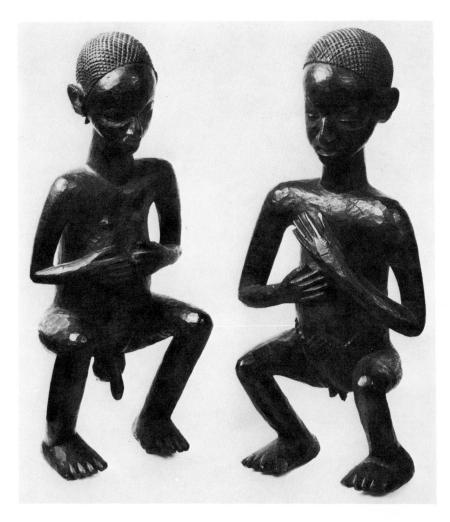

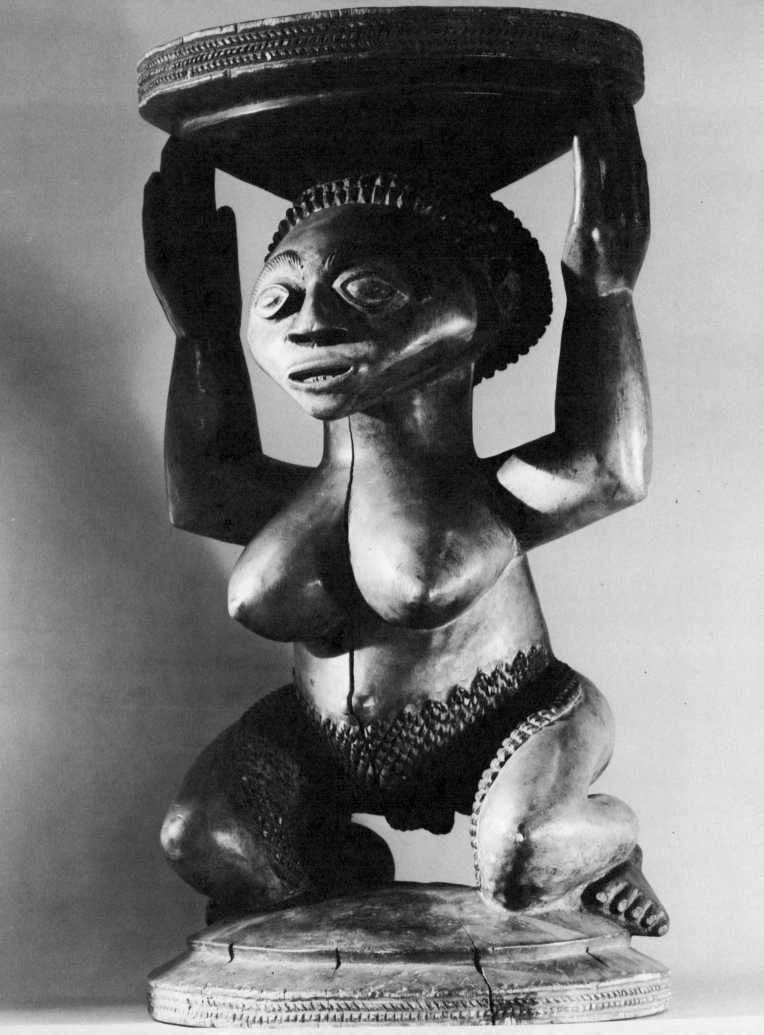

165 *on right* Stool supported by kneeling female figure
Kanyoka, Zaïre; wood, 52 cm (20½"). high. M.R.A.C., Tervuren

165a Seated female with child on her leg and a bowl in her right hand
Nsapo Nsapo, Zaïre; wood, animal horn, seashell with magic material, leather thong, 50.8 cm (20") Private Collection, New York

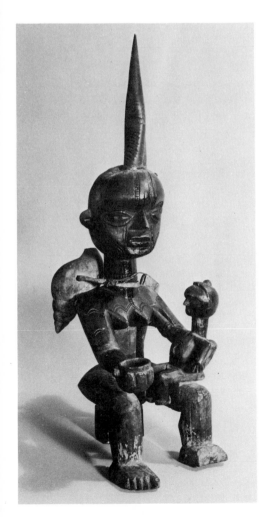

cannibals. Although there is a certain Luba influence discernible in some figures, the Songye clearly achieved a style of their own. In fact it is apparent that the influence worked both ways and that some Luba masks were inspired by Songye art. Both masks and figures of the Songye have a cubistic tendency in which geometric form and volume are skilfully used to create works of great power. Most statues represent standing males and many are containers of magic materials which are placed in an opening of the stomach or fixed to the head, or sometimes inside an animal horn inserted into it. The figures are sometimes hung with a variety of charms including small fetish figures, necklaces of beads or snake skin, animal horns and skins, while face and body are decorated with round or conical brass-headed nails. A few have nails and blades driven into the body or the base but there is no evidence of their use being in any way similar to that of the Kongo *nkisi*. It is thought that all the paraphernalia attached to or embedded in the Songye fetish figure—called *buanga*—are meant to enhance its magic power or that of the spirit symbolized by it. However, very little is known so far about the rites or beliefs for which these figures are used. Style characteristics are a square opening of the boxlike mouth and eyes usually carved in the shape of or formed by cowrie shells. Frontality and symmetry are the rule. The few exceptions are figures with their head turned to one side. Other Songye carvings are stools supported by human figures and headrests which are all influenced by Luba style. The extraordinary pipe illustrated in pure Songye style is a rare exception and is one of the most imaginative works of African sculpture (see pl. XXII).

273

322

The oldest type of Songye *kifwebe* masks is almost naturalistic with high rounded forehead and only the triangular nose, square mouth and incised grooves are what is now considered typically Songye. Out of this developed a fantastic type of mask with a high crest on the head continuing into a triangular nose, enormous hemispherical, cylindrical or rectangular eyelids and square box mouth all projecting from the striated, polychromed face which is broken down into planes like a modern European cubist sculpture. The grooves outlining the planes and mass are painted in alternating colours which adds to the supernatural impression made by this mask in movement. These masks represent the spirits of the dead and were used by the leaders of initiation rites. (Western demand has had a lot to do with the proliferation of this mask type since the Second World War.)

258

273

A small subtribe of the Songye are the NSAPO-NSAPO who live in the area of Kananga (Luluabourg) in Luluwa country. Through wars and frequent migrations they appear to have come under the cultural influence of the Jokwe and this is reflected in their sculpture along with Songye characteristics. In fact, according to Torday, they are not an ethnic unit at all but a group of fugitives made up of several tribal units. The mother-and-child sculpture illustrated is a good example of the sculptural style developed by them.

326

The Mongo-speaking TETELA, north of the Songye territory, are a

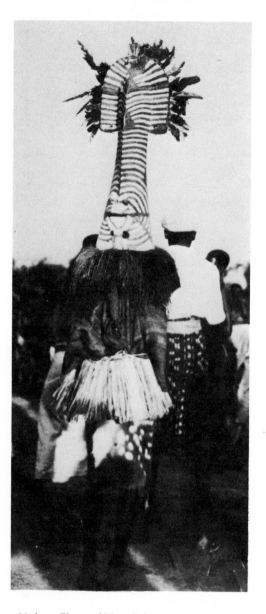

166 *above* Photo of Mwadi dance
Taken by Major White, depicting the mask in plate XXIV in use

warlike tribe who fought most of their neighbours and joined at times with marauding Arabs in widespread invasions. They include the Sungu, a subtribe from whom early this century Torday collected two masks which he labelled Tetela, and said that they were used for white magic. The fetisher of white magic is called *umpa* by the Tetela and *wichi* by the Songye whereas the practitioner of black magic which is 'death-provoking' is called *doka*. The Tetela made figures in human form for so far unknown purposes. The mask illustrated here, perhaps the finest example known, was collected about 1925 by an American missionary, Major John White, who lived in Tetela country for four years. According to his detailed, as yet unpublished records, the mask, called *mwadi*, was used for 'the dance of the new moon', for funerals and martial celebrations. Women attending the dance fled to their huts when cries announced the arrival of *mwadi*. White's report is the only known eye-witness record of the use of these masks and his faded snapshot showing the mask in action is reproduced here. Until the report by White came to light little was known about the use of Tetela masks, but their cubistic treatment and painted striations link them stylistically to Songye and Luba *kifwebe* masks.

To the east of the Luba around the southern part of Lake Tanganyika are the TABWA whose little-known sculpture, mostly ancestor figures, is Luba-influenced. While some Tabwa figures have diamond-shaped scarifications in the Luba manner, a figure in the British Museum has straight cicatrice lines dividing chest and belly into a system of triangles. As this type of body scarification has been found among east African tribes it is not unreasonable to speculate on Luba cultural diffusion to the east, through the Tabwa or other peoples living about the southern tip of Lake Tanganyika.

To turn to the north-western end of the lake, the cluster of tribes there has been referred to as the Bembe (Zaïre) group, and stylistically it should be linked with the Luba. Until recently, the art of the BEMBE, the Kasingo and the Boyo were all treated together but should be considered separately.

The Bembe are an acephalous group who were exposed to a variety of cultural influences. In addition to the cult of ancestor spirits—both immediate and primordial—the Bembe worship the nature spirits which in their mythology inhabit Lake Tanganyika, rivers, mountains and the forest. The numerous secret societies include the *Elanda*, '*Alunga* and *Bwami* and the last is the strongest link between Bembe and Lega cultures.

The '*Alunga* society helmet masks for which Bembe art is probably best known are double faced, each face consisting entirely of two concave ovals painted with kaolin, each having a star shaped relief with a cylindrical centre representing an eye. The helmet is topped with feathers and fibre decorations. Janus statuettes called *kalonga* and face masks each with concavities serving as eye sockets are also used in '*Alunga* rites. During initiation new members are made aware of the omnipresence of the helmet or 'bell' mask which represents the spirit

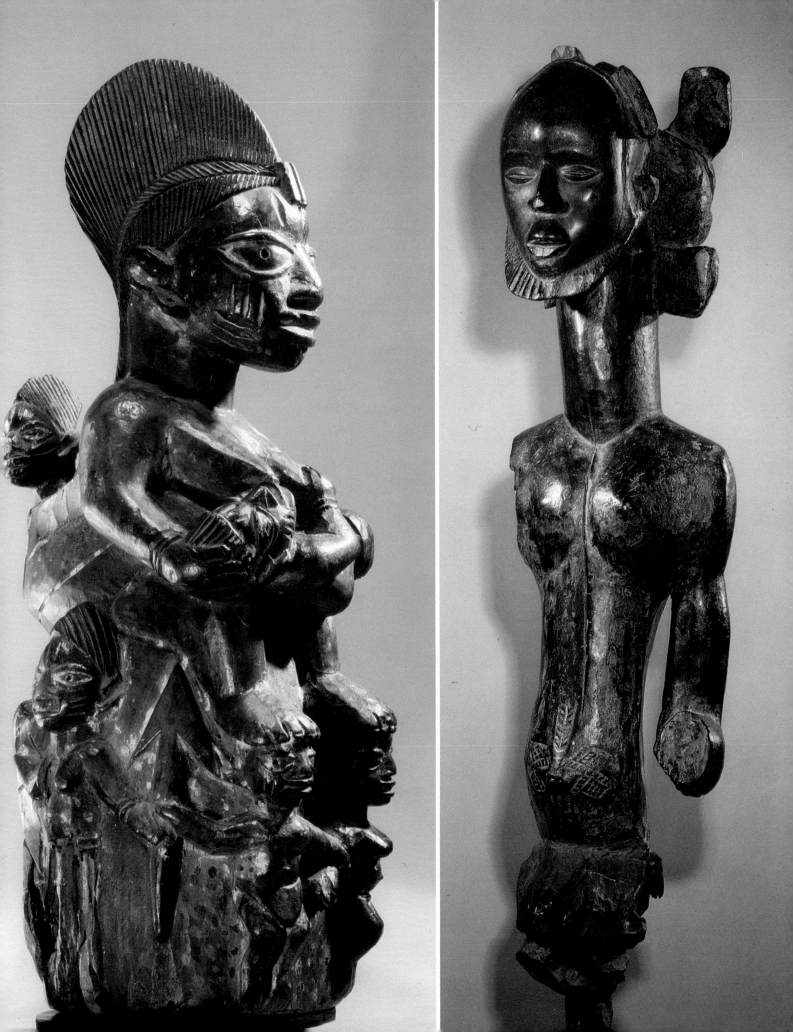

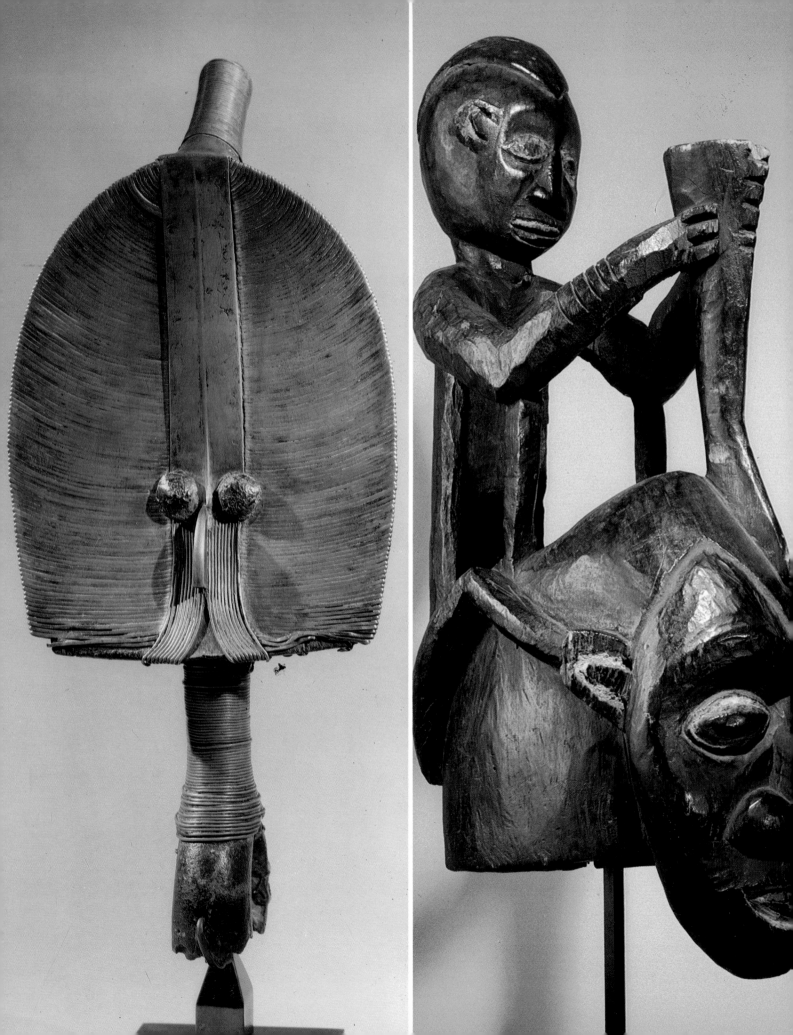

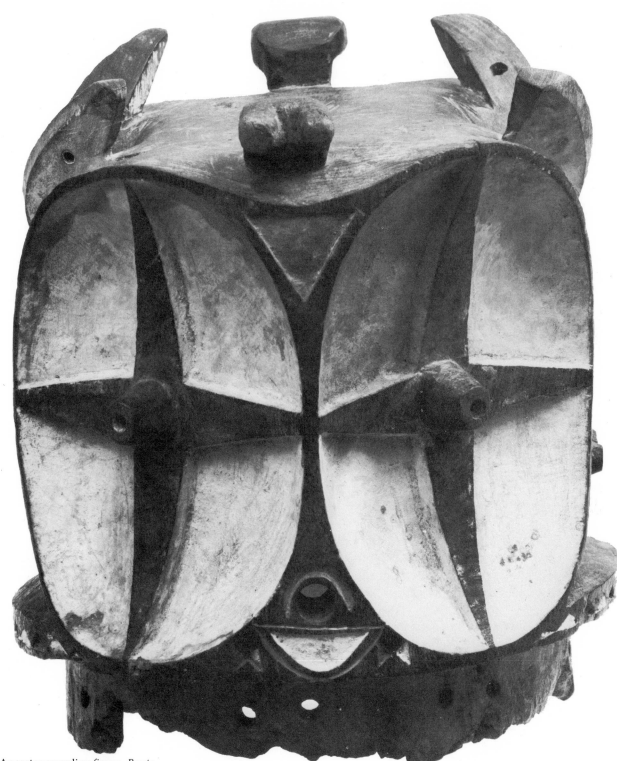

XVIII *left* Ancestor guardian figure, *Bwete*
Hongwe, Gabon; wood, brass/copper strip and wire.
Height of face 25 cm (9¾″). Coll. Marc and Denise
Ginzberg, New York

XVIII *right* Mask surmounted by seated male
figure
Babanki—Tungo, West Cameroon; wood 63.5 cm (25″).
Coll. Marc and Denise Ginzberg, New York

167 *above* Helmet mask
Bembe, northwestern shores of Lake Tanganyika, Zaïre;
wood, kaolin, 45.75 cm (18″). Dona and Lee Bronson
collection, New York

of the bush. This mask is also used in public dancing ceremonies by which the 'Alunga society exercises social control. The Bembe believe that dangerous forces can be activated by dead ancestors through the great 'Alunga mask which must therefore be placated by sacrifice and dance. 258

The Bwami society structure resembles that of the Lega and initiation objects consist of small ivory and wooden figurines both in animal and human form. They are emblems of rank, symbols of status and 'iconic devices which help to underscore the high moral and philosophical principles of the association'. Bembe circumcision rites are also based 309
on Lega traditions and are equally under the control of the Bwami society.

Impressive tall figures with triangular bearded faces, heavy lidded round eyes and a cubistically treated body are used by a small tribe called KASINGO who live close to Bembe territory. They were already identified as a separate group in the early part of the century but these sculptures have only recently been recognized as Kasingo. Another small tribal grouping, closely related to both the Bembe and the Kasingo, are the BOYO (or Buye). Their most famous sculptural 318
creations are male statues nearly a metre high (see pl. XVI left). They have large spherical heads with round faces and beak noses. The short neck is set on squared shoulders and the chest and torso are rendered in the round. The face, body and arms are richly decorated in a variety of incised patterns.

The LEGA—also known as Rega—live to the north of the Bembe region in the Maniema area of north-eastern Zaïre. Lake Kivu is their eastern border and according to their oral history they came to their present country from Uganda and Rwanda in the east, at an unknown date. The Lega are an acephalous tribe of about a quarter of a million people. Their social, political and religious cohesion was achieved by the Bwami association to which all men belong from the time of circumcision. From this they can advance through five grades by successive initiation. The wives of initiates automatically become members of Bwami and their grade corresponds to that of the husbands.

Practically all sculpture is closely related to the rituals and ceremonies of the Bwami society. Although the Lega have a distinctive sculptural manner, it is impossible to attribute any variants of Lega style to a particular local school or substyle because of the patterns of ownership and transfers of objects. They are held either individually or collectively and the transfer is tied to the kinship system; thus sculptures may travel far from their village of origin. The objects—mostly used in initiation rites—are symbols in the metaphorical language of the tribe. The keys to it are the form of the sculpture, its location in the initiation hut, and the manner in which it is held during the ceremony. The Bwami society, persecuted by the colonial authorities, was proscribed in 1948 but made legal again after Zaïre became independent. Much damage was done to Lega art during the period of suppression, and as a result carvings made by the Ngbetu and even objects such as

168 Mask, a Bwami Society badge
Lega, Maniema area of northeastern Zaïre; wood,
kaolin, and fibre beard, 12.7 cm (5"). M.R.A.C.,
Tervuren

celluloid dolls and electric light bulbs have taken a place alongside Lega sculpture in *Bwami* ceremonial.

Lega masks, of wood with a highly polished surface, are often treated with white pigment. The ivory masks are smaller and are worn on forehead, arms or shoulders or held in the hand. They are used by high-ranking members of the society. Some masks are made from the sole of an elephant's foot which is cut into a disc into which holes are pierced to indicate eyes and nose with small holes for the attachment of fibre beards. Such beards are a common feature of most Lega masks, some fifteen different shapes of which are known. The common denominator of many of them is their oval form, high forehead and heart-shaped face. A rectangular, almost cubist type is another, rarer, variant. The eyes are often in the form of cowrie shells and the expressive mouth is usually slightly open. The wooden statues are reputed to be the older, and their rarity is partly due to the fact that they are not used in all regions of Lega country. Carvings of animals are mostly rather naturalistic and include representations of elephants, anteaters, snakes and monkeys. A number of ritual instruments and spoons carved of ivory in exquisite designs and richly patinated are also among Lega art objects. All figures, whether of wood or ivory, are small but their impact is as great as that of monumental sculpture. Some portray human beings with a minimum of stylization while others vary from cubistic treatment to symbolic transformations. In those the figures may be carved with two faces or with heads fixed straight onto legs, or the carver may take unusual anatomical liberties. One type—called *sabitwebitwe*—may have as many as six faces all turned in different directions. The eyes are indicated—as in the case of masks—by cowrie shells or by circled dots in the centre, a motif widely used on Lega statuary, and probably derived from Arab slavers.

One of the great attractions of Lega art for the western collector is the beautiful patina of ivory objects in hues of golden brown to dark red. This is achieved by the frequent use of palm-oil during rituals. But the very simplicity of some of the more abstract figures has made imitation easy and fakes of Lega sculpture are abundant.

310

The METOKO and the LENGOLA are Mongo tribes who live in the forest areas of north-eastern Zaïre. The *Bukota* association, related to the *Bwami* society, appears to have considerable influence with both tribes. Its functions involve funeral and circumcision rites, healing and judicial activities. The Lengola have in addition the influential *Lilwa* society which they share with the Mbole and the Yela. The Lengola use large wooden figures with a very elongated trunk painted with dark resin and white dots and sceptres in the form of Janus-headed half figures said to be specially made for circumcision rituals. Very little documented evidence, however, is available regarding the actual use of any of the Metoko or Lengola figures.

Also of Mongo origin are the MBOLE, who occupy an area in the lower regions of the Lomami River to the west of the Lengola. The YELA to the south-west are closely related to the Mbole both physically

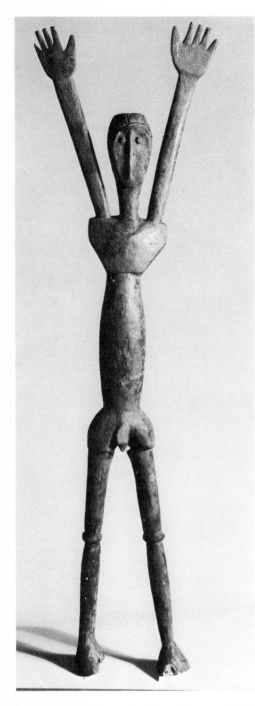

169 Large male figure, standing with arms raised
Lengola, northeastern Zaïre; wood, 169 cm (66¼").
M.R.A.C., Tervuren

and culturally. The best-known carvings are the figures representing persons who were hanged by executioners of the *Lilwa* society. The crimes for which they were condemned were disclosure of *Lilwa* secrets, adultery or murder. The figures are kept in full view of initiates as a warning of the fate that befalls those who break the moral and legal codes of the *Lilwa* society. The carvings are full length figures with a large head, white heart-shaped face in which eyes and mouth are indicated by narrow slits. The body clearly shows the posture of a hanged person with dangling arms and bent legs and they are usually not made to stand. They are often painted black, and ochre and red pigments are daubed on various parts of the body.

312

In the same forest area live the KOMO, a large tribe widely scattered in the Lubutu and Bafwasende zones of Kisangani Province. Very little was known about this people or about any of the tribes of the forests of north-east Zaïre until Biebuyck's work was published in 1977. To this and the work of de Mahieu, van Geluwe and a few others we owe detailed information about the Komo. The *Esumba* initiation rites are central to their tribal structure. A number of wooden masks and figures in human, animal and abstract form carved of wood or ivory, are used in the *Esumba* rites for circumcision and for other male initiations, or are connected with sickness and healing. *Nkunda* is the initiation ceremonial for the association of diviners, and is performed by dancers wearing different types of wooden polychrome masks. It appears that one type also serves at the funeral of members. Komo women selected for their high standing in the community become members of a medical sect. Among the many sacred objects used by them are rudimentary male and female wooden sculptures with black head and red body, or red legs and the rest of the figure black, covered with white dots.

312

320

The PERE are a neighbouring tribe who inhabit an area near the Lindi River. Very little information is available about this small group, organized into miniature kingdoms under the central authority of a divine ruler. Their fame as sculptural artists is based on a trumpet in anthropomorphic form. The extreme abstraction of this object is truly astonishing. The purpose of the instrument has remained an enigma but Biebuyck believes that it is related to the anthropozoomorphic musical instruments connected with Pygmy *Molimo* initiations. Another fine sculpture is the highly stylized wood carving of a bird which, according to the very scanty information available, represents 'the hen offered to the chief when entering his village'.

273
311

319, 327
328

The NGBETU occupy a large area in the region of the Wele River in north-east Zaire, the Republic of the Sudan and in parts of the Central African Empire. They are believed to have come to this area from the west possibly as long as a thousand years ago. They found Pygmies there and the Mbuti people of that race still live there, forming a kind of symbiotic relationship with the Ngbetu.

The German traveller, G. Schweinfurth, visited the region in about 1870 and was received by the great Nbgetu king Manzu. He describes the astonishing structure of the palace, fifty metres long, twenty

325
306

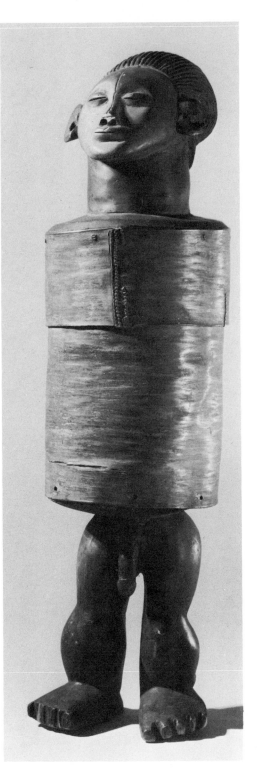

170 Anthropomorphic bark box
The lid is surmounted by a head, and the lower part of a male body protrudes from the cylindrical box. Ngbetu, Wele river region, northern Zaïre; wood, bark, 63.5 cm (25"). Museum of Mankind, London

metres wide and seventeen metres high, built of palm stalks with a flat horizontal roof. Schweinfurth writes that the Ngbetu worked in iron and copper and that they were also skilful carvers using mostly the soft rubiacea. He describes slit drums, stools, shields, boats and water bottles as their artefacts but does not mention statuary or five-stringed bow harps. As his report is very comprehensive it is possible that most of the Ngbetu art now known to us developed after 1870.

Ngbetu figures are mostly carved of light-coloured wood which shows hardly any patina. The important characteristic of all Ngbetu anthropomorphic statues is an elongated head emphasized by a high coiffure, sometimes with a disc top. This is a portrayal of the cranial deformation achieved by the custom of binding babies' heads during their first years. Practically all Ngbetu sculptures, including pottery vessels, pipes, the hafts of swords or daggers and the tops of bark boxes, incorporate this feature. There seems to be no evidence of ritual use of Ngbetu figures as they were mostly produced as prestige objects for kings and chiefs.

258

The ZANDE and Ngbetu are close neighbours and although constantly at war with each other there was undoubtedly also a great deal of mutual cultural influence. The Zande constitute a number of small kingdoms and their society is based on a hierarchy led by a hereditary aristocracy controlling the appointment of chiefs.

Zande ancestor figures are in a naturalistic style, and some carvings are mother-and-child groups. Their bowharps are constructed like those of the Ngbetu but the neck is usually surmounted only by a human head instead of a complete figure, and without skull deformation. The Zande also make remarkable pottery vessels, surmounted by human heads and their artistry in metal is shown by their throwing knives. Much recent Zande statuary is connected with the rites of the *Mani* secret society, for which very stylized figures either in wood or pottery were produced. Known as *yanda*, they were kept in secret shrines. The head is usually hemispherical or globular, neck and torso forming a cylindrical or rectangular block.

The territory of the BOA is south of the Zande region and they are said to have once been part of the Ngbetu empire. Wood carving here is almost entirely restricted to masks made for the society of warriors who used them in battle. Most masks are oval with large saucer-shaped ears and the face is divided into polychromed facets. Some small figures with stereometric bodies and concave faces were used by secret societies but there is no documentation on rituals. Boa harps resemble those of their Zande neighbours.

The acephalous NGBAKA tribe speak a Sudanic language and live in the Ubangi River area. They make few carvings and these are generally of little artistic quality. The exceptions are a few remarkable naturalistic figures representing the founding ancestor couple. Other figures are stylized with rhomboid or square faces, cylindrical trunks and short legs. White masks were used for male and female initiation rites. Their musical instruments resemble Zande harps and whistles in the shape

171 Anthropomorphic Pipe
Ngbetu, Wele river region, Zaïre; 11 cm (4⅜").
M.R.A.C., Tervuren.

172 *facing page* Male and female figure
The female has a child carved on her body. Zande, Wele
river region, northern Zaïre; wood, traces of pigments
and paint, 38 cm (15"). Coll. Marc and Denise Ginzberg,
New York

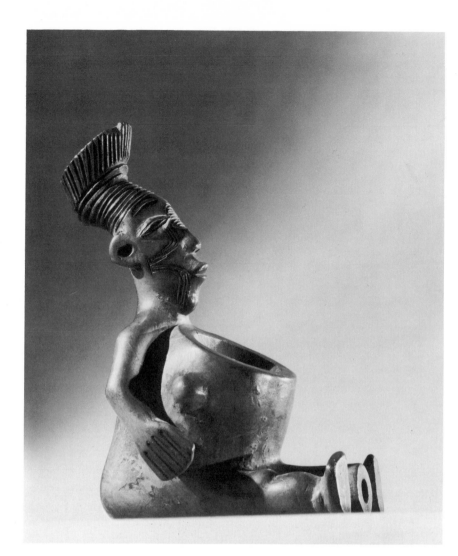

of human heads were used by diviners. The neighbours of the Ngbaka
in the Upper Ubangi region are the NGBANDI, ruled by chiefs who also
supervise their strong ancestor cult. Their best known products are
their daggers and lances and the very few masks or figure carvings
which have been found, appear to be derived from the more lively
Ngbaka style. However, the anthropomorphic cup illustrated must
rank with the best of Congo art.

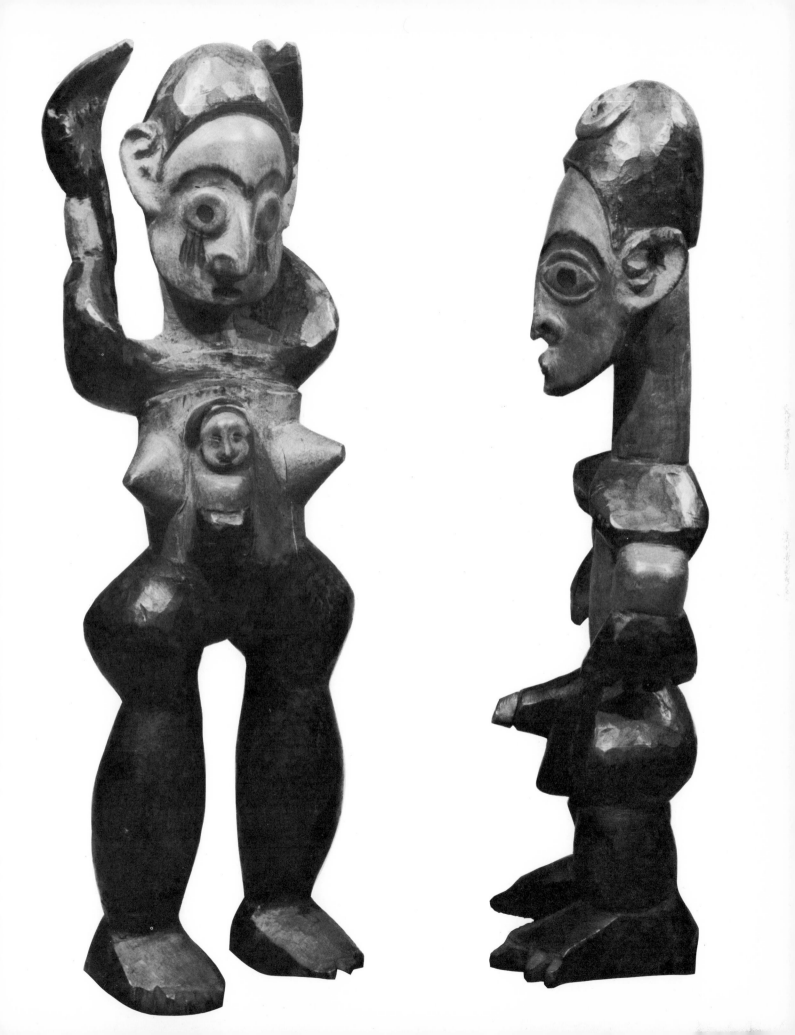

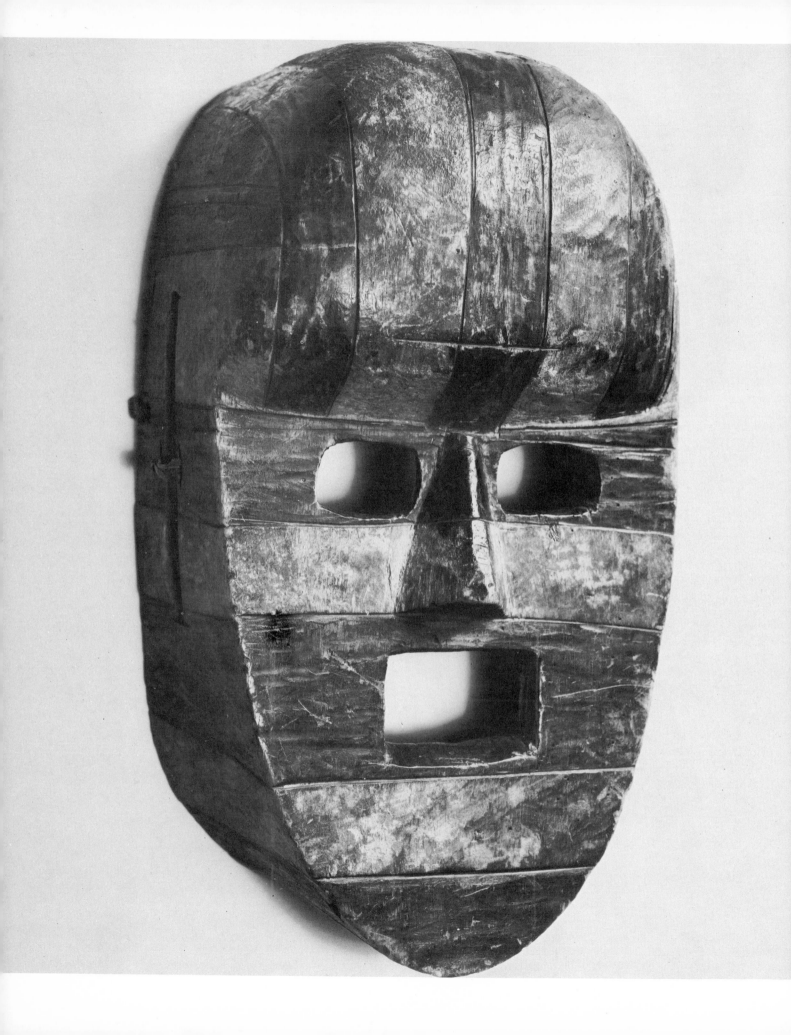

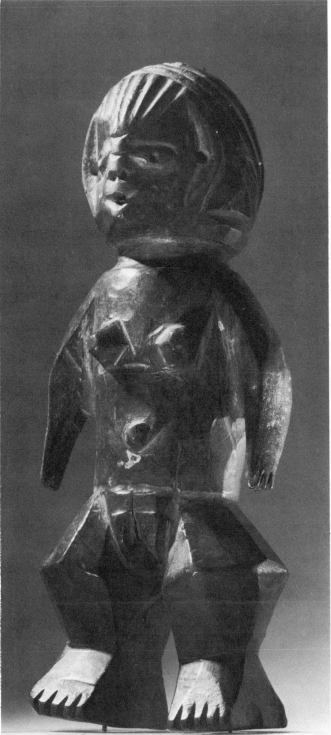

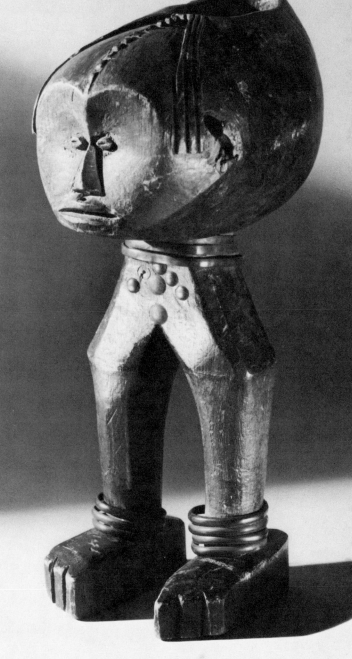

173 *facing page* Mask
Said to have been collected by a member of the Stanley
expedition. Boa, Likati river, northern Zaïre; wood, black
and white pigments (the saucer-shaped ears are missing)
35.5 cm (14"). Coll. Patricia Withofs, London

174 *above left* Standing female figure
Ngbaka, Ubangi river, Zaïre; wood, 24 cm (9½"). Coll.
Josef Herman

175 *above right* Anthropomorphic cup
Ngbandi, Ubangi river, Zaïre; wood, metal, 27.8 cm
(11"). M.R.A.C., Tervuren

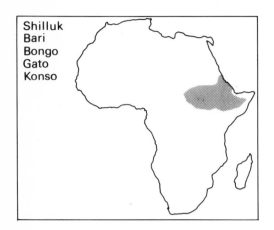

Shilluk
Bari
Bongo
Gato
Konso

XIV Eastern Africa; Southern Sudan and Ethiopia

Music, the sound of the drum, the rhythm of dance, gay colours and ornamentation are integral parts of the life of all black nations south of the Sahara from the Atlantic coast to the Indian Ocean. But with regard to plastic art it has been shown that many tribes in Africa west of the Great Lakes produce carvings of great distinction while others in the same areas have no sculptural traditions. No plausible reasons have been agreed upon by ethnographers for these differences nor for the plaucity of plastic art in east and south Africa, but in those areas one may speculate on the influence of a nomadic pastoral life, the frequent irruptions of wars and slave raids in the area, and later, of course, the arrival of European settlers. The advance of Islam is another factor in changing tribal customs and society, though several sculpture-producing tribes do live in the most Islamised coastal area.

In the distant past the people of east and southern Africa produced the high cultures of Meroe and Great Zimbabwe of which so little is known. The many rock paintings found in other parts of east and southern Africa are witness of a still earlier artistic tradition and some of the carvings of the Makonde, Shambala and Hehe are pointers to the possibility of an existence in the past of art east of the Lakes.

Such carvings could not have been produced in a cultural vacuum. Indeed, the fact that the present peoples of east Africa show a decorative and artistic sensibility in the production of calabash work, pottery, basketry, jewellery, arms and household objects (such as stools and headrests) suggests that the art of sculpture may have existed in the east only to die out a century or two before its demise in the west.

The eastern kingdoms, such as those of the Rotse, Shilluk and Bemba, never achieved the greatness of Benin, Songhai or Kuba. But initiation rites, ancestor and spirit cults still exist, and such rites tend to need masks and figures. However, few fully documented pieces are known, for often a sculpture is identified only by the place of acquisition, perhaps just a trading centre, and the territories of these pastoral and nomadic people are large and ill-defined. It is not possible to be dogmatic about the exact origins or forms of tribal art until more research has been done.

The SHILLUK, a tribe of about 100000 people, live on the west bank of 337 the Nile in the vicinity of the town of Malakal. Their divine hereditary 332 king or *reth* is said to be the reincarnation of their first ruler and god Nyikang, for whom wooden statues were erected in shrines. The best-known examples of their art are pipebowls made of pottery. The zoomorphic ones may have been all made by one man.

The BARI of the Province of Equatoria in the Republic of Sudan are a 335 small tribe that produced some wood carving. The examples in various European museums are all primitive pole structures depicting humans, probably used in ancestor cults and some headrests. The BONGO who number about 5000 and live further south in Bahr el Ghazal Province, are settled agriculturalists. They have some cultural 331

176 *facing page, left* Pipe, the bowl in the form of an animal
Shilluk, White Nile, Malakal Area, Republic of Sudan. Clay, Bamboo, Metal beads, pigments, 74 cm (29¼"). Museum of Mankind, London

177 *facing page, right* Standing female figure
Attributed to Bari, White Nile, Province of Equatoria, Republic of Sudan, wood, 51 cm (29⅛"). Museum of Mankind, London

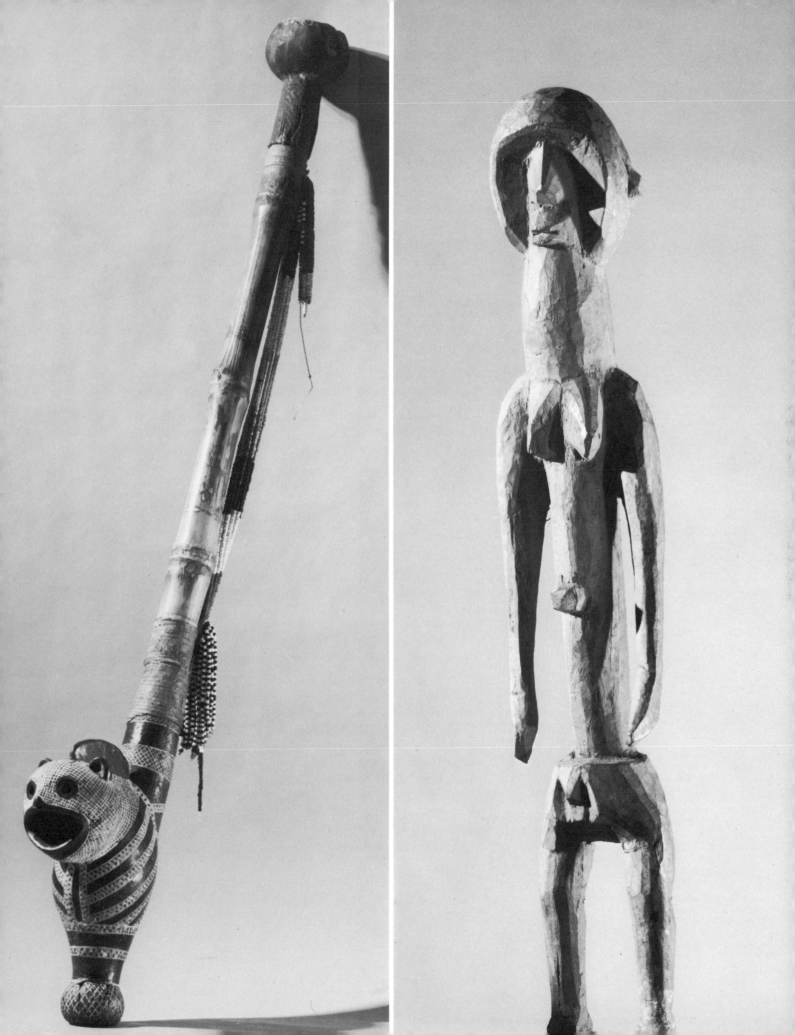

affinities with the Zande who introduced them to bush initiation rituals. Wooden posts carved into semblances of human figures were erected on graves or served as gate posts in villages, and figures of ancestors who were known as outstanding warriors or hunters, as well as sculptures representing murdered people, were carved by the, Bongo, many in a primitive—even rudimentary—pole style, but some of considerable grace. The carver tried to achieve a likeness of the ancestor and decorated the statues with the dead man's beads and other ornaments. In neighbouring Ethiopia the cushitic GATO and KONSO made impressive wooden tombmarkers which are placed in the entrance to the village in the case of the Konso and on the graves of men and women by the Gato. Depending on the deeds by which the dead are remembered a number of smaller posts are also erected. These types of memorial posts are found sporadically along the east coast, from the Sudan to Madagascar.

334

49

XV East African Lakes, Kenya and Tanzania

The area bordered by the Great Lakes in the west and the Indian Ocean in the east consists of Uganda, Kenya and Tanzania. It is believed that Cushitic-speaking tribes of Caucasian and Negro origin moved into the area from Ethiopia in about 1000 B.C. while the Bantu migration reached east Africa in the first millennium A.D.

In the region of the Great Rift Valley and Lake Victoria live a number of art producing tribes and among them are the Ziba, the Karagwe and the Kerewe, who inhabit the island of Ukerewe in the south east of Lake Victoria. The ZIBA made oval wooden masks, the square open mouth usually set with human or animal teeth and round holes indicating the eyes. Lines painted white frame the face.

When Stanley visited the area in 1876 he discovered in the Palace of Rumanika of KARAGWE a number of iron figures depicting animals which have great artistic strength. Some of these iron animals and other artefacts are in the Linden Museum of Stuttgart, some are still in the Palace of the Chief of the Karagwe. They are attributed to that tribe but some doubt must exist as to their origin because of both the unusual medium and the artistic concept.

In Kenya carving is mainly confined to the Digo, the Giryama and the Kamba who are Bantu-speaking agriculturalists living in the coastal area. The KAMBA, now best known for their figures made for trade, were traditionally good artisans. They still produce a variety of stools, calabashes, jewellery and iron implements. In the last century the Kamba carved wooden stoppers and also figures to protect their houses from evil spirits. These objects are said to bear some resemblance to the tourist figures which came on the market at the time of the outbreak of the First World War.

340

349, 350

352

The GIRYAMA and the DIGO are today still producing all the essential objects required for their rituals and for the needs of their medicine men. Carvers of these two tribes are believed to sell some of their

Ziba
Kamba
Karagwe
Giryama
Kerewe
Dumbo
Nyamwezi
Gogo
Holo-Holo
Jiji
Pare
Masai
Hehe
Shambala
Zaramo
Zegura
Kami
Doë

178 *facing page, left* Standing figure
Possibly Bongo, Republic of Sudan; wood, 98 cm (38½").
Museum of Mankind, London

179 *facing page, centre* Memorial Statue
Konso, south western Ethiopia; wood, 112 cm (44").
Museum of Mankind, London

180 *facing page, right* Standing female figure
Kamba, southern Kenya; wood, 13 cm (5"). Coll. Josef
Herman, London

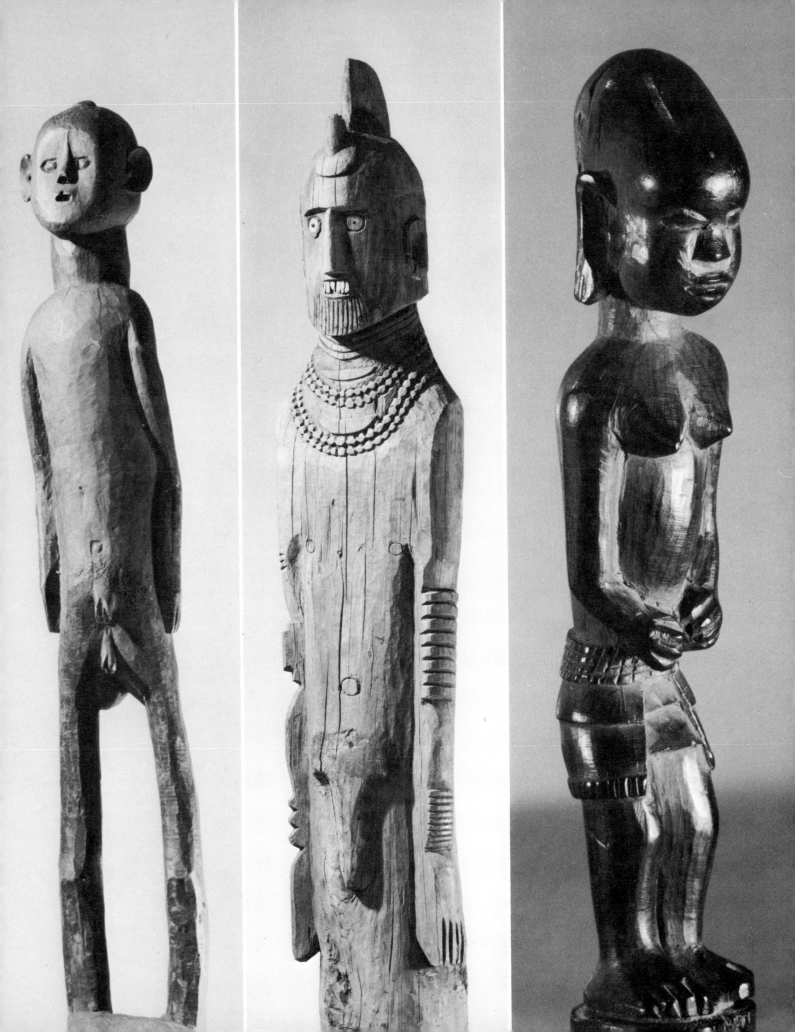

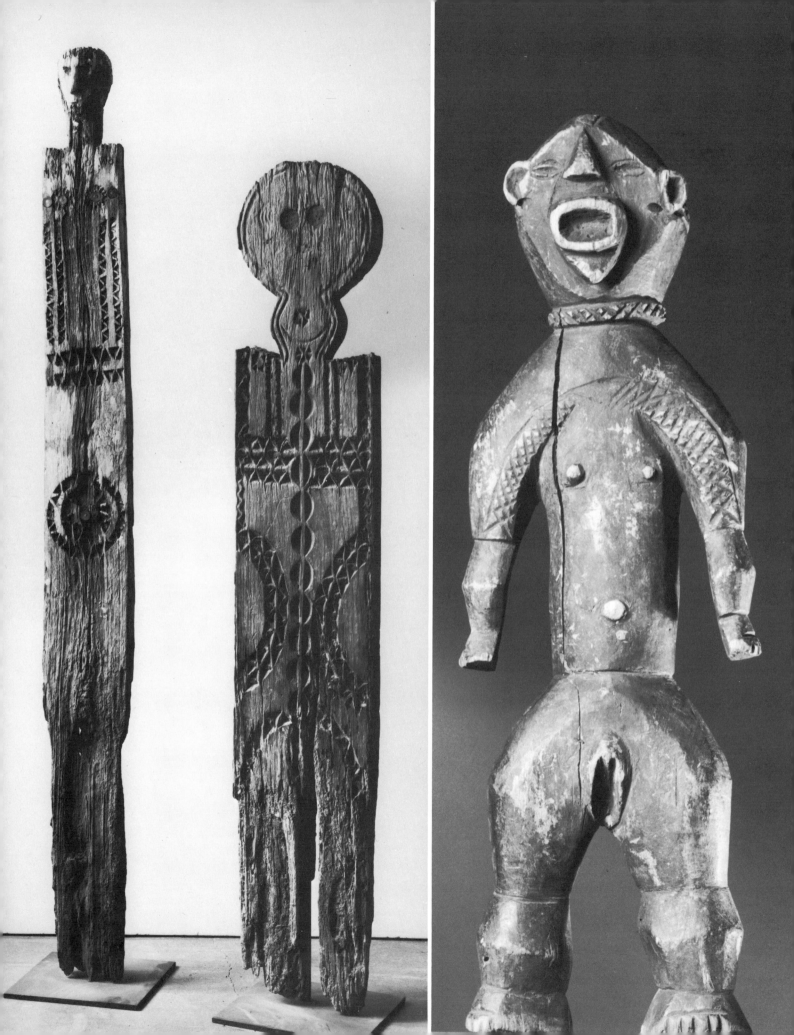

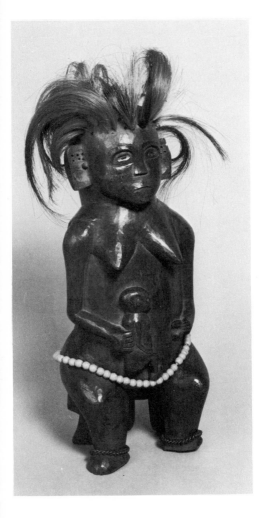

183 Female figure
She is seated on a stool, and a child is carved on her body. Attributed to Kamba, southern Kenya; wood, shell eyes, beads, hair, 27 cm (10¾"). Private collection, New York

181 *facing page, left* Grave markers, male and female
Said to be 19th century. Giryama, Kenya/Somalia coast; wood. The male is 207 cm (82"). the female, 178 cm (70"). Private collection

182 *facing page, right* Standing female
Perhaps an ancestor figure. Dumbo, south western Uganda; wood, 53 cm (21"). Museum für Völkerkunde, Berlin

sculpture to Kamba sorcerers. The Giryama also carve wooden posts of about two metres height as grave-markers, which are meant to represent the deceased.

On Ukerewe island live the KEREWE, known for some ancestor figures, but mainly for the fine statue in the Berlin Museum, which, however, seems to have been made by a visiting artist. Only a very limited number of carvings were collected from the DUMBO who inhabit an area in south-west Uganda. They were probably used in ancestor cults. 347 348 49

The NYAMWEZI, a people of about one million, inhabit a large part of central Tanzania. They were organized in territorial chiefdoms without specific tribal affiliations and were traders travelling frequently to the coast. They had a number of secret societies for diviners, and for spirit possession ceremonies and hunters' ceremonies. Apart from crude pottery figures they made wooden toys, poles with figures of ancestors with elongated trunks and small heads, well-carved pipes and horns used apparently as powder flasks, and fairly simple ancestor statues. The famous throne of the Sultaness of Buruku (now in the Berlin Museum) is of high artistic quality compared with the rest of known Nyamwezi sculpture. There is a similar chair in the Vienna Museum attributed to the GOGO, the eastern neighbours of the Nyamwezi. The Gogo's customs and perhaps their origins apparently differ to a considerable extent from those of their neighbours. 49 338 342

A subtribe of the Luba, the HOLO-HOLO, live on both the western and eastern shores of Lake Tanganyika and their carvings show this Luba influence. The female figure illustrated here was collected in 1907 on the eastern side of the Lake. The same area is also the home of the JIJI whose sculpture appears also to have been influenced by both the Luba and the Tabwa. 49

The PARE are a Bantu-speaking people, in the Upare Mountains on the borders of Kenya and Tanzania. They are not a homogeneous tribe but rather a group formed by migrants who are said to have arrived in the area between the sixteenth and eighteenth centuries. Their crude pottery figures, similar to those produced by many tribes in the area, were used for instruction in initiation ceremonies. Wooden sculpture is rare and the simple human figures and stoppers of gourd bottles were believed to have magic powers to give protection and deal with spirits. 346

The MASAI are nomadic pastoralists presumably of Nilotic origin but showing considerable cushitic influence in both language and customs. Only a few woodcarvings are known. The fine ebony staff illustrated was collected in 1899 in the tribe's territory. 341

The HEHE probably settled in central Tanzania in the eighteenth century. They fought and defeated the invading Ngoni in 1881. The Hehe themselves raided the Masai to the north, until the German intervention of 1898. Hehe art consists of crude, yet imaginative, pottery figures depicting bulls and other animals, wooden staffs with carvings of human heads and several fine standing female figures. The

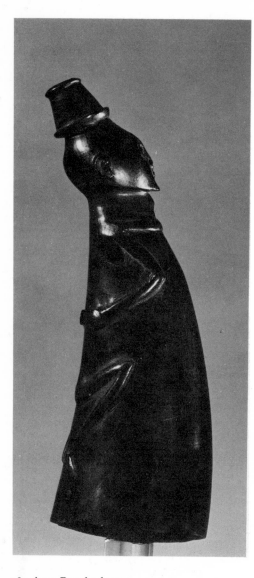

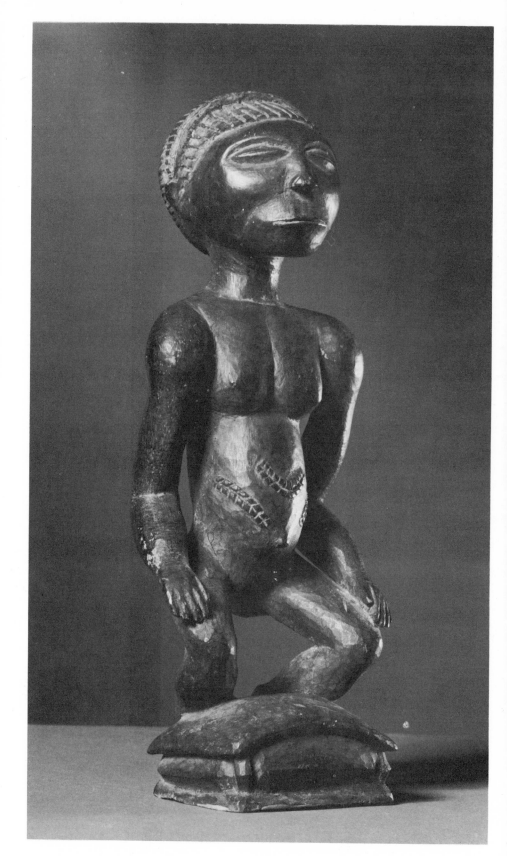

184 *above* Powder horn
Attributed to Nyamwezi, Tanzania; animal horn,
wooden plug (at base), 10 cm (4″). Private collection,
London

185 *right* Standing female figure
Collected on the eastern shore of Lake Tanganyika.
Holo Holo, Tanzania; wood, 26 cm (10¼″). Museum für
Völkerkunde, Berlin

XIX Helmet mask *Mbombo*
Kuba, Kasai region, Zaïre; wood, brass sheets, beads,
cowrie shells and cloth, 40 cm (15¾″). M.R.A.C.,
Tervuren

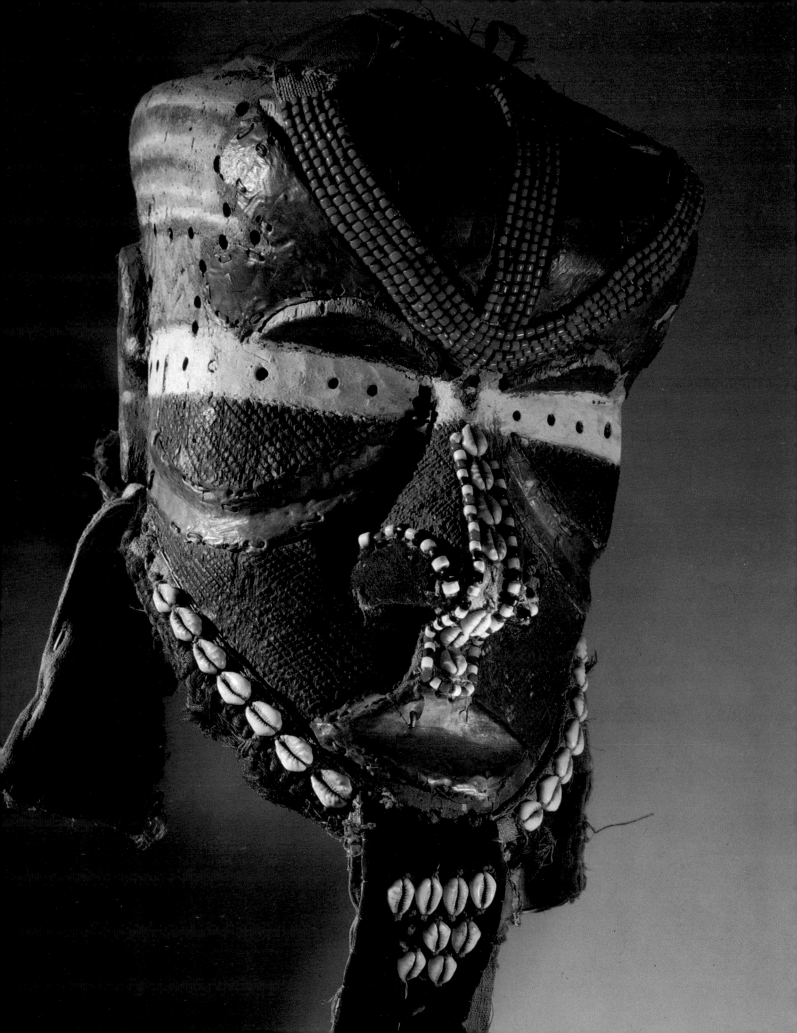

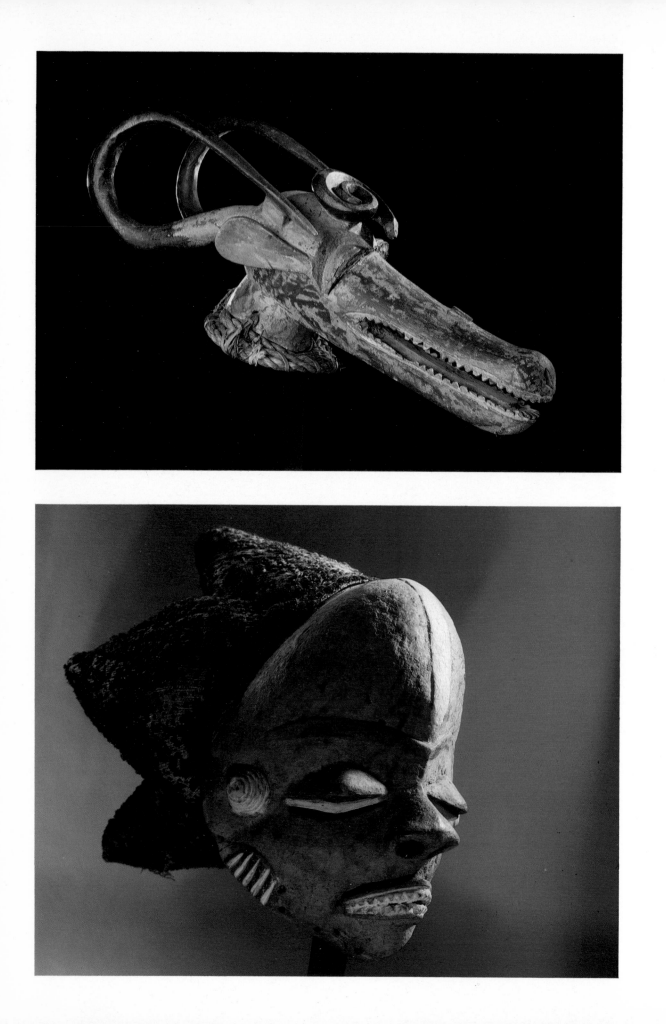

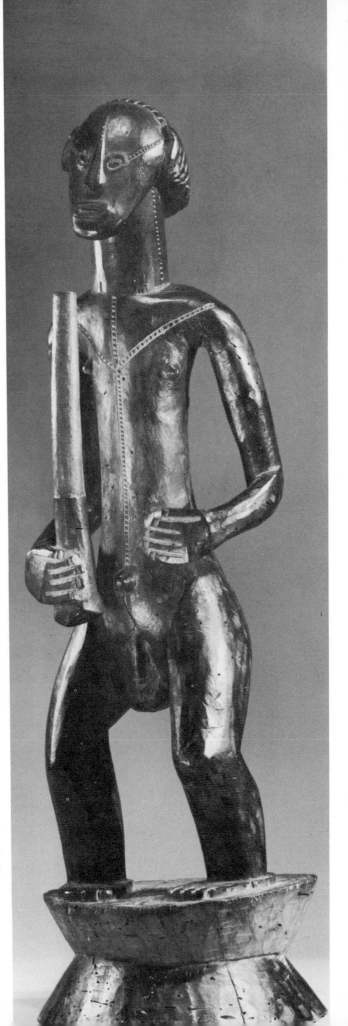
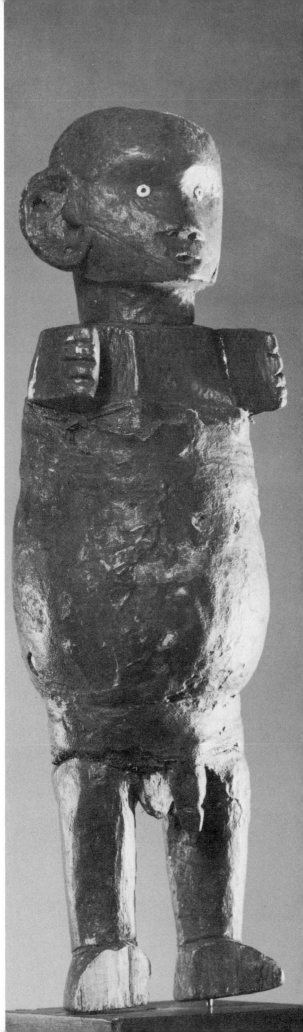

XX *facing page*
above Zoomorphic headdress
Isoko, Niger Delta, Nigeria; wood, paint, fibre 67 cm (26½"). Private collection

XX *facing page*
below *Mbuya* mask
It is Katunda style with 'four-part' coiffure. Pende, Loange River Area, Zaïre; wood, raffia, pigments, 38 cm (15"). Tara Collection

186 *left* Standing male figure holding a club
Jiji (eastern shore of Lake Tanganyika) Tanzania; wood, 55 cm (21¾"). Coll. Monica Wengraf, London

187 *right* Standing male figure
Collected in 1906. Upare Mountains, Kenya highlands; wood, 21 cm (8¼"). Museum für Völkerkunde, Berlin

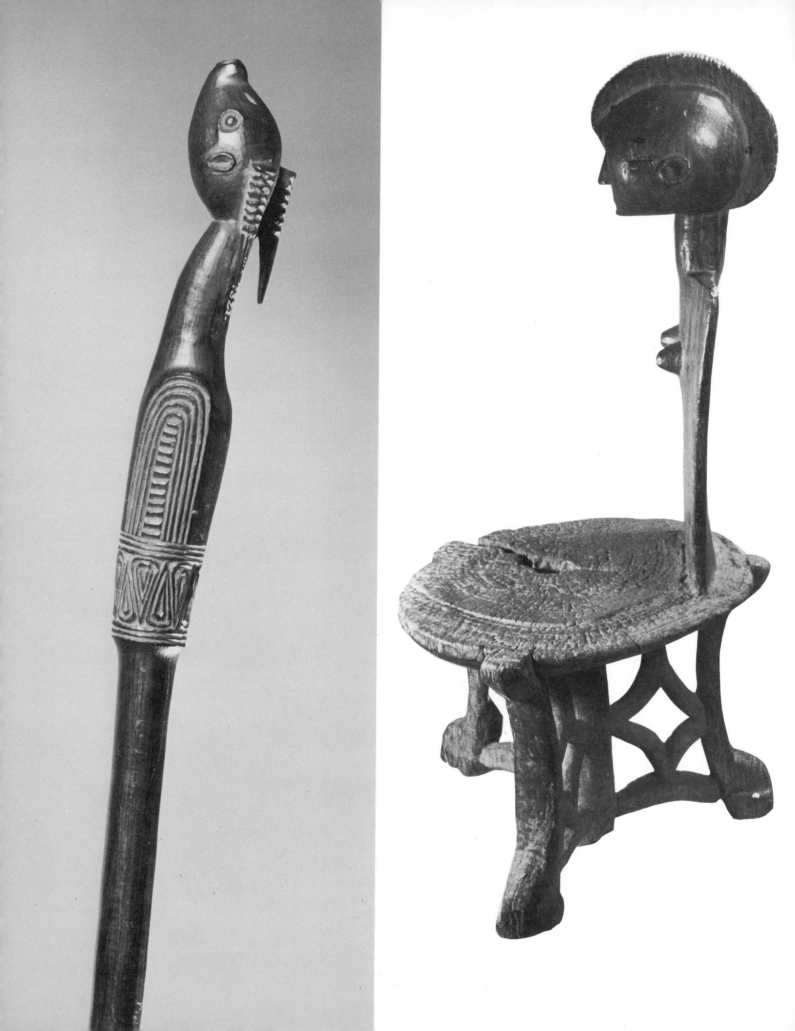

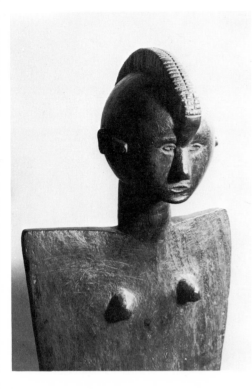

188 *facing page left* Staff with animal finial
Collected in 1899. Masai, Kenya and northern Tanzania;
wood, 61 cm (24"). Museum für Völkerkunde, Berlin

189 *facing page right* Ceremonial throne
Attributed to the Hehe, Tanzania; wood, 79 cm (31¼").
Private collection
Detail of no. 189 above

ceremonial stool (Figure 189) attributed to the Hehe is certainly one of the finest examples not only of Hehe art but of east African art in general.

The SHAMBALA inhabit an area in the Kenya Highlands near the coast of the Indian Ocean in north-west Tanzania where some of the finest of east Africa's wood carvings originated. Two of the best known sculptures are the female figure in the Linden Museum of Stuttgart and the seated male in the University of Zürich Collection. Both figures have great sculptural qualities, comparable with those of west African carvings. The Shambala are renowned in the area for their craft and supply their neighbours with a variety of wooden vessels and implements. Of special interest are stoppers for gourds, other vessels and horns, usually with well carved human heads. The Shambala stools are generally carved in zoomorphic forms very similar to those of the Ngindo. The clay figures made for their initiation rituals were destroyed after use. They produced also a variety of fine terracotta pipes and statuettes in anthropomorphic and zoomorphic forms. Some of these, like the seated male in Figure 191 are black due to the treatment of the surface with graphite. This example, collected in 1905, may have been used by a medicine man for curing the sick, but is more likely to have been made under the influence of European missionaries.

The ZARAMO live on the coast of Tanzania and in the hinterland of Dar es Salaam and although they are Islamized—like most of the multiracial peoples on the coast—their customs and art are derived from their African traditions. They make tomb figures with movable arms and legs very similar in style to the seated female statue illustrated (Figure 197) attributed by Brosig who collected it in 1898 to their neighbours, the ZEGURA (Zigula group). Staffs surmounted by human figures are said to have been used for medicine and magic. The Zaramo and the KAMI carved highly stylized fertility dolls called *mwana kiti*, carried by young girls and by married women until after their first pregnancy. A most interesting group consisting of a large statue, a face mask with a hyena skin body cover and a drum (destroyed during World War II), were collected in Zegura territory west of Sadani by von Bennigsen in 1897. According to his report the figure was carried around in circles by a dancer wearing the hyena mask supposed to represent the *Shatani* or devil, a figure unknown to indigenous African art. He was accompanied by other dancers and the sounds of singing and drumming. The occasion of these festivities was the celebration of the Moslem Ramadan.

The DOË, other inhabitants of the hinterland of the coast of Tanzania, produce wooden dolls similar to the *mwana kiti* as well as large and small sculptures in human form which may be ancestor figures. They could also be male and female-paired figures such as the Zaramo used in female initiation rites.

49

351

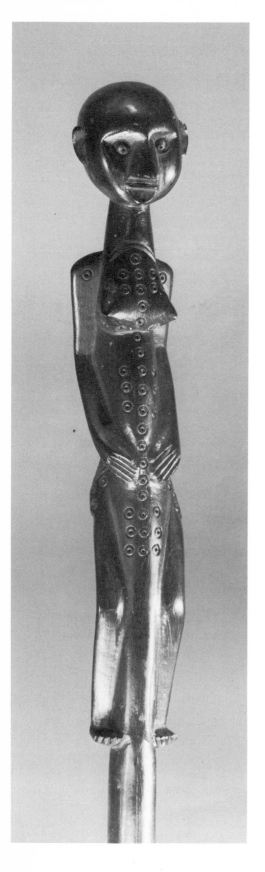

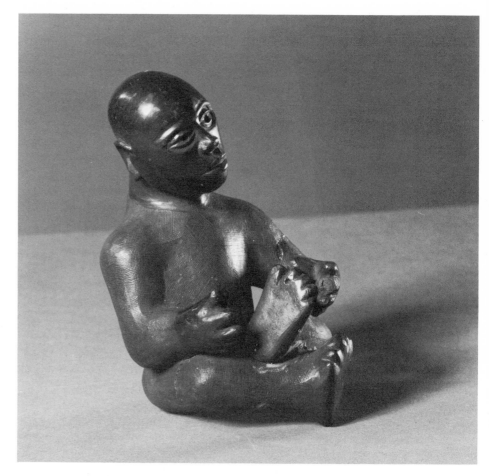

190 Staff
From an unknown tribe, perhaps in Kenya or Tanzania,
as the work shows Swahili influence. Wood, 96.5 cm
(38″). overall. Tara collection

191 *above* Pipe in form of seated male *Shambala*
Kenya Highlands, Kenya; black pottery, 10.5 cm (4″).
Museum für Völkerkunde, Berlin

192 *right* Mask
Attributed to Zaramo, Tanzania; wood, 44 cm (17¼″).
Museum für Völkerkunde, Hamburg

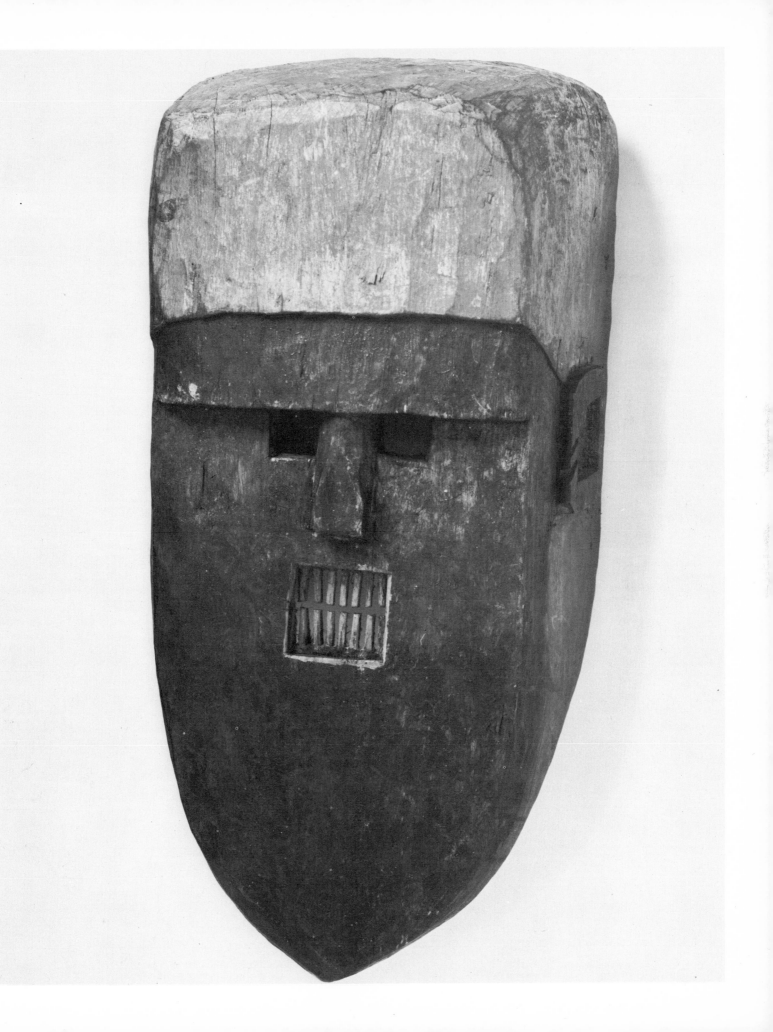

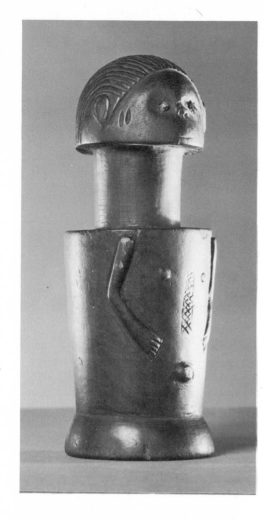

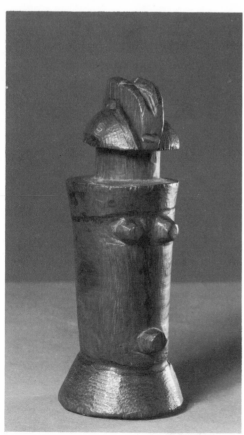

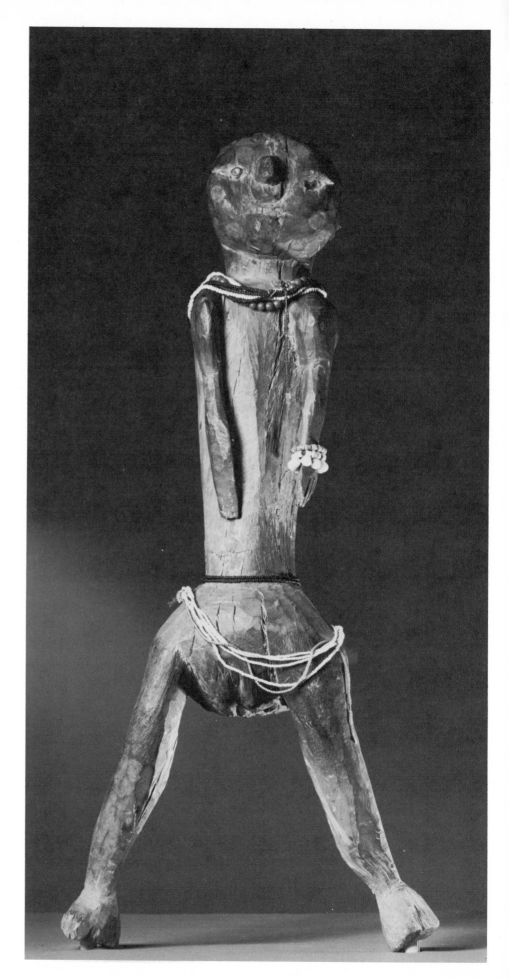

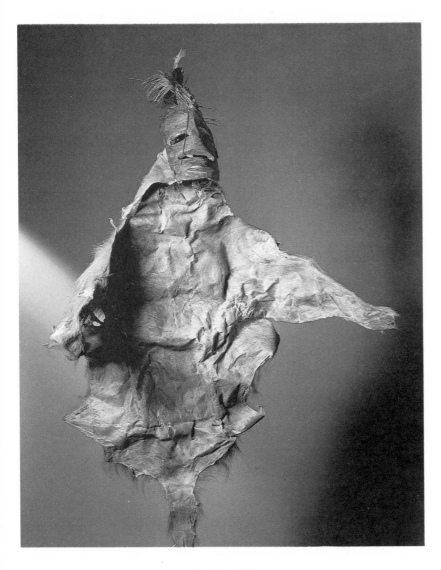

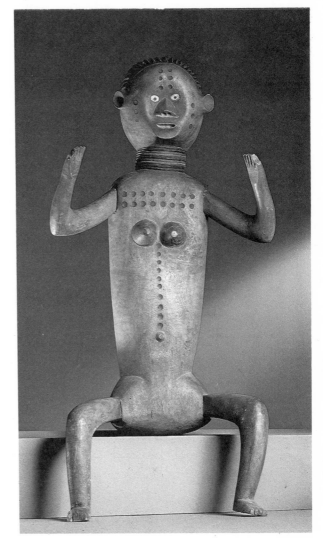

193 *facing page above left* Mwana Kiti *fertility doll*
Collected in 1902. Kami, coastal area of Tanzania; wood
18.7 cm (7¼"). Museum für Völkerkunde, Berlin

194 *facing page, below left* Mwana Kiti *fertility doll.*
Collected in 1894 Zaramo, coastal area of Tanzania;
wood, 14 cm (5½"). Museum für Völkerkunde, Berlin

195 *facing page right* Standing figure
Used in Muslem Ramadan Celebrations together with
mask (figure 196) representing the *Shatani* or devil.
Zegura, west of Sadania, Tanzania; wood, metal, beads,
71 cm (30"). Museum für Völkerkunde, Berlin

196 *above left* Mask with Hyena skin
(see figure 195) Zegura, Tanzania; wood and animal
skin, 160 cm (63") overall. Museum für Völkerkunde,
Berlin

197 *above right* Seated female figure with
articulated limbs
Collected in 1898. Attributed to Zegura, Tanzania;
wood, 75 cm (29½"). Museum für Völkerkunde, Berlin

XXI Mask
Only six of this type are known. Mbole, Lomami river, northeastern Zaïre; wood, 44.5 cm (17½"). Private collection

XXII Anthropomorphic pipe
Songye, Zaïre; wood, metal, cowrie shells, 64.75 cm (25½"). Coll. Robert and Nancy Nooter, Washington, D.C.

198 *below* Female half figure
Doeë, Tanzania; wood, pigments, metal, chains, and copper wire, 8 cm (3"). Museum für Völkerkunde, Berlin

199 *right* Standing female figure
Unknown tribe, from perhaps Tanzania or Malawi; wood, fur, metal, 38 cm (15"). Private collection, New York

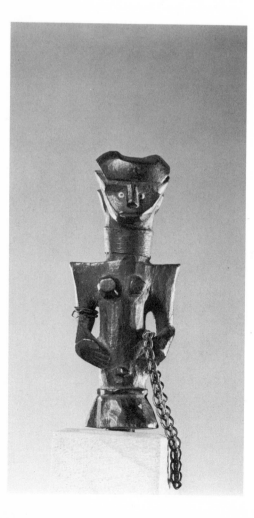

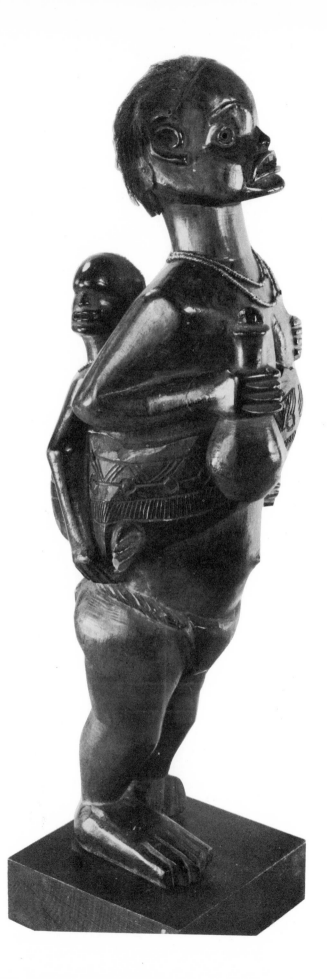

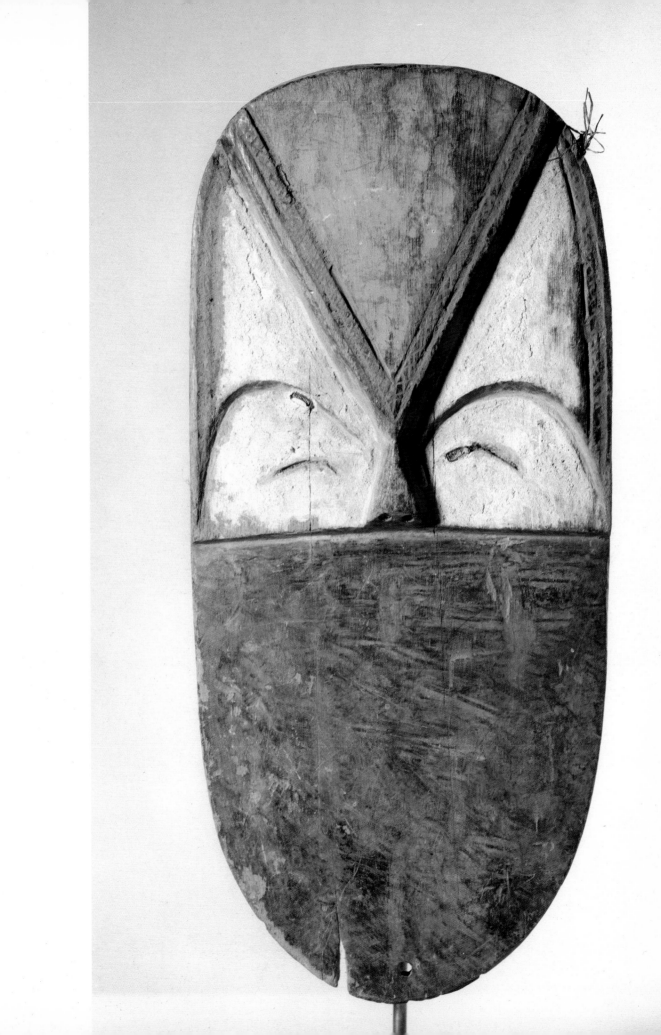

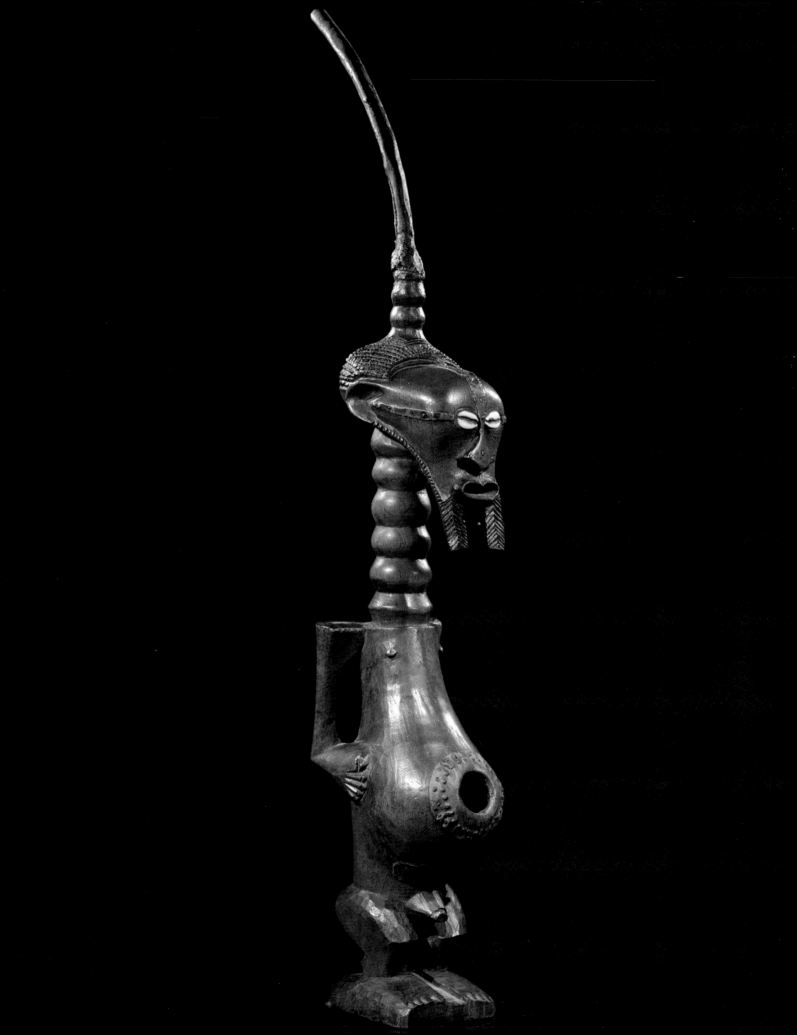

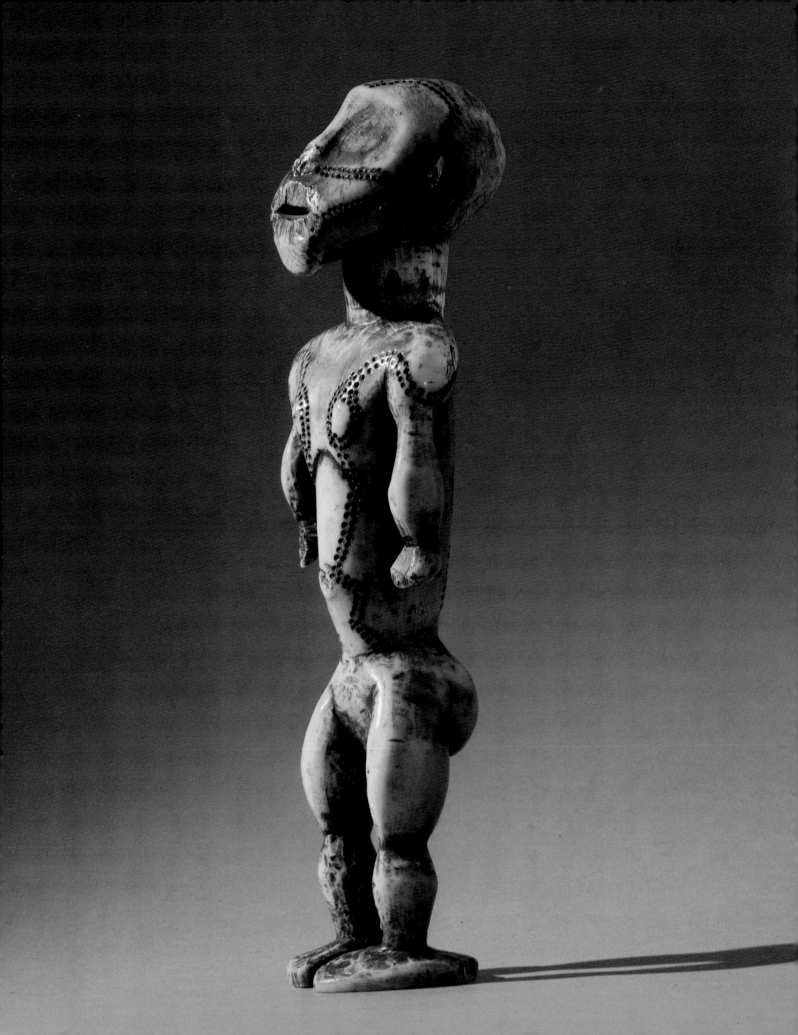

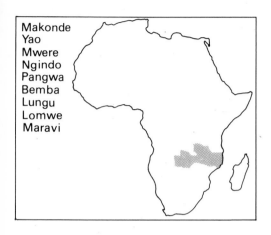

Makonde
Yao
Mwere
Ngindo
Pangwa
Bemba
Lungu
Lomwe
Maravi

XVI Zambia, Malawi and north Mozambique

The Makonde, Yao, Mwere and related people live in southern Tanzania and northern Mozambique with some spillover into Malawi. The whole region suffered for centuries from Arab slave raiders and the wars of the Ngoni, some of whom eventually settled in the territory. In spite of Arab influence and mixed ethnic composition the MAKONDE were neither Islamized nor did they give up their traditional institutions or their sculpture. They have matrilineal succession, local headmen (but no overall chiefdom) and continue to hold initiation rites for boys and girls. They are settled agriculturalists and do not raise cattle. Their plastic art was far superior to much of that known in the rest of eastern and southern Africa, and instead of a simple rigid polestructure, there was a degree of naturalism, movement and sculpture in the round. The large number of Makonde artefacts, mostly contained in German collections, makes it possible to develop a stylistic typology which cannot be done for most other east African material because of the lack of sufficient examples.

The masks, which constitute the best of Makonde art, are conceived as naturalistic representations, often with hair and beards and lip plugs, which were at one time worn by males and females. Scarification marks are either rendered in beeswax or, in more recent examples, incised. One of the finest known Makonde masks, beautifully carved, realistically decorated and ornamented, is in the Linden Museum. Many masks represent women: others depict men, horned demons or animals. Face masks are mainly from the north-eastern Makonde and helmet masks from the south. A remarkable example of the helmet type is in the British Museum. Some of the Makonde helmet masks have an element of caricature. Masks with superstructures, so frequent in west Africa, are almost unknown anywhere in east Africa except for a mask in the Munich Museum für Völkerkunde where the male facemask is surmounted by a seated figure of a woman. The Makonde also carved breastplates to cover the body from neck to navel, to be used together with masks. Most masks were worn by men in initiation dances which demonstrated the sex relationship to boy and girl initiates in explicit ways. Masks are usually painted in red and black. Makonde figures, while mostly perhaps not of the same artistic standard as the masks (Kjersmeier called them 'grotesque peasant art of feeble artistic value'), represent women, round and fleshy, standing or dancing. There is only one known male figure which may be of fairly recent origin judging by such details as the use of pokerwork for scarifications. Figures—like the masks—are painted red or black. The preponderance of female masks and figures is said to be due to the tribal myth about the first Makonde', according to which a lonely man carved a female figure which came to life and conceived, her offspring being the first of the Makonde, who was, it appears from some legends, female—the matriarch founder of the tribe.

For a long time the reports of the German ethnographer Weule were

377

375

49
359

354

XXIII Standing figure
Lega, Maniema area of northeastern Zaïre; ivory, 26.5 cm (10½"). Lance and Roberta Entwistle collection, London

XXIV *left Mwadi* helmet mask
Tetela, Zaire; wood, kaolin, pigments, raffia, 99 cm (35") without raffia fringe. Collected in 1925 by Major John White. London collection

XXIV *right* Abstract Mask
Luntu, Kasai, Zaïre; wood, 28 cm (11"). Tara collection

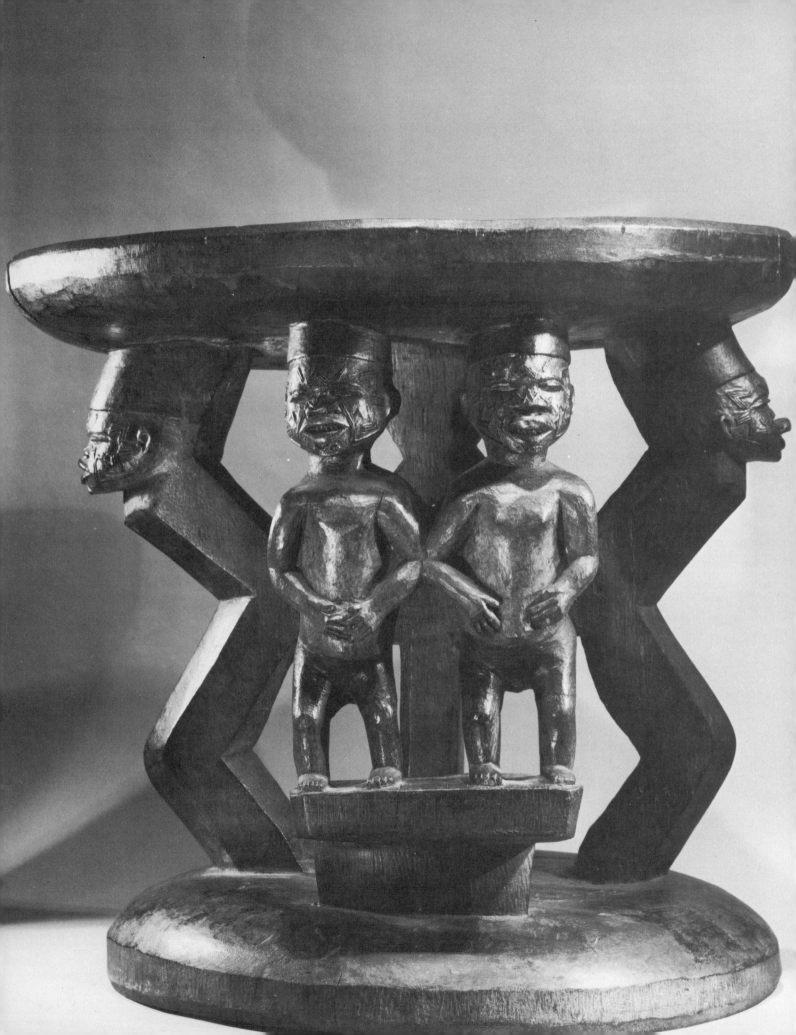

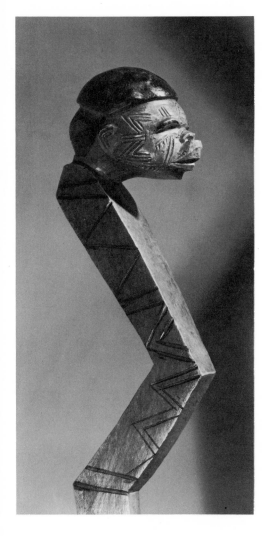

200 *facing page* Stool, supported by human figures
Makonde, Mozambique; wood, paint, 39 cm (15½").
high, 44.5 cm (17½") diameter. Private collection,
London

201 *above* Diviner's staff
Makonde, Mozambique; wood, 61 cm (24"). overall.
Private collection

practically the only source of information on the art of the Makonde and related tribes. Valuable recent additions are a publication by Franz and an article by Wembah-Rashid on the masked dancers of the Makonde, YAO and KUA in their *Isinyago* and *Midimu* rites. The sculpture used in these are face and helmet masks, worn by regular and stilt dancers, and 'bed dolls'. The latter are a pair of nude puppets representing a male and a female fixed on a bed and manipulated to perform the act of coitus. Similar—and apparently older—customs exist from Angola across to Zambia where puppets are shown in dance followed by copulation. In *Midimu* rites emphasis is on social instruction and the religious aspects of initiation. The involvement of dead ancestors in the ceremonies is emphasized, but *Midimu* dances also serve as a form of social entertainment. 360 382

The MWERA produced some fine carvings with stylistic resemblance to Makonde art—the head on a staff in the Berlin Museum has a lip plug. This staff was collected in 1907 by Perrot who described it as 'sorcerer's staff, very old and rare piece'. Figures are carved in the round and often show a degree of motion and asymmetric posture. Some individuality of style can be recognized in the few examples of the sculpture of the NGINDO and PANGWA, both located north-east of Lake Malawi in southern Tanzania. The figure of an animal in the Berlin Museum, collected in 1896, is attributed to the Ngindo, while a curious carving in Hamburg labelled simply 'East Africa', may be of Pangwa origin, an assumption based on its stylistic concept.

To the BEMBA of Zambia (not to be confused with the Bembe of eastern Zaïre), some interesting figures and masks have been attributed. A standing female figure, since stolen, was in the Horniman Museum, London. A male figure in the Berlin Museum which—according to Glauning who collected it in 1900—was specially made for sale by a Bemba carver. An interesting mask collected in 1890 by Stuhlmann in Tabora during his expedition in central Tanzania with Emin Pasha, was also attributed to the Bemba. It has strong features with cowrie-shell eyes set in an oval concave face divided by a narrow nose rooted in the forehead. The head is covered with chicken feathers to represent hair. The style is reminiscent of the art of the Luba of Zaïre, and attribution to the Mbunda of north-west Zambia has also been suggested. 49 371 376

The LUNGU of Zambia belong to the same group of tribes as the Bemba. Little is known of their art, but a headrest with two figures, collected by Glauning in 1900, is attributed to them.

Good examples are known of carvings of the LOMWE, MARAVI and other tribes in the general area of Malawi and of southern Tanzania. Two figures, both representing standing females, which were collected in 1901 in Lomwe territory are in the Berlin Museum. They differ considerably in style but are both attributed to the Nguru, part of the Lomwe group.

A standing female figure in the Berlin Museum was the only example of Maravi carving known until the publication of research work 49

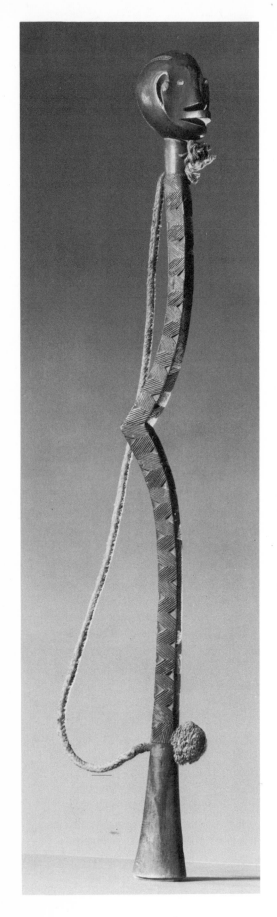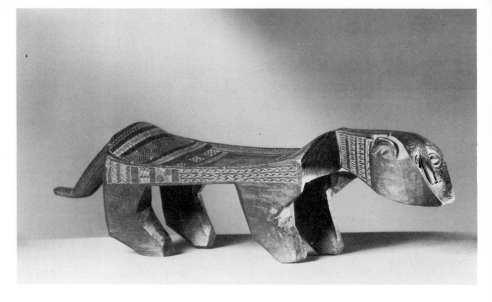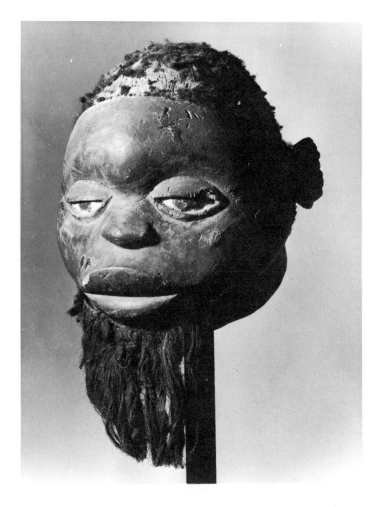

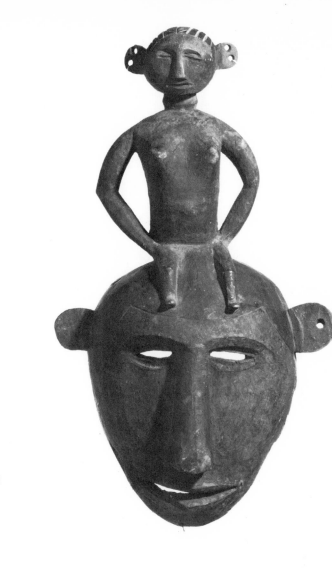

202 *facing page left* Medicine man's staff
Collected in 1907 by Perrot who described it as a 'Sorcerer's staff, very old and rare piece'. Mwera, northern Mozambique; wood, metal, fibre, 59 cm (23¼").
paint, 15.5 cm (6") high. Museum für Völkerkunde,

203 *facing page above right* Animal figure stool
Collected 1897. Ngindo, Southern Tanzania; wood, 15 cm (6") high. Museum für Völkerkunde, Berlin

204 *facing page below left* Helmet mask
Makonde, Mozambique; wood, hair, fur, wax, paint, 23 cm (9¼").
Brooklyn Museum, New York

205 *right* Human figure
Attributed to Pangwa, Southern Tanzania; wood, 35.5 cm (14"). Museum für Völkerkunde, Hamburg

206 *above* Mask surmounted by female figure
This is the only mask surmounted by figures known from East Africa. Makonde, Mozambique; wood, 31 cm (12¼"). Museum für Völkerkunde, Munich

207 Headrest supported by two figures
Collected 1900. Lungu, Zambia; wood, traces of white paint, 15.5 cm (6″) high. Museum für Völkerkunde, Berlin

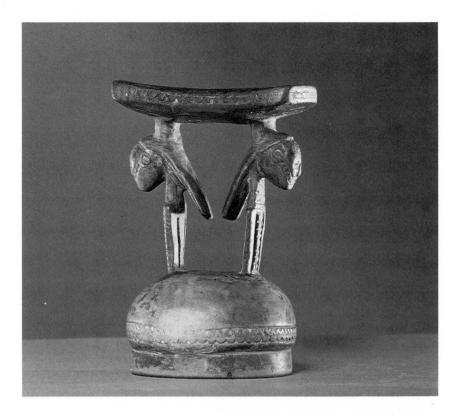

undertaken by Blackmun and Schoffeleers who illustrate a number of masks. The accelerated slave trade of the mid-nineteenth century and the Ngoni invasions from the south spelled disaster for the Maravi who practically ceased carving stools, headrests and pipes. It appears that they continued to produce masks and to use them in their rituals for the *Nyan* society, thus carrying on a tradition believed to be about three hundred years old. 356

XVII Africa south of the Zambesi, and Madagascar

The ruins of Great Zimbabwe are situated about 180 miles east of Bulawayo on the borders of Shonaland. They were first mentioned in Portuguese records in 1506 and described as the capital of the Mwene Mutapa (or Monomotapa). Great Zimbabwe is one of about 150 sites of stone ruins, which puts east Africa, so poor in known sculptural art, at the top of African architectural achievements. The carvings found at the sites are of archaeological and ethnographical importance. Great Zimbabwe appears to have been a religious centre for many centuries but in spite of much research, no firm conclusions can be drawn as to the use of the soapstone carvings, some of considerable artistic merit, and other artefacts found. These consist mainly of bird figures, perhaps each standing for a ruler, ornamented stone columns—some surmounted by human heads—groups of stone monoliths and small pottery figures. The method of carving used points to the possibility of the artists being familiar with wood carving. 361

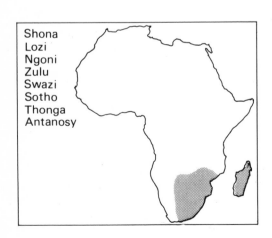

Shona
Lozi
Ngoni
Zulu
Swazi
Sotho
Thonga
Antanosy

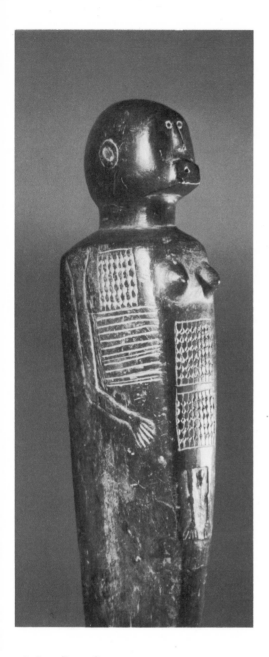

208 *above* Stone figure
Great Zimbabwe, Zimbabwe (Rhodesia); steatite, 40.5
cm (16"). Museum of Mankind, London

209 *above right* Headrest
Shona, Zimbabwe (Rhodesia); wood, 15 cm (6") high.
Private collection, New York

It is possible that one day a connection with the Great Zimbabwe
remains and the religious cults of the SHONA or earlier settlers may be
established. The Shona—or Mbire as they were called in ancient
times—are believed to have settled in the area in the fourteenth cen-
tury, displacing earlier inhabitants. There is evidence that Great Zim-
babwe was built and inhabited between A.D. 1100 and A.D. 1500 by 'a
people indigenous to south-central Africa'. The Shona of today cannot
be considered as a homogenous nation but language and cultural
traditions distinguish them from other tribes in Zimbabwe (Rhodesia).
The women make pottery, some with fine ornamentation including
human symbols, while the men are skilled blacksmiths and artisans
working copper and gold. Mats and baskets are made out of reeds and
men used to weave coarse cotton and made barkcloth. Stools, wooden
implements and headrests are expertly carved and some are beauti-
fully ornamented. The Shona have no initiation rites, and only a few of
their tribes practise circumcision. Their cults concern their supreme
god *Mwari*, tribal and family ancestor spirits and the *Shawi* spirits.

The LOZI of Zambia, also referred to as Rotse, are said to be related
to the Lunda and to have their ethnic and cultural roots in southern
Zaire. They have no circumcision rites, masked dances or secret
societies, but, it appears, make masks of painted bast and others
carved of wood. The best-known sculpture of the Lozi are the figures
representing birds, antelopes, lions, or horsemen carved on the lids of
wooden bowls. In these Lozi carvings, and in some of their ivories, a
similarity with the sculpture of Great Zimbabwe can be seen and a

368

362
49

370
379

210 Dish with equestrian figure on lid
Lozi (Rotse) Zambia; wood, 33 cm (13"). Museum of
Mankind, London

zoomorphic pottery dish in the Frankfurt Museum für Völkerkunde is
stated to be almost identical with vessels found in the ruins of Great
Zimbabwe. Two sculptures of very dissimilar styles, both representing
women, are also attributed to the Lozi. One of them, the kneeling
woman with dish in the British Museum—although found in Lozi
territory—has strong attributes of Congo art. The Nguni-speaking
peoples, consisting of a great number of clans and tribes, are the
descendants of those Bantu migrants who settled in Natal and reached
the Cape of Good Hope by the thirteenth or fourteenth century. 16

The Dutch Boer penetration and the Zulu Wars led to the north-
wards movements of warring Ngoni tribesmen who after wars and
conquests, settled as far afield as Malawi, southern Tanzania and 336
Zambia. The Nguni-speaking peoples of the South African Republic 367
include the ZULU, SWAZI, SOTHO, THONGA and others. An exact
attribution of sculpture to any particular group within this large ethnic 373
combine is usually impossible unless the piece has been well
documented.

Madagascar—now the Malagasy Republic—is an island off the coast
of Mozambique. Many centuries before it was discovered by the Por- 357
tuguese, Madagascar had been trading with countries in the Far east. 358
Indonesians settled there early, attracted by the island's favourable
position for trade. Although geographically a part of Africa and ethni- 369
cally a mixture of Indonesians, Arabs and Bantu Negroes, the predo-
minant artistic influence on the island is clearly Indonesian. Memorial
posts, made of wood and usually eroded from exposure in cemeteries
are the best known examples of that art.

We conclude this survey of tribes and regions with the ANTANOSY,
a Malagasy people numbering about 400000 (including their neigh-
bours, the Antandroy). They live in the Madagascar plains, and are
pastoralists, supplementing their income with fishing and agriculture.
The beautiful naturalistic statue illustrated here is attributed to them.

211 *facing page left* Staff with figure
Attributed to Sotho (Basuto) Botswana and South
Africa; wood, 114 cm (45") overall. Museum of Mankind,
London

212 *facing page right* Standing female figure
Zulu, south east Africa; wood, 21.5 cm (8½"). Coll. Josef
Herman, London

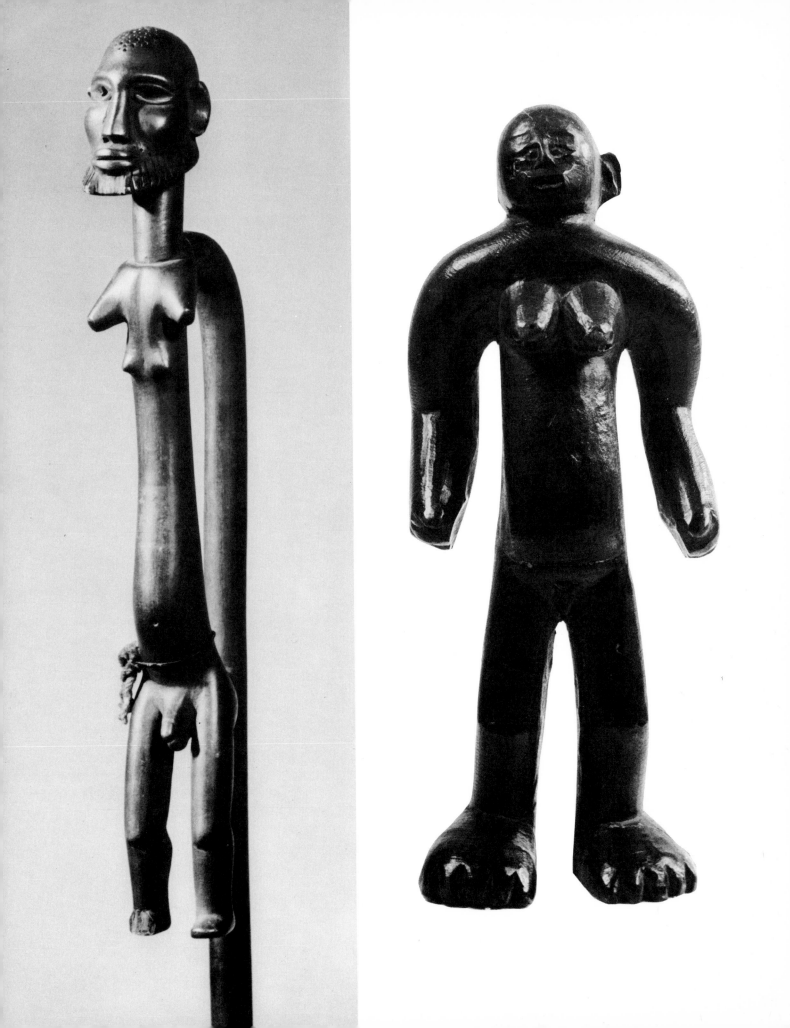

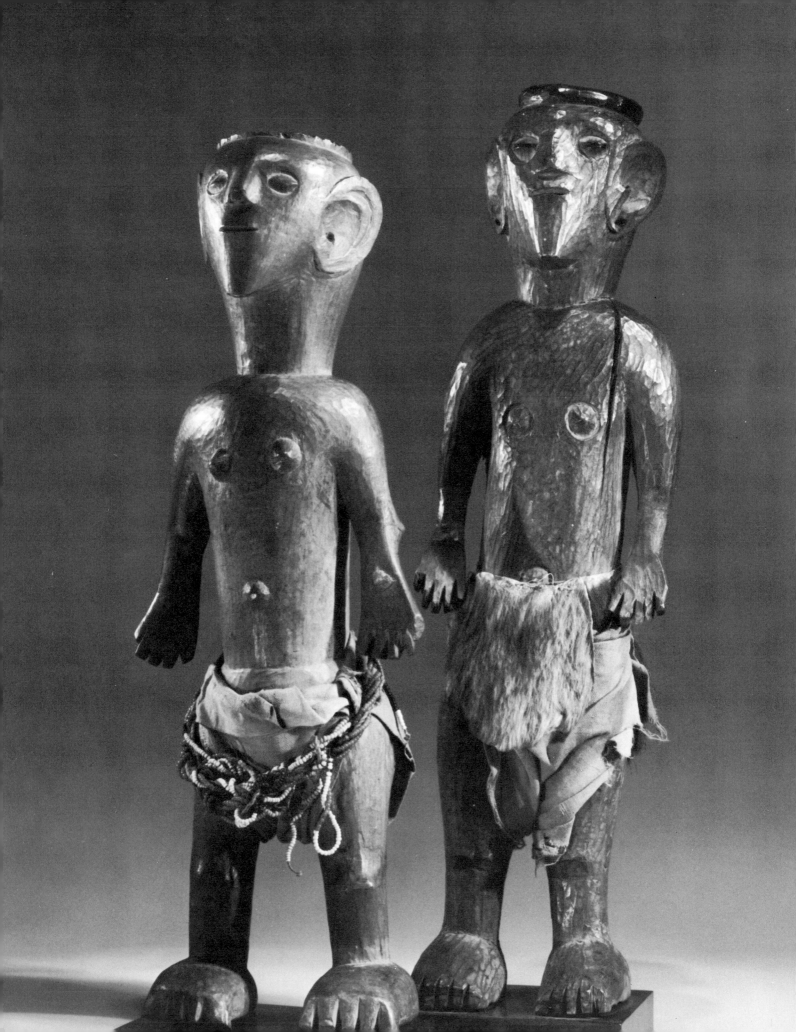

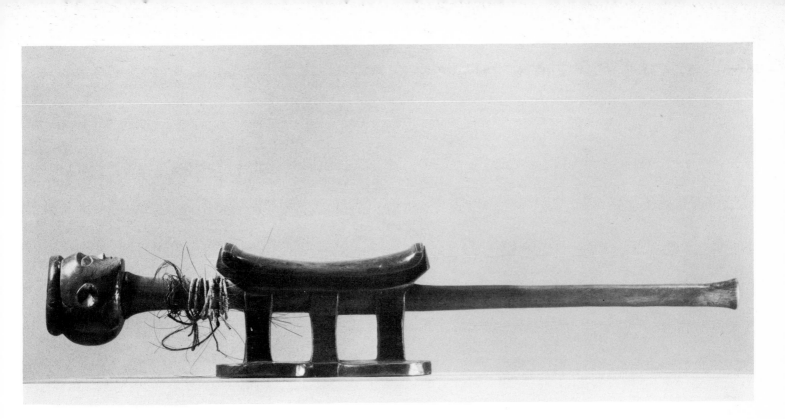

213 *facing page* Standing male and female figures
Nguni (probably Zulu, judging by the characteristic
headring of the male and the tuft of hair on the head of
the female), south-east Africa; wood, animal skin, cloth,
beads, male figure 35.5 cm (14″) high. Private collection,
London

214 Headrest
Nguni (possibly Zulu or Shangaan-Tsonga), south-east
Africa; wood, beads, animal hair, 61 cm (24″) long.
Private collection, London

215 *right* Bowl
Perhaps Swazi, south-west Africa; wood, 48 cm (19″)
high. Private collection, London

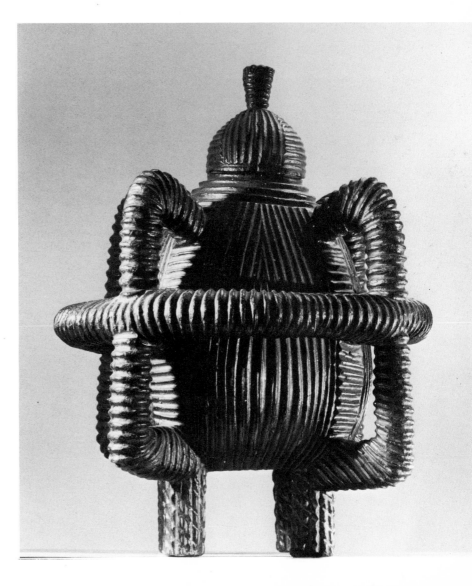

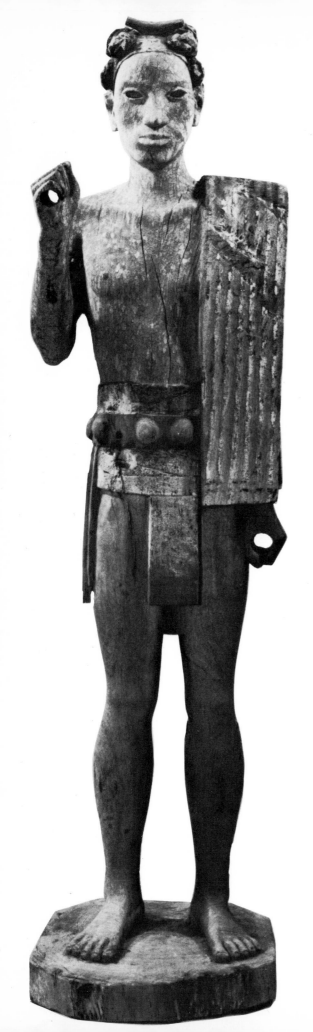

216 Royal Statue
Antanosy, Malagasy Republic; wood, 104.75 cm (41¼″).
Private collection

Acknowledgements

The author wishes to thank the following for making available to him previously unpublished material on aspects of African art:

Marie-Louise Bastin, on the absence of sculptors among the Lunda, and the sources for the design of the *nzambi* of the Songo
D. Biebuyck, on the distribution of Lega statuary
Margret Carey, on the occurrence of 'bed doll' and similar rites
William Fagg, on the role of the blacksmith in making Dogon *Kanaga* masks
H. van Geluwe, on the use of Luluwa statuettes as charms and spirit repositories
John Picton, on Yoruba pottery, the cult of *Eshu* and its interpretation, and the *Ogboni* society.

The author and publishers wish to acknowledge the use of work by the following photographers or sources:
Arcade Gallery, 110: courtesy Marie-Louise Bastin (line drawings), p. 124: British Museum (by courtesy of the Trustees), 17, 22: Christie's, 18, 28: the Eliot Elisofon Archive (Museum of African Art, Washington D.C.), 5, 6, 7, 8, 10, 11, 25, 26, 29, 32, 144, 146, 155, 162, 204: William Fagg, 68: Thomas Feist, 54, 55, 67, 112, 123, 137, XVI *r*, XVIII *l*: Werner Forman, 3, 9, 12, 13, 14, 21, 27, 34, 38, 40, 41, 46, 47, 48, 49, 53, 56, 59, 62, 63, 66, 71, 74, 80, 85, 86, 99, 116, 117, 119, 128, 132, 133, 135, 136, 139, 140, 141, 143, 145, 148, 149, 150, 151, 152, 154, 158, 159, 163, 165, 168, 169, 170, 171, 174, 175, 176, 177, 178, 179, 180, 182, 184, 185, 186, 187, 191, 193, 194, 195, 196, 197, 198, 200, 201, 202, 203, 207, 208, 210, 211, 213, 214, 215, II *r*, IV, VIII *l*, IX *l*, XII, XIV, XVII *l*, XVIII *r*; XIX, XX *b*, XVI *l* & *r*, XXIV *l* & *r*: Jo Furman, 33, 36, 37, 39, 64, 87, 88, 96, 98, 103, 109, 113, 118, 124, 130, 134, 160, 161, 183, 189, 199, 209, 216: Horst Kolo, X *l*: Raoul Lehuard, 125, 127, 129: Henri Lhote, 15, 16: courtesy Pace Gallery, New York, 1, 30, 31, 44, 50, 51, 60, 61, 65, 72, 73, 92, 102, 105, 107, 108, 115, 153, 167, V *r*: Luigi Pelletieri, 121, 157: U. von Schroeder, 76: Sotheby Parke Bernet, 2, III: F. Willett, II *l*.

List of Museums

EUROPE

Austria

Bad Deutsch Altenburg
African Museum, Schloss
Ludwigstorff,
2405 Bad Deutsch Altenburg

Mödling
St. Gabriel's Mission House,
Missionshaus St. Gabriel,
Gabrielestrasse Al, 2340 Mödling,
Niederösterreich

Vienna
Museum für Völkerkunde,
Heldenplatz, Neue Hofburg,
1014 Wien

Belgium

Antwerp
Ethnografisch Museum,
Kloosterstraat 11, Antwerpen

Tervuren
Musée Royal de l'Afrique Centrale,
1980 Tervuren

Bulgaria

Sofia
Ethnografski Musei

British Isles

Aberdeen
Anthropological Museum, University
of Aberdeen, Aberdeen AB9 1AS

Birchington
Powell-Cotton Museum, Park Lane,
Birchington, Kent

Birmingham
City Museum & Art Gallery, Cosgrave
Str., Birmingham B3 3DIT

Barnard Castle
The Bowes Museum, Barnard Castle,
County Durham

Brighton
Royal Pavilion Art Gallery & Museum,
Church Str., Brighton BN1 14E

Bristol
City Museum & Art Gallery, Queens
Road, Clifton, Bristol BS8 1RL

Cambridge
University Museum of Archaeology &
Anthropology, Downing Str.,
Cambridge CB2 3DZ

Dorchester
Dorset County Museum, Dorchester,
Dorset DT1 1XA

Dublin
National Museum of Ireland, Kildare
Str., Dublin 2, Eire

Edinburgh
Royal Scottish Museum, Dept of Art &
Archaeology, Chambers Str.,
Edinburgh EH1 1JF

Exeter
Royal Albert Memorial Museum,
Queen Str., Exeter, Devon EX4 3RX

Glasgow
Hunterian Museum & Art Gallery,
University of Glasgow, Glasgow G12
8QQ
Glasgow Museums & Art Galleries,
Kelvingrove, Glasgow, G3 8AG

Halifax
Bankfield Museum, Akroyd Park,
Halifax, HX3 6HG

Ilfracombe
Ilfracombe Museum, Wilder Road,
Ilfracombe, Devon EX34 8AF

Ipswich
Ipswich Museums & Art Galleries,
The Museum, High Str., Ipswich,
Suffolk 1PI 3QH

Leeds
Leeds City Museum, Municipal
Buildings, Leeds 1

Liverpool
Merseyside County Museum, William
Brown Str., Liverpool L3 8EN

London
Horniman Museum & Library,
London Road, Forest Hill, London
SE23 3PQ
Museum of Mankind, 6 Burlington
Gardens, London W1 2EX
Wellcome Museum of Medical
Science, The Wellcome Building, 183
Euston Road, London NW1 2BP

Manchester
Manchester Museum, University of
Manchester, Manchester M13 9PL

Newcastle upon Tyne
Hancock Museum, University of
Newcastle upon Tyne, Barras Bridge,
Newcastle upon Tyne NE2 4PT

Nuneaton
Riverside Park Museum & Art Gallery,
Nuneaton, Warwickshire

Oxford
Ashmolean Museum of Art &
Archaeology, Oxford University,
Beaumont Str., Oxford OX1 2PH
Pitt Rivers Museum, Oxford
University, South Parks Road, Oxford

Saffron Walden
Saffron Walden Museum, Museum
Str., Saffron Walden, Essex CB10 1 JL

Czechoslovakia

Holice v Cechach
Africa Museum, Dr. Emil Holub
Memorial Kulturni dum, Holubova
ulica 1/768, Holice v Cechach

Prague
Naprstkovo Muzeum,
Betlemske namesti 1

Denmark

Aabenvaa
Aabenvaa Museum,
H. P. Hausseus Gade, Aabenvaa

Copenhagen
Ethnographical Dept., Danish
National Museum, Ny Vestergade,
Kopenhagen K. 10

France

Angoulême
Musée Municipal, 1 rue Friedland
Angoulême

Lyon
Musée des Missions en Afrique, 150
Cours Gambetta, Lyons

Paris
Musée des Arts Africain et Océaniens,
293 ave. Daumesnil, Paris
Musée de l'Homme, Palais de Chaillot,
Paris

La Rochelle
Musée de l'Histoire Naturelle et de
l'Ethnographie, 28 rue Albert,
La Rochelle

Saint-Germain-en-Laye
Musée des Antiquités Nationales,
Château de St Germain, Saint
Germain-en-Laye

Strasbourg
Musée de l'Ethnographie, 1 place de
l'Université, Strasbourg

East Germany

Berlin
Anthropological Collection of
Humboldt University

Leipzig
Völkerkundemuseum, Leipzig

Dresden
State Museum of Ethnology,
Japanisches Palais, Karl Marx Platz,
Dresden 801

West Germany

Berlin
Museum für Völkerkunde
Arnimallee 23–27, 1000 Berlin 33

Bremen
Übersee Museum
Bahnhofsplatz 13, 7800 Bremen

Cologne
Rautenstrauch-Joest-Museum für
Völkerkunde, Ubierring 45,
5000 Köln 1

Frankfurt
Städtisches Museum für
Völkerkunde, Schaumainkai 29,
6000 Frankfurt 70

Freiburg-im-Breisgau
Museum für Völkerkunde
Adelhauser Str. 33, 7800 Freiburg

Hamburg
Hamburgisches Museum für
Völkerkunde Binderstrasse 14,
2000 Hamburg 13

Hanover
Völkerkunde–Abteilung des
Niedersächsischen Landesmuseums,
Am Maschpark 5, 3000 Hannover

Heidelberg
Völkerkundliche Sammlung der J. u E.
von Portheim–Stiftung, Haukstr. 235,
6900 Heidelberg

Kiel
Museum für Völkerkunde
Hegenischstr. 3, 2300 Kiel

Munich

Institut für Völkerkunde und Afrikanistik, Schellingstr. 33/Rgb. 1, 8000 München 40

Staatliches Museum für Völkerkunde, Maximilianstr. 42, 8000 München

Münsterschwarzach

Missionsmuseum, 8711 Münsterschwarzach/u Kitzingen (Ufr)

Stuttgart

Linden-Museum Stuttgart, Staatliches Museum für Völkerkunde, Hegelplatz 1, 7000 Stuttgart 1

Ulm

Museum der Stadt Ulm, Neuerstr. 92–96 Ulm

Hungary

Budapest

Museum of Ethnography, Konyves Kalman Korut 40, Budapest VIII

Neprajzi Muzeum Kossuth Lajos tir 12, Budapest V

Italy

Florence

Museo Nazionale di Antropologia e Etnologia, Via del Proconsolo 12, Firenze

Rome

African Museum, Via Ulisse Aldovrandi 16A, Roma

Museo Missionario Etnologico, Vatican City, Roma

Museo Nazionale Preistorico Etnografico Luigi Pigorini, Piazza Marconi, 00144 Roma

Turin

Museo del Etnografica, via dell'Accademia Albertina 17, Torino

Netherlands

Cadier en Keer

Africa Centre, Rijkisweg 3, Cadier en Keer, Limburg

Breda

Volkenkundig Museum Justinus van Nassa, Kastellplein 13, Breda, Noord Brabant

Amsterdam

Koninklijk Instituut voor de Tropen, Linnaeusstraat 2, Amsterdam

Berg en Daal

Afrika Museum, Berg en Daal, Nijmegen, Gelderland

Leiden

Rijksmuseum voor Volkenkunde, Steenstraat 1, Leiden, Zuid Holland

Rotterdam

Museum voor Land en Volkenkunde, Willemskade 25, Rotterdam, Zuid Holland

Tilburg

Netherlands Museum of Ethnology, Kloosterstraat 24, Tilburg, Noord Brabant

Norway

Oslo

Ethnographical Museum, Univ. of Oslo, Frederiksgate 2, Oslo 1

Poland

Krakow

Ethnographical Museum, Pl. Wolnical Krakow

Warsaw

National Ethnographical Museum, Ul. Mazowiecka 13, Warsawa

Portugal

Lisbon

National Museum of Archaeology & Ethnology, Praca do Imperio, Lisbon.

Overseas Ethnography Museum, R. Portas de St. Antao, Lisbon

Spain

Barcelona

Museum of Ethnology, Parque de Mont Juich, Barcelona

Madrid

African Museum, Paseo de la Castellana 5, Madrid

Museo Nacional de Etnologia Alfonso XII No. 68, Madrid 7

Sweden

Göteborg

Ethnographical Museum, 12 Norra Hamingatan, Göteborg

Stockholm

Etnografiska Museet, Norra Djurgurden, Stockholm

Switzerland

Basel

Museum der Basler Mission, Missionsstrasse 21, Basel

Museum für Völkerkunde und Schweizerisches Völkskunde, Augustinergasse 2, Basel

Bern

Bernisches Historisches Museum, Helvetiaplatz 5, Bern

Geneva

Musée d'Ethnographie, 65–67 Boulevard Carl-Vogt Genéve

Musée Barbier–Muller 4, rue de l'Ecole de Chimie Genéve

Neuchâtel

Musée d'Ethnographie, St Nicolas 4, 2000 Neuchâtel

St Gallen

Historiches Museum, Museumstrasse 50, 9000 St Gallen

Zürich

Museum Rietberg, Gablestrasse 15, 8002 Zürich

Völkerkundemuseum der Universität Zürich, Rämistr. 71

U.S.A.

Alabama

George Washington Carver Museum, Tuskegee Institute, Tuskegee, Alabama 36088

Arizona

The Heard Museum of Anthropology and Primitive Art, 22 E Monte Vista Road, Phoenix, Arizona 85004

Phoenix Art Museum, 1625 North Central Avenue, Phoenix, Arizona 85004

Arizona State Museum, The University of Arizona, Tucson, Arizona 85721

California

Robert H. Lowie Museum of Anthropology, 103 Kroeber Hall, University of California, Berkeley, California 94720

Long Beach Museum of Art, 2300 E. Ocean Boulevard, Long Beach, California 90803

Museum of Cultural History, Haines Hall, UCLA, Los Angeles, California 90024

M. H. de Young Memorial Museum, Golden Gate Park, San Francisco, California 94118

Santa Barbara Museum of Art, 1130 State Street, Santa Barbara, California 93101

The Stanford Museum, Museum Way, Stanford, California 94305

Colorado

Denver Art Museum, 100 West 14th Avenue, Parkway, Denver, Colorado 80204

Connecticut

Peabody Museum of Natural History, Yale University, 170 Whitney Avenue, New Haven, Connecticut 06520

Florida

Museum of Art and Sciences, 1040 Museum Boulevard, Daytona Beach, Florida 32014

Georgia

Columbus Museum of Arts and Crafts Inc., 1251 Wynton Road, Columbus, Georgia 31906

Illinois

The Art Institute of Chicago, Michigan Avenue at Adams Street, Chicago, Illinois 60603

Dusable Museum of African–American History, 3806 S. Michigan Avenue, Chicago, Illinois 60653

Field Museum of Natural History, Roosevelt Road at Lake Shore Drive, Chicago, Illinois 60605

Clark Arts Center, Rockford College, Rockford, Illinois 61101

Illinois State Museum, Spring and Edwards Streets, Springfield, Illinois 62706

World Heritage Museum, University of Illinois at Champaign Urbana, 484 Lincoln Hall, Urbana, Illinois 61801

Indiana

Indiana University Art Museum, Fine Arts Building, Bloomington, Indiana 47401

Indiana University Museum, Student Building 107, Bloomington, Indiana 47401

Indianapolis Museum of Art, 1200 W. 38 Street, Indianapolis, Indiana 46208

Iowa

University of Iowa Museum of Art, 727 Switzer Avenue, Iowa City, Iowa 52240

Louisiana

New Orleans Museum of Art, Lelong Avenue, City Park, New Orleans, Louisiana 70119

Maryland

Baltimore Museum of Art, Art Museum Drive, Baltimore, Maryland 21218

Massachusetts

Peabody Museum of Archaeology and Ethnology, 11 Divinity Avenue, Cambridge, Mass. 02138

Peabody Museum of Salem, 161 Essex Street, Salem, Mass. 01970

Wellesley College Museum, Jewetts Art Centre, Wellesley, Mass. 02181

Michigan

Albion College Art Museum, Albion, Michigan 49224

Museum of Anthropology, University of Michigan, Washtenaw Drive, Ann Arbor, Michigan 48104

Detroit Institute of Arts, 5200 Woodward Avenue, Detroit, Michigan 48202

Michigan State University Museum, West Circle Drive, East Lansing, Michigan 48823

The University Art Gallery, Oakland University, Rochester, Michigan 48063

Missouri

St Louis Art Museum, Forest Park, Missouri 63110

Nebraska

Joslyn Art Museum, 2218 Dodge Street, Omaha, Nebraska 68102

New Jersey
The Newark Museum, 43–9
Washington Street, Newark, New
Jersey 07101
Museum of Natural History, Princeton
University, Princeton, New Jersey
08540

New York
The Brooklyn Museum, 188 Eastern
Parkway, Brooklyn, New York 11238
Buffalo Museum of Science, Buffalo,
New York 14211
The American Museum of Natural
History, 79th Street and Central Park
W., New York 10024
The Museum of Primitive Art—now
the Department of Primitive Art at the
Metropolitan Museum of Art, Fifth
Avenue at 82nd St., New York 10028
Rochester Museum and Science
Center, 657 E. Avenue, Rochester,
New York 14602

Ohio
Cincinnati Art Museum, Eden Park,
Cincinnati, Ohio 45202
The Cleveland Museum of Art, 11150
East Boulevard, Cleveland, Ohio
44106
Dayton Art Institute, Forest and
Riverview Avenues, Dayton, Ohio
45405
Allen Memorial Art Museum, Oberlin
College, Oberlin, Ohio 44074

Pennsylvania
Museum of the Philadelphia Civic
Center, Civic Center Boulevard and
34th Street, Philadelphia, Penn. 19104
Philadelphia Museum of Art, 26th
Street and Parkway, Philadelphia,
Penn. 19101
University Museum, 33rd and Spruce
Sts., Philadelphia, Penn. 19104

South Carolina
Old Slave Mart Museum, 6 Chalmers
Street, Charleston, South Carolina
29401

South Dakota
W. H. Over Dakota Museum,
University of South Dakota,
Vermillion, South Dakota 57069

Tennessee
Carl Van Vechten Gallery of Fine Arts,
18th Avenue and Jackson Street N.,
Nashville, Tennessee 37203

Texas
Texas Memorial Museum, 24th and
Trinity Streets, Austin, Texas 78705
The Museum of Fine Arts, Fair Park,
2nd Avenue, Dallas, Texas 75226
Kimbell Art Museum, Fort Worth,
Texas 76107
Museum of Fine Arts, 1001 Bissonnet
St., Houston, Texas 77005

Vermont
Robert Hull Fleming Museum,

University of Vermont, Colchester
Avenue, Burlington, Vermont 05401

Virginia
The College Museum, Hampton
Institute, Hampton, Virginia 23368

Washington
Seattle Art Museum, 14th E. and E.
Prospect Streets, Seattle, Washington
98102
Thomas Burke Memorial, Washington
State Museum, University of
Washington, Seattle, Washington
98100

Washington D.C.
Museum of African Art, 316–332A St.,
N.E., Washington D.C. 20002
Smithsonian Institution, Jefferson
Drive SW, Washington D.C. 20560

Wisconsin
Logan Museum of Anthropology,
Beloit College, Beloit, Wisconsin 53500
The Milwaukee Public Museum, 800
W. Wells Street, Milwaukee,
Wisconsin 53233

Africa

Algeria
Le Bardo Musée d'Ethnographie 3 ave.
F. Roosevelt, Alger

Angola
Museu de Angola, Rue de Nossa
Senhora de Maxima, Luanda
Museu do Dundo, Companhia de
Diamantes de Angola, Dundo

Benin (formerly Dahomey)
Musée de l'Histoire, PO Box 25,
Abomey
Musée Ethnographique Régionale,
Porto Novo

Cameroon
Mankon Museum, Bamenda,
Cameroon
Musée National, PO Box 1271, Duala
Musée des Arts et Traditions, PO Box
71, Foumban
Musée d'Art Nègre, PO Box 876,
Yaoundé

Central African Empire
Musée Barthelemy Bosanda, PO Box
349, Bangui

Chad
Musée National, PO Box 503,
N'Djamena

**Democratic Republic of the
Congo**
National Museum, Avenue Patrice
Lumumba, Brazzaville

Ethiopia
Archaeological Museum; PO Box 1907,
Addis Ababa
Archaeological Museum, Asmara

Gabon
Musée National des Arts et Traditions,
Avenue de Général de Gaulle,
Libreville

Ghana
Ethnographic Collection, Institute of
African Studies, Maintenance Road,
Legon, Accra
Ghana National Museum, Barnes
Road, Accra
Prempeh II Jubilee Museum, PO Box
3508, Kumasi

Guinea
Musée National de Guinée, PO Box
561, Conakry
Musée Kissidougou, Kissidougou
Musée Fédérale, Koundara

Guinea–Bissau
Museum of Guinea, Bissau

Ivory Coast
Musée du Centre des Sciences
Humaines, PO Box 1600, Abidjan

Kenya
Stoneham Museum and Research
Centre, Kitale
Lamu Museum, PO Box 48, Lamu
National Museum, Fort Jesus,
Mombasa
National Museum, PO Box 40658,
Nairobi

Liberia
National Museum of Liberia, Capitol
Hill, Monrovia
Tubman Centre of African Cultures,
Robertsport

Malagasy Republic
Museum of Art & Archaeology, PO
Box 564, Isoraka, Tanarive

Malawi
Museum of Malawi, PO Box 30360,
Chichivi

Mali
Musée National et Maison des
Artisans Maliens, Bamako

Mbini
Museum of Ethnography, CM & 7,
Apartado 10, Santa Isabel

Mozambique
Municipal Museum, Rua Correia de
Brito, Beira

Niger
Musée National de Niger, PO Box 248,
Niamey

Nigeria
Benin National Museum, Benin City,
Bendel State
Esie Museum, Esie, Kwara State
Institute of African Studies, Ibadan
Museum of Ife Antiquities, Ife

Museum of the University of Ife, Ife
Jos Museum, Jos
Gidan Makama Museum, Kano
Museum of Nigerian Antiquities,
Onikan St., Lagos
Oron Museum, Oron, Calabar
Owo Museum, Owo

Namibia
State Museum, Leutwein St.,
Windhoek

Republic of South Africa
Malan Ethnographical Museum, Port
Hare, Alice, Cape Province
South African Museum, Queen
Victoria St., Cape Town
Zululand Historical Museum, Fort
Nongquai, Eshowe, Natal
Archaeological Museum,
Witwatersrand University, Jan Smuts
Avenue, Johannesburg, Transvaal
Alexander McGregor Memorial
Museum, Chapel St., Kimberley
Natal Museum, 237 Loop St,
Pietermaritzburg

Republic of Sudan
Ethnographical Museum, University
Avenue, Khartoum

Senegal
Institut Fondamental d'Afrique Noire
Place Tacher, Dakar

Sierra Leone
National Museum, PO Box 908,
Freetown

Tanzania
Bwerenyange Museum, Bwerenyange
National Museum, Shabab Robert St.,
Dar es Salaam

Upper Volta
Musée National de Haute Volta,
Avenue de l'Independence,
Ouagadougou

Zaïre
Musée National, Kananga
Musée Mayombe, Kangu
Mission Protestante, Kimpese
Musée de Préhistoire, Université
Nationale, PO Box 125, Kinshasa
Institut National des Musées de Zaïre,
Kinshasha
Collection de l'Ecole d'Art, Mushenge

Zambia
Livingstone Museum, PO Box 498,
Livingstone

Zimbabwe Rhodesia
Khami Ruins Site Museum, Bulawayo
National Museum, Centenary Park,
Bulawayo
Zimbabwe Ruins Site Museum,
Private Bag 9158, Fort Victoria
Queen Victoria Museum, Rotten Row,
Salisbury

Bibliography

General Works on African Art and History

ABBREVIATIONS:
A.A: African Arts
A.A.N: Arts d'Afrique Noire
J.A.H: Journal of African History
J.R.A.I: Journal of the Royal Anthropolog. Institute

1 ALDRED, Cyril *Old Kingdom Art in Ancient Egypt* London 1949

2 ALLISON, Philip *African Stone Sculpture* London 1968

3 BALANDIER, G. et HOWLETT, J. ed. *L'Art Nègre* Paris 1966. First published Paris 1951 in *Présence Africaine* 10/11

4 BASCOM, W. R. *African Art in Cultural Perspective,* New York 1973

5 BASCOM, W. & GEBAUER, P. *West African Art,* Milwaukee 1953

6 BASSANI, E. *Scultura Africana* Bologna 1977

7 BAUMANN, H. *Afrikanische Plastik und Sakrales Königtum,* München 1969

8 BIEBUYCK, Daniel ed. *Tradition & Creativity in Tribal Art* Los Angeles 1969

9 BOAHEN, Dr. A. Adu *Kingdoms of West Africa* In: Horizon History of Africa N.Y. 1971

10 BODROGI, T. *Afrikanische Kunst.* Wien, München und Budapest 1967

11 BRAVMANN, René A. *Open Frontiers: The Mobility of Art in Black Africa,* 1973

11a *Islam and Tribal Art in West Africa* Cambridge Univ. Press 1974

12 CLARK, J. Desmond *The Prehistory of Africa* London 1970

13 COLLINS, Robert O. *Problems in African History* Englewood Cliffs, 1968

14 CROWLEY, D. *Art Market in Africa* A.A. IV/I

14a *West African Market Revisited* A.A. VII/4

15 *Stylistic Analysis of African Art,* A re-assessment of Olbrecht's 'Belgian method' A.A. IX/2 Jan 1976

16 DAVIDSON, Basil *Africa, History of A Continent* New York 1966

17 D'AZEVEDO, W. L. (Ed.) *The Traditional Artist in African Society* 1st pub. 1973 2nd Ed. 1975 Indiana Univ. Press

18 DELANGE, Jacqueline *Arts et Peuples de L'Afrique Noire* Paris 1967

19 EINSTEIN, C. *Afrikanische Plastik* Berlin 1921

20 *Negerplastik* Leipzig 1915

21 ELISOFON, E. & W. B. FAGG *The Sculpture of Africa* London 1958

22 FAGG, William B. *The Webster Plass Collection of African Art,* British Museum London 1953

23 *The Study of African Art* Bulletin of the Allen Memorial Art Museum 1955

24 *Tribes and Forms in African Art* New York 1965 & London 1966

25 *African Tribal Images*: The Katherine White Reswick Collection Cleveland 1968

26 *Divine Kingship in Africa* London 1970

27 *Miniature Wood Carvings of Africa*: Herman Collection New York 1970

28 *African Sculpture* Washington D.C. 1970

29 *African Sculpture*: The Tara Collection Southbend, Indiana 1971

30 with FORMAN, W. & B. *Afro-Portuguese Ivories* London 1959

31 with PLASS, M. *Webster African Sculpture*: An Anthology London 1964

32 FLEMING, Stuart J. *Authenticity in Art. The Scientific Detection of Forgery* London 1975

33 FORGE, A. ed. *Primitive Art and Society* Oxford Univ. Press London 1973

34 FRASER, D. & COLE, H. ed. *African Art and Leadership* Wisconsin 1972

35 FROBENIUS, Leo *Die Masken und Geheimbünde Afrikas* Halle 1898

36 *Und Africa Sprach* 3 Vols, Berlin 1912, translation, *The Voice of Africa,* 2 vol, London 1913

37 *Das Unbekannte Afrika* München 1923

38 *Mythologie de l'Atlantide* Translation from German Paris 1949

39 FRY, Roger *Last Lectures* 1st Pub. London 1939 Republished Boston 1962

40 GERBRANDS, A. A. *Art as an Element of Culture especially in Negro Africa* Leiden 1957

41 GOLDWATER, R. *Traditional Art of the African Nations* (in the Museum of Primitive Art) New York 1961

42 GREENBERG, J. H. *The Languages of Africa* Bloomington, Indiana Univ. 1963

43 GUTHRIE, M. *Some developments in the Pre-history of Bantu Languages* J.A.H. III.2

44 HEROLD, E. *Tribal Masks from the Nráprestek Museum, Prague* London 1967

45 HERSKOVITS, M. J. *Backgrounds of African Art* Denver 1945

46 HIERNAUX, J. *Bantu Expansion* (1968) J.A.H. IX.4

47 HIMMELHEBER, Hans *Negerkunst und Negerkünstler* Braunschweig 1960

48 *The Concave Face in African Art* African Arts. IV/3 Spring 1971

49 HOLY, Ladislav *Edited and notes on plates by Margret Carey The Art of Africa Masks and Figurines from Eastern and Southern Africa* London 1967

50 HOOVER, Robert, L. *The Origins & Initial Migrations of the Bantu* Univ. of Colorado, Museum of Anthropology, Miscellaneous Series. No. 34. 1974

51 IMPERATO, Pascal James *The Whims of Termites* A.A. IX/3 Spring 1976

52 JEFFERSON, Louise, E. *The Decorative Arts of Africa:* New York 1973

53 KJERSMEIER, C. *Centres de Style de la Sculpture Nègre Africaine* 4 vols. Paris and Copenhagen 1935–38

54, 55, 56, KRIEGER, Kurt *Westafrikanische Plastik,* I, II, III (Berlin 1965, 1969, 1969) & **57** and KUTSCHER, Gerdt *Westafrikanische Masken* Berlin 1960

58 LAJOUX, Jean-Dominique *The Rock Paintings of Tassili* London 1963

59 LEIRIS, M. & DELANGE, J. *Afrique Noire* Paris 1967 *African Art* London 1968

60 LEUZINGER, Elsy *The Art of Black Africa* Studio Vista: London 1972

61 LHOTE, Henri *The Search for the Tassili Frescoes* London 1963

62 LOMMEL, Dr. A. & KECSKESI, Dr. Maria *Afrikanische Kunst* München 1976

63 MAIR, Lucy *Primitive Government* Penguin 1962

64 McNAUGHTON, Pat *The Throwing Knife in African History* A.A. Vol. III. 2. Winter 1969

65 MAQUET, Jaques *Afrique, les Civilizations Noires* Paris 1962

66 *Introduction to Aesthetic Anthropology* (Case Western Reserve University. A. McCaleb Module in Anthropology) Addison-Wesley Publishing Co. Inc. 1971

67 MAZONOWICZ, Douglas *Tassili* A.A. Vol. 2. No. 1. p. 24. Autumn 1968

68 MEAUZÉ, Pierre *African Art* (Sculpture) London Cleveland and N. York 1968

69 MERRIAM, Alan, P. *African Music in 'Continuity and Change in African Cultures'* (ed. William Bascom and Melville J. Herskovitz) Chicago 1959

70 MIDDLETON, John & TAIT, David *Tribes without Rulers* London 1958

71 MUENSTERBERGER, W. *Sculpture of Primitive Man* New York 1955

72 MURDOCK, George Peter *Africa. Its Peoples and their Culture history* New York 1959

73 OLIVER, Roland *The Problem of the Bantu Expansion,* J.A.H. VII 3

74 PAULME, Denise *African Sculpture* London 1962

75 PICKET, Elliot *The Animal Horn in African Art* A.A. Vol. IV No. 4

76 PLASS, M. Webster *African Tribal Sculpture* Univ. Mus. Philadelphia 1956

77 RICE, D. Talbot *The Background of Art,* London 1939

78 ROBBINS, Warren *African Art in American Collections* New York, London 1966

79 ROOSENS, Eugène *Images Africaines de la Mère et l'Enfant* (Publications de l'Université Lovanium de Kinshasa) Paris 1967

80 RUBIN, Arnold *African Accumulative Sculpture* Catalogue. Pace Gallery New York 1974

81 SCHWEEGER-HEFEL, Annemarie *Plastik aus Afrika* Museum für Völkerkunde Wien 1969

82 SELIGMAN, T. K. *An Indigenous Concept of Fakes?* p. 29 in Fakes, Fakers & Fakery: Authenticity in African Art A.A. Vol. IX/3 April 1976

83 SHINNIE, P. L. *The African Iron Age* Oxford 1971

84 SIEBER, Roy & CELENKO, Th. *Rayons X et art Africain* A.A.N. No. 21

85 SMITH, M. (ed.) *The Artist in Tribal Society* London 1961

86 SYDOW, Eckart von *Handbuch der Afrikanischen Plastik Band 1: Die Westafrikanische Plastik* Berlin 1930

87 *Afrikanische Plastik* ed. G. Kutscher Berlin New York 1954

88 THOMPSON, Robert Farris *African Art in Motion* U.C.L.A. Art Council Berkeley and Los Angeles 1974

89 TROWELL, M. *Classical African Sculpture* London 1954 2nd ed. 1964

90 *African Design* 1960 London 2nd ed. 1965

91 UCKO, P. & ROSENFELD, A. *Palaeolithic Cave Art* London 1967

92 UNDERWOOD, Leon *Figures in Wood of West Africa* London 1947

93 *Masks of West Africa* London 1948

94 *Bronzes of West Africa* London 1949

95 VANSINA, Jan *Les Zones Culturelles de l'Afrique* in *Africa* Tervuren 1961 Vol. 7 No. 2

96 *Inner Africa* in *Horizon History of Africa* New York 1971 p. 267

97 WASSING, R. S. *African Art; its Background and Tradition* N.Y. 1968

98 WESCOTT, Robert W. *Ancient Egypt & Modern Africa* J.A.H. Vol. 2 No. 2 1961

99 WILLETT, Frank *African Art* London 1971 reprint 1975

100 WINGERT, Paul S. *Further Style Analysis in African Sculpture* A.A. Vol. VI Winter 1973

I Western Sudan including Upper Volta

101 BEDAUX, R. *Tellem.* Berg en Dal 1977

102 CONVERS, Michel *Masques en Étain Senoufo* A.A.N. No. 16 Winter 1975

103 DIETERLEN, G. *Les Âmes des Dogons* Paris 1941

104 GOLDWATER, R. *Bambara Sculpture from the W. Sudan* New York 1960

105 *Senufo Sculpture from West Africa* Greenwich, Conn. 1964

106 GRIAULE, M. *Masques Dogon* Paris 1938

107 *Dieu d'eau Entretiens avec Ogotemmêli* Paris 1948

108 *The Dogon* in African Worlds; ed. Forde, D. 1954

109 *Le Renard Pâle:* Trav. Inst. Ethnol. Paris No. 72 1965

110 HIMMELHEBER, Hans *Figuren und Schnitztechnik bei den Lobi, Tribus* 15 Stuttgart August 1966

111 IMPERATO, Pascal James *Last Dances of the Bambara* Natural History April 1975

112 *Bamana and Maninka Twin Figures* A.A. VIII No. 4 Summer 1975

113 KNOPS, P. *Toxicologie Senufo* Bulletin de la Societé Royale Belge d'Anthropologie 1975, No. 86, p. 4762

114 *L'Artisan Senufo dans son cadre Ouest Africain* Bulletin de la Societé Royale Belge d'Anthropologie et de Préhistoire 70: 83. III. 1959

115 LAUDE, Jéan *African Art of the Dogon (The Myths of the Cliff Dwellers)* New York 1973

116 LEIRIS, M. & DAMASE, J. *Sculpture of the Tellem and the Dogon* Hanover Gallery London 1959

117 LEM, F. H. *Sculptures Soudanaises* Paris 1948 English translation: Sudanese sculpture London 1948

118 PAGEARD, Robert *Recherches sur les Nioniosse* in: *Études Voltaiques* Ouagadougou, 1963 Mémoire No. 4

119 SCHWEEGER-HEFEL, Annemarie *Die Kunst der Kurumba* Archiv für Völkerkunde 1962/63 Vienna XVII/XVIII p. 194–260

120 *Nioniosi-Kunst* Baessler Archiv. XIV 1966

121 SKOUGSTAD, Norman *Traditional Sculpture from Upper Volta* Catalogue, African–American Institute New York 1978

122 ZAHAN, Dominique *The Bambara* E. J. Brill, Leiden 1974

II Guinea and Sierra Leone

123 BERNATZIK, Hugo Adolf *Athiopien des Westens* Two Vols: Wien 1933

124 *Im Reich der Bijogo* Innsbruck 1944

125 DELANGE, Jacqueline *Le Bansonyi du Pays Baga* in *Objets et Mondes* 1962 11/1 p. 3–12

126 DITTMER, K. *Bedeutung, Datierung und Kulturhistorische Zusammenhänge der 'Prähistorischen' Steinfiguren aus Sierra Leone und Guinee:* Baessler Archiv N.F. XV. 1967

127 DUQUETTE, Danielle G. *Informations sur les Arts Plastiques des Bidyogo* A.A.N. No. 18 Summer 1976

128 EBERL-ELBER, Ralph *West-Afrikas Letztes Rätsel* Salzburg-Leipzig-Berlin 1936

129 GAISSEAU, Pierre-Dominique *The Sacred Forest (The fetishist and Magic Rites of the Toma)* London 1954

130 GORDTS, André *La Statuaire Traditionelle Bijogo* A.A.N. No. 18 Summer 1976

131 HARRIS, W. T. *The Idea of God among the Mende* in: Smith, E. W. ed. *African Ideas of God* London 1950

132 HARRIS, W. T. & SAWYERR, H. A. *The Springs of Mende Belief and Conduct* Freetown 1968

133 HELMHOLZ, R. C. *Traditional Bijago Statuary* A.A. Vol. 6 No. 1 Autumn 1972

134 PAULME, Denise *Les Gens du Riz* (Recherches en Sciences Humaines. 4) Kissi de Haute-Guinée Français Paris 1954

III Liberia and the Ivory Coast

135 DONNER, Etta *Kunst und Handwerk in Nord-Ostliberia* Baessler Archiv. 23 Berlin 1940

136 FISCHER, Eberhard and HIMMELHEBER, Hans *Die Kunst der Dan* Zurich 1976

137 G'BEHO, Philip *The Indigenous Gold Coast Music* Journal of the African Music Society I (5) 1952

138 HARLEY, George, W. *Notes on the Poro in Liberia* Papers of the Peabody Museum. Vol. XIX: No. 2 1950

139 *Masks as Agents of Social Control in North East Liberia:* Ibid., Vol. XXXII: No. 2 1950

140 HIMMELHERBER, H *Negerkünstler* Stuttgart 1934

141 *8 Vo Die Dan* Stuttgart 1958

142 MCLEOD, Malcolm, D. *Goldweights of Asante* A.A. Vol. V/1 Autumn 1971

143 MENEGHINI, Mario *The Grebo Mask* A.A. Vol. VIII: No. 1 Autumn 1974

144 MENZEL, B. *Goldgewichte aus Ghana* Museum für Völkerkunde Berlin 1968

145 NEBOUT, Albert *Notes sur le Baoulé* A.A.N. No. 15 Autumn 1975

146 PLASS, M. Webster *African Miniatures* Goldweights of the Ashanti New York 1967

147 RATTON, Charles *L'or Fétiche in L'Art Nègre* Paris 1951 *Fetish Gold* (abridged translation) University Museum Philadelphia 1975

147a RATTRAY, R. S. *Ashanti* (Oxford) 1923

147b *Religion and Art in Ashanti* Oxford Univ. Press London 1927

148 VANDENHOUTE, P. J. L. *Classification Stylistique du Masque Dan et Gueré de la Côte d'Ivoire Occidentale* Leiden 1948

149 VOGEL, Susan Mullin *People of Wood: Baule Figure Sculpture* Art Journal XXXIII/1 Fall 1973

IV and V Ivory Coast, Ghana, Togo, Benin (Dahomey) and Yoruba (Nigeria)

150 ARGYLE, W. T. *The Fon of Dahomey,* Oxford 1966

151 BEN AMOS, Paula, *Men & Animals in Benin Art Man,* Vol. II/2. June 1976

152 BEIER, Ulli *The Egungun Cult,* Nigeria, No. 51, Lagos 1956, p. 380–392

153 *The Story of Sacred Wood Carvings in one small Yoruba Town* Lagos 1957

154 *Gelede Masks* Odu, Ibadan 1958, No. 6, p. 5.3

155 BRADBURY, R. E. *The Benin Kingdom & the Edo speaking peoples of S.W. Nigeria* London 1957

156 *Divine Kingship in Benin* Nigeria LXII. 1959

157 *Chronological Problems in the Study of Benin History* J.H.S.N. I 1959

158 *Ezomo's Ikegobo & the Benin Cult of the Hand Man.* 1961 No. 61

159 *Benin Kingdom* London N.Y. Ibadan 1973 VW 301.2 199251

160 *Benin Studies:* ed. P. M. Williams London. N.Y. Ibadan 1973

161 BURT, Ben *The Yoruba and their Gods* Museum of Mankind, London 1977

162 CARROLL, Kevin *Yoruba Religious Carving:* London 1967

163 CHAPPEL, T. J. H. *Critical Carvers:* Man. 1972 N.S. 7:2

164 *The Yoruba Cult of Twins in Historical Perspective* Africa Vol. XLIV (Vol. 44:3). 1974

165 DAPPER, O. *Naukeurige Beschrijvinge der Afrikaensche Gewesten* Amsterdam 1668

166 DARK, Philip *The Art of Benin* Chicago 1962 *An Introduction to Benin Art and Technology* Oxford 1973

167 with W. & B. FORMAN *Benin Art* London 1960

168 DREWAL, H. J. *Gelede Masquerade: Imagery and Motif* A.A. Vol. VII/4. Summer 1974

169 *The Arts of Egungun among Yoruba peoples* A.A. Vol. XI/3. Spring 1978

170 *More Powerful than Each Other.* An Egbado classification of Egungun. A.A. Vol. XI/3, Spring 1978

171 and M. T. DREWAL *Gelede Dance of the Western Yoruba:* A.A. Vol. VIII/2 Winter 1974

172 EGHAREVBA, J. V. *A Short History of Benin* Ibadan: 1953

173 EYO, E. 1969 *Excavations at Ile Ife* A.A. III/2 1970

174 *Two Thousand Years [of] Nigerian Art* Lagos and London 1977

175 FAGG, Bernard *Nok Terracottas,* Lagos 1977 and London 1978

176 *New Light on the Nok Culture* World Archaeology Vol. 1 1969/70

177 FAGG, William, B. *Nigerian Images* London 1963

178 FAGG, William, B. and UNDERWOOD, Leon: *An Examination of the So-Called Olokun 'Head of Ife, Nigeria'* Man. Vol. 49 1949

179 FLEMING, STUART J. and WILLET, Frank *A Catalogue of Important Nigerian Copper-Alloy Coatings dated by Thermoluminescence* Archaeometry 18.2.1976

180 HERSKOVITS, M. J. *Dahomey,* 2 vols. New York 1938

181 HOULBERG, M. H. *Ibeji Images of the Yoruba* A.A. Vol. VII/1 Autumn 1973

182 *Egungun Masquerades of the Remo Yoruba* A.A. Vol. XI/3 Spring 1978

183 *Notes on the Egungun Masquerade among the Oyo Yoruba* A.A., Vol. XI/3 Spring 1978

184 LUSCHAN, F. von *Die Altertümer von Benin* 3 vols. Berlin 1919

185 MERLO, Christian *Ibedji, Hohovi, Venavi, Les statuettes Rituelles de Jumeaux en civilisation Beninoise* A.A.N., No. 22)

186 MORTON-WILLIAMS, Peter *The Yoruba Ogboni cult in Oyo* Africa 30 1960 p. 362

187 MURRAY, K. C. *The Stone Images of Esie and their Yearly Festival in:* Nigeria 37, 1951

188 NYENDAEL, D. van pub. in BOSMAN, W. *Naukeurige Beschrijvinge Van de Guinese* Utrecht 1704 A new and accurate description of the Coast of Guinea London 1705 reprint London 1907

189 PEMBERTON, J. *Eshu-Elegba: The Yoruba Trickster God* A.A. Vol. XI./1. Autumn 1975

190 *Egungun Masquerade of the Igbomina Yoruba* A.A. Vol. XI/3 Spring 1978

191 POYNOR, Robin *The Egungun of Owo* A.A. Vol. XI/3 Spring 1978

192 READ, C. H. & DALTON, O. M. *Antiquities from the City of Benin and from other parts of West Africa in the British Museum,* London 1899

193 RYDER, A. F. C. *A reconsideration of the Ife-Benin relationship* J.A.H. VI 1965

194 SHAW, C. Thurstan *Lectures in Nigerian Pre-History* Ibadan 1969

195 *Igbo-Ugwu: An Account of Archaeological Discoveries in Eastern Nigeria.* 2 vols. Evaston Illinois and London 1970

196 *Nigeria: Its Archaeology and Early History.* London 1978

197 STRUCK, B. *Chronologie der Benin Altertümer,* Zeitschrift für Ethnologie, 55. 1923

198 THOMPSON, Robert Farris *Black Gods and Kings:* Los Angeles 1971

199 *Aesthetics in Traditional Africa* in C. P. JOPLING (Ed.) *Art and Aesthetics in Primitive Societies* New York 1971

200 *Yoruba Artistic Criticism* in W. L. d'Azevedo (ed.) *The Traditional Artist in African Societies,* Bloomington, Illinois 1973

201 VANSINA, Jan *Kingdoms of the Savanna,* Milwaukee 1966

202 VOGEL, Susan Mullin *Gods of Fortune: The Cult of the Hand in Nigeria.* New York. Mus. of Prim. Art. 1974

203 WESCOTT, Joan & MORTON-WILLIAMS P. *The Symbolism and Ritual Context of the Yoruba Laba Shango* Journal of Royal Anthro. Inst. Vol. 92. p. 23 1962

204 *The Sculpture & Myths of Eshu Elegba, the Yoruba Trickster: Definition and Interpretation in Yoruba Iconography* Africa 1962, p. 336. Vol. XXXLL/4

205 WILLETT, Frank *Ife in the History of West African Sculpture* New York 1967

206 *The Benin Museum Collection* A.A. Vol. VI/4 Summer 1973

207 *An African Sculptor at Work,* A.A. XI/2 1978

208 and FLEMING, Stuart J. *A Catalogue of Important Nigerian Copper-Alloy Castings dated by Thermoluminescence* Archaeometry 18.2.1976

VI South East Nigeria and Niger Delta

209 ALAGOA, E. J. *Ijo Origins & Migrations* Nigeria Magazine No. 91

210 BOSTON, J. S. *Ikenga figures among the North West Igbo and the Igala* Lagos and London 1977

211 FOSS, Perkins *Images of Aggression: Ivwri Sculpture of the Urhobo in African Images,* Essays in African Iconology 1975 New York, London

212 Ed. D. McCALL & E. C. BAY, *Urhobo Statuary for Spirits & Ancestors* A.A. Vol. 9. No. 4, Summer 1976

213 HENDERSON, R. N. *The King in Every Man, Evolutionary Trends in Onitsha Ibo Society & Culture,* New Haven, Yale, London 1972

214 HORTON, Robin *The Gods as Guests,* Lagos 1960

215 *The Kalabari Ekine Society:* A borderland of religion and art. Africa 1963 33:2

216 *Kalabari Sculpture,* Nigeria 1965

217 JONES, G. I. *Sculpture of the Umuahia area of Nigeria* A.A. Vol. 6, No. 4. Summer 1973

218 MESSENGER, John C. *Anang Art, Drama and Social Control* African Studies Bulletin, 5. 1962

219 MURRAY, K. C. *Ekpu, the Ancestor Figures of Oron.* Burlington Mag. Vol. 89, Nov. 1947

220 OTTENBERG, S. *Masked Rituals of Afikpo; The context of an African Art* Seattle, 1975

221 PEEK, Philip M. *Isoko Sacred Mud Sculpture* A.A. IX/4, July 1976

222 RUBIN, Arnold *Figurative Sculptures of the Niger River Delta* Catalogue Gallery K. Los Angeles 1976

222a WELCH, James W. *The Isoko Tribe* Africa Vol. VII No. 2 1934

223 TALBOT, P. A. *Tribes of the Niger Delta:* London 1932

VII and VIII Central Nigeria, Benue River Valley, Chad, East Nigeria and Cameroon

224 BASSING, Allen *Masques Ancestraux chez les Idoma* A.A.N., No. 5 Spring 1973

225 BRAIN, R. & POLLOCK, A. *Bangwa Funerary Sculpture,* London 1974

226 EGERTON, F. Clement C. *African Majesty (Bamileke) A record of refuge at the court of the King of Bangangpe in French Cameroons.* London 1938

227 FRY, P. H. *Essai sur la Statuaire Mumuye in: Objets et Mondes,* Vol. X/I Paris, 1970

228 GEBAUER, Paul *Art of Cameroon:* A.A. Vol. IV, No. 2. Winter 1971

229 *Cameroon Tobacco Pipes,* A.A. Vol. V. No. 2. Winter 1972

230 GEBAUER, Paul and BASCOM, W. *West African Art,* Milwaukee 1953. (Public Museum Handbook 5)

231 GEBAUER, Paul and Clara *A Guide to Cameroon Art from the Collection of Paul & Clara Gebauer,* Oregon 1968

232 HARTER, Pierre *Four Bamileke Masks: an Attempt to Identify the Style of Individual Carvers or their Workshops* Man N.S. 4.3. 1969

233 *Les Masques Dits Batcham* A.A.N. No. 3

234 JANSEN, Gerard and GAUTHIER, J. G. *Ancient Art of the Northern Cameroons; Sao and Fali* Oosterhout 1973

235 JOSEPH, Marietta B. *Dance Masks of the Tikar:* A.A. Vol. VII, No. 3. Spring 1974

236 LEBEUF, Jean Paul *Archéologie Tchadienne Les Sao du Cameroun et du Tchad,* Paris 1962

237 LEBEUF, Jean Paul and MASSON-DETOURBET, Annie *Art Ancien Du Chad in Cahiers d'Art,* Paris 1951, No. 26, pp. 7–28

238 LECOQ, R. *Les Bamiléké, Une Civilisation Africaine,* Paris 1953

239 LINCOLN, Bruce *The Religious Significance of Women's Scarification among the TIV.* Africa, Vol. 45, No. 3, 1975

240 MEEK, C. K. *The Northern Tribes of Nigeria* Vols. I & II, London 1925

241 *A Sudanese Kingdom,* London, 1931

242 NADEL, S. F. *Nupe Religion,* London 1954

243 PICTON, John *Masks and the Igbirra* A.A., VII.2 Winter 1974

244 RUBIN, Arnold *Bronzes of the Middle Benue in West African Journal of Archaeology* 3 (1973) pp. 221–231

245 SCHWARTZ, Nancy, B. A. *Mambilla: Art & Material Culture* Milwaukee, 1972

246 SIEBER, Roy *Sculpture from Northern Nigeria* New York 1961

247 STEVENS, Phillips Jr. *Nupe Woodcarving in Nigeria 88*

248 *Nupe Elo Masquerade* A.A. VI/4 Summer 1974

249 *The Danubi Ancestral Shrine* A.A., X/I October 1976

IX Gabon and Congo (Brazzaville)

250 BOLZ, Ingeborg *Zur Kunst in Gabon,* Ethnologia, Cologne 1966

251 CHAFFIN, Alain *Art Kota* A.A.N. 5. Spring 1973

252 PERROIS, Louis *La Statuaire Fang Gabon,* Paris 1972

253 *La Statuaire des Fang du Gabon,* A.A.N., No. 7, Autumn 1973

254 *L'Art Kota, Mahongwe* A.A.N., No. 20, Winter 1976

255 SIROTO, Leon *The Face of Bwiti* A.A., 1/3 Spring 1968

256 TESSMANN, G. *Die Pangwe,* 2 vols, Berlin 1913

X and XI Lower Congo, Stanley Pool, Southwest and Central Zaïre

257 CLAERHOUT, Adrian *Two Kuba Wrought Iron Statuettes* A.A., Vol. IX. 4. Summer 1976

258 CORNET, Joseph *Art of Africa: Treasures from the Congo,* London, 1971

259 *Art from Zaïre,* New York 1975

260 *A Propos des Statues Ndengese,* A.A.N. No. 17, Spring 1976

261 *A Survey of Zaïrian Art,* The Bronson Collection, North Carolina Museum of Art, Raleigh, N.C. 1978

262 GELUWE, H. van *Préliminaires sur les Origines de l'Intérêt pour l'art Africain et Considérations sur le Thème de la femme dans la Sculpture Congolaise,* Africa-Tervuren 7/3 1961

263 HOTTOT, R. *Teke Fetishes* J.R.A.I. LXXXVI. 1956

264 LEHUARD, Raoul *Statuaire du Stanleypool,* Villiers-le-Bel, 1972

264a *De l'Origine du Masque 'Tsaye'* A.A.N. No. 23

265 *Les Phemba du Mayombe,* A.A.N., Arnouville 1977

266 Mac GAFFEY, Wyatt *The Religious Commissions of the Bakongo.* Man: 5:1, March 1970

267 with JANZEN, John M. *An Anthology of Kongo Religion,* (Univ. Kansas, publ. in Anthrop. 5. 1974)

268 MAES, J. *Figurines na Moganga de Guérison,* Paris 1927, Pro-Medico No. 3 & 4

269 *Aniota-Kifwebe: Figurines Commémoratives et Allégoriques du Congo Belge,* IPEK 77–91. 1928

270 *Figurines Npezo,* Pro-Medico. No. 2. Paris 1929

271 *Les Figurines Sculptées du Bas Congo,* Africa III/3, London 1930

272 *Les Appuis-Tête du Congo Belge* Annales du Musée du Congo Belge. VI:1:1

273 MAESEN, A. *Umbangu,* Brussels 1960

274 *Les Holo du Kwango in Reflets du Monde,* 9, 1965

275 *Art of the Congo* Walker Art Centre, Minneapolis 1967

276 *Une Masque de type Gitenga des pende Occidentaux du Zaïre* Africa-Tervuren, XXI–1975 (3/6)

277 OLBRECHTS, Frans M. and MAESEN, Albert *Plastiek van Kongo,* Antwerpen 1946

278 *Les Art Plastiques du Congo Belge,* Brussels 1959

279 ROSENWALD, Jean B. *Kuba King Figures* A.A., Vol. VII, No. 3, p. 26, Spring 1974

280 SÖDERBERG, Bertil *Les instruments de Musique au Bas-Congo* Stockholm 1956

281 *Les Sifflets Sculptés du Bas-Congo* A.A.N., No. 9, Spring 1974

282 *Les Figures d'Ancêtres chez les Babembé* A.A.N.: 13, 14, 1975

283 SOUSBERGHE, L. de *L'Art Pende,* Brussels 1958

284 TIMMERMANS, P. *Essai de Typologie de la Sculpture des Bena Luluwa du Kasai* Africa-Tervuren 1966

285 TORDAY, E. *Camp and Tramp in the African Wilds,* London 1913

286 *On the Trail of the Bushongo,* London 1925

287 with T. A. JOYCE *Notes Ethnographiques sur les Peuples Communement Appelés Bakuba. Ainsi que sur les Peuplades Apparenteés. Les Bushongo (Documents Ethnographiques Concernant les Populations du Congo Belge.* Bruxelles 1911

288 *Notes ethnographiques sur les peuplades habitant les bassins du Kasai et du Kwango oriental . . .* Brussels 1922

289 VANSINA, Jan *Initiation Rituals of the Bushong,* Africa Vol. XXV/2 1955

290 *Le Royaume Kuba,* Tervuren M.R.A.C. 1964

291 VAZ, Jose Martins *Filosofi Tradiconel dos Cabindas* Lisbon 1969

292 VERLY, R. *Les Mintadi: la Statuaire de Pierre du Bas-Congo* Louvain 1955

293 VOLAVKA, Zdenka *Nkisi Figures of the Lower Congo* A.A. Vol. 5, No. 2, Winter 1971

294 *The Ndunga, a Mask, a Dance, a Social Institution in the Ngoyo* A.A.N., 17 Spring 1976

295 WEEKS, J. H. *Among the Primitive Bakongo,* London 1914

296 WING, R. P. J. van *Etudes Bakongo II, Religion et Magie,* Brussels 1938

297 WIDMAN, Ragnar *Le Culte du Niombo des Bwendé,* A.A.N. No. 2, 1971

298 ZWERNEMANN, Jürgen *Spiegel-und Nagelplastiken vom Unteren Kongo im Linden-Museum Tribus,* No. 10, 1961

XII and XIII Southern Zaïre, Angola, Eastern and Northwestern Zaïre

299 BASTIN, Marie-Louise *Art Décoratif Tshokwe,* Lisbon 1961

300 *Arts of the Angolan Peoples,* Chokwe: A.A., Vol. II, No. 1

301 Lwena: A.A., Vol. II, No. 2

302 Songo: A.A., Vol. II, No. 3

303 Mbundu: A.A., Vol. II, No. 4 1968/69

304 *Les Styles de la Sculpture Tshokwe,* A.A.N. No. 19, Autumn 1976

305 *Statuettes Tshokwe du Héro Civilisateur Tshibinda Ilunga* Arnouville-France, 1978 Oral Comm. to Author 21.3.78

306 BAUMANN, H. *Die materielle Kultur der Azande und Mangbetu* Baessler Archiv II Berlin 1927

307 *Lunda, Bei Bauern und Jaegern in Inner Angola* Berlin 1935

308 BAXTER, P. T. W. & BUTT, A. *The Azande, and Related Peoples of the Anglo-Egyptian Sudan and Belgian Congo* Ethn. Surv. East. Central Africa Ed. D. Forde Part IX, London 1953

309 BIEBUYCK, Daniel *Bembe Art,* A.A., Vol. V/3, Spring 1972

310 *Lega Culture,* Berkeley 1973

311 *Sculpture from the Eastern Zaïre Forest Regions: Mbole, Yela & Pere,* A.A., Vol. X/1. 1976

312 *Sculpture from the Eastern Zaïre Forest Regions: Metoko, Lengola & Komo,* A.A. X/2 1976

313 BUCHNER, Max *Durch das Land der Songo* Allg. Zeitung, München 1883

314 BURSSENS, H. *La Fonction de la Sculpture Traditionelle chez les Ngbaka* Brousse Nr. 2. 1958

315 DIAS DE CARVALHO, H. A. *Expedišao Portugesa ao Muatiavua (1884–88) Ethnographia e Historia Tradicional dos Povos da Lunda,* Lisbon 1890

316 FLAM, J. D. *The Symbolic Structure of Baluba Caryatid Stools* A.A., Vol. IV, No. 2. Winter 1970

317 FORDE, Daryll, ed. *The Azande & Related Peoples of the Anglo-Egyptian Sudan & Belgian Congo—Ethnographic Survey of Africa* International African Inst. 1953

318 GOSSIAUX, Pol. P. *Recherches sur l'art Bembé* A.A.N. 11, Autumn 1974

319 HOFFMAN, A. T. *Croyances et Coutumes de Bapére Kingiri,* Aimo 1932

320 MAHIEU, Wauthier de *'Le Temps dans la Culture Komo'* Africa, XLIII (1973) 2–17

321 MARET, Pièrre de, DERY, Nicole and MURDOCH, Cathy *The Luba Shankadi Style,* A.A., VII I Autumn 1973

322 MERRIAM, Alan P. *Culture History of the Basongye* African Studies Program Indiana Univ. 1975

323 NEYT, François *La Grande Statuaire Hemba du Zaïre,* Louvain 1977

324 STRYCHER, L. de *Approche des arts Hemba* Viliers-le-Bel 1974

325 SCHWEINFURTH, G. *Heart of Africa* London 1874

326 TIMMERMANS, Paul *Les Sapo-Sapo Près de Luluabourg* in *Africa Tervuren,* Tervuren 1962, Vol. 8

327 TURNBULL, Colin *The Elima: A Pre Marital Festival among the Bambuti Pygmies* Zaïre XIV.4. 1960

328 *The Forest People,* London 1961

329 WOLFE, A. W. *Art and the Supernatural in the Ubangi District* Man. 1955. 76. p. 65–67

XIV Eastern Africa, Southern Sudan and Ethiopia

330 CLARK, J. D. *Dancing Masks from Somaliland,* Man LIII, 1953

331 Evans PRITCHARD, E. E. *The Bongo* in Sudan Notes and Records, Vol. XII. Part 1. 1929

332 HOFMAYR, W. *Die Shilluk,* Moedling 1925

333 HUNTINGFORD, G. W. B. *The Northern Nilo-Hamites* Ethnog. Surv. East Cent. Af., Part VI, London 1953

334 SELIGMAN, C. G. *A Bongo Funerary Figure,* Man XVII, 1917

335 *The Bari,* JRAI. LVIII. 1928

336 SHINNIE, P. L. *The Sudan-Meroe* London 1967

337 WESTERMANN, D. *The Shilluk People,* Philadelphia, Berlin 1912

XV East African Lakes, Kenya and Tanzania

338 ABRAHAMS, R. G. *The Peoples of Greater Unyamwezi, Tanzania* in Ethnographic Survey of Africa. Ed. D. Forde East Central Africa. Part XVII London. Internat. Af. Inst. 1967

339 ADAMSON, Joy *The Peoples of Kenya,* London 1967

340 BARRETT, W. E. H. *Notes on the Customs & Beliefs of the Wa-Giriama,* East Africa, J.R.A.I. XLI. 1911

341 BAUMANN, O. *Durch Massailand zur Nilquelle,* Berlin 1894

342 BLOHM, W. *Die Nyamwezi. Gesellschaft und Weltbild,* Hamburg 1933

343 BROWN, Jean *Traditional Sculpture in Kenya* A.A., Vol. VI. No. 1. Autumn 1972

344 CLARK, J. D. *Dancing Masks from Somaliland,* J.R.A.I. Vol. LXXXIII 1953

345 CORY, H. *African Figurines,* London 1956

346 GERMANN, P. *Zauberglaube und Mannbarkeitsfeiern bei den Wapare,* Deutsch-Ost Afrika, Yearbook of the City Ethnological Museum—Leipzig V. 1911

347 HARTWIG, Gerald W. *A Historical Perspective of Kerebe Sculpture* Tribus 18. 85–102. Stuttgart 1969

348 KROLL, H. *Plastische Menschendarstellungen von der Insel Ukerewe im Victoria See* Ethnolog. Anzeiger 1, 1933 (2nd enlarged edition)

349 LINDBLOM, K. G. *The Akamba,* Uppsala 1920

350 MIDDLETON, J. *The Kikuyu & Kamba of Kenya,* Ethnol. Surv. Part V. E. Cent. Af. London 1953

351 SWANTZ, Marja-Liisa *Ritual and Symbol in Traditional Zaramo Society* Uppsala 1970

352 TRACEY, Andrew *Kamba Carvers,* African Music II, 1960

353 WERNER, A. *The Bantu Coast Tribes of the East African Protectorate* J.R.A.I. XLV. 1915

354 WEULE, K. *Wissenschaftlische Ergebnisse meiner Ethnographischen Forschungsreise in den Südosten Deutsch Ostafrikas* Berlin 1908 (Mitteilungen aus den Deutschen Schutzgebieten Ergämzungsband I)

XVI and XVII Zambia, Malawi, North Mozambique, Africa south of the Zambesi and Malagasy

355 BARNES, J. A. *The Fort Jameson Ngoni* in 7 Tribes of British Central Africa Ed. Gluckman, M. & Colson, E. London 1951, Reprint 1961

356 BLACKMUN, Barbara & SCHOFFELEERS, M. *Masks of Malawi* A.A., Vol. V. No. 4. Summer 1972

357 CAMBOUE, Paul *Aperçu sur les Malgaches et leurs Conceptions d'art Sculptural,* Anthropos Vol. XXIII, 1928

358 DECARY, R. *La Mort et les Coutumes Funéraires à Madagascar,* Paris 1962

359 DIAS, Jorge, & DIAS, Margot *Os Macondes de Moçambique,* Vol. 1–4, Lisbon 1967–70

360 FRANZ, Mary Louise *Traditional Masks & Figures of the Makonde* A.A., Vol. III, No. 1. Autumn 1969

361 GARLAKE, Peter, S. *Great Zimbabwe,* London 1973

362 GLUCKMAN, Max *The Lozi of Barotseland in Northwestern Rhodesia* in: Ed. Gluckman, M. & Colson, E.

363 *Seven Tribes of British Central Africa* London 1951, reprint London 1961

364 HARRIES, Lyndon *The Initiation Rites of the Makonde Tribe* (Communications, Rhodes, Livingst. Inst. 3) 1944

365 JASPAN, M. A. *The Ila-Tonga Peoples of N. Western Rhodesia* Ethnographic Survey, East Central Africa, Part VI, London 1953

366 JUNOD, H. A. *The Life of a South African Tribe (Thonga)* London 1913

367 KUPER, Hilda *The Swazi, Ethnographic Survey of South Africa,* Part 1, London 1952

368 with HUGHES, A. J. B., & Van VELSEN, J. *The Shona and Ndebele of Southern Rhodesia* Ethnographic Survey of South Africa, Part IV, London 1955

369 LEUZINGER, E. *Zwei Alo Alos aus Madagaskar* in Museum Rietberg, Zurich in: *Festschrift Alfred Bühler,* 1965

370 REYNOLDS, Barrie *Magic, Divination & Witchcraft among Barotse of N. Rhodesia* Univ. Calif. Press 1963

371 RICHARDS, Audrey, I. *The Bemba of North Eastern Rhodesia* in 7 *Tribes of British Central Africa* Ed. E. Colson & M. Gluckman, London 1951

372 RICHARDS, A. I. & SCHOFIELD, J. F. 'Pottery Images or Mbusa used at the Usungu Ceremony of the Bemba People of Rhodesia' South African Journal of Science XLI, 1945

373 SHEDDICK, V. G. J. *The Southern Sotho* Ethnographic Survey of South Africa, Part II London 1953

374 SLASKI, J. *Peoples of the Lower Luapula Valley* Part II, Ethnog. Surv. E. Cent. Af., London 1951

375 STANNUS, H. S. & DAVEY, J. B. *The Initiation Ceremony for Boys among the Yao of Nyasaland* J.R.A.I. XLIII, 1913

376 TEW, Mary (Mary Douglas) *Lake Nyasa, Bemba* Ethno. Survey of Africa, East Central 1–2, London 1950

377 *Peoples of the Lake Nyasa Region* Ethnographic Survey Africa East

Central, Part I Oxford University Press, 1950

378 TREVOR, T. G. *Some Observations on the Relics of the Pre-European Culture in Rhodesia and South Africa,* J.R.A.I., XLVII, 1930

379 TURNER, V. W. *The Lozi Peoples of North Western Rhodesia* Ethno. Surv. E. Cent. Af. Part III, London 1952

380 VINNICOMBE-CARTER, Patricia *Myth, Motive and Selection in Southern African Rock Art* Africa 1972, Vol. 42:3

381 *People of the Eland,* Univ. of Natal Press, 1976

382 WEMBAH-RASHID, J. A. R. *Isinyago & Midimu Masked Dancers of Tanzania & Mozambique* A.A., Vol. VI/2, Winter 1970

383 WHITELEY, Wilfred *Bemba & Related Peoples of Northern Rhodesia* Eth. Surv. E. Cent. Af. Part II, London 1951

384 WILLCOX, A. R. *The Rock Art of South Africa,* Johannesburg 1963

385 WOODHOUSE, H. C. *Rock Paintings of Southern Africa,* A.A. Vol. II, No. 3, Spring 1969

Magazines and periodicals

African Arts (A.A.) Los Angeles. Quarterly

Archiv Für Volkerkunde, Vienna

Arts d'Afrique Noire (A.A.N.) Arnouville, France. Quarterly

Africa, Journal of The International African Institute, London

Africa-Tervuren, Tervuren. Quarterly

African Studies' Bulletin, New York

Baessler Archiv, Berlin

Bulletin de l'institut Français d'Afrique Noire, Paris and Dakar

Ethnologica, Cologne

Journal of African History (J.A.H.), Cambridge, England

Journal of The Historical Society of Nigeria, Ibadan

Journal de la Société des Africanistes, Paris

Kongo-Overzee, Brussels

Man—J.R.A.I. **Journal of The Royal Anthropological Institute,** London. Quarterly

Mededelingen van het Rijksmuseum voor Volkenkunde, Leiden

Nigeria, Lagos. Quarterly

Objets et Mondes, Revue du Museé de l'Homme, Paris

Papers of the Peabody Museum of American Archaeology & Ethnology, Harvard University

Présence Africaine, Paris

Primitive Art Newsletter, New York. Monthly

Tribus, Publication of the Linden Museum, Stuttgart

Zaïre, Louvain

Zie-Zeitschrift für Ethnologie, Braunschleig

Index